T0248581

THE IMAGE OF CELESTINA

Illustrations, Paintings, and Advertisements

ENRIQUE FERNÁNDEZ

The Image of Celestina

Illustrations, Paintings, and Advertisements

UNIVERSITY OF TORONTO PRESS
Toronto Buffalo London

ISBN 978-1-4875-4978-7 (cloth) ISBN 978-1-4875-4980-0 (EPUB)
 ISBN 978-1-4875-4982-4 (PDF)

Library and Archives Canada Cataloguing in Publication

Title: The image of Celestina : illustrations, paintings, and advertisements /
 Enrique Fernández.
Names: Fernández, Enrique, 1961– author.
Description: Includes bibliographical references and index.
Identifiers: Canadiana (print) 20230484093 | Canadiana (ebook)
 20230484115 | ISBN 9781487549787 (cloth) | ISBN 9781487549800
 (EPUB) | ISBN 9781487549824 (PDF)
Subjects: LCSH: Rojas, Fernando de, –1541. Celestina. | LCSH: Rojas,
 Fernando de, –1541. Celestina – Illustrations. | LCSH: Celestina
 (Fictitious character) in art.
Classification: LCC PQ6428 .F47 2023 | DDC 862/.2–dc23

Cover design: Chris Crochetière, BW&A Books, Inc.
Cover image: *La Celestina*, by Vicente Arnás Lozano, 2012, oil on canvas.
Reproduced by permission of the artist.

We wish to acknowledge the land on which the University of Toronto
Press operates. This land is the traditional territory of the Wendat, the
Anishnaabeg, the Haudenosaunee, the Métis, and the Mississaugas of the
Credit First Nation.

This book has been published with the help of a grant from the Federation
for the Humanities and Social Sciences, through the Awards to Scholarly
Publications Program, using funds provided by the Social Sciences and
Humanities Research Council of Canada.

University of Toronto Press acknowledges the financial support of the
Government of Canada, the Canada Council for the Arts, and the Ontario Arts
Council, an agency of the Government of Ontario, for its publishing activities.

Canada Council Conseil des Arts
for the Arts du Canada

ONTARIO ARTS COUNCIL
CONSEIL DES ARTS DE L'ONTARIO
an Ontario government agency
un organisme du gouvernement de l'Ontario

Funded by the Financé par le
Government gouvernement
of Canada du Canada

Contents

Illustrations

Cover image: *La Celestina*, canvas by Vicente Arnás Lozano, 2012. By courtesy of the painter.

Acknowledgments

I want to thank the Social Sciences and Humanities Research Council of Canada (SSHRC) for awarding me the Insight Grant 435-2014-0519 that allowed me to conduct the research for this book. In addition, the University of Manitoba offered me financial support through grants, teaching releases, and sabbatical leaves that expedited the writing process. The first steps in my research were supported by Joseph T. Snow, who allowed me to access and scan his vast collection of Celestina documents and images. With them, I started the online database celestinavisual.org, which has been instrumental in the production of this monograph.

A unique experience during the composition of this book was the opportunity to meet artist, painters, graphic artists, and theatre professionals, whose commentaries and materials gave me new perspectives on the figure of Celestina.

Within the academic world, Amaranta Saguar García, María Bastianes, Enriqueta Zafra, Beatriz de Alba Koch, and Rachel Schmidt helped with their expertise in different aspects of Celestina's rich visual history. Especially helpful were the commentaries and corrections by the anonymous readers to whom the University of Toronto Press sent my original manuscript for evaluation. They helped me write a better book, not only by correcting my mistakes but also by pointing out connections that I had not followed in my initial version. I want to thank Suzanne Rancourt, editorial director, Humanities, at the University of Toronto Press, for her interest in the book and and for her efficient and expeditious guidance through the publication process. I am especially indebted to those who proofread the manuscript: my wife, Lynne Fernandez, and Karalyn Dokurno. Maria Rodrigo Tamarit helped as research assistant, and her expertise in art was a great asset.

Summary of *La Celestina* (c. 1499)

Published at the end of the fifteenth century in Spain, the book originally entitled *Comedy of Calisto and Melibea* and later *Tragicomedy of Calisto and Melibea and the Old Bawd Celestina* eventually became known simply as *La Celestina*. It is a tragic love story believed to have served as an inspiration for Shakespeare's *Romeo and Juliet*. Not surprisingly, sometimes *La Celestina* is described as a "dirty" *Romeo and Juliet* because sexual activity and the worlds of prostitution and crime are explicit in the text. It is uncertain who the author or authors of *La Celestina* were, but a young student of law at the University of Salamanca, Fernando de Rojas, played a role in its creation. The text is written exclusively in dialogue but is intended to be read aloud, not performed onstage.

The action takes place in an unnamed city, which could be Salamanca or Seville, in the same period in which the book was published. It is the tragic love story of a young man of middle nobility named Calisto, who becomes infatuated with Melibea, the only daughter and heiress of the very rich Pleberio. The story begins when Calisto accidentally runs into Melibea upon entering her garden to recover a falcon that flew away when he was hunting. In the ensuing conversation, Melibea is offended by his direct words and rebuffs his open sexual advances. Back home, he burns with sexual desire for her, which he expresses in the hyperbolic language of courtly poetry, reflecting half-baked erudition. On the advice of his duplicitous servant Sempronio, Calisto hires Celestina to convince Melibea to give in to his desires. The elderly Celestina is a former prostitute who has known better days. She works as a procuress and also restores hymens and practises sorcery. Two young women are working as prostitutes under her control. Celestina is cunning and knowledgeable of human weaknesses, which makes her rhetoric irresistible.

As part of her plan, she needs to convince Pármeno, a teenage servant of Calisto, to join her and Sempronio in taking advantage of their master's infatuation with Melibea. Celestina succeeds in bringing Pármeno into the plot by offering him the sexual favours of her pupil Areúsa. Later, with the excuse of selling yarn, Celestina gains access to Pleberio's house and to Melibea. Behind the back of Melibea's parents, Celestina persuasiveness, with the help of a spell, easily breaks the young woman's initial resistance to Calisto and convinces her to agree to an intimate date in her garden at night. The couple eventually consummate their love, but soon things take a tragic turn. Celestina is murdered by Calisto's servants Pármeno and Sempronio after she refuses to share the generous payment Calisto offered for her mediation. The two murderous servants are immediately apprehended and executed in the public square. Meanwhile, Calisto continues his nightly visits to Melibea's garden. One night, after enjoying a month of clandestine sexual encounters, he falls from the ladder he uses to climb over the high walls surrounding Melibea's garden and immediately dies. Driven mad by the death of her lover, Melibea commits suicide by jumping from a tower in her house in the presence of her father, who in vain tries to dissuade her. His lamentation by the dead body of his only child is a pessimistic denunciation of life as a grim affair in which suffering and irrationality rule.

Although she dies halfway through the story, Celestina drives the actions of the other characters and is the most memorable character. She became a prototype in Spanish literature. The underworld of prostitution and delinquency in which she thrived was integral to the development of the genre of the Spanish picaresque novel, which developed in the two following centuries. Today *La Celestina* is considered second only to *Don Quixote* in the Spanish literary canon, although it never received the international acclaim of Cervantes's book. Nonetheless, the success of *La Celestina* was immediate, and it was translated into the main European languages in the decades following its original publication. Visual renderings of this central character were included in the first editions of the book, many of which were illustrated, and have continued to be created to this day.

THE IMAGE OF CELESTINA

The Visual Culture of Celestina

Human beings communicate with words, not with images; this is why a specific language of images would appear as a pure and artificial abstraction ... But there is more: for human beings, an entire world is expressed by means of significant images ... This is the world of memory and of dreams.

Pier Paolo Pasolini[1]

Five Hundred Years of Images of Celestina

La Celestina (*LC*) is not only a crucial text in the history of literature but also the origin of myriad images at whose centre is the character of Celestina. She escaped the confines of the text to become a prototype, even a myth. This book refers to the whole of these images as Celestina's visual culture or visual legacy.[2] This legacy contains the images of the original literary character and those of the book eventually renamed for her, as well as those of the prototype and mythical figure she soon became. Some images in this visual corpus, such as the images in illustrated editions of *LC*, clearly represent Celestina in only one of these specific senses. Other images are difficult to ascribe to a single category, such as illustrations that include the character of Celestina or paintings with the word "Celestina" in the title. To that latter group belongs Picasso's famous 1904 *Portrait of Carlota Valdivia*, also known as *La Célestine*, which includes elements from both the literary character and the prototype.

Because the Celestina character contains the germ of the rest of the book, any image of Celestina can also be considered a form of illustration of the book. The opposite is also true: that is, not only is the rest of the book implicit in the character of Celestina, but Celestina is implied in any episode or character of the book. Even if she is not included in

the image, her presence is implied in illustrations of episodes of *LC* and promotional pictures of screen and stage adaptations. Celestina looms even on the many modern book covers of *LC* that, instead of depicting human figures, display objects, such as keys, empty ladders, or bleeding hearts.

The first items in the long history of Celestina images were the seventeen woodcut illustrations of the allegedly first edition (Burgos, usually dated to 1499), soon followed by many other illustrated editions.[3] Eventually, images inspired by the central character of Celestina, jumped to canvases and other media. The resulting imagery is of interest not only because it documents the reception of *LC* and its many sequels but also because it plays a significant role in other social and cultural manifestations. An example is Sorolla's canvas *Trata de blancas* (White slave trade, 1894) (image 28). It includes the figure of an old minder presiding over a scene with trafficked women at the end of the nineteenth century. This woman is depicted with features that can be traced back to the original Celestina: although she is elderly, and a humble, dark cloak covers her head, she projects a controlling, alert demeanour. By analysing the implications of including a Celestina character in a painting intended as a statement about the controversial legalization of prostitution at the time, we may gain many insights. We can learn not only about how *LC* was read at the time but also about contemporary debates about prostitution.[4]

The ascent of the character of Celestina started soon after the publication of the *Comedia de Calisto y Melibea*, which soon came to be referred to simply as *La Celestina*.[5] Equally soon after the publication, this character, who also practised sorcery and other trades, both licit and illicit, became a multifaceted literary and popular type, and came to be used as the generic moniker in Spanish for any procuress or intermediary in amorous liaisons.[6] Many Celestina-inspired characters pullulated in the literature and folklore of Spain and other Spanish-speaking countries, as well as in the visual arts. To avoid confusion with the use of the word "Celestina," this book follows certain conventions. It will use "*La Celestina*," generally abbreviated as "*LC*," to refer to the book. "Celestina" in Roman font refers to the original literary character. Different reincarnations through art and literature are referred to as "a Celestina," "a Celestina character," or "a Celestina type."[7]

Although this use of the same word to refer to the original literary character and her later recreations and reincarnations may seem imprecise, it is a workable solution. It foregrounds the ambiguous yet undeniable continuity between Celestina and her descendants. It would be difficult and often counterproductive to mint more specific terminology

to specify the exact relation these Celestinas redux have with the original literary character. They can be the surviving original Celestina – some sequels and traditions assume that she was not actually killed, and that her magic made her immortal. They can also be a reincarnation, a daughter or other descendant, or a generic procuress or madam. In many of the images I will examine, the authors of the images intentionally keep this relation ambiguous, calling their production simply "Celestina" in the title and relying on the viewer to recognize her as such.[8]

I will avoid forcing the Spanish word *celestina* into English when referring to images from countries outside the Spanish-speaking world depicting women who arrange sexual encounters. In such images in which the direct influence of Celestina, both literary character and prototype, cannot be posited, we use the English term "procuress." This English word covers the meaning that the generic Spanish term *celestina* implies, although many subtleties are unavoidably lost. In this book, "procuress" is used as the translation of *alcahueta* in Spanish, *maquerelle* in French, *ruffiana* in Italian, *Kupplerin* in German, and *koppelaarster* in Dutch in the titles or texts accompanying the images. When referring to modern prostitution, we will use the more modern word "madam."

As continuations and recreations of the original story and characters came out, various aspects of Celestina were added, emphasized, or ignored.[9] The descendants of Celestina are so numerous that she can be considered a mythical figure, as Jéromine François does in her recent 2020 monograph. Celestina is clearly not an ethno-religious myth, even if she is connected to some illustrious ancestry reaching back to antiquity. She is a specific human figure and the epitome of another kind of mythical figure: the one developing from a literary character through later rewriting and elaboration, such as Faust, Don Quixote, or Don Juan. Like them, her multifaceted figure encapsulates several themes, or "mythemes" in Lévi-Strauss's terminology, ready to be activated according to the context. Every time the word "Celestina" appears, it acts as a condensed indicator or pointer that evokes the whole text and its vast descendance.[10]

The visual culture of this Celestina, the mythical figure, which includes and widely exceeds the literary text in which she originates, is the theme of this study. Unfortunately, unlike other Spanish literary figures such as Don Quixote and Don Juan, she was largely excluded from the broader European imaginary: there is no edition of *La Celestina* illustrated by Doré, or operas or ballets by non-Spanish composers based on her character. While modernity forgave, and even celebrated, the sins of Don Juan and the insanity of Don Quixote, Celestina's immorality

was not embraced, and she remained a popular figure only in Spanish-language countries.

Celestina has unique characteristics that make her especially suitable for the type of comprehensive study I am undertaking. In contrast to Don Juan and Don Quixote, Celestina's visual images started at the same time as the text was published in the profusely illustrated Burgos *Comedia*. No other literary title from this period was illustrated so early in its publishing history. The reasons range from their genres' lack of tradition of including illustrations to the financial situation of the printing press at the moment of their publication. *Don Quixote*'s early editions had no illustrations: its images began to slowly develop only decades after its first publication.[11] *El burlador de Sevilla y convidado de piedra* (The trickster of Seville and the stone guest, 1616), the play in which Don Juan appears for the first time, was published without images, and a visual tradition developed only much later, mostly in nineteenth-century illustrated editions of remakes of the story.[12] Other Spanish literary classics, including *Lazarillo* (1554) and picaresque novels, were rarely illustrated before the twentieth century. Similarly, significant books published during the early modern period in other countries did not develop a visual culture until much later – the first illustrated edition of any of Shakespeare's work appeared only in 1709.[13]

The other characteristic that makes the visual culture of Celestina suitable for comprehensive transhistorical study is that it is large and varied enough to yield significant results. This is not the case with, for instance, the Spanish literary myth of Don Juan. Don Quixote meets and surpasses this criterion, but its visual culture is of such daunting proportions that a comprehensive treatment would require volumes. Illustrated editions of *Don Quixote* range into the hundreds, while the illustrated editions of *LC* amount to around seventy. The canvases and other images of these literary myths reach equally large numbers. The result is that the visual culture of Celestina constitutes a sizable yet manageable and well-defined corpus extending across five centuries. It takes the form of illustrations and paintings but also images in promotional posters and other advertising media in the entertainment industry.

Not all of these different forms and media are uniformly represented across the centuries. For instance, only in the twentieth century did show business promoters start to publicize images of *La Celestina* – of its adaptations to the stage and later to the screen. In contrast, the illustrated editions are a relatively constant presence since the book first appeared, although an important gap exists. After the illustrated editions that appeared in the sixteenth century, the publication of *LC*, with

and without illustrations, ceased by the mid-seventeenth century. It did not restart until nearly the second half of the nineteenth century, but it has since continued to the present day. Celestina images on canvas and other formats used by artists were popularized by Goya and the Spanish *costumbrista* school of painting in the nineteenth century, and Celestina characters remain a common painterly motif.

A noticeable absence in the visual culture of Celestina is that of canvases depicting episodes from the book itself. Unlike Don Quixote, whose adventure with the windmills has been depicted in canvases ad nauseam, not a single episode of *LC* has become a painterly motif. Only Celestina herself made it into painting, in a myriad of different scenarios, mostly unrelated to the plot of the text in which her character originates.

Despite its significance, the visual culture of Celestina was mostly ignored until a few decades ago, when it began to be studied in a piecemeal fashion.[14] The early illustrated editions of *LC*, Picasso's paintings of Celestina-like characters, and various screen and stage adaptations have been most analysed. Many other images are only briefly mentioned or are ignored altogether. Departing from these valuable studies, this book aims to trace the entire range of the visual culture of Celestina, as well as to establish criteria for its significance and classification.

The Methodological Frame of Visual Studies

The transhistorical study of the images of Celestina is made feasible by the recent digitalization of images by libraries, museums, and archives, which makes them easily available.[15] Most importantly, the study profits from the relatively recent discipline of visual studies' approach to images as signs that can be read like a linguistic system. For visual studies, images are signs with their own grammar of representation, which permits us to analyse them with techniques that originate in literary studies, from philology to cultural studies. As in these disciplines, the approach of visual studies emphasizes the need to consider the images' historical context.

This consideration of historical context is implied in Dikovitskaya's often quoted definition of visual studies as "a research area and a curricular initiative that regards the visual images as the focal point in the process through which meaning is made in a cultural context."[16] Visual studies' emphasis on meaning as the result of circulation in concrete social contexts lies in the discipline's origins. Visual studies originated as the combination of two disciplines in which the historicity of their subjects is central: art history and cultural studies. This historicizing

approach does not oppose but further attunes previous methods in the analysis of images, such as Gombrich's model of image perception through cultural schemata, or Arnheim's theory of visual input being filtered through psychologically predetermined patterns. Visual studies adds to these approaches the undeniable fact that subjects who perform those psychological processes are not ahistorical but "caught in the congeries of cultural meanings."[17]

Also important for our analysis of Celestina imagery is a tenet visual studies inherited from cultural studies: the freedom to apply methods from disciplines ranging from literature to painting to architecture. This methodological leeway allows us to resort to the trove of LC scholarship. Another advantage of visual studies' latitude for the choice of approaches is that it allows us to treat images as creations subject to an atemporal aesthetic criterion, in other words, as art.[18] In this study, I refer to art critics' judgment as well as my own informed opinion. To approach, for instance, the posters of stage and screen performances with the eye of an art critic enables me to relate them to paintings and other manifestations of the visual culture of LC.

To put both types of images under the same light is possible thanks to another important tenet of visual studies: the freedom to treat low and high culture as related, and not radically separate, entities.[19] This licence is especially pertinent to this study because the distinction between low and high culture was not operative when LC was written and its early illustrated editions printed. These illustrations were not conceived as high art but as commercial, mass-produced images. However, today, as we find them in rare books, we cannot but see them as high culture. The same impossibility of separating low and high culture applies when we think that Goya's engravings of Celestina characters were born as low culture, and became high culture only much later. Analysing low and high culture together is central to understanding how the promotional images of Celestina continue previous trends in Celestina visual culture.

Finally, visual studies' understanding of words and images as similarly functioning signs allows us to take advantage of the reality that Celestina images are always next to text.[20] This proximity can be literal, as in illustrations and advertising, and metaphorical, as in paintings. In illustrated editions, the images are interspersed through the printed text. Equally, in advertisements, Celestina images are surrounded by headings announcing the show and by taglines, often taken directly from the text. In paintings, even if the title does not include the word "Celestina" or a similarly clear reference, the mere presence of her easily recognizable figure evokes the whole text of LC.

All these formats in which Celestina's figure appears surrounded by words exemplify Mitchell's insight that all art is mixed media.[21] The concept of both images and words as equally codified signs to be interpreted allows us to approach this image/word hybridity of Celestina's visual culture. Yet, when we take this approach, we have to avoid several pitfalls implied by the specific nature of the visual side. One, as Mitchell warns, is that the "image is the sign that pretends not to be a sign, masquerading as ... natural immediacy and presence."[22] The deceiving immediacy of images is a mirage, and we must keep reminding ourselves of their nature as a complex, codified sign. We also have to avoid treating the images as mere "translations" of the text into the visual realm, a luring trap, especially in the case of the illustrated editions. We must not treat images as the translation of text, because semiotic systems are not synonymous, as Benveniste exemplified when he stated that we cannot "[say] the same thing with spoken words we can with music as they are systems with different bases."[23] We especially have to avoid overlooking the aspects of one system that cannot be easily rendered in the other. In the case of the present study, we must avoid overlooking the visual aspects that are outside the linguistic perspective.[24] An image of Celestina, no matter how much it may reflect her description in the text, is neither the same as nor freely interchangeable with the text.

Organization of This Book

The size, variety, and temporal extension of the visual culture of Celestina compel us to separate the images into groups. In this book, I divide the images into three threads, based on their medium and format, dedicating a chapter to each. This partition is most appropriate because the meaning of Celestina images highly depends on how their media and format are perceived in each period. The analysis of Goya's *Maja y Celestina al balcón* (*Maja* and Celestina on the balcony, c. 1808; image 26), for example, yields different meanings when we encounter it on the cover of a modern edition than as a canvas in a museum. Equally, an early illustration takes on a new meaning when it is reproduced as an example in the prologue of a modern edition.

The first of our three threads comprises the illustrations that accompany the text in the illustrated editions of *LC*. The second deals with the paintings, mostly oil on canvas but also autonomous works in other media, that portray Celestina and Celestina-like figures. The final thread examines the images used for the advertising of a Celestina product for sale. These include the images on the hardcovers of *LC* editions and

those used for the promotion of performances of *LC* as stage or screen adaptations.

This formal division has many advantages but also a few problems. One of the main advantages is that, indirectly, it provides a basic chronological scaffolding for this study, because some media and formats are the exclusive or predominant product of a specific period. The most evident case are the images used for advertising cinema and stage performances, which appeared only when *LC* began to be adapted for performance in the early twentieth century. The same chronological specificity applies to the images on hardcovers – not to be confused with the illustrated title pages – which started to be produced only toward the end of the nineteenth century, when this kind of printing on hard surfaces became economically feasible. A similar chronological specificity of image format applies to the illustrated editions of *LC*, although, in this case, two separate periods are clearly identifiable. The first period is that of the early illustrated editions, which extends through the sixteenth century and into the first decades of the seventeenth. Illustrated editions then disappear for over two centuries, until the early nineteenth century, when a second period, which lasts until today, established itself. The resulting two groups of illustrated editions, then, are clearly separated in time, as well as in style and intention, as I explain in chapter 2.

The second thread, that of paintings of Celestina, cannot be confined to a single period, because artistic elaborations of her figure appear at different points in history. Given this continuous presence, I organize this side of Celestina images by schools of painting and other categories traditionally used in art history. For instance, I analyse the many genre paintings portraying tavern and merry-making scenes in which there is a procuress present produced by several masters of the Golden Age of Dutch genre paintings. Some luminaries in painting history, such as Goya, Picasso, and, most recently, Botero, had a lifelong engagement with the figure of Celestina. We treat each one individually. These movements and painters provide a basic chronological frame upon which to place other Celestina paintings.

The division of the images into three threads based on medium and format also has the advantage of grouping them according to their proximity to the text of *LC*. This is so because the selected media and formats imply how representationally faithful the images are to their inspiration. Illustrations, by definition, are the most faithful because they are images born to be subservient to a text. They have to faithfully follow the text and the description of the characters, transferring them into images that "illustrate" the text to make it easier to understand.

However, as will be clear from the analysis of the actual illustrations in chapter 2, their representational relation to the text is not that simple.

The second group, consisting of paintings considered as an independent art form, is the freest in its representational relation to *LC* and the character of Celestina. The connection between paintings and the figure of Celestina varies, with some being not far removed from the textual description and the traditional type of Celestina. Sometimes the relationship, not so evident at first sight, is reinforced by the inclusion of the word "Celestina" in the title of the painting, as in Picasso's famous 1904 *Portrait of Carlota Valdivia / La Célestine*. In other cases, a combination of the title and the features of the portrayed figures clearly establishes the connection, as in Sorolla's canvas *Trata de blancas* (White slave trade, 1894). In yet other works, neither the title nor the features of the figures depicted suffice to clearly connect the subject to Celestina. Another example of the difficulty in precisely connecting an image and *LC* is the aforementioned paintings of the Dutch Golden Age period depicting procuresses in tavern scenes that recall the banquet in Celestina's house in act 9 of the book. Given the wide circulation of the book in Dutch and German translations at the time, as well as the strong political presence of Spain in the Netherlands, *LC* may have influenced some of these canvases. Even if it did not, these paintings influenced later images of Celestina. Moreover, many appear on covers of twentieth-century and later editions of *LC*, therefore affecting readers' reception of the text.

Finally, the images of the third group, the promotional materials, relate to Celestina and *LC* in a way also predetermined by their format and medium. Images on modern hard-cover editions of the book are conditioned by a tenet of the modern book industry: illustrated covers do not have to represent the content of the book so much as allude to or suggest it. Following this principle, designers often take liberties in selecting or creating images that do not represent any episode or character of the book. Bleeding hearts, spider webs, or the reproduction of pre-existing paintings of carousing young couples and evil-looking old women are common. Placed under the title *La Celestina*, printed in big font, these images become vague promises of exciting content. The promotional materials of stage and film adaptations of *LC* are also designed to maximize allure, but they are bound by an implicit vow of fidelity that recalls the work of illustrators. However, designers of show business advertising are bound not by the text, but by the actions shown on the stage or screen.

This division of Celestina images also has the advantage of respecting the specificity of artistic technique and styles each medium and format imposes. Illustration is a variety of commercial art and, as such,

demands images that are fast and easy to reproduce, and tends to rely on linear art. Destined to be printed in the small format of a book page, often sharing space with text, illustrations cannot include much detail. In the case of early woodcuts, the added difficulty of carving in dense wood made, for instance, the inclusion of detailed facial expressions impossible in the small sizes required for page illustrations.[25] Painting, despite its artistic freedom, is also regulated by stylistic conventions and traditions regarding the treatment of figures, compositions, and so on. Finally, advertising images are also strongly conditioned by their materiality and display conventions. Images on modern hard covers are often repurposed paintings that had to be trimmed to fit their new location and make space for the all-important title and author. Promotional images for theatre and film are mostly made of pictures, especially close-ups of the actors, with a tendency to present the main actors in standardized poses.

The book is organized into three chapters corresponding to the above-mentioned threads. The first chapter, "Illustrating Celestina," deals with the illustration of the book. This comprehensive review of illustrated editions contains new hypotheses with regard to the publishing history of LC and analyses how these images illuminate aspects of the reception of the text, such as the ascent of Celestina, the eroticization of certain episodes, and so on.

Chapter 1 opens with an examination of the implications of a text accompanied by illustrations and the diverse ways in which images and words can interrelate when they share a page. I explore how illustrators facilitate readers' reception of texts, a task that makes illustrators a special kind of reader who aligns not with the writers but with the readership.[26] Their task – often with the input of the editor and sometimes, perhaps, the author – starts with the all-important moment of choice.

The chapter includes two sections dealing with the two different periods of illustrated editions of LC. The first focuses on the period of the early illustrated editions (1499–1616). In it, I discuss the reasons and consequences of the high percentage of illustrated editions of LC compared to other books of the time. I analyse in detail the illustrations of the 1499 Burgos edition and try to reconstruct its creation. The chapter then summarizes the use of illustration in the early years of the printing press in Spain as well as the influence of German engravers. I use the iconographic program of the 1499 Burgos as a guide for examining later illustrated editions of this first period, including the illustration of new scenes. The modifications introduced in the 1520 Augsburg and a 1545 Zaragoza are examined, especially their treatments of the banquet

scene. I pay attention to the abundant inclusion of double scenes in a woodcut, as well as the inconsistences in portraits of the same character and house interiors. This section concludes with an analysis of the title pages of the early editions, which pays special attention to how they reflect a gradual ascent of Celestina against the other characters.

The chapter then moves on to the illustrated editions that started to appear in the nineteenth century and are still being produced. It analyses how new readings of the book as a romantic text influenced the two illustrated editions of the nineteenth century and examines how the new printing technologies based on lithographic methods made possible a new form of illustrating. A detailed analysis of the images of Gorchs's 1841 edition, the first with illustrations in this later period, is followed by the analysis of the illustrated editions until today. They are divided into two groups: the expensive illustrated editions for bibliophiles and the economical ones, some for young readers. Some editions for bibliophiles, especially those printed in France, started the trend of images that openly eroticize parts of the text, a move that eventually caught on in Spanish editions. Picasso's famous engravings accompanying the text of *LC* fall within this category, even if they are not illustrations in the traditional sense but his own recreations. The section concludes with an analysis of the mostly romantic overtones of editions for young readers, as well as of the recent influence of comics.

The second chapter, "Painting Celestina," focuses on free-standing artworks – largely paintings on canvas, but on some other media as well – that feature Celestinas and Celestina types but were not created as book illustrations. These images are not directly connected to the events narrated in *LC*: they are free interpretations of the mythical figure of Celestina, many based on real women who worked as procuresses and madams. The chapter takes account of the chronological, geographical, and stylistic diversity of these painting and examines their often-realistic scenarios.

The chapter opens by differentiating between illustration and painting. It then establishes the criteria for considering a painting part of the visual culture of Celestina. These criteria are intentionally wide to permit the inclusion of paintings with the word "Celestina" in their title and those representing procuresses. The first section examines images of procuresses produced before the publication of *LC*, including rare images from antiquity, such as Greco-Roman mosaics that depict *lenae* (women in charge of prostitutes). I also examine the few cases that exist in manuscripts and as moralizing carvings in religious buildings before moving on to the more abundant images of procuresses in fifteenth- and sixteenth-century moralizing and satirical engravings of northern

Europe. I analyse the procuresses in the doomsday scenarios in Bosch's paintings and in the theme of the temptations of Saint Anthony and then examine the allegorical figures standing for greed and other vices that display the same features of the procuresses. An important group of canvases that contain a procuress are the many representations of the episode in the Parable of the Prodigal Son in which he lives with prostitutes. These images became a genre in northern Europe, especially in the Low Countries, and painters as important as Vermeer, Steen, and van Honthorst repeatedly produced them. Given the connection of this area with Spain, the influence of Celestina on these depictions cannot be discarded.

This chapter also examines the paintings by Murillo and other artists of the Spanish Golden Age that depict Celestina in scenes of picaresque life. However, the ascent of Celestina as a stock character in visual formats starts clearly with Goya, through his treatment of *majas* and Celestinas in his engravings and paintings. Goya's caricaturizing treatment of the old woman and her brutal contrast with the beautiful *maja* are studied here. I analyse the Celestina images in *costumbrista* painting, especially by Alenza and Lucas Velázquez. Then I examine the presence of Celestina in the social paintings that denounced the unjust treatment of prostitutes at the end of the nineteenth century. The chapter also includes a summary of the estheticized visions of the trade in Romero de Torres's and Zuloaga's paintings of the early twentieth century.

The recurrence of Celestina in Picasso's work is studied in detail as an example of his unique treatment of her figure as an ally or an enemy across his different stylistic periods. The chapter concludes with the recurring figure of Celestina in Latin American *costumbrista* paintings and the highly personal treatment in the quaint brothel scenes by the world-famous Colombian painter Botero.

The third chapter, "Advertising Celestina," explores a mostly ignored group of images, those used to advertise and sell Celestina as a product. These are the images that appear on the illustrated hard covers of modern editions of *LC* and on the playbills and other advertising materials of its stage and screen adaptations. All the promotional images share similarities imposed by their advertising function and the specific format to which they are adapted. These images began to appear toward the end of the nineteenth century, when technical advances in printing and marketing strategies made them possible.

Hard covers of *LC* on which images could be printed began to be technically possible only in the nineteenth century thanks to lithographic printing and advances in the manufacturing of paper. Posters and other

types of advertising material began to be printed in this period thanks to similar advances. Together they provide us with valuable insights into the reception of *LC* at the precise moments when its text and, later, its performance were marketed as a commodity. Their creators selected images to highlight facets of the book that they deemed enticing, in order to attract specific readerships and audiences, and they influence how the Celestina product was consumed or interpreted by those who acquired it. In addition, these images are useful for the study of the intra-history of Celestina's visual culture because they are often recreations of existing paintings or illustrations.

The first illustrated book cover (Barcelona, 1833) reproduces an old engraving from a title page. It is, however, altered to make the book look attractive while keeping the prestige associated with its long publishing history. The reproduction of old engravings is only one type of modern *LC* cover: a widespread practice was, and continues to be, to reproduce existing paintings. Images by Goya and Picasso, as well as other pertinent images, are used for these covers, although strange choices of apparently unrelated images are common. In all cases, the images serve to emphasize particular aspects of the text, from its old pedigree to its romantic erotic content, often with images of young couples from the Renaissance and the Romantic period. The ascent of Celestina as the protagonist of the story is also detectable in these covers. However, the romantic aspects of the text are commonly emphasized through the image of the lovers, or of Melibea alone.

The chapter then deals with the promotional images for adaptations of *LC* for the stage and screen. It analyses the images in posters, lobby cards, and similar materials. Although cinema and live theatre are different forms of show business, they are clearly connected in their use of advertising techniques. They both rely on a contract of veracity that makes them use images only of what is actually shown on stage or on screen, with photography as the favoured medium. The chapter includes a detailed analysis of the promotional images used in 1909 for the stage adaptation of *LC* by the company of Carmen Cobeña in Madrid. The predominance of images of the most famous actor as the main graphic element can already be detected at this early date.

Then I analyse the advertising images for some of the most important stage adaptations as well as the few cinema adaptations. Several aspects of the story are emphasized in these images, depending on the audience they target and the popularity of the actors in the performance. In the case of the movies, because they were made in a brief period in which the eroticization of the screens was predominant, a voyeuristic

approach is detectable. I also examine the moments of choice in these promotional images compared to their equivalents in the early and later illustrated editions.

Lastly, the conclusion provides some final comments on the visual culture of Celestina as a whole and its relation to *LC* and the myth of Celestina.

Illustrating Celestina

The illustration of *La Celestina* started with the seventeen engravings in the Burgos edition (usually dated to 1499). Since then, around seventy illustrated editions have been published in two periods neatly separated by the two hundred years, between the early seventeenth and early nineteenth centuries, in which *LC* was not issued in any format. There are over thirty illustrated editions from the first period (1499–1616), while those published in the second period (1841–present) number in the forties. These two periods are separated not only in time but also in the technique and style of their images. The images of the first period are monochromatic woodcuts, while those of the second period are sometimes in colour and are reproduced with techniques ranging from lithography to photographic printing. The images of the two periods diverge also in fundamental aspects of content and style, such as the choice of which episodes to illustrate. Despite their differences, all meet the generic condition of being images that share the printed page with a text.

Although the mixture of text and image is as old as the practice of writing, scholars have only recently begun to theorize how the two elements interact.[1] Hodnett defines three relations between text and image on a page: representation, interpretation, and decoration. Decorative images, such as non-figurative designs around the margins of a text or elaborate capitals and uncials, do not enter a descriptive relation with the content of the text and, therefore, do not pertain to our study, even if they are important for the study of books as material culture.[2] In contrast, representation and interpretation are pertinent to the kind of interaction between images and text characteristic of illustrated books. The images in these categories differ in their descriptive proximity to the text they accompany. Images that function as representation stand closest to the text, which they aim to render in visual terms. Images

that function as interpretation take liberties in their highly subjective rendering of the text.

Barthes proposes a somewhat similar classification of how images and words relate, through anchorage and relay. Images act as anchorage when they select or "anchor" a specific meaning among the many implied by the text. They act as if they answer the question "What is it?" in a selective or partial way. Images act as a relay when they expand on the significance of the text, making the final meaning a combination of both images and words with results that are deeper than those of the two components on their own.[3]

In most of the illustrated editions of *LC*, images relate to the text as representation – or anchorage, in Barthes's typology. As Hodnett puts it in speaking about England, "through the first four centuries of English book illustrations ... the typical illustrator was primarily a craftsman with a modest idea of himself, one that excluded passion and vision and concentrated mainly on technical proficiency."[4] Such comments are also perfectly applicable to Spain. The illustrators' creations fulfil the traditional role of images as "illustrations" in the etymological meaning of throwing light on a text. They faithfully render it in visual terms and make it easier to understand.

Gombrich considers this subservient role of illustrations in relation to text in illustrated editions to be integral to the logocentric Western tradition and a constant in the role of visual arts since the Renaissance:

> Speaking somewhat schematically, it may be argued that from the Renaissance to the eighteenth century, the function of art was conceived in the same way as it had been in ancient Greece – the artist should show his mettle by interpreting known texts. It was the "how" and not the "what" the connoisseur admired and pondered. He appreciated the way the painter rendered a particular episode from the Bible or from the Classics and desired to share and understand the reaction of participants through an act of imaginative empathy.[5]

Even if, after the Romantic period, painting and other visual arts became more independent from discourse, the supremacy of words over images in illustrated books has continued until today. Readers of modern illustrated books still expect images to be subservient to the printed text. Readers of literary works especially tend to privilege textual aspects of the book over its images, and they are, as Hodnett puts it, "more likely to welcome pictures of characters and settings 'the way they really looked' than the way they might have appeared to Pablo Picasso."[6] Aware of readers' expectations about the role of illustrations,

most illustrators of *LC* conceived their work as the faithful visual rendering of the text.

This faithfulness of illustrators to the content of the text of *LC*, their desire to depict simply what the text says, provides us with insights inot how they interpreted the words they read. Despite their privileged position in the editorial process, illustrators – the name we use here to encompass all the people involved in the design and making of the illustrations, including the editor, who is often the most influential person in the selection of images – are readers who align not with the author but with the reader, because their images originate in their reading of the text and not in the author's mind.[7] They are influential readers because they precondition other readers' understanding of the passage they illustrate and, by extension, of the whole text. Furthermore, illustrators are attentive, gifted readers capable of conveying the subtleties of their interpretations in images. The choice of the episodes to illustrate, a crucial decision that Hodnett dubs "the moment of choice," is the first step in their interpretation.[8] This choice may be imposed or influenced by the editor and the author, who may specify the events to illustrate or, most often, the number of illustrations to be included and their locations in the printed book.

The specific moments chosen by an illustrator among the many possible "snapshots" contained in a text provide us with important insights into their readings. As we will see, the moments of choice of the first period of illustrated editions of *LC* differ considerably from those of the second period, evidencing radically different readings. Besides the moment of choice, the editor's and illustrator's framing of the scene and other compositional decisions of what to include or exclude reveal key aspects of their reading. A good example is the gradual promotion of the Celestina character from the background to the foreground in the woodcuts on title pages. This move matches the parallel ascent of Celestine's name in the book title, in detriment to those of Calisto and Melibea.

Art history helps us understand other aspects of an image, such as the inclusion of common compositional schemes to position characters in complex scenes.[9] These schemes can be borrowed from sources as varied as sacred history or the illustrations of sentimental romance of the early modern period. These sources reveal the iconographic traditions illustrators had in mind when they were creating their images. Thus, the illustrator of the 1514 Valencia edition represented the fall and death of Calisto with a visual scheme borrowed from the deposition of Christ: an empty ladder standing in the background with the dead body in a slanted position, as one of those carrying the corpse is in a

kneeling position (image 1). The result is a compositionally attractive combination of intersecting vertical and horizontal lines. The decision of the illustrator to deploy this well-known compositional scheme indicates that, while they pondered how to represent the scene, a connection between the deaths of Calisto and Christ occurred to them.[10]

We can also reconstruct illustrators' readings of *LC* by understanding the strategies they resort to in their difficult role as inter-semiotic translators between words and image. Their task requires transferring meanings between two systems that rely on radically different forms of encoding the surrounding world into signs. One of the main differences between the systems derives from the dissimilar ways in which words and images relate to the categories of time and space. Famously, Lessing, in his *Laocoon: An Essay on the Limits of Painting and Poetry*, states that images and words depend on space and time for their transmission: images are seen in space and words are read in time. A consequence of this difference in transmission is that the two systems have difficulties in expressing the category that they do not use for their transmission. Thus, images are ill suited to express the passing of time because they are snapshots of a single moment in time.

To cope with this obstacle, visual artists traditionally recur to seriality and repetition to express the passing of time, as in cartoons. This strategy is not only central for illustrators but also for Western art in general, which tends to produce images in series, such as the cycle of the Passion of Christ.[11] The procedure implies the repetition of the characters – and occasionally of the backgrounds – across several consecutive images but with changes in each to convey the sensation that time has passed.

A close look at this technique of repetition and change provides us with interesting insights into how the illustrator envisions the characters. As we will see, to make the characters easily identifiable from one illustration to the next, their clothing and personal objects – Calisto's hat and sword, Celestina's money bag – are used as defining attributes in each image. The choice of attributes shows what features of the characters, such as their social position or age, the illustrator emphasizes. Equally revealing of how the illustrator conceives the characters are their gestures and positions. Thus, we can see them using their hands in rhetorical gestures in the early editions and in more dynamic and dramatic postures in modern editions.

The First Period of Illustrated Editions
of *La Celestina* (1499–1616)

In this first period, we find approximately forty illustrated editions of *La Celestina*, published between the 1499 Burgos and the 1616 Antwerp

translation into Dutch.[12] The dates of production of these editions are not uniformly spread across the decades. The vast majority were published in the first half of the sixteenth century, at an average of five per decade; by contrast, in the second half of the century, only one or two per decade were published.[13] This unequal distribution coincides with the book's popularity, which reached its acme in the first part of the sixteenth century, especially in the three first decades.

The second part of the century saw fewer editions, both illustrated and non-illustrated, but this decrease affected the illustrated editions most. This significant reduction in illustrated editions reflects the well-known decline in the quality of the printing industry at the time. Although the crisis in the industry was a pan-European phenomenon, it was especially noticeable in Spain, which, unlike Italy, France, and Holland, had not developed a thriving printing sector.[14]

As the sixteenth century progressed, the scarcity of paper and the demand for cheap editions affected illustrated books, which were costly due to the added labour and paper they required. Savings in paper were achieved by reducing the size and number of illustrations, as well as by using smaller font sizes and minimizing white space. These new practices resulted in the text of *LC* being compressed into fewer and fewer pages. The magnitude of the reduction can be appreciated if we compare the ninety-two quarto folios that, according to Griffin, were used in the 1499 Burgos illustrated edition to the sixty-four in Cromberger's illustrated editions (Seville, 1502 and 1511) and the even fewer folios in later editions.[15]

The approximately forty illustrated editions of *LC* represent about 40 per cent of the over one hundred illustrated and non-illustrated editions of the title issued in this first period.[16] The proportion of illustrated editions is clearly high, but how does it compare with similar books of the period? Unfortunately, no title offers a perfect basis for comparison, as no text with such a regular inclusion of illustrations was printed in Spain for such a prolonged period or in sufficient quantities to provide a useful parallel. Comparing *LC* with a book published in another country is of limited value, because the conditions of the book trade varied considerably.

Given these difficulties, the most appropriate comparators are the chivalry books.[17] Such a comparison is only partially valid, because it matches a single title to a whole genre. This evaluation cannot be limited to just one chivalry book: not even the popular *Amadís de Gaula* had enough editions, much less illustrated editions, for a meaningful comparison. Trying to balance the terms of the comparison by using, instead of *LC* alone, the *celestinesca* corpus (Salazar y Torres and de la

Cruz's *La segunda Celestina*, Salas Barbadillo's *La hija de la Celestina*, and so on) is not feasible either, because these sequels never reached enough momentum to be considered a cycle. Moreover, the *celestinesca* titles were rarely published with illustrations.

Despite all these caveats, the publishing conditions of the chivalry books as a group show enough similarities with those of *LC* to serve as a valid basis for comparison. For example, in its first period, *LC* was in print during the same years as the chivalry books, which started with *Amadís de Gaula* in 1496 (no copy survives until 1508) and *Historia de Oliveros de Castilla y Artús d'Algarve* in 1499, ending with *El espejo de príncipes y caballeros III* in 1623. Also, chivalry books are literary texts, and, as such, they were often illustrated. Sometimes the same printers of the illustrated editions of *LC* printed chivalry books with illustrations clearly similar in style and execution.[18]

For the numbers in my comparison, I rely on Lucía Megías's estimates that around one hundred chivalry books were printed in Spain in this period. Although he does not give exact numbers, he clearly notes that few were illustrated beyond the title page.[19] This limited output of illustrated editions, compared to the forty or so illustrated editions of *LC*, shows that the ratio of illustrated editions of *LC* is exceptionally high for a book of literary fiction in the period

This exceptionally high proportion of illustrated editions can be attributed to a coincidence of factors. As Cacho Blecua proposes, there is a strong tendency for an illustrated title to keep being printed when an important illustrated edition is produced early in its publishing history, as was clearly the case with the 1499 Burgos.[20] This first illustrated edition of *LC* compelled subsequent printers to illustrate their editions in order to be competitive. Including illustrations made a printed book competitive not only with other books but also in the still buoyant market of manuscript copies, often illustrated, circulating in the early years of the sixteenth century.[21] Illustrations not only beautified books but also made them more valuable for their owners, who often annotated and even memorized whole passages to quote in their own writing, with the illustrations serving as interpretative and mnemonic aids. The theory that the Burgos inspired publishers to illustrate later editions is supported by how its iconographic program was copied in these later editions. Even the two illustrated editions closing this early period, the 1590 Salamanca and 1616 Antwerp, respect most of the moments of choice and the general design of Burgos.

It is difficult to understand why the printer of the Burgos edition, Fadrique de Basilea, took the risk of investing in the costly illustration of a new, untested title. The widespread practice was to illustrate only

proven bestsellers. As Canet Vallés states, possible explanations for this decision, such as the need to publish new titles to obtain fast profits, would be factors only in later decades.[22] Indeed, Burgos stands out in peculiar isolation, as Alvar notes, both because it is an unprecedented case of a costly edition of a new text and because, against the norms of the period, its woodcuts were never reused for later editions.[23]

Canet Vallés has advanced a curious idea to explain why Fadrique de Basilea took the financial risk of printing such a lavishly illustrated edition: *LC* was meant as a teaching text to be adopted by some professors at the University of Salamanca. They wanted to reform the content and manner of teaching in Spanish universities and, in this, had the support of a powerful figure, Cardinal Cisneros. The book offered them a valuable teaching tool because of its many references to the classics and the possibilities it opened up for studying moral issues in a practical context. If the Burgos *LC* was a tool in this reformation, a wide readership was assured. This guarantee, along with the likelihood of a substantial advance payment, would have lessened the financial risk of publishing an illustrated edition. To support this hypothesis, Canet Vallés adds that the fact that only one copy of this edition survived is due to the use and abuse of teaching materials. He notes, for example, that all of the *cartillas escolares* (readers or primers) that were widely used to teach reading at the time have been lost.

One of the strongest points in Canet Vallés's argument is that it places this edition and its production at the centre of the university milieu. In support of this argument, we can adduce the illustrated edition of Terence's *Eunuchus* by Conrad Dinckmut, published in Ulm in 1486. This first printed illustrated work of a German translation with a commentary on the comedy "is strongly didactic, aimed at drawing moral lessons from Terence's play for the education of younger readers, reflecting a contemporary trend in southwest Germany of employing Terence's plays for this particular purpose."[24] Last but not least, there is the influence of the 1493 Lyon Terence, which is discussed below. This edition of Terence's comedies is the first illustrated classical work in original Latin and that set a precedent for other classical setting set a trend for subsequent editions of other classical texts. Although *LC* is not a Latin classical text, it is seen as a "comedy" in the tradition of Terence.[25]

Another explanation for the inclusion of images in the first and later editions of *LC* is related to the use of images for meditative practices. Saguar García attributes the inclusion of images in *LC* to the popularity of the *imago agens*. It was a practice of the period based on memorizing an image of the suffering of Christ to move the reader to moral behaviour. A related practice would justify the presence of the violent images

of the falls and deaths of Calisto and Melibea. The inclusion of other images, such as the banquet in Celestina's house or the visit of Celestina to the houses of Calisto and Melibea, could contribute to a moralizing reading of the text.[26]

Another factor that helps explain why the first edition of LC was illustrated is that the book appeared at a unique stage of early printed illustration. Between the end of the fourteenth and the beginning of the fifteenth centuries, printers had to include illustrations in their books to compete with the market for hand-written copies. But this need to compete was short lived, extending only until the last two decades of the fifteenth century and the first two of the next century. As the production of printed books exploded during the sixteenth century, their prices went down so much that the commercialization of handmade copies was not profitable anymore. Printers, not needing to compete with these copies anymore, gradually eliminated costly illustrations. Had LC been born more than a few years before, the printing press in Spain would have been too embryonic to produce such a profusely illustrated book. If it had been born more than a few decades later, it would have been most likely published in a non-illustrated format except for a title page and a few factotums (woodblocks of generic characters that could be used to illustrate any episode). Then, we could have passed on it a sentence often applied to the shoddy editions in which the masterpieces of Golden Age Spanish literature were first published: "magnificent content in a poor container."[27]

The 1499 LC not only appeared at the right time but was printed in the right shop for illustrated books. Fadrique de Basilea's press met all the conditions for the task. It had an lineage of high-quality illustrated books as well as the technical expertise and connections with German printers who had produced high-quality illustrated books for the previous two decades. Many print-shop owners in Spain were of foreign origin, mostly from German-speaking areas: Fadrique de Basilea himself was, as his name suggests, from Basel. In Spain, they chose to establish themselves in cities such as Burgos, Salamanca, Seville, Zaragoza, and Valencia, where they were assured steady business. These were university cities and religious capitals with a bishopric, which regularly required printed bulls and other publications. These and other regularly commissioned documents of one or two pages provided them with the regular income they required.

The business of printing depended on the constant advancement of capital. Paper was expensive – the highest cost of production – and it was necessary to own several sets of movable letters, which needed regular replacement. The sale of all the copies of a given work could take a

long time and was not assured: books were an expensive product, attractive only to that minority of the population that was literate and affluent. Referencing sixteenth- and seventeenth-century Spain, Chevalier estimates that eighty per cent of the population had no interest in printed books, because they were illiterate and/or could not afford them.[28] Consequently, it was common for printers to go out of business in the early (and even later) period of the printing press. Given the societal benefits of printed materials, the authorities, including the Catholic Monarchs, sometimes afforded printers a form of protection. In these precarious circumstances, fictional books were only a fraction of a printer's output, and were insufficient on their own to keep a business afloat. The production of fiction grew only as books became cheaper, and readership increased as the sixteenth century progressed.

The inclusion of images in printed books was a double-edged sword: it increased their appeal and marketability but also made them more expensive. Placing images next to the printed text had begun soon after Gutenberg invented the press. The addition of visual materials was the logical next step in adapting old manuscripts and their illuminations to the new medium. In a few cases, hand-painted images were added after a book was printed. However, a new method that allowed the mechanical reproduction of images was needed to keep up with the printing of the text.

The most suitable technique for placing images next to the lines of movable type under the screw press was adapting the pre-existing technique of woodcut images (also known as engravings) to this new task.[29] This technique involved cutting out the main lines of an image in relief on a slab of wood. Confusingly, the term "woodcut" (and sometimes "woodblock") is applied both to the carved planks and the images they leave on the page when pressed. The few carved planks to have survived reveal the time-consuming, delicate process their creation required. Once the narrow lines made to stand in relief were directly drawn or copied by a process of tracing on the wood, the surrounding material had to be painstakingly removed with high precision. This technique for reproducing images developed long before the printing press. In Asia, textile patterns and even images accompanied by words had been hand printed using this technique since antiquity. In Europe, a similar technique was used in the late fourteenth and early fifteenth centuries to produce religious images, playing cards, and the chapbooks (booklets made up of a few pages in which words and images cut out in a wood plank were hand printed).[30]

Eventually, woodblocks were integrated into the printing of books with movable type.[31] The page, composed with movable metal letters

in relief, could accommodate a woodcut between lines of text. The main difficulty was to set the type and the woodblocks at exactly the same height in the galley (wooden frame) and to apply the pressure uniformly in order to obtain a proper impression. The production of a printed book with woodcuts required several collaborators, whose roles are difficult to demarcate. As discussed above, those involved in the process probably had to consider the input of editors and perhaps authors regarding what episodes to represent. The person(s) who designed the images and those who cut them in wood may or not be the same. In addition, those who cut out the images in the wood plank, known as the woodcutters (*Formschneider* in German), were often divided between the masters, who did the intricate parts, and inexperienced workers and apprentices, who did the easy ones. All groups were considered manual workers, and their names have rarely survived.[32]

The first datable printed book with woodcut illustrations is *Edelstein*, a collection of fables with one hundred one woodcuts, published by Albrecht Pfister in Bamberg in 1461 – only six years after Gutenberg's famous Bible. Other printers in German-speaking areas were pioneers in combining woodcuts and printing. Among them are Zainer and Grüninger: the latter is considered the inventor of factotums and produced illustrations that, as we will see, directly influenced those of the 1499 Burgos *LC*.[33]

It took a few years for the use of woodcuts in books to arrive in Spain, where printed books with illustrations were rarely found before 1490. The first known case is an edition of Rolevinck's *Fasciculus temporum* published by Bartolomé Segura and Alonso del Puerto in 1480 in Seville. This book was originally published in Cologne in 1474, and it had great success due to its practical content: a compendium of ecclesiastical and secular world history. The engravings in the Spanish edition are different from those in the German edition but are the same as those found in a version printed in Venice in 1479.[34] This first illustrated book printed in Spain exemplifies a characteristic we see twenty years later in the Burgos *LC*: the use of foreign models. The images used in Spanish books of the fifteenth century were at first printed mainly from woodcuts imported from Germany and other countries and were copies made from illustrations published in these other countries.[35]

In spite of this relatively economical option of copying images from earlier books, very few of the three hundred known books printed in Spain in this early period had images. This select group includes fiction and didactic titles, such as Enrique de Villena's *Los doce trabajos de Hércules* (1483), and the profusely illustrated edition of Aesop's fables printed by Hurus and Planck in 1482 under the title *Isopete istoriado*. In

the 1490s, as the production of books matured in Spain, more and better engravings were included. By the time *LC* appeared in print at the end of that decade, the use of engravings was a well-established practice in the Spanish printing press.[36]

Fadrique de Basilea's *Comedia de Calisto y Melibea* (Burgos, 1499?)

Fadrique de Basilea's print shop exemplifies the state of the art in Spain at the time. He published over eighty incunabula, some of them illustrated. Some of his most profusely illustrated books, such as his edition of Badius's *Stultifera navis* (c. 1499), include images copied from the German editions of the same titles. His editions of *Cárcel de amor* (1496) and of Philippe Camus's *Historia de Oliveros de Castilla y Artús d'Algarve* (1499) are just as profusely illustrated (image 2). These two books' engravings show many points in common with those in his *LC*, as we will see. Equally connected to *LC* because of the theme is the title page – the only illustration in the book – of his *Tratado de amores de Arnalte y Lucenda* (1491).

Some scholars believe that Fadrique de Basilea included over eighty different engravings in his books, but a complete catalogue of his engraving does not exist. In any case, among printers in the Kingdom of Castile, he included the most engravings, and he was second in the number of illustrated books and the quality of his engraving only to Hurus, who worked in the Kingdom of Aragon and produced eighteen illustrated books.[37] Fadrique and Hurus both originated from German-speaking areas, and they had strong professional connections to each other. Fadrique's engravings are often copies of other engravings from German sources via the editions of Hurus, who brought woodcuts from Germany, since bringing the artisans themselves to Spain was too expensive. This influence is so strong that some scholars consider Fadrique de Basilea to be a Castilian branch of Hurus's press.[38] The illustrations in the Burgos *LC* are no exception to this practice, and, even if they are not taken directly from any of Hurus's books, the influence of those books is clear.[39]

The only extant copy of Fadrique de Basilea's illustrated *LC*, housed today in the Hispanic Society of America, has generated much debate regarding its actual date of printing. This copy is missing at least the title and the final pages. The colophon with the name Fadrique de Basilea and the date 1499 is a facsimile of the lost original. The Gothic type used matches the one used by this print shop in this period. Despite the date on the facsimile, scholar have proposed printing dates ranging from

1499 to 1502. Those who think it was printed in 1499 consider it, if not the *editio princeps* of *LC*, at least one of the oldest ones. Should the 1499 date be correct, this places the publication at the same time as an edition supposedly printed in Salamanca that year, although nothing definitive is known about that version of the book. For our purposes, there is little doubt that Burgos is the first illustrated edition of *LC*. Most important, it set the iconographic program for the first hundred-year period of illustrated editions. However, if the Burgos edition was printed after 1500, the first image of *LC* would be the title page of the 1500 Toledo edition by Hagenbach, which is not illustrated beyond the title page.[40]

The sixteen different woodcuts in Fadrique de Basilea's *Comedia de Calisto y Melibea* (one is repeated, making a total of seventeen illustrations) were made specifically for the book. The actions they depict are so true to the text that it would have been impossible to find pre-existing images that would have matched the actions. Although the engravings are completely original in this sense, their style and execution respond to the standardized design of the day. Artistic innovation was not expected in book illustrations or many other art forms – Dürer, whose engravings stand out for their originality, is the exception. The norm was to save time and money by adapting established patterns inherited from medieval art. Thus, when illustrators needed to represent new situations, they resorted to ingenious transformation and adaptation of pre-existing models.[41]

The illustrations for the Burgos *LC* were clearly produced following this practice. The illustrator needed to illustrate a new story. Despite its innovations, the text of *LC* was related to the *comedia humanistica* and the Roman comedy, the sentimental romance, and even the chivalry. Not surprisingly, the illustrator resorted to illustrated books of these genres for inspiration. Modern critics notice striking similarities between the images in the Fadrique de Basilea *LC* and the buildings and human figures in Terence's illustrated comedies published by Trechsel in Lyon in 1493, known as the Lyon Terence, and by Grüninger in Strasbourg in 1496.[42] The influence of the comedies is significant, given the vital role that Terence played in the rebirth of the classical tradition, especially of the Roman theatre. Griffin states that this similitude of images "suggests that its first known printer considered *LC* to be a descendant of classical comedy and to form part of a long tradition of drama, albeit a drama which was at that time thought to be unactable."[43] More recently, Cull added an earlier illustrated play by Terence to this list of influencing images, the *Eunuchus* published in Ulm in 1486.[44] Yet there were also clear differences in the illustrations. Rodríguez-Solás points out that, while the Burgos *LC*'s engravings are

dynamic, Trechsel's and Grüninger's are static, an issue I will expand on later in this chaper.[45]

The illustrators of the Brugos edition were also influenced by the engravings in books of sentimental romance, a popular genre related to *LC*.[46] The woodcut in Burgos of Calisto lying in his bed, pining for Melibea, strongly resembles the lovesick Leriano in Hurus's *Cárcel de amor* (Zaragoza, 1493). Interestingly, the image in *Cárcel de amor* was previously used to illustrate Louis Cruse's edition of Camus's *L'Histoire d'Olivier de Castille* (Geneva, 1492).[47]

Illustrators of later editions of *LC* continued to seek inspiration or even copy images from books in genres related to its subject matter. Thus, the 1534 Venetian edition used factotums inspired by illustrations of Plautus's comedies. For the title page of the 1507 Zaragoza edition, the printer, Coci, used the same image that appeared in his 1493 edition of *Cárcel de amor*. Similarities across genres play a role in explaining why a few woodcuts from the Burgos *LC* were reused in later books. A good example is the Burgos engraving from act 12, in which Lucrecia and Melibea are inside the garden while Calisto is outside, accompanied by Pármeno and Sempronio. Fadrique de Basilea reused this image in his 1514 edition of Pedro de Urrea's sentimental novel *Penitencia de amor* (image 3). In their new location, the unidentified character stands for the noble lady Finoya, who is receiving in her house the gentleman Darino accompanied by two of his servants. Much less appropriate is the use of the same engraving for the undated *Romance de Amadís y Oriana*, as it does not relate to any specific scene of the text. In other romances from the first half of the sixteenth century, the same engraving is reused to represent a scene from the Trojan war.[48]

Although we do not know the identity of the illustrator of the Burgos *LC*, the woodcuts are clearly in the German style. They resemble those used by Hurus, some of which were, as noted above, directly copied from German books.[49] The illustrations of the 1499 edition show the strongest similarities to the woodcuts in Hurus's 1494 edition of *Las mujeres ilustres*, a translation of Boccaccio's *De claris mulieribus*. The illustrations in the two books share techniques for the treatment of space, such as depicting beds in a slanted perspective to better show those lying in them, or the pointed shoes of the male characters typical of the Burgundian fashion. These and other similarities identify these illustrators as followers of the "Ulm style of illustration," a style characteristic of one of the most significant areas for illustrated book production in this period, the German southwest.

Some modern critics dismiss this style as medieval and outdated in comparison to the contemporary aesthetic trends of the Italian

Renaissance. This unfair judgment was later abandoned, and today we tend to consider it on its own merits, not in opposition to later paradigms. The Ulm style started in 1470 in cities with an important printing industry in what is today southwest Germany and border areas of France and Switzerland, especially Ulm, but also Basel, Augsburg, and Strasbourg.[50] Those involved in making printed books, including illustrators, circulated between these cities following local market demand. Especially important were two printers, brothers Johann Zainer, who worked in Ulm, and Günther Zainer, who worked in Augsburg and later in Ulm. The two produced some important illustrated books of the incunabula period that epitomize the Ulm style. Johann Zainer's first illustrated book, an edition of Boccaccio's *De claris mulieribus* (1473), started a vogue in illustration with its eighty high-quality woodcuts. This text became so popular that it was reprinted in Augsburg, Strasbourg, Paris, Louvain, and Florence. Most important for its possible influence on *LC*, it was also printed in Zaragoza by Hurus in 1494. Its influence on the 1499 *LC* shows in the clarity of the latter's cut lines and the unabashedly medieval tone of the so-called Burgundian, Flemish, or late Gothic style. This style, sometimes considered a simplified final stage of the international Gothic style, was notoriously long lived in Germany, and acts as a bridge between the Middle Ages and the Renaissance. It combines the stylized hieratism of medieval art and some of the movement and natural expression of later art, with a strong Byzantine influence on the conception of the background.[51] Although Gothic style was used mostly for religious art, late Gothic style had a strongly secular side, influenced by its development coinciding with the foundation of the rich cities of Germany. There, sculptors opened shops in the sixteenth century and worked for institutional patrons such as churches as well as for wealthy individuals. Some of their best productions are sculptures made for the decoration of buildings, especially cathedrals. Their work is characterized by marked lines, most noticeable in the folding of clothes. The resulting angularity contributes to dramatic human figures and is responsible for some of these sculptors being called "the Romantics of the fifteenth century."[52]

Some of the best works of these sculptors are the figures in the main portal of the west façade of Strasbourg Cathedral. Although these are stone statues, wood statues were often carved for the inside of the building. The best examples of wood statues – usually in basswood, which permitted much detail – are inside Ulm Cathedral. Its construction in the fifteenth century was responsible for the city becoming a hub of craftsmen, artists, and woodcarvers, such as Jörg Syrlin the Elder and his son Jörg Syrlin the Younger. Their best-known works are the

carvings for the choir stalls of Ulm Cathedral. They exemplify the use of strong angular profiles to convey the sensation of volume in the limited depth of a base relief (image 4). This technique is also suited to the creation of woodcuts for book illustration, and woodcutters looked for inspiration to altarpieces of the period. Some scholars even propose that the person who drew the illustration for Aesop's *Vita et fabulae* for Johann Zainer (1476) had to be one of those involved in the design of the carving of Ulm Cathedral's choir stalls.[53]

The epitome of Ulm style in printing can be seen in the above-mentioned eighty engravings in Zainer's *De claris mulieribus* (Boccaccio, 1473), to which we can add those in his edition of *Historia Griseldis* (Petrarca, 1473) and *De duobus amantibus Guiscardo et Sigismunda* (Boccaccio, 1476). These engravings are defined by clear-cut outlines and an architectural space accentuated by simple parallel lines with the inclusion of curved lines. Equally of note is a dynamic, narrative conception of the scene. All these features are clearly present in the engravings of the 1499 *LC*. The illustrator of that edition of *LC* also follows specific techniques found in the Ulm style, such as positioning figures as if they were statues within their own niches. The Ulm style of engraving adopted this technique from sculptors of statues used to decorate niches, wall panels, and altars. An illustration reminiscent of this practice can be seen in the engraving of Celestina handing Melibea's girdle to Calisto in act 6, in which a wall with arches in the background helps to depict the luxurious abode of Calisto while framing the figures between columns as if they were statues in a church or factotums in a common space. These columns can also be a reminiscence of some images and early illustrations of the Terentian plays, in which columns are supposed to allude to a stage with curtains and doors.[54]

All these stylistic influences came to *LC* probably via Hurus's 1494 edition of *De claris mulieribus*, which reproduces the engravings of Zainer's 1473 edition (image 5). The illustrator of the 1499 *LC* followed the general style of clear-cut lines and general architectural elements, as well as the Burgundian fashion of the clothes. The artist also followed specific design solutions, such as the use of scenes divided in two by a door and interiors with Gothic windows on the walls. Ulm style is also reflected in the depiction of figures in dynamic poses. Such dynamism was absent in Terence's works published in Lyon and Strasbourg, although those works clearly inspired the clothes and general body type of the Brugos *LC*. This absence sustains Cull's idea that the bridge between Terence and the dynamic figures of the Ulm style was Dinckmut's illustrated *Eunuchus* (Ulm, 1486).[55] That book is an advanced

example of the Ulm style, which depicts characters moving graciously in sophisticated surroundings.

The similarity in appearance between Ulm-style engravings and those in the Burgos *LC* make it likely that the illustrator of the latter was trained and worked at some point in southern Germany. One can also surmise that the illustrator was probably the same person who did the illustrations for Fadrique de Basilea's 1496 edition of Aesop's *Libro del Ysopo*.[56] That the illustrator saw a relation between Aesop's didactic fables and the content of *LC* is possible. However, the similarity in images can be attributed the artist's style of choice for narrative illustrations. Most interesting is that, even if we cannot pinpoint this engraver's identity, we can establish the style's lineage from Ulm to Strasbourg, later to Lyon, and eventually to Spain. This path matches the professional network of Fadrique de Basilea, including his ties to Hurus, who – as proven by how his edition of Boccaccio's *Las mujeres ilustres* (Zaragoza, 1494) reuses the illustrations of the Ulm edition of 1473 – was connected to these cities.

Fadrique de Basilea himself, as his name indicates, lived at some point in the German-speaking city of Basel, around one hundred fifty kilometres from Augsburg.[57] All these connections make the Burgos edition a southern link in the Ulm illustration style. The use of this style for the confluence of influences that materialize in Burgos was justified by the precedent set by illustrated books in related genres – Terence's comedies, narrative, and exemplary texts – printed in the Ulm area.[58] The style was especially appropriate for the combination between new and old ingredients characteristic of *LC*. Like the text of *LC* itself, the Ulm style was defined by a combination of the medieval respect for the past and the interest in the urban present we associate with the Renaissance. Because of its origin and evolution, the Ulm style made the rich traditions of religious art available for representing the scenarios of the new secular cities. The style was familiar to the Spanish readers of *LC* because it was similar to the one used for altars and other religious works in the omnipresent international Gothic style.

The Iconographic Program of the Early Illustrations

The Burgos edition is important not only because it is the first illustrated edition of *LC* but also, as Snow has pointed out, because it established the iconographic program followed by all the illustrated editions of the book in the sixteenth century.[59] The planning of the iconographic program of a book begins with deciding the moments of choice. This decision is often determined by how many illustrations are budgeted

for and by the number of chapters in a book. The illustrator's decision about how many images to include in the 1499 *LC* was based on the book's division into sixteen acts (in the *Comedia* version), with one illustration per act, plus one for the beginning of the book that represents actions from the first act (the first act, thus, exceptionally, having two illustrations). The total number of illustrations, then, is seventeen, although one image is used twice (in acts 1 and 5).

The illustrations are placed after the summaries at the beginning of each act, except for the first act, which has one illustration before and one after the summary. The illustrations are not spread evenly throughout the book, because some acts are extremely long while others are short. The placement of the illustrations was most likely inspired by the similar approach of one illustration at the beginning of each act implemented in the Lyon Terence. The illustrator of Burgos placed the illustrations next to the words they illustrate – the summaries of each act – once again following the example of the Lyon Terence, which itself followed the practice used in medieval manuscripts.[60] To be precise, in the case of Burgos, the images are placed between the summary of each act and the actual beginning of the act.[61] Rivera states that, placed in this location, the images could help the readers visualize, anticipate, and later recapitulate the text. Furthermore, the illustrations helped to "enhance the text or to elaborate the meaning of a given passage, creating an internal network of references that readers could use to intensify their response to the text."[62]

In spite of their position at the beginning of each act and their proximity to the summaries, these illustrations were not conceived as visual summaries of the whole act: they depict only one specific event of the many that take place in each act.[63] With this decision, the illustrator departs from the Lyon Terence's strategy for illustrations, most of which include the cast as static figures, not engaged in specific actions. These static figures serve as a visual version of the dramatis personae, the list of characters commonly included at the beginning of each act in dramatic texts since antiquity.[64]

The decision of the illustrator of Burgos to depict specific events resulted in images more dynamic than those of the Lyon Terence. However, some illustrations, such as that in act 6, still show the characters standing and talking, with few hints of action or gesticulation. In making this decision, the illustrator may have been influenced by illustrated books from the Ulm school, whose illustrations were narrative in nature (for example, the *De claris mulieribus*), or by another illustrated book such as San Pedro's *Cárcel de amor* or Camus's *L'Histoire d'Olivier de Castille et Artus d'Algarbe*.[65]

The dynamism of the Burgos images as well as of these other models does not mean that the figures are moving or agitating their limbs in unstable or transitional positions. Such figures were uncommon in medieval art, in which static figures prevailed. Only subtle hints of movement were included, but they are noticeable because the figures are depicted in profile instead of in frontal view. The Burgos illustrator includes only subtle hints of movement, mostly indicated through the direction in which the feet and arms point. The scenes in which violent movement is paramount, such as the falls of Calisto and Melibea, are evident exceptions.

Most often, only the subtle movements associated with the uttering of dialogue are indicated. The characters are presented "acting the text" not so much in the sense of performing the action as in being engaged in the verbal exchanges.[66] The small size of the engravings makes it impossible to represent the movement of the characters' lips when talking. Instead, declamatory gestures such as pointing with one finger, advancing an open hand, or raising the palms are deployed to indicate that the characters are in conversation. Some of these were well-known gestures at the time, such as holding a hand with a finger extended when enumerating the different points of an argument. The characters' gestures also express their reactions to words or actions, as in the left side of the illustration in act 13, in which Tristán raises his hands, surprised when told by Sosia of the execution of Pármeno and Sempronio (image 6).[67] Some gestures or, better said, positions, seem to recall those associated with an old stage tradition that is recorded in the illustrated Terentian manuscripts. For instance, the position of male authority, which originates as a military pose, is "one arm akimbo, often partially or totally concealed by the cloak, [while the] other arm rests along the body or supported by a stick."[68] This pose is reflected in the position of Calisto in the first illustration in the book, when he meets Melibea, and in that of Sempronio in the illustration in act 1, repeated in act 5 (image 7).

The engravings in the Burgos edition also include subtle hints of movement to depict specific action verbs from the summaries, mostly with respect to characters entering or leaving the scene. For instance, the illustration in act 3 represents the movements implied in the final words of this act's summary: "Celestina goes to the house of Pleberio. Sempronio and Elicia stay at the house of Celestina" (47).[69] Accordingly, the image depicts Sempronio and Elicia inside a building while, on the right, Celestina is walking in the street toward Pleberio's house.

The preference of the illustrator for depicting these and other movements that indicate transitions between scenes and their spaces is most noticeable in the abundance of double-panel illustrations, including

the preceding example. Eleven of the engravings in Burgos are double panels.[70] The two-panel illustrations represent moments in which the action in one is about to interrupt or influence the events in the other in a chain of cause and effect. The resulting sensation is one of action, of a succession of logically connected events. Such division of an image into two or more related panels is a convention commonly used in medieval art to illustrate narrative cycles such as Genesis or the Passion of Christ.[71]

Medieval painters often repeated the same human figure in different poses at different points of the same painting to suggest action. Versions of the figure are normally presented in order, but not always from left to right, as is the norm in the West. The frames follow each other without a dividing line in between, almost like a long, single roll of film. Occasionally, a character who participates in two adjacent scenes – for example, an angel – is placed in between the frames, acting as the division between the two panels and allowing the illustrator to avoid having to carve this figure in both frames. The figure acts as a divider between the two scenes as well as a connector.[72]

Burgos uses this practice of connecting divided spaces by showing figures in the process of going through doors, an action we can see in the illustrations for acts 1, 4, 5, 9, and 10. The illustrator seems to be following the lead of illustrated editions of stories such as Jean d'Arras's *Melusina* (Augsburg, c. 1488), which had taken this practice from medieval manuscripts.[73] Variations on this convention can be seen in the illustrations for acts 2, 3, 7, 8, and 12. They present the character not crossing a threshold, but in proximity to a door they have gone through or intend to go through. The connection of the two adjacent spaces is reinforced in some of these illustrations by transparent walls, also a convention of medieval painting. In the illustrations for acts 4 and 10, Lucrecia is coming out of the front door of Pleberio's house. We can see inside because the exterior wall has been removed. This trick allows the viewer to see half of Lucrecia's body inside and half outside the house, connecting the two spaces. The connection of the spaces is emphasized in the illustration from act 4 by her arm, unnaturally coming out through the transparent wall as if embracing the door's frame.[74]

The simultaneous presence of characters at the door in the two panels differs from the narrative use of the above-mentioned medieval images. In the 1499 *LC*, these panels do not represent two different moments in time but the same moment in two spaces. In other words, the two panels do not imply the passing of time between them, unlike, for example, in modern comics. Most double panel illustrations in Burgos represent

reasonably contiguous spaces, such as room and the adjacent street space to which a door may connect.

Only in a few cases does the wall between two panels separate non-contiguous spaces, acting metaphorically as a break in space and time. This is the case in the closely related illustrations from acts 3 and 7. Both include similar images in the left frame to represent, respectively, the young couples Sempronio and Elicia, and Pármeno and Areúsa inside a room. The right sides of the two illustrations represent Celestina on the street about to enter another building – Pleberio's house in act 3 and her own house in act 7. The viewers, after reading the summary, easily understand that the streets separating these rooms from Pármeno's and Celestina's houses are omitted. They also understand the implicit time that it took Celestina to get to those houses after leaving the two couples. The two panels are still separated by a wall with a door, as in previous cases, but no character is in the process of going through it.

Despite the Western convention that a left-to-right order implies the passage of time, the panels in the majority of the 1499 LC double illus-trations represent simultaneous actions.[75] Their order represents the rel-ative position of the words mentioning or implying these spaces within the text of the summaries. So, the image of Pármeno and Calisto inside the house is on the left panel of the illustration of act 1, while Celestina and Sempronio are on the right, reflecting the textual order in which the two groups are mentioned in the summary: "Calisto, at his home, is speaking to yet another of his servants, Pármeno by name; their con-versation lasts until Sempronio and Celestina return to the home of Cal-isto" (5). The wall separating the two panels represents precisely the change of scenarios that the "until" introduces in the text. Calisto and Pármeno are in the panel on the left because the summary mentions them first – on the left in the lineal order of the text. They are before – to the left of – Celestina and Sempronio, who are mentioned later and therefore depicted to the right.

Even the left-to-right location of the characters in each panel reflects the order in which they are mentioned in the text: Calisto, Pármeno, Sempronio, and Celestina. Listed from left to right, they recall the list of dramatis personae, in which the characters' names are ordered according to their first appearance in a comedy. If we removed the background, the result would be the images of the characters lined from left to right in the same order in which they speak for the first time, as in a list of dramatis personae of a play. However, here, the order in which the images are lined up matches the order in which the summary of the chapter mentions them. An in-depth analysis of the arrangement of the characters in this and other editions of LC is

needed before this statement can be generalized to these illustrated editions as a whole.

The direction of visual narrative from left to right based on the textual order of the summary explains a curious reversal: that of the panels in the two otherwise highly similar double illustrations from acts 4 and 10. The double illustration of act 4 depicts, on the left, Alisa in the street with a servant departing to visit a sick relative. To the right, Celestina and Melibea talk inside the house. This order is reversed in the double illustration of act 10: Alisa returning home is on the right, and Celestina talking to Melibea is on the left (image 8).

That the double illustration from act 10 was designed with a copy of act 4 in mind is evidenced by their obvious similarities. Among other things, the two share the inclusion of the male servant who accompanies Alisa both when she departs and returns. It should be noted, however, that the returning servant is not mentioned in the summary or the text itself, although his presence can be implied. Also similar in the two illustrations is the position of Lucrecia – Melibea's servant – at the door's threshold, connecting the inside and outside spaces represented by each panel.

Interestingly, even if the left-to-right order of the panels is reversed from act 4 to 10, Lucrecia is, in both cases, looking to the right: in act 4 to the outside, and in act 10 to the inside. The direction of her gaze implies the *logical* order of the events, even if they occur simultaneously. In act 4, the departure of Alisa is on the left side because it is a logical prerequisite for the private talk between Celestina and Melibea in her room represented on the right side. Here, Lucrecia is not outside by the door but inside, notifying the women in the room that Melibea's mother has departed, and Celestina can begin to talk about Calisto. The order of the words of the summary describes this logical arrangement of cause and consequence: "A messenger arrives to summon Alisa. She leaves. Celestina is left in the house with Melibea, and she reveals the reason for her visit" (56). In act 10, however, the arrival of Alisa in the street is located to the right because it interrupts the pre-existing talk between Melibea and Celestina in her room, represented on the left side. The logical order of the event is reinforced by Lucrecia's gaze, always to the right, but now watching the return of Alisa in the street.

A condition for readers to understand the narrative nature of the illustrations is that they are able to identify the characters when they reappear in different positions and scenarios as the plot moves on. The illustrator would, as much as possible, depict them with consistent, distinct features in each appearance, but, in addition, the Burgos *LC* labels the characters, placing their names above them.[76] Also, because

the small woodcuts did not permit detailed facial features, clothing and some props are carefully used to personalize the figures: Calisto is always represented wearing a hat with a prominent feather and a sword – except when he is in bed in act 13 and when he has fallen from the ladder in act 14. These attributes, together with the breeches and pointed shoes of Burgundian fashion, make his figure easy to recognize, presenting him as a typical wealthy young man of the day.[77]

Yet the consistent use of clothes and apparel is not so carefully followed for the secondary characters. Sempronio wears a sword in acts 1 and 3, but not in 2, in which Pármeno is the one wearing the sword. Celestina, being a central character, is always clearly identifiable by a cloak that also covers her head. Also, she often carries props mentioned in the text, such as a rosary or a moneybag; indeed, she carries them even in the illustrations for acts in which these objects are not mentioned and do not play a significant role. This licence is also a reflection of the systematic use of attributes in medieval art, especially in religious art, to identify figures, such as Saint Peter's key or Judas's moneybag.

The illustrator is not so careful with the spaces in which the action takes place, and does not bother to make the same space recognizable through the use of distinct layout or furniture. The illustrations even show minor inconsistencies, such as depicting an eye-catching floor of diagonally laid tiles in Melibea's room when she is visited by Celestina in act 4 but not in the visit in act 10, two illustrations we saw mirroring each other in most other aspects. Confusingly, this distinct floor pattern is used for three different houses: those of Areúsa in act 7, Calisto in act 10, and Celestina in act 3. A likely reason for this carelessness in representing the background is that floors, doors, roofs, and walls were probably the work of apprentices. They followed standardized, efficient solutions to complete these areas, while masters did the intricate work on the figures.

The 1499 *LC* set the iconographic program – which episodes to illustrate and how – for all the illustrated editions of this first period except for some additions Cromberger introduced in its edition of the book (Seville, 1502/1511), which had twenty-one rather than sixteen acts.[78] Cromberger cut costs by replacing most illustrations with factotums of the characters in the respective acts and copied the general design of some images of the Burgos edition. However, he added three new illustrations: Calisto climbing into Melibea's garden, the death of Celestina at the hands of Pármeno and Sempronio, and their execution immediately after they are apprehended. Burgos did not represent these deaths, only Sosia telling an astonished Tristán about them, which is true to the text.

The inclusion of these violent illustrations in Cromberger's edition may be due to a desire to emphasize the tragic aspects of a text after it was relabelled a "tragicomedia." This iconographic program also accentuates the tragic elements by using factotums for most episodes except for the four deaths in the text: the stabbing of Celestina, the executions of Pármeno and Sempronio, the fall and death of Calisto, and Melibea's suicide (the last two already in the 1499 LC). The image of Calisto entering the garden is less innovative because it is based on the illustration of Calisto falling from the ladder. It is, however, a spicier image than the equivalent scene of Calisto and Melibea talking through the door in the garden wall used in Burgos to represent the lovers' encounters.

Cromberger's additions were successful in the sense that all later editions include illustrations of these violent scenes. These new illustrations follow the same double-panel structure we saw in Burgos, but now used in a different way. On the left panel of the illustration of the murder of Celestina, we see Pármeno and Sempronio stabbing Celestina while Elicia watches in horror. The right panel shows the men jumping through the window to escape. One of them is coming out of the window, but the other, who has already landed on the ground, is unconscious while the judge is passing sentence. This double scene breaks with the strict simultaneity we saw in the Burgos panels. Here, the action on the left, the death of Celestina, precedes the jump on its right, which precedes the judge's intervention further to its right. It also breaks a rule of the double panels in Burgos, in which the characters are never represented twice in the same illustration. Now, Pármeno and Sempronio are represented two times, once in each side panel: inside the room while killing Celestina and outside the house, jumping and being sentenced by the judge (image 9).[79]

We can speak of three temporal spaces: the murder of Celestina to the left, the jump of Pármeno and Sempronio in the centre, and the judge sentencing them to the right. The left panel, the death of Celestina, is clearly separated from the one in the middle by the house wall. However, the elbow of Elicia is slightly overlapping, which recalls how Alisa's arm crosses the transparent wall in act 4 of the Burgos LC. Now, instead of simultaneity, the overlapping arm suggests that the scenes are successive but close in space as well as in time. A similar tactic, this time clearly against the rules applied in Burgos, is used to connect the second and third panels: the character lying unconscious on the ground is also represented jumping. And he is present in the frame of sentencing, which is a different temporal frame, despite the continuous representation of the space.

Cromberger's second additional illustration is of the decapitation of the servants by the executioners. No gory detail is spared: one of the executioners holds the blood-dripping head in his hand, while the other is about to cut off the second servant's head. Once again, the right-to-left order is followed in the scenification of the events. The images are not simultaneous, and a triple temporal frame is implied in a spatially undivided panel: the judge passing sentence, the preparation for the execution, and the culmination of the execution, with the decapitaion. The changes in time are not as perceptible as they are in the previous illustration of the leap from the window, and it would be possible to interpret the three events as simultaneous. A curious detail of the illustration is how this scene is not presented as Sosia's narration in the text. However, the illustrator includes a character that can be identified as Sosia witnessing the event.

One of the surviving copies of this Cromberger edition, described in Norton's catalogue under number 878 and of which the only known copy is at the library of the University of Michigan, includes a second illustration of this event. It is located in act 14, perhaps to illustrate the words of Calisto when he mentions the execution of his servants to Melibea. This illustration shows a young man being carried out to be hanged, with a cross in his hand, while a ladder stands next to the gallows. This depiction does not represent the actions as narrated in the text and was probably taken from another book, which has yet to be identified. The reason for placing this illustration in act 14 may have been to avoid repeating the image of Calisto climbing the wall of the garden used again in act 19. This repetition occurs in the copy of Cromberger's edition kept at the British Library. Curiously, this illustration in the University of Michigan copy is printed at the end of the first page of the act. It appears, then, next to the words of Tristán asking his master to climb the ladder on the wall. This textual presence of the ladder may have been one reason for the inclusion of this otherwise inappropriate illustration.

Cromberger's inclusion of the death of Celestina and the executions of Pármeno and Sempronio are copied by all the subsequent illustrated editions of this first period, including the next edition, printed in Valencia in 1514. Although it follows Cromberger's innovation, the order of the panels of the death of Celestina and the jump of Pármeno and Sempronio is reversed: the jump is on the left and the murder on the right. The illustrator connects the two scenes by overlapping the hands of Pármeno into the frame in which he and Sempronio are murdering Celestina. Another difference is that Elicia is not present in the murder scene. This edition includes the judgment and execution but simplifies it, excluding the figure of Sosia as a witness. Only one executioner is

present, and the background, representing a big public space such as a square, is emphasized through perspective.[80]

The 1514 Valencia edition also follows another approach that Cromberger's edition introduced: the replacement of illustrations by factotums of the characters at the beginning of each act. The use of factotums, together with the reuse of older engravings often barely appropriate for the new scenes, became practices many printers followed to save costs as the sixteenth century progressed.[81] *LC* was not an exception, and most of its editions in the sixteenth century did not have illustrations, properly speaking, but only factotums.

Only three editions of the sixteenth century illustrate all or most of the episodes that were in the iconographic scheme of Burgos, later enlarged by Cromberger's Seville addition: the 1520 Augsburg; the 1545 Zaragoza published by Coci, Bernuz, and Nájera; and the 1557 Estella. The 1520 Augsburg, republished in 1534, includes the text in German and illustrations attributed to Weiditz.[82] Properly speaking, it is the second fully illustrated edition of *LC* after the 1499 Burgos edition – as we have seen, Cromberger's editions and the ones printed in Valencia replaced many descriptive illustrations with factotums. The Augsburg edition follows the iconographic program of Burgos with the additions of Cromberger, although it introduces some interesting innovations. The quality of the engravings is superb, clearly superior to any *LC* produced in Spain or Italy at the time. Kish rightly states that the engravings are superior to any illustrated editions of the book, with only the possible exception of Picasso's.[83] Saguar García recently advanced the interesting possibility that this edition was meant as a present for the emperor Charles V, which would explain the lavish engravings and the relatively few extant copies.[84] Given its quality, this is the edition critics have paid most attention to, second only to Burgos.[85] The engravings do not reflect the medieval style of Burgos but have an overall Renaissance feeling, which is clearly perceptible in details such as the systematic use of perspective and a more natural depiction of figure instead of medieval rigidity. The use of double panels and transparent walls, which equally have a medieval feel, is minimized. The illustrator depicts with detail the events described in the book, but using buildings like those of Augsburg as background, a contemporizing practice common in book illustration from this period.[86]

An interesting innovation in the Augsburg edition is the way the banquet in Celestina's house in act 9 is depicted: the participants are not standing, as in Burgos, but sitting at the table and revelling (the Seville editions by Cromberger and those printed in Valencia use factotums for this act). The Burgos illustrator chose to represent the characters as

standing, at the moment when Lucrecia knocks at the door and Celestina comes to open it. The Burgos edition made them all stand, probably following reference in the summary of the act to the quarrel between Sempronio and Elicia, which reads, "She gets up from the table. They calm her. As they talk among themselves, Lucrecia, Melibea's servant, arrives to tell Celestina that Melibea wants to see her" (126). Having the two other lovers, Areúsa and Pármeno, also standing seems to be an adaptation meant to fit the whole event into the frame (image 10).

Another probable reason the Burgos edition did not represent the characters sitting at the table could be to avoid having the scene look like a parody of the Last Supper. The German illustrator, although he respects the iconographic program of Burgos, innovates in Augsburg: he depicts the characters sitting and enjoying the food and drink that Celestina is distributing. Lucrecia's appearance at the door is not included, therefore eliminating the double-panel scheme of the Burgos edition. We can only speculate why the German illustrator changed this image. A plausible reason is the fashion of depicting similar scenes of debauched banquets in northern European paintings and engravings at the time.[87] Especially popular were scenes of young men with prostitutes in a tavern or brothel, in which wine, carousing, and food are present. They appear often around a table and with a procuress, as we will see in the next chapter.

Besides their exceptional quality, the engravings in the 1520 Augsburg are important because of their influence on later Spanish editions via the third fully illustrated edition of LC, the 1545 Zaragoza printed by Jorge Coci, Pedro Bernuz, and Bartolomé de Nájera. Coci was of German origin and began to work as printer as early as 1492. Always working in Zaragoza, he bought Pedro and Juan Hurus's press in that city in 1499. In 1507, Coci published an edition of LC with no illustrations except on the title page. He was a prolific printer, with over two hundred titles, some as important as Rodríguez de Montalvo's Los cuatro libros de Amadís de Gaula (1508), or Livy's Las quatorze décadas (1520). He died in 1546, one year after the publication of the illustrated edition of LC. Given his age, it is likely that he was not much involved in this edition, which lacks the quality of his previous work.[88]

This edition is unlike the books printed by the two other printers that appear on the title page. It is difficult to understand why they risked the expense of an illustrated edition when the competition from several other editions in circulation would have been strong. Indeed, in the same year, another edition of LC was also published in Zaragoza, by Diego Hernández; it was illustrated, but mostly with factotums. Despite this competition, Coci's partners dared to publish their fully

illustrated edition. Its engravings were all newly made, clearly inspired by the Burgos and Cromberger's models, whose iconographic program it follows. Unfortunately, the quality of the whole book is low, due to the general crisis associated with printing practices in Spain. The illustrations do not come close to having the limpidity of the Burgos or Cromberger editions. Heavy black spaces poorly transferred to paper resulted in blotches of ink and overall dark, unbalanced images. Moreover, some images do not accurately represent the events and were probably reused from a different book.[89]

Despite all these problems, this edition deserves attention because it is the last completely illustrated edition of LC in the sixteenth century for which new engravings were created. The images reveal ingenious design solutions that show that the illustrator knew the previous illustrated editions well, including the 1520 Augsburg. Although the Zaragoza illustrator follows the iconographic program of the Burgos illustrations and the modifications by Cromberger, he implements Augsburg's adaptation of reflecting contemporary fashions in clothing and architecture. The result is an illustrated version of LC that, for the first time, reflects the reality of life in contemporary Spain.[90] The engraver leaves behind the international medieval style of the 1499 Burgos images, eliminating the Burgundian fashion and the steep rooflines of northern origins and replaces them with the background and clothes of mid-sixteenth-century Spain.

Especially noticeable is the inclusion of some Spanish habits of Arabic origins, such as the way women sat not on chairs but on cushions on a platform (depicted in the engravings for acts 3, 6, 10, and 16). The illustration of Calisto's death shows a typical Morisco-style *adarga* – a light leather shield. A chair with two crossed curved legs in the form of a Roman *sella curulis*, fashionable in Spain at the time, is shown in the images for acts 13 and 16. The flat hats worn by the men in the illustrations match those in portraits of Spanish characters of the period, as do the women's skirts, made of several folds with ribbons at the bottom. Also, the hieratism of the characters – the rigidity of their posture, recalling the imagery of ancient Egypt – of Burgos and Seville are replaced with more dynamic and expressive figures, following the style of the Augsburg edition and new tendencies in art.

The illustrator of this 1545 Zaragoza makes interesting decisions that reflect the new reality of a book market and the need to save paper. To do that, the medieval practice of dividing an illustration into panels – which we saw used for contiguous spaces in Burgos and for consecutive actions in Cromberger – is broadened. The solution is to place side-to-side scenes that are not simultaneous, consecutive, or close

in space. Curiously, the illustrator takes licence to incorporate images of the Augsburg edition into the Burgos-Seville iconographic program. It is as if they wanted to offer the fanciest iconographic program possible on a restricted budget. This way, they could compete with the edition of *LC* by Diego Hernández that had also appeared in Valencia the same year. The act 1 illustration follows Augsburg's innovation of including three illustrations for this act. While the Burgos and Cromberger editions had only two illustrations for act 1 (the encounter of the lovers at the garden and the arrival of Celestina escorted by Pármeno to Calisto's house), Augsburg added a third image (Calisto pining for Melibea in the presence of Sempronio). The Zaragoza edition published by Coci et al. follows this program of three new images but, to save paper, compresses them into a single engraving made up of three panels separated by columns. Unlike the use of multi-panel engravings that we saw earlier, these adjacent panels do not imply any temporal or spatial proximity between the scenes.

The left panel, whose content is inappropriate in this context, seems to be a reused image: it shows a man talking to a woman sitting on a cushion in a room rather than the initial encounter of Calisto and Melibea in the garden. The middle panel is correct: Calisto is pining for Melibea, with his head resting on his hand and his elbow on a table, which follows the new image of the Augsburg edition. However, the figure of Calisto in this Zaragoza version has a problem: even if he seems to be wearing the same clothes as in the image to the left, in which he meets Melibea, he suddenly has grown a beard. This incongruence is repeated in other images in the edition. The third panel, on the right, also reveals a cost-cutting decision: instead of showing Celestina coming with Sempronio to meet Calisto, it depicts Celestina by herself, with a rosary, an image that has all the aspects of a factotum inspired by those in Cromberger's edition.[91]

The ingenuity of the illustrator of this Zaragoza edition in integrating the images in Burgos and Seville with those in Augsburg while keeping costs down shows in other illustrations. At the banquet in act 9, the characters are sitting at a table. We saw that the Augsburg edition introduced this composition at the cost of leaving out the arrival of Lucrecia. The illustrator of Zaragoza does not want to give up that character and manages to squeeze her into the scene. The resulting composition combines the characters sitting and frolicking at the table from Augsburg's innovative design and the image of Lucrecia knocking at the door from Burgos.

The ingenuity with which the Zaragoza designer amalgamates the influences of the previous illustrated editions is noticeable in other

illustrations as well. This is the case with his treatment of the visit of Celestina to Areúsa and the ensuing night of sex with Pármeno in act 7. In Burgos, this act has a double image: the left panel shows Pármeno and Areúsa standing and talking in a room, while, in the right one, Celestina is in the street, about to enter her home. Augsburg spices up the scene: it presents a semi-naked Areúsa – her breasts are clearly visible – reclining in bed while listening to Celestina. In the left corner, we see Pármeno listening in on the conversation. Zaragoza, while keeping the double panel distribution of Burgos, takes the new treatment of Augsburg to its highest degree of eroticization: in the right panel, it presents Pármeno and Areúsa in bed, one on top of the other. The same tendency to increase the erotization of Augsburg's images is also behind how Zaragoza represents Sosia's visit to Areúsa in act 17 – an event not represented in Burgos. In Augsburg, the two characters are kissing in front of the bed. In Zaragoza, the hand of Areúsa is shown advancing toward Sosia's sword handle, which has the shape of an erect penis.

The illustrator of Zaragoza introduces other minor innovations, such as the presence of a cat or lap dog at the feet of Melibea in act 4. The most noticeable innovation is the illustration for act 11. It shows Calisto on his knees, praying in front a religious statue at a chapel or church. Celestina is arriving to meet Pármeno and Sempronio, who are waiting outside the church. Sempronio seems to be talking to his master. This is probably an allusion to when, at the beginning of the act, he tells his master to quit praying so as not to be accused of being a phony devotee. This whole design is innovative, and it succeeds in conveying the attitude of Calisto toward Celestina as a propitiatory deity. The artist places Celestina and a religious statue of a woman as mirror images at opposite edges of the illustration. We can see an evolution toward greater dynamism in the illustrations, from Burgos to Augsburg to Zaragoza. Burgos places this meeting between Calisto and Celestina inside Calisto's house, when Calisto is about to give Celestina a gold chain; Augsburg places the four characters outdoors, next to an elaborate door, which may represent the church of the Magdalene; the Zaragoza engraver takes things a step further and places Calisto praying inside the church before giving Celestina the chain.

Many other details of Zaragoza can be adduced that attest to the ingenuity of the illustrator, who, on some occasions, takes excessive creative licence. The illustration of the execution of Pármeno and Sempronio includes three poles forming a place to hang their bodies or heads after the execution, of which nothing is mentioned in the text.[92] Equally unprecedented is a detail in the suicide of Melibea. Previous editions included three witnesses – Pleberio, Alisa, and Lucrecia. Zaragoza

includes two other characters looking from the other side of the wall that separates Pleberio's house from the street. Several others are inside. Given the advanced age and the pointing hand of one of them, he may represent the judge or other authorities. Their implicit role is to prevent Melibea from being buried in a Christian cemetery because of her suicide, as implied in Pleberio's lamentation.

As Saguar García points out, the 1545 Zaragoza illustrations represent the last point in the evolution of the Burgos-Seville-Augsburg cycle of the illustration of *LC*: until the end of this first period, no editions add anything new. Furthermore, the images of the Zaragoza edition, or their copies and imitation in later editions, were probably the ones seen by most people in the first centuries after the publication of *LC*. They came out in a period of wider circulation of books. The long service life of these late editions is due to the two centuries that passed without new editions of the book. Their illustrations not only have the merit of being the first properly Spanish visual recreations of the plot; they also anticipate trends, such as increasing eroticization, that would continue after the rebirth of *LC* in the nineteenth century.

The later editions published until the early decades of the seventeenth century were copies or remakes of this Zaragoza edition plus a few factotums: the same woodcuts were used in the Zaragoza edition of 1554 by Bernuz, who probably inherited them from his previous partnerships with Coci and Nájera. The images were copied and rotated in the 1561 Valladolid; poorly copied and executed in the 1577 Salamanca and the 1582 Medina del Campo; intermixed with factotums and one image of the death of Celestina of unknown origin in the 1590 Salamanca; and copied for the 1574 Dutch edition (Antwerp), which was reissued in 1616, the last illustrated edition of this first period of illustration of *LC*.[93]

La Celestina Title Pages

The images on the title pages of *La Celestina* deserve to be examined on their own because they are not illustrations, properly speaking. Although they were produced with the woodcut technique and contain scenes and characters from the story, they are comprehensive, synoptic images. They try to convey the gist of the text and attract those who see the book on the shelves of print shops. In their synoptic function, they are a descendant of the list of dramatis personae.[94] At the same time, they function as curiosity triggers to promote sales – something that modern covers have made an art form, as we will see in chapter 3. This promotional role explains why printers in this first period of *LC* editions deemed the inclusion of images on title pages important. More

than half of the total editions, regardless of whether they are illustrated, have images on their title pages. These images provide us with valuable insights into how the book was presented to make it attractive to potential readers. Furthermore, given their conspicuous position, they had an impact on the myth of Celestina, influencing to those who never read the book or even opened its covers.

The titles pages of this early period differ from what we call a title page today, which is a page in the prefatory material containing succinct archival information. They also differ from modern covers, despite containing some of the same information, such as the title and the name of the author. Unlike modern covers, they were printed on the same soft paper as the rest of the book. They were conceived as temporary covers while the book was for sale in the form of an unbound pile of printed sheets. The buyers themselves were expected to have the books bound and protected with a hard cover, services that were not offered by printers or booksellers.

Despite their limited utility, title pages were a valuable innovation developed around the time *LC* first appeared in print. Before then, books came out as a pile of sheets whose first page began with the first written words of the book. Sometimes the first words were written on the verso, so that the recto was a blank page. The information about the author, printer, date, and so on, if present, was crammed into a colophon on the last page. To facilitate the identification of these piles of printed pages, printers started to put a labelling piece of paper on top of them. Soon printers and booksellers realized the importance of the title page for selling books. Producing attractive first pages became imperative, and printers began to use images for that purpose. Erhard Ratdolt, a German printer working in Venice, is credited with the earliest complete title page, for his 1476 *Calendarium*.[95]

In a detailed study of the title pages of early Spanish books, Morato Jiménez explains how they began to develop in the 1470s, becoming common by the early 1500s. Interestingly, Fadrique de Basilea was the first printer in Spain to use illustrations on a title page, in his 1491 *Tratado de amores de Arnalte y Lucenda*. The illustration depicts two lovers interacting outdoors, with a background of secondary characters. Morato Jiménez points out that sentimental novels were likely to have illustrated title pages that advanced the content of the book to induce the readers to acquire it.[96]

Even if *LC* is not a sentimental romance, the images on its title pages of the sixteenth and seventeenth centuries follow a similar model of presenting interacting lovers with an entourage of secondary characters – especially Celestina – that provides the gist of the most significant

episode and characters of the book.[97] LC's first extant title page is that in the 1500 Toledo edition (image 11). The only existing copy of the 1499 Burgos is incomplete, and its title page missing. Given the doubts about the date of the Burgos edition discussed earlier, it is possible that the Toledo edition may contain the first title page of LC, regardless of whether the Burgos edition had a title page. Thus, it may be the first extant image of the Celestina visual corpus. Its half page engraving is a model of simplicity and efficacy in conveying the gist of the story and the three main characters: Melibea in the centre, Calisto on her one side, and Celestina on the other side, in the background. The two lovers are depicted in their first encounter, which is denoted by the presence of the falcon on Calisto's arm. Celestina is entering the house of Pleberio to sell her yarn.

The image evidently illustrates two different episodes, in acts 1 and 4, respectively. This difference is reflected in the backgrounds of the two groups of characters: while Calisto and Melibea are placed in nature, surrounded by exotic trees, Celestina is in an urban environment, by the door of a house. The youth of the couple is emphasized by their erect postures – Calisto's stance can even be seen arrogant – which contrast with Celestina's bent upper body, which may also be interpreted as conveying false modesty. The clothes are also significant: Calisto and Melibea are richly clothed. Celestina's head is covered, as befits an old woman, while Melibea sports an elaborate cap. The lovers' hands indicate that they are arguing.[98] From an iconographic point of view, the presence of the falcon – mentioned in the summary of act 1 – connects the scene to the courtly love commonplace that paints love as hunting. The trees may refer to the imagery of Adam and Eve in a paradise in which Celestina acts as the snake.[99] The shape of the yarn Celestina carries can symbolize a vagina, a counterpart to Calisto's phallic sword.

This pattern of the two lovers interacting and Celestina in the background becomes the basic design to which later title pages of this early period keep adding elements. Polono's edition (Seville, 1501) adds the figure of the servant Lucrecia behind Melibea, and an unnamed servant with a horse behind Calisto. The presence of the two servants and the horse seems to promise a complex book with many characters, as well to reinforce the important social position of the two lovers. The inclusion of the energetic horse adds, as critics have pointed out, a suggestion of sexual lust to the figure of Calisto, who also has the falcon in his hand.[100] Celestina looks the same as in the 1500 Toledo edition, although she is knocking at a door upon which a big metal ring, a vaginal symbol, serves as a knocker. The outfits of the young lovers are

more elaborate than in Toledo, especially Calisto's, who wears a longer, more formal outfit.

The same procedure of adding characters and details to the basic model of the three main figures is followed by the title page of the 1514 Valencia edition. Its important innovation is to replace the first, fortuitous encounter of the lovers with a later encounter in which Calisto has to climb the wall to access Melibea's garden. Besides Celestina, Lucrecia, and Calisto's two servants, another seven characters are included: in the background two young men, probably Pármeno and Sempronio, meet two women, who could be Elicia and Areúsa or Celestina, at the corner of the street. Three characters, probably Alisa, Pleberio, and Lucrecia, are visible through a window in Pleberio's house and therefore are represented twice in the illustration. Celestina is the character who changes the least from previous covers: she appears again knocking at the door, but this time without the yarn. The result is a complex multilayered image with allusions to many episodes. The symbolic falcon and the horse have disappeared. This title page promises not so much the intimacy of the sentimental story, as do the title pages of the 1500 Toledo and the 1501 Seville, as the complexity of one of Terence's comedies. It follows Grüninger's cover of Terence's work in introducing all the characters and different scenarios. The result is a good promotional image for a book by then called *Tragicomedia* and expected to contain a convoluted roller coaster of a story.

The image of the 1526 Toledo title page is the first not to relegate Celestina's figure to the background. She is still at Pleberio's door but now in the foreground, drawn in larger proportions than Calisto and Melibea. Her figure is more expressively depicted in a gesture of bending forward to knock at the door. Even if the title printed on this page continues to refer to the book as the *Tragicomedia de Calisto y Melibea*, the image confirms Celestina's growing prominence, which continues unabated. Significantly, on the title page of the edition that closes the first period of illustrated *LC* editions, the 1616 Antwerp edition, Celestina has grown to occupy half of the woodcut.

During this first stage, many other details change across the over forty covers that contain engravings with images of the story. For instance, the spool of yarn initially depicted in the hand of Celestina while she knocks at the door is replaced by a rosary in the 1523 Seville (in reality printed in Venice). In the 1514 Valencia, she has nothing in her hands, but in the 1526 Toledo she carries both the rosary and the yarn.[101] Similar variations affect Calisto, presented with and without the falcon. A peculiar variation is the 1529 Valencia, which presents Calisto riding a horse with three servants, one of them black, and a small dog, moving

toward Pleberio's house. The 1534 Augsburg does not have a title page. However, the summary of the whole argument of the book is illustrated with a scene that could be taken from act 14 or 19: the encounter of the two lovers in the garden, with Lucrecia in the background. Calisto's two servants are visible on the other side of the wall. Celestina, as the logic of this scene demands, is absent. The 1540 Lisbon introduces a modification: the central image is the encounter of Calisto, with the falcon, and Melibea. Lucrecia is present, which suggests that we are not witnessing the first accidental encounter. Most curiously, Celestina, yarn in hand, is depicted entering the garden though a door, in place of the usual image of her knocking at the door.

Only three illustrated title pages depart significantly from the prevalent model of representing the lovers' meeting outdoors, with Celestina's mediations somehow indicated. The 1507 Zaragoza forgoes the presence of Celestina altogether and presents just the two lovers in a formal situation. It does not seem to represent a scene of the book, but rather the generic tradition of courtly love and sentimental romance: Calisto kneeling in front of a Melibea sitting in an elaborate throne-like chair in a luxurious room, an image created in the shop of Hurus for an edition of *Cárcel de amor*. Generic effigies of the two lovers are used in cheap late editions, such as the 1557 Estella and 1569 Madrid. In the latter, a little Cupid with a bow is between the effigies of the lovers.

A similarly simplified model is used in editions that resort to factotums of a male and a female figure next to each other, such as the 1595 Tarragona and 1607 Zaragoza. But even some title pages made up with factotums, such as the 1563 Alcalá de Henares, include crude effigies of the classic triangle of Calisto, Melibea, and Celestina. Another variation is editions that choose for a title page the illustration of a specific scene other than the encounter of the two lovers with characters in the background. Some do this to avoid having to produce a new woodcut – for example, Zaragoza 1545, which uses on the title page the same engraving of Calisto accessing Melibea's garden with a ladder that is used two more times inside the book, for acts 14 and 19.[102] One of the problems with this unusual choice of characters is that Celestina cannot logically be included on the cover.

The third exception to the preferred triadic pattern of the two lovers and the procuress is the 1519 Venice (image 12). It shows the scene of act 4 where Celestina visits Melibea (or the later visit in act 10): the two women are sitting in a room in which a bed is prominently visible in the background. Celestina's hands are extended as if begging or demanding something from Melibea. The Latin legend "vetula cauda scorpionis" (The old woman is the tail of a scorpion) is visible above

the two characters. On this title page, "scorpion" is clearly used in the sense of treachery, often associated with the snake in paradise.[103] The Latin *vetula* is near synonymous with "procuress" and connects to the Roman comedy and the Ovidian tradition of *Amores*. The exceptionality of this image is such that we must assume that it was taken from a previous book of which no copies have survived.[104] Interestingly, as we will examine in chapter 3, some modern covers reuse these early title pages: recontextualized as part of collages and other modern design patterns, these engraving acquire completely new meanings.

The Second Period of Illustrated Editions of *La Celestina* (1842–present)

After the 1616 Dutch edition, no illustrated edition of *LC* was published until 1841. This gap of over two hundred years exceeds the one between 1640 – the year in which the book was included in Sotomayor's *Index*, which objected to some passages – and 1822, during which no editions at all were published in Spain.[105] The long drought in the publication of *LC* was due to a combination of factors, including a gradual loss of popularity. The book was expurgated in 1632, and later included in the Index of Prohibited Books. In the eighteenth century, changes in literary trends made it an unfashionable book.[106] During this period of editorial and pictorial neglect, the literary character of Celestina escaped the confines of the book, becoming a stock character in Spanish folklore and language.[107] That the gap between illustrated editions exceeds that of non-illustrated editions is explainable by the added cost of producing the former. Beginning in the second part of the seventeenth century, the financial factor was especially significant. The Spanish printing industry suffered a prolonged crisis in the quantity and quality of its production.

The lengthy period without illustrated editions of *LC* ended in 1841. Nineteen years after Amarita's 1822 edition, which inaugurated the modern publishing period of the book, an illustrated edition appeared after three preceding ones without illustrations. The 1841 edition included four engravings, resuscitating the tradition of publishing *LC* with illustrations.

In this modern period, the proportion of illustrated editions compared to the total output of editions of *LC* is much smaller than in the earlier period. While hundreds of editions of the book have been published since 1841, barely forty are illustrated. This low ratio reflects the tendency of adult readers to regard illustrations in literary books as dumbing down their content, and thus as an embellishment appropriate

only for young readers and pedagogical editions. Illustrated editions for adults were printed, but only for a small market of expensive editions for bibliophiles and sophisticated readers. These limitations do not mean that the modern illustrations of *LC* are uninteresting. Quite the contrary, new printing techniques and new creative styles of illustration have resulted in images that reveal radically new interpretations of the book's content.

Initially, the return of illustrated editions of *LC* was slow. Only two were printed in the nineteenth century, the 1841 edition with four illustrations and the profusely illustrated one of 1883. Despite being over forty years apart, they share a romanticizing perspective and new styles that lithography made possible. They differ radically from those of the first period: as Simon notes, "almost every generation demands the classics in modern dress, set forth pictorially by a favourite modern hand."[108] The two editions are the result of renewed interest in *LC* in the nineteenth century, especially toward its end, thanks to the work of Menéndez Pelayo and other scholars.

Several important editions of the book, none of them illustrated, appeared in the nineteenth century, such as the one by Amarita in 1822, republished in 1835, the Aribau 1846 and 1872, the Cortezo 1886, and others. The scarcity of illustrated editions is due to the technical backwardness of the Spanish printing industry in comparison to other countries, such as England and France, where illustrated books were common. Also, because *LC* was reborn not as the morally didactic book of its early period but as a masterpiece of national literature to admire and enjoy, illustrations, perceived as appropriate only for didactic (or children's) books, were not commonly included in its editions.[109] The new status of the book is stated in the publishers' introductions to the editions by Amarita in 1822 and Gorchs in 1841. In his introduction, Amarita emphasizes the perfection of its language, reclaiming its place among the European masterpieces (iii). Gorchs compares it to *Othello*, identifying it as the beginning of the Spanish theatre that Lope de Vega would bring to fruition (vii). He places it next to *Don Quixote* and the *Romancero* in importance and praises its formal beauty (xii–xiii). But *LC* was read in the nineteenth century not only as a monument of national literature but also as a tale that satisfied the Romantic taste for fatal love stories in a remote, picturesque past. As we will see, the illustrations of the 1841 edition have a penchant for the story's erotic aspects. The 1883 edition, without ignoring the erotic, also excels in the reconstruction of a romanticized past.

New printing techniques and especially the use of lithography enabled illustrators to exalt the romantic content of the story by making possible

impactful images in strong black-and-white contrast. Although the techniques that permitted this type of image were discovered centuries earlier, they achieved their most brilliant period only in the nineteenth century. Gustave Doré's famous engravings of literary masterpieces epitomize this golden age. The new method of etching in metal and stone permitted subtle lines and tones that were far more sophisticated and realistic than the crude and schematic woodcuts. Instead of painstakingly cutting out wood, the illustrator worked with a stylus to remove wax applied on a copper plate. The plate was submerged in an acidic medium that corroded the surface where the stylus had removed the wax. Lithography used a variation of this method, relying on the principle that grease-based ink and water repel each other. Thus, the surface of a porous material, such as stone, was protected from taking on water except in the spots where the stylus had not removed a protective layer of masking. The whole surface was wetted and then the ink applied, but it stayed only on the parts that had remained dry thanks to the masking agent.

The result was detailed designs with thin lines that could be hatched when needed to produce delicate shadows. Some forms of lithography, such as aquatint and mezzotint, permitted lighter tones for greyscale images. The printed images were more realistic and more dramatic, with strikingly mysterious black spaces contrasting with bright grey and white areas. For the first time, the darkness of the nights in which the lovers Calisto and Melibea meet in the garden could be represented, as well as the gloominess of Celestina's den.

The two illustrated editions of *LC* that appeared in the nineteenth century were both printed in Barcelona. The most advanced printing presses in Spain were located in this city, and they took advantage of the new possibilities in image reproduction. Barcelona was also a city from which scholars and printers were recovering old texts and creating the tradition of a Spanish national literature, in which *LC* occupied a foundational place. After centuries of neglect, many important books of the early modern period, labelled for the first time as the Golden Age of Spanish literature, were reprinted in Barcelona, including the poetry of Quevedo in 1846 (*La cumbre del parnaso español*).

Tomás Gorchs, the publisher of the illustrated *LC* of 1841, was part of this environment.[110] He took over the printing house previously called Viuda de Gorchs, most likely run by his mother, and printed some important editions. He is especially known for his illustrated *Don Quixote* in several volumes (1859), considered one of the best Spanish illustrated editions of the title and second only to Doré's.

His illustrated edition of *LC* is more modest. As noted, it contains only four illustrations: the visit of Pármeno to Areúsa's house in act 7, the banquet in Celestina's house in act 8, Melibea and Lucrecia getting up at night to meet Calisto in act 12, and the two lovers in the garden in act 19. These scenes are full-page illustrations set apart from the text, with captions consisting of the characters' lines.[111] The four sheets are the result of a printing process separate from the printed text. They are on better quality paper than the text and are what in Spanish was called *láminas* – literally "thin metal sheets." The caption for each illustration includes a number identifying the page in which the words are spoken by the character. This inclusion indicates that the book was sold unbound, probably in instalments. It was up to the owner to bind it, and the page number on the illustrations indicated where to place them in the bound volume.[112] That the book was sold unbound is confirmed by how different extant copies have the illustrations inserted sometimes immediately before and sometimes after the indicated page. Some copies have one or more of the images bound at the beginning of the book, and others are missing one of the illustrations. This variety indicates that the illustrations were conceived of as embellishments that could be used independently of the text, including being framed and hung on a wall, a common practice in the period. Although the person who engraved these illustrations was an anonymous operator hired by the press, the care and elaboration indicate artistic and highly personal involvement. These are the last of the anonymous illustrations: those of later editions are signed, and sometimes the illustrator is mentioned on the title pages after the author and the editor.

The illustrations in Gorchs's 1841 edition differ from the ones of earlier editions in more than technique. They reflect a fundamental change in their relation to the text: the new illustrations are not meant to help readers understanding the action while they read the summaries, but to thrill readers as they read the actual episodes. To maximize this emotional impact, the new moments of choice privilege sentimental, erotic, and picturesque passages. This decision met the expectations of a readership accustomed to dramatic stories, such as those that appeared in feuilletons, that were interspersed with sensationalist images depicting the protagonists' adventures. Such illustrations made the readers' relationship with the text more personal and emotional.[113]

In Gorchs's edition, the images, accompanied by captions quoting the most descriptive and impactful lines of dialogue, are meant to be seen simultaneously with the text of the scene. Maximum impact is the guiding criterion both for the choice of image and caption. Not surprisingly, three of the four illustrations depict erotic scenes: the banquet in

Celestina's house, the visit of Pármeno to Areúsa, and the encounter of Calisto and Melibea in the garden. The fourth illustration, Melibea secretly leaving her bedroom for her encounter with Calisto in the garden, conveys the titillating secrecy, danger, and desire leading up to the encounter. The other three images are part of the iconographic program of the early illustrated editions. However, now the general design and the selection of piquant lines for the captions emphasize the exciting aspect of the plot. That this strategy worked is confirmed by the critic Soravilla, who, writing in 1895, claimed that the bad reputation of *LC* could be attributed to its "pornographic" content having been enhanced by some illustrations in modern editions, likely referring to Gorchs's edition.[114]

Part of the impact of the new illustrations relied on the ability of the new techniques to depict facial expressions and gestures that conveyed the characters' emotions in a mysterious yet realistic background. Seeing a climatic episode in high definition allows the readers/viewers to become voyeuristic participants. This role of the reader can be exemplified by the treatment of the encounter between Pármeno and Areúsa in Gorchs's edition (image 13). The scene was, at least in theory, to be read as an example of lasciviousness and sexual misconduct. The titillating aspects made it an early choice for illustrations, like the image of Pármeno on top of Areúsa under the blankets in Zaragoza 1545. However, neither that early illustration nor the more elaborate one in Augsburg 1520, in which Areúsa's breasts are visible, can compete with the erotism in Gorchs's image. In it, Areúsa's nipple is showing under her vaporous night gown. Pármeno's right arm, not visible, is touching her body under the sheets, and the coquettish invitation in her eyes contradicts her words at the bottom of the image: "Be civil, for the sake of courtesy. Leave, for I am not one of those you think I am!" (112). Celestina is sitting to the left of the image. She is pointing to Pármeno's genitals, whose form is noticeable through his tight pants, as if encouraging us to join her as voyeurs in the scene.

The same attention to erotic detail is evident in Gorchs's other illustrations. The caption for the illustration of the banquet in Celestina's house precisely selects Celestina's voyeuristic intentions: "Put your arms around each other and kiss, for I have nothing left but to enjoy watching" (134). The image, as in the old engravings, shows the lovers at the table with Celestina presiding. However, the tone of debauchery implied in the words is clearly depicted: one of the men's heads is on the lap of one of the young women; the other is passionately kissing his lover. One of his hands is on her breasts, probably in allusion to

Celestina's words in the passage at the table that all types of caresses above the belt are allowed.

Gorchs's illustration of the lovers' encounter in the garden in act 19 is also part of the old iconographic program, but depicts a different moment. It does not present the ominous climbing of the wall, but the lovers in the garden. The new techniques make it possible to represent a mysterious dark garden illuminated by a romantic moon. Once again, the caption chooses a loaded line, Calisto's words to Melibea: "I would wish, my dearest mistress, that the dawn would never come, considering the glory and repose my senses receive" (231).

Only one of the four illustrations is new in the iconographic program of *LC*: Melibea and Lucrecia secretly getting up at night to meet Calisto in the garden. The caption is Melibea's words, "But what would they do if they knew I had left my chamber?" (172). The two illustrations traditionally chosen for this act are either that of the lovers talking through the interposed door, as in the 1499 Burgos edition, or that of the death of Celestina. The new choice is more integral to the romantic plot, a nocturnal scene of intrigue with soft erotic touches, such as the naked calves of Melibea in her nightgown. The bed in the background is an allusion to sex, and, as we saw earlier, the symbol was also used in illustrations in some older editions. The long shadows the two women cast and the darkness of the background contribute, together with Lucrecia's gesture of calling for silence, to the mysterious ambience of the scene.

The second illustrated edition of *LC* in the nineteenth century was published over forty years later, in 1883. Unlike Gorchs's version, this one has thirty illustrations as well as several decorative vignettes of flowers, cherubs, and other images to fill empty space at the end of pages. It is also the first edition to have an illustrated hard cover (see chapter 3 for a discussion of book covers). We can surmise that this profusely illustrated edition was extremely successful, given the many copies that have survived. As an added curiosity, it is likely the one Picasso read as a young man.[115]

Like Gorchs's edition, a soft romantic eroticism prevails in these illustrations. They are, however, much less elaborated than the full-page illustrations in Gorchs's edition, quantity having replaced quality. This 1883 edition appeared in the Biblioteca Amena e Instructiva series, later known as the Biblioteca Salvatella. The series was one of several ambitious collections published in Barcelona at the time, a more modest version of the prestigious Biblioteca de Artes y Letras, which after 1881 published lavishly illustrated books by Spanish writers and translations of famous masterpieces from other languages. These collections

were the product of publishing houses specializing in texts by classical authors, which they printed as carefully designed books, beautifully bound, and often illustrated. They were part of an effort to elevate the general level of culture in Spain in the spirit of progress and renovation.[116] They included some of the best authors among the European Romantics, and some the best Spanish illustrators of the moment collaborated or reproduced images by internationally famous illustrators, such as Doré.[117]

The illustrations in this edition of *LC* are by Ramón Escaler (1862–93), who is considered one of the pioneers of Spanish cartoons for his work in the periodical *La Semana Cómica*.[118] Among other books, he illustrated Byron's *Don Juan* (1883) for the Biblioteca Salvatella, displaying the same romantic tone as in his illustrations of *LC*. He was only twenty-one years old at the time, and his immaturity as an artist, as well as the burden of work he had to do for periodical publications, shows in his *LC* illustrations. They are, for the most part, small vignettes of open lines and clearly were rapidly executed. He knew the text well but probably was not familiar with the early illustrated editions. The moments of choice are all his own, with no perceptible concession to or elaboration of the tradition of the *LC* illustrated editions.

Escaler preferred to depict the amorous scenes, ignoring the murder scene and the fatal falls. His most important innovation and notable image is the only full-page illustration in the book: Celestina casting the spell (image 14). This is the first time this scene is illustrated, inspiring many similar images in later editions. His dramatic image emphasizes the demonic nature of Celestina, with the inclusion of a little demon dancing on top of a cauldron at which Celestina is reciting an incantation. A vignette of a dancing demon is also added to fill the space at the end of the act. Except for this illustration, Melibea's innocence and beauty is the leitmotif of Escaler's iconographic program. Even her suicide is represented in the romantic tradition of the beautiful corpse. The romantic tone is reinforced at the end of some chapters by boilerplate vignettes featuring hearts crossed by arrows or dead little birds. With all its virtues and defects, the significance of this widely circulated edition was to consecrate *LC* as a classic.

The 1883 edition inaugurates the rapidly executed drawings and the emphasis on the tragic love story typical of pedagogical editions of *LC* in the twentieth century. It was also the last illustrated edition of the book for a general market. Even if the images and format implied a simplified, naïve reading, they were not for a young audience, given the inclusion of piquant elements such as Areúsa's partial nudity during Celestina's visit.

From the beginning of the twentieth century, and even earlier, illustrated editions of literary texts were no longer being printed, except for two niche markets: young readers, who require the addition of images to break the monotony of a fully printed page, and bibliophiles, who collect lavishly illustrated books released in limited, expensive editions. Consequently, most of the editions of *LC* published since the end of the nineteenth century are without images. Unlike *Don Quixote*, for example, the crudeness of some scenes in *LC* and the aura of immorality the book conveys prevented production of illustrated editions for young readers.[119] This view seems to have disappeared in the second part of the twentieth century, when editions for students in secondary education became common. Some contain pedagogical introductions and other supporting materials, and their illustrations tend to be straightforward depictions of the main events. Frequent in these editions is the emphasis on the romantic aspects of the love story of Calisto and Melibea, as well as spectacular events, such as the death of the characters or Celestina's witchcraft. Sexual crudity is generally avoided but not completely absent, especially in the most recent editions.

The first of these didactic editions was published in 1959 with a preface and notes by the Spanish scholar Martín de Riquer. It contains nine full-colour, eye-catching images that are highly descriptive of the events they illustrate. Since then, many similar editions have been produced. Some are staples in the catalogues of publishers, who re-edit them periodically with minor changes, especially new covers and additional supporting materials. Some contain black-and-white images, but, more often, the illustrations are colour. Good examples are the several editions published in the past twenty years by Anaya, a Spanish publishing house that specializes in textbooks. A branch, Didáctica Anaya, publishes this type of didactic edition of classics. In some illustrated editions, such as Editilia 2010, in its series Clásicos de Fácil Lectura, the text is shortened and simplified for young or inexperienced readers. Some of the most recent illustrated editions aimed at a popular audience depart from realistic imagery. They include a few expressionistic illustrations, such as in Buenos Aires 2002 and Anaya 2017.

The only illustrated editions of *LC* from the first half of the twentieth century are for bibliophiles or, at least, for readers who know the story and want to acquire an edition with carefully designed, original illustrations. These illustrations are often printed on separate pages. They act as representations of the text as well as autonomous works of art that convey a strong personal imprint of their creators, often well-known artists. The first of these editions appeared in France in 1922. The text is in French and the images, one per act, recreate the appearance of

the old factotums of characters but with high quality, newly designed engravings.

In Spain, the first illustrated edition for bibliophiles was published in a limited run of three hundred copies in 1946. It is printed in Gothic font on the highest quality paper, and some copies are bound with a luxurious engraved leather cover bearing the image of Celestina. The text is based on the 1514 Valencia edition. The introduction is by the director of the Spanish Royal Academy of Language, the writer José María Pemán, a staunch supporter of the Franco regime. This exclusive edition contains nine illustrations by Josep Segrelles, the most prestigious graphic artist of the period, who worked for journals and designed posters and advertisements. He also illustrated numerous books and painted canvases. Segrelles was an enemy of avant-garde trends, and his illustration of *LC* combines academicism with a historicist and romanticized vision that was a remnant from the previous century. The restrictive morality of the Francoist dictatorship in sexual matters was even stronger than the moralism of the previous century. Therefore, the rough aspects of earlier illustrations had to be softened. Not surprisingly, Segrelles's edition is disappointing, falling short of the imagination and display of colour in many of his other illustrations. Most are bland scenes of two characters talking to each other. More dramatic scenes that were traditionally illustrated, such as the banquet in Celestina's house, are missing. The visit of Celestina to Areúsa shows the latter ready to go to bed, with most of her clothes still on. Exemplary scenes, such as the death of Celestina, are represented, as is the suicide of Melibea. However, the execution of Pármeno and Sempronio is absent, as is the fall of Calisto and all the love scenes in the garden.

A year later, in 1947, an illustrated edition of LC was published in Mexico that, in many aspects, is the opposite of Segrelles's edition. It was illustrated by the Spanish political exile Miguel Prieto, an active member of the Communist Party who participated in theatrical productions and designed propaganda posters during the Republic and the Spanish Civil War.[120] He produced this edition of *LC* with other Spanish exiles. His drawings and coloured plates hold nothing back when it comes to erotism and nudity, and his style is more modern than that of Segrelles. Some of the illustrations do not represent the action as narrated but depart in imaginative interpretations of the events, influenced by contemporary surrealist and expressionist tendencies in painting. For instance, an illustration included in the introduction shows Celestina surrounded by mythological characters, one of them a minotaur that clearly references Picasso. In Prieto's image, a naked Melibea rests on the lap of the minotaur figure in a garden that looks like a cemetery.

This illustration epitomizes a characteristic of this edition: an expressive, often surrealist combination of sex and death. This approach is also noticeable in an illustration in act 6, in which a figure combining Celestina and a skeleton as a death allegory approaches a dove on a tree.

Prieto's – and, a quarter of a century later, Picasso's – reworking of the sexual content of *LC* into subconscious imagery is an exceptional departure from the sexual element of the story. In most cases, twentieth-century illustrators depicted the sexual scenes in realistic detail, enhancing their erotic allure. The partial nudity and innuendo of the nineteenth century and earlier illustrated editions culminate in openly sexualized images starting in the mid-twentieth century. The first of this type is a 1943 French edition, in which sexually explicit content is softened by caricature-like, even humorous deformation of the figures.[121] It is a limited edition for bibliophiles, superbly illustrated with thirty images in reddish-brown ink by Maurice L'Hoir, who had illustrated classic texts, such as Erasmus's *Praise of Folly* (1946), as well as erotic titles, such as Charles P. Duclos's *Les confessions du Comte de x* (1929) and, later, Du Bellay's *La vieille courtisane de Rome* (1949). He uses voluptuous naked figures for the female characters in scenes such as the banquet, Celestina's visit to Areúsa, and the encounter of Calisto and Melibea in the garden. However, the erotic tone is subdued by the highly expressive, often caricaturized style of the drawings, which recalls Goya's ironic treatment. The braggadocio Centurio looks like a character from a children's cartoon, while Celestina is a peculiar combination of the old women of Goya and the quaint witch of modern comics.[122] A "spooky" treatment is added in the background – for example, Pleberio's house is a castle suitable for a Gothic story – which contributes to making this edition a playful interpretation of the book, with erotic touches.

The eroticized images of *LC* reached their highest point in the French edition of les Bibliophiles de France (1949). This exclusive edition is illustrated with coloured lithographs by Maurice Lalau, a prolific French commercial illustrator who had made lithographs for classics such as Wagner's *Tristan and Isolde* as early as 1909. While he treated *Tristan and Isolde* in an elevated, tragic tone, with art deco–style images, he used the realistic style characteristic of modern illustration for *LC*. His sixty-eight illustrations make this book the most prolifically illustrated *LC* edition: the emphasis on sexuality and the often-gratuitous nudity of the female characters also make it the most blatantly sexualized.

The erotism of these illustrations is reinforced by backgrounds of an exotic medieval Spain of Arab sensuality. Some present Celestina's house as a harem in which naked women rest in indolent poses, and

Pleberio's house is clearly inspired by the Court of the Lions in the Alhambra. Areúsa and Elicia are gratuitously shown naked or semi-naked at every opportunity, often in episodes in which the text does not justify the decision. For instance, one of the two women is depicted topless while carrying a tray with food at the dinner in Celestina's house. Her allure is accentuated by flowing dark hair, adorned with a carnation, as if she were a medieval Carmen. The result is a curious book of soft pornography that presents a romanticized Spain of oriental erotism. (When the cover is analysed in chapter 3, the Thousand Nights ambience of an orientalized Spain in this edition will become even clearer.)

Unlike France, no erotic editions appeared in Spain in this period, due to the sexual repression and censorship exerted under the long dictatorship of Franco. Toward the final years of his regime, censorship relaxed temporarily, allowing the more daring 1968 Barcelona edition to appear. This opportunistic edition was also timed to profit from the debut in the same year of the much-advertised and scandalous film adaptation by Ardavín. This illustrated *LC* appeared in a collection of three classics of Spanish literature with strong erotic content, the other two being *Libro de buen amor* (Arcipreste de Hita, 1968) and *Retrato de la lozana andaluza* (Delicado, 1968). The engravings by Ezquerro touch on the erotic element, but it is downplayed by a parodic, cartoonish style, like that in the French edition of 1943. The result is a peculiar comic-erotic edition of a contradictory style, appropriate for young readers despite its adult content, which managed to pass the state's temporarily, and minimally, softened censorship.

Interestingly, when democracy arrived and censorship disappeared in Spain altogether, making possible a fully "adult" version of *LC*, one was never made. A curious combination of factors intervened. First, cinematic adaptations took over the successful exploitation of Spanish classics, such as *LC*, that contained erotic scenes.[123] Another factor was its renewed prestige as a socially engaged text. It was revendicated as a fundamental book for reinterpreting Spanish history. Its representation of class and gender struggle made it an iconic text not suitable for banal, erotic editions for voyeuristic readers.[124]

The new readings of *LC* after the return to democracy in 1975 did not exclude sexuality but integrated it as part of the conflictive world the book describes. This conception is best achieved in the edition with illustrations by Teo Puebla issued to commemorate the five hundredth anniversary of *LC* in 1999. Puebla, an award-winning illustrator and painter born in Puebla de Montalbán, Rojas's hometown, had painted a series of thirty-two large-format canvases representing scenes and

characters of the book, which were exhibited in the Museum of Albacete the same year.[125] Some of these paintings were selected to illustrate this commemorative edition, whose introduction was written by the left-ist intellectual Juan Goytisolo. He presents *LC* as part of a progressive, even subversive, vein of Spanish literature that was ignored under the dictatorship of Franco and earlier by conservative forces. He considers the expressionist style of Puebla's illustrations perfect for Rojas's intent to criticize the chaotic, unjust society of his time, comparing them to the powerful social commentary in many of Goya's images.

Puebla's strong brushstrokes in black and red merge the characters into a stormy background that represents the dramatic reality of the time.[126] The red colour predominant in many of the images places the characters in a hell-on-earth of their own making. The background, as the illustrator suggests, tries to reproduce the Gothic architecture and the dark oppression of the times and cities in which Rojas lived.[127] Puebla intentionally left aside the conventions of previous illustrations of the text to create a new expressionistic cycle. This approach can be exemplified by how he substitutes the traditional encounter of the two lovers in the garden with an image of Celestina restoring the hymen of a woman (image 15). The scene of the banquet in Celestina's house is not represented. Instead, we have the image of a priest or bishop fondling the breasts of a young woman, an allusion to Celestina's role in pro-viding members of the church with young women. Equally unconven-tional is the illustration from act 8, which presents Calisto masturbating in bed. These illustrations show a highly personal engagement with the text's darkest aspects that connect with Goya and the *España negra* of painters such as Gutiérrez Solana, but executed with a personal, mod-ern style. Sex, in its crudest aspects, is only one of the ingredients.

While Puebla's images, despite being highly personal, represent the content of the text, this is not the case with Picasso's 1971 edition of *LC*. His images are not illustrations, properly speaking. They are free renderings that depart from the story to fulfil the function that Barthes calls "relay" and Hodnett calls "interpretation." This treatment is not completely unprecedented: some of the illustrations by Prieto in the 1947 Mexico edition can be considered of this type. However, Picasso's is the only edition of *LC* whose totality of images – we cannot call them illustrations – fall fully within the category of free interpretation.

Along with a French version of the text, Picasso's 1971 book repro-duces sixty-six etchings taken from his *347 Suite*. The book was pub-lished by Editions de l'Atelier Crommelynck, Paris, in a run limited to four hundred copies, auctioned at high prices. Later, the images were reused in more affordable editions, such as the German translation by

Fritz Vögelsang, Frankfurt 1989, and a Spanish version published in Barcelona in 2007. The etchings do not represent, even loosely speaking, any of the events that take place in *LC*. They are mostly erotic scenes unrelated to the story, although a Celestina-like character is often present, together with a young woman and a suitor. In these images, the young woman may be interpreted to represent Melibea, Areúsa, or Elicia, and the young man Calisto, Pármeno, or Sempronio. The male character often is characterized as a "musketeer," a figure common in Picasso's pictorial universe.[128] Picasso also includes a tiny caricature of himself in one of the engravings. Some of the scenes contain clear allusions to famous paintings, such as Rubens's *The Rape of the Sabine Women* (c. 1635). The images reveal Picasso's lifelong interest in the character of Celestina, which we will examine in the next chapter.[129]

The Picasso edition has received much attention from critics, who all coincide in calling it not an illustrated edition in the traditional sense but a "livre d'artist" or an "art book."[130] Nowak writes that "Picasso's Celestina images function more like related but non-sequential vignettes in which the various moments of the lovers' relationship are visited and revisited." He adds that, "after reviewing the order of the images in relation to the text, I can find no direct correspondence between written word and the image printed next to it."[131] The images, created well in advance of the edition, do not physically integrate with the text in the traditional way of illustrations. Furthermore, they are not printed on the same page as the text but on separate sheets, of which the reverse is not printed, following Picasso's specifications. This separation matches what Salus considers Picasso's intention "not to illustrate the text, but likely to compete wilfully with Rojas's literary methods and to muse upon its content."[132] Nowak considers that the two lovers and the procuress, who are the backbone of Picasso's visual appropriation of Celestina, "are the props he uses to flesh out his meditation on the portrayal of sexual seduction and intercourse as a metaphor for literary (or artistic) expression."[133] Kleinfelder considers them Picasso's way of exploring his own sexual decadence as an old man who identifies with the voyeuristic aspect of Celestina.[134]

In spite of the uniqueness of Picasso's book, some features permit us to place it in the tradition of illustrated editions of *LC*. Even if the images do not describe the events in the story, they are somehow inspired by it and the figure of Celestina. We know that these sixty-six etchings were personally selected by Picasso. They were part of the over three hundred etchings in *347 Suite*, which contain many Spanish-inspired themes, such as bullfighters. Baker contends that the order in which Picasso created and later placed the etchings in this edition suggests

that he had *LC* in mind when he created the images.[135] Picasso saw some unifying aspect to them, as confirmed by the repeated presence of the figures of Celestina, the young woman, and the suitor.

Celestina appears in twenty of the sixty-six images and is clearly depicted as an old, sinister woman clad in traditional dark clothes.[136] Holloway goes further in seeing some similarity between the figure of Celestina that Picasso uses in this edition and the engravings in the 1534 illustrated Venice edition, which we know Picasso owned, but, in my opinion, the similarities are too generic to ascertain if he was directly inspired by the earlier volume.[137] Kleinfelder connects the Celestina figure dressed in black with the *memento mori* that Celestina often uses in the text. She is ominously placed between the lover and his object of desire, the naked woman. Like death, "the cloaked Celestina, thus, becomes their audience, the voyeur who watches the voyeur."[138]

Conclusion: Two Periods, Two Readings

The history of the illustration of *La Celestina* is divided into two periods clearly separated not only in time but also in technique, style, and overall conception of the role of illustration. The differences in the illustrations from the two periods reflect changes in how the text was received. Originally it was seen as a story narrating the fatal results of uncontrolled passions and social disorder, and it could be read as entertainment or as a didactic story. Later it became a classic literary piece, open to personal, atemporal interpretation. The difference between the two periods is widened by the role the illustrations play in a printed text, affecting the whole concept of what an illustrated edition is.

The first period, from 1499 until the first decades of the seventeenth century, used woodcuts, a medium that imposed limitations on detailed representation. At the same time, the representational conventions of the day, such as the use of transparent walls and double-panel illustrations, introduced peculiar narrative effects. Two defining characteristics of this period are the high proportion of illustrated editions as well as the stability of the iconographic program. Both are connected to what is likely the first edition, the 1499 Burgos.

The illustration of this edition created a precedent that compelled printers to illustrate many later editions. It also created an iconographic program that, with only small modifications, was followed by later editions of the period. The lack of interest in artistic originality of illustrations explains this stability. The most noticeable changes were imposed by the need to save paper and lower costs as the sixteenth century progressed. These considerations resulted in the use and abuse

of factotums, as well as of poorly copied or repurposed illustrations. The most significant additions and modifications were the inclusion of the crime-and-punishment sequence of the death of Celestina and the execution of Pármeno and Sempronio. Also innovative was a cruder, more descriptive treatment of the banquet scene and the visit of Celestina and Pármeno to Areúsa. Under the pretence of showing morally loaded actions, these changes responded to an intention to present the most spectacular elements of the story.

Illustration served to foster sales, as well as to reinforce the didactic value of a book whose crude story could be justified only in this vein. At the time, images also enjoyed the prestigious status of aids to convey religious history and doctrine. In their supporting role, the illustrations for LC were created and positioned in ways that clarified who the characters were, the key episodes, and the moral lessons. For these purposes, the iconographic program responded to a systematic exposition of the content, act by act. The illustrations supplemented the summaries at the beginning of the acts, a function reinforced by the placement of these elements beside each other. The frequent use of two-panel illustrations helped create a narrative appreciation of the whole, of the concatenation of actions and their inner logic. Eventually, the thrilling events portrayed in the images conjoined their exemplary purpose and their explanatory function.

The illustrators of the modern period of editions of LC rely on a variety of techniques and styles that contrast with the unity of the first period. The events are depicted with optics ranging from realistic to expressionistic to surrealistic, and there is no uniform iconographic program. Compared to the early illustrated editions, a smaller proportion of the modern editions of LC are illustrated, as they are limited to the niche markets of young readers and bibliophiles. Those for young readers are didactic editions, not in the moral sense of the first period but in that of helping inexperienced readers. They help them cope with the difficulty of reading a long text that describes a distant worldview in unfamiliar language and style. The illustrations contribute not so much to explaining the action as to making the text lighter and engaging the reader. The illustrations in such editions are in the most realistic and conventional style, with some connected to the style of comics. Romantic and dramatic scenes are preferred, and the figures of the young lovers Calisto and Melibea are central.

The illustrated editions for bibliophiles are more lavishly produced and varied in their approach to the story. The illustrators of these editions, who see their role more as artists than as illustrators, employ their individual style and criteria, and the results are richer and more varied.

They play with point of view and perspective, and their highly personal productions can be expressionistic or surrealistic. They are creative in terms of how they portray the characters, especially Celestina. That said, her most creative and influential treatments are not in books but on the canvases that we will study in the next chapter.

The iconographic programs of the editions for bibliophiles are highly personal and mostly independent from the tradition of the early illustrated editions. Only some of the old moments of choice, such as the banquet in Celestina's house, fare well in these editions. Others, such as the deaths of characters, are not popular choices. At the same time, episodes not represented in the early editions have become common, such as Celestina working in her laboratory or putting the spell on the yarn. Erotic and sexual images are the biggest winners. The initial romanticizing of the nineteenth-century editions was followed by the erotization that began in French editions. This reached its culmination in Picasso's use of the story as a platform for his sexual ruminations.

Chapter Two

Painting Celestina

This chapter studies Celestina images in pictorial formats, including oil paintings or etchings, that were created as independent works and not as illustrations for *La Celestina*. In most cases, these images differ from the book's illustrations in format and content. However, the distinction may become blurry, as in some of Picasso's engravings in his *347 Suite,* which he later repurposed to illustrate an edition of *LC*. Except for these rare cases, the difference between the Celestina images examined in this chapter and the illustrations analysed in the preceding chapter is clear, and is reinforced by the fact that no specific episodes from the book ever made it onto canvas, unlike *Don Quixote*, whose famous adventures became the subject of some canvases.[1] Even episodes as dramatic as the suicide of Melibea were not taken up by painters, in spite of their potential to become a pictorial theme as successful as the dead Ophelia was in nineteenth-century English painting.

A combination of factors prevented artistic depiction of episodes of *LC* from going beyond book illustrations. The aura of immorality that surrounds the book was likely an impediment in the first centuries after its publication, especially when the Council of Trent advised against depicting lewd subjects, a recommendation that was included in painting treatises such as Francisco Pacheco's *Arte de la pintura, su antigüedad y grandezas* (1649).[2] Later, when, in the nineteenth century, painters found inspiration in national literatures for their historicist canvases, *LC* was not included. Its characters and episodes did not fit the epic, celebratory tone that the enterprise of European nation-making demanded.

The non-existence of canvases depicting episodes from *LC* does not mean that Celestina as a prototype based on the literary character did not appear in paintings. Quite the contrary, many paintings contain Celestinas. But these images were never intended, unlike those in the illustrations, to be faithful renderings of the character in the book. They

are highly personal amalgamations of the literary character and the popular type or figure. They are combined with the procuresses and madams of the day and expressed in the style of a painter. The resulting images vary in their relation to the text of *LC*, the character of Celestina, and the prototype of the procuress: the ones that have the closest relation are those in paintings by Spanish-speaking artists familiar with the book and in which the word "Celestina" is included in the title. The presence of the word "Celestina" in the title is significant because the title of a painting is not only a classificatory label for cataloguing or differentiating purposes, but it is also an attempt to direct the viewers' interpretation of the painting. A problem is that the titles of many old paintings are not the painters' choice but that of later critics and collectors. As a result, paintings known by several titles are common, as we will see with paintings by Murillo that include alleged Celestinas.[3]

A second group is paintings that represent procuresses and, even if they do not include the word "Celestina" in their titles, are painted by artists familiar with the figure of Celestina. This familiarity can be assumed for painters from Spanish-speaking countries, due to the extended use of the moniker *Celestina* for a procuress. An example of this type is Sorolla's *Trata de blancas* (White slave trade, 1894), which depicts a group of young women in a train car being escorted to a city brothel. The title does not include the word "Celestina," but the women are escorted by an old woman, dressed in a humble dark cloak that covers her head, who clearly recalls that character.

Finally, we have images with procuresses and madams by painters from non-Spanish-speaking countries, who may or may not have known of *LC* and Celestina. In some cases, such as the Dutch genre paintings of brothel and tavern scenes, the influence of *LC* may be suspected, given the political and cultural influence of Spain in the region. But even if a direct connection between these images and Celestina does not exist, they are of interest because they developed from the same genome as Celestina, although in a different environment.[4] In spite of their differences, some of the same anxieties underlying *LC* are revealed when we analyse these images. As we will see, many canvases from the Golden Age of Dutch painting depict the Prodigal Son's time with prostitutes. They include a procuress and reveal concerns about how dangerous the habit of associating with such a figure was for wealthy young men. The analysis of these images helps us place *LC* in a pan-European context, opening the possibility of new interpretations, such as Calisto as a money-squandering prodigal son who never returned home.[5]

Although the chapter considers the painted figures' faithfulness to *LC*, that will not be its guiding principle. Examining the paintings only

from this point of view would limit the study to an exercise of matching visual features and specific lines of the text. Such an approach was productive for the study of illustrations, but it is insufficient for the study of pictorial works where more creativity is expected. It would also imply the existence of an ideal or real image of Celestina that must be rendered with photographic fidelity. Instead, the chapter follows an approach based on a combination of chronology and painting school. In many cases, the focus shifts from schools and styles to specific painters, such as Goya and Picasso, who have given us particularly rich and complex depictions of Celestina types.

Images of Procuresses before *La Celestina*

The oldest predecessor of Celestina of which we have images is the *lena*, the woman in charge of the prostitutes in Plautus's and Terence's comedies. The *lena* is a stock character that appears in four Roman comedies as an older woman, sometimes conflating the characters of the *vetula* or *anus* (a poor old female servant who acts as an adviser to young women, often in sexual matters) and the *nutrix* or wet nurse. As Lida de Malkiel has demonstrated, the *lenae* of the Latin comedies and Celestina share their trade and their greed, but not other specific features.[6] Most significant for us, the *lena*'s influence on the visual culture of Celestina is limited because her visual legacy is minimal.

A few images of her figure have survived in illustrations in medieval manuscripts, which may be copies of sketches taken from real *lenae* characters during performances on Roman stages. A figure representing the old *lena* Syra in the comedy *Hecyra* is in the *Codex Ambrosianus*, a collection of manuscript documents from the second half of the tenth century that is a copy of older manuscripts.[7] The lavishly illustrated manuscript of Terence's plays known as the *Térence des Ducs* (c. 1410) also presents an image of *lena* Syra. She is portrayed as an old woman with her hair covered, not dressed in the Roman way but in the style in vogue when the manuscript was produced.[8] She is next to a young woman inside a house. Her hands are gesturing as if to support her argument. In this case, she is convincing her protégée, the courtesan Philotis, to take advantage of the men soliciting her. Philotis is standing, while Syra is sitting, symbolizing her old age and authority. Syra appears next to her protégée in another illustration in the manuscript, but here her role is limited to acting as a contrast to the beauty of the young woman.[9]

Curiously, the other old woman in the comedy, the suitor Pamphilus's mother, Sostrata, is portrayed as being much younger than Syra

in the *Térence des Ducs*, to the point that she can be taken for a young woman in spite of sitting in a way that emphasizes her age and authority.[10] As Saunders has noticed, Syra is the only figure among all those representing old women in illustrated manuscripts of Roman comedies to show clear signs of age, as if to emphasize that decrepit old age and ugliness are the consequences of the sinful life her trade implies.[11]

Another of the rare extant images of a *lena* is in Roman mosaics representing the first scene of Menander's comedy *Synaristosia* (Women lunching together). Only fragments of this comedy have survived, but, because Plautus's *Cistellaria* is based on it, we know that the opening scene of the play contains an unnamed *lena* talking to her daughter and a courtesan.[12] Three images of this opening scene have survived. The best-known and oldest is a mosaic from the second century BCE found at the Villa of Cicero in Pompeii (image 16). It shows "three actors dressed as women wearing masks, seated around a circular table, two of them youthful and the other an old hag; the vases on the table suggest that the sorceress might be preparing love potions, assisted by a serving girl."[13] This old image of a predecessor of Celestina interestingly contains some of what, centuries later, would be her main features, and places her in some of her typical environments: old age contrasted to youth, a space of female privacy, the presence of magic and/or cosmetics, the prominent presence of wine – the *lena* complains in the text that the servant is not pouring enough wine and that it was watered down.[14]

Although few images of the procuress are found in antiquity and the medieval period, many women practised this trade, as proven by the abundant laws penalizing their activities and the figure's popularity in literature and folklore.[15] Their visual underrepresentation could be due partially to the general lack of images of older women. Only in early modernity did images of older women start to appear, mostly for the representation of biblical figures, such as Saint Anne, Naomi, Sarah, and Saint Elizabeth. They are all old women characterized by their chastity, abstinence, spirituality, and wisdom, as well as an authority that made them equivalent to men. In this period, characterized by an increased interest in the regulation of married and domestic life, these women became inspirational figures. Virtuous older women, in their roles as grandparents or widows, were deemed appropriate examples and advisers for younger women. Widows, with their experience in sexual matters, were considered important for the instruction of young virgins.[16]

The figure of the procuress was clearly a travesty of these exemplary old women. She was a former prostitute who did not have a proper family and could instruct young women how to avoid pregnancy or

fake virginity. Medieval art, being mostly sacred art, did not pay much attention to such questionable figures except as counterexamples in scenarios of induction to carnal sin. One of these extremely rare images to have survived is a twelfth-century bas-relief on one side of the baptismal font in the church of Rebanal de las Llantas, in Palencia, Spain (image 17). Torres describes it as depicting "a scene with a male on the left of a naked couple watching them copulate, while an obese woman on their right pushes the buttocks of the young girl toward the naked man."[17] This woman, a procuress, is "slightly stooped and obese; she lacks the elegant proportions of the other figures on the font." Torres further notes that "obesity was a sign of ... carnal indulgence. Similar physical characteristics of obesity were used to distinguish rural, lower-class women from aristocrats." The doctrinal message of the scene is made clear by the other side of the baptismal font, which shows hell and an allegory of lust, with Eve feeding two snakes at her breasts.[18]

Another of the rare pre-Renaissance images of procuresses is in the illustrated manuscript *Der Renner* (The courier, 1425). The manuscript contains an illustrated copy of a text about sin written by Hugo von Trimberg at the beginning of the fifteenth century. On folio 27r, an illustration for the chapter on lust (*Unkeuschheit*) shows three characters: a young woman, an old woman, and a young man. The small figure of a devil is sitting on the shoulder of the old woman, who is rejoicing at how the young woman is soliciting the young man.[19]

The first images of procuresses of the early modern period appeared in northern Europe. There, the early development of the printing press resulted in the popularity of engraved loose sheets for moral instruction. These are single sheets meant to be displayed or framed, but their fragility is responsible for only a few having survived. These engravings belong to the same moralizing tradition as the illustrations of *Der Renner* or the baptismal font of Rebanal de las Llantas, but they present elaborate scenarios with more characters and detailed backgrounds.

These engravings warning of the dangers of frequenting prostitutes and brothels are especially interesting because they were published around the same time as *LC*. They show wealthy young men with prostitutes and a procuress in brothels or taverns, which, at the time were often the same place.[20] They typically depict scenes with abundant food and wine, and sometimes music, in which a young man is robbed while he is distracted by the mercenary caresses of a young woman. An old procuress is to one side or in the background, together with other characters ranging from other young men to social parasites. Some characters assume the disguise of the fools that the moralizing and parodic literature of the period made popular, as in Brandt's popular

Das Narrenschiff (The ship of fools, 1494). One of the most interesting of these engravings is Erhard Schoen's *The School of the Procuress* (1531) (image 18).[21] It shows a client sitting at a table and being caressed by a young woman who is surreptitiously reaching for his moneybag. To their left, the procuress is passing the pilfered money to a man in the background. The young woman is attractively dressed, and the young man is richly dressed. The procuress, clearly depicted as old, shows an appetite for wine. Meanwhile, a *Narr* (fool) is making eye contact with the viewer. He is pointing to the client, as if identifying him as a member of the guild of fools.

A second engraving by Schoen, *The Cage of the Fools* (c. 1522), depicts a cage full of men kept as prisoners by a procuress, who is teaching them to sing. She is holding a music sheet and pointing to the notes with a stick she uses to discipline the caged men. (The symbolism is rife, as a birdcage at the doorsill of a house was a discreet manner of advertising prostitution at the time.)[22] A second procuress is letting the men out of the cage once her purse is full of money. The two procuresses are not haggard old ladies, but mature women elegantly dressed.[23] The production of similar moralizing engravings depicting brothels and procuresses continued into the seventeenth century in northern Europe. Besides lust, other vices were chastised in these engravings, as in the Dutch engraver Jacob Matham's *Couple Drinking* (c. 1621), which depicts the customary image of debauchery in a brothel, accompanied by a Latin inscription connecting drinking and promiscuity: "The habit of drinking especially triggers all kinds of lecherousness and lewdness."[24]

Protestantism's condemnation of prostitution explains the popularity of these moralizing images in northern Europe. Moral and civil authorities in Protestant areas disliked the toleration of prostitution in Catholic countries. There, controlled prostitution was considered a lesser evil, an outlet for uncontrolled male passions, and a source of state revenue. By contrast, Protestant cities often forbade prostitution, which resulted in men's resorting to the discreet services of procuresses. Because the Reformation considered marriage an important institution, prostitution was seen as a risk for society at large, and the houses in which prostitution was practised were considered a travesty of the Christian home.[25]

Northern European opponents of prostitution also demonized it on political grounds – revealingly, they identified Rome as the Whore of Babylon in the Book of Revelation. They saw Rome as a decadent city in which prostitution was rampant, with clergy the main clients. Not surprisingly, then, some of these engravings can be connected to artists' conversion to Protestantism. This is the case with Schoen. He was a highly productive engraver who also created illustrations for

books – 1,200 illustrations in 116 books have been attributed to him. In his final years, he converted to Lutheranism, and it was during this period in which he made the engravings that chastised men for frequenting brothels and dependence on procuresses.

Despite coming from an area so distant from Spain, the engravings from northern Europe responded to concerns about the risks of prostitutes and procuresses that were similar to those reflected in *LC*. Indeed, the engravings warning against procuresses may have contributed to the interest in *LC* in northern Europe.[26] However, beyond the condemnation of procuring and prostitution, no direct connection can be posited between these engravings and the book. The one possible exception is Jan Cornelisz Vermeyen's 1545 engraving *A Spanish Feast*, which represents a young woman stealing from a young man's purse. She is kissing him at a table around which several people are banqueting. In the background, an old procuress is playing a musical instrument. A cryptic connection with Spain is implied in the inscription in Latin accompanying the engraving: "So the Spanish Venus enchants the private rooms, so the stupid lover steals mock kisses."[27] Since Vermeyen, a Dutchman, worked as a painter for Charles V of Spain and lived in that country for different periods, it would be not surprising if he knew the text of *LC*.[28] Also, the reference to witchcraft implied in the Latin word "excantat" in the inscription seems to point in the direction of Celestina.

A common characteristic of these northern European engravings is the emphasis on the procuresses' old age as the degeneration resulting from a life of vice that began in their dissipated youth when they worked as prostitutes. Their decrepit look and their unscrupulous pursuit of gold result in old women who, in some cases intentionally, closely resemble the allegories of avarice from the period. From the time of Aristotle's *Nicomachean Ethics*, avarice and old age have been connected, and avarice is represented by the figure of an old woman hoarding coins.[29] Cesare Ripa's influential *Iconologia* (1593) describes avarice as an old woman, pale and ugly, escorted by a wolf, and with her eyes on a moneybag.[30] Albrecht Dürer's painting *Avarice* (1507) similarly depicts an old woman of dishevelled appearance holding a bag of money and showing a flaccid breast, a reference to her past beauty.

Not surprisingly, the explicit identification of procuresses and avarice is frequent in paintings. Such is the case with an engraving by the Dutch engraver and painter Cornelis Anthonisz. He wrote the word "avaritia" above the figure of the procuress in his rendering (c. 1540) of the episode of the Prodigal Son in the brothel. Similarly, Pieter Bruegel the Elder's painting *Avarice* (1558) is a portrait of an old woman who "wears a crescent-shaped head covering, a shape symbolic of the profession of

procuress in northern European painting."[31] The identification between procuresses and avarice is so prevalent that sometimes it is impossible to decide if an image is the allegory of avarice, a procuress, or a combination of both. An example is Ribera's *Vieja usurera* (The old usurer, 1638), a painting interpreted as an allegory of avarice in the form of an old usurer as well as that of a procuress.[32]

Some of the most intriguing images of procuresses in this period come from northern Europe, specifically Hieronymus Bosch's symbolic representations of sin and damnation, so difficult to interpret because they originate in lost iconographic sources.[33] Bosch's intriguing procuresses, even if not connected to *LC*, are of interest because they anticipate Goya's and Picasso's highly personal and complex use of Celestina's multifaceted figure. This influence is clearly noticeable in some *Caprichos* by Goya, who knew Bosch's work well because some of his paintings were part of the Spanish royal collection of paintings to which Goya had access in his role as appointed court painter.[34] The left panel of Bosch's triptych *The Hermit Saints* (c. 1493) depicts Saint Anthony's temptations. A naked woman in the background appears next to a brothel, inside of which we can see the head of an old woman looking for clients from behind a curtain. A similar peering woman is on the left panel of his triptych on the same subject, *Temptations of Saint Anthony* (c. 1500), which includes a brothel metamorphosed into the legs and buttocks of a woman (image 19).[35]

Several other possible procuresses appear in Bosch's paintings. On the right panel of *Temptations of Saint Anthony*, an old woman pours wine into a glass held by a toad, while a naked young woman hides inside a tree. The triptych *Last Judgment* (c. 1504) includes a tent with an old lady dressed in the typical outfit of a procuress. She is looking outside through a window, while the head of another old woman eating a naked man is on the top of the tent. Behind the tent, a group of naked men are giving a bag of money over a table made up of wine barrels to an old woman guarding the entrance to a gigantic wine jar, with obvious sexual connotations.

Finally, *The Temptations of Saint Anthony Abbot* (c. 1510) is a highly enigmatic painting with a figure of a procuress. (This work, which is distinct from Bosch's *Temptations of Saint Anthony* referred to above, is attributed to Bosch.) It includes the roof of a house metamorphosed into a procuress' gigantic head crowned by a birdcage, which, as we saw, was used to identify brothels at the time. Next to the figure of Saint Anthony, we can see a brothel in which there is a naked woman and the gigantic head of a cloaked old woman.[36]

Dutch Painting: Celestina and the Prodigal Son

Bosch is a forerunner in the depiction of one of the scenarios in which a procuress often appears in northern European art: the episode of the Parable of the Prodigal Son in which the young man is carousing with prostitutes.[37] Initially, this scene was sketchily included in paintings to allude to its symbolic and religious meanings. This is the case with Bosch's *The Pedlar* (c. 1500), the only remaining panel of a triptych, which depicts a character that critics identify as the Prodigal Son leaving the brothel.[38] The main character in this painting represents Everyman on the path of life – a similar figure appears in Bosch's *Path of Life* panel on the exterior of *The Haywain Triptych* (c. 1512). The house the character is leaving is a dilapidated tavern or brothel. A couple of lovers are on the threshold of the door, while a female figure, likely a procuress, is looking outside through the window. The characters are dressed in contemporary clothes, a widespread practice from the Middle Ages to which Dutch painters were especially prone.[39]

Different renderings of the sojourn of the Prodigal Son with the prostitutes became so popular and elaborate in later Dutch painting that they constitute their own subgenre. Images of the Prodigal Son drinking with prostitutes started to multiply around the fifteenth century.[40] This popularity is not surprising because, since the days of the Fathers of the Church (forth to sixth centuries CE), the Parable of the Prodigal Son had all kinds of allegorical interpretations, to the point that the Prodigal Son became Everyman, the protagonist of a compressed narrative of the *peregrinatio vitae* from sinfulness to salvation, away from and back to God.[41]

Part of the parable's popularity resulted from it being a story adaptable to different interpretations and purposes. This was especially true in the Low Countries, where the episode with the harlots was singled out. It has been argued that the popularity of the newly discovered Greco-Roman theatre triggered interest in the episode of the carousing of the Prodigal Son with prostitutes.[42] The episode was used in sermons, for which a procuress, although not included in the biblical narrations, was often added. This is the case in the sermon preached in 1501 by the Franciscan Maillard: "O damned sinners, who are written in the book of the devil! O procuresses and prostitutes, and you, burgesses, who rent them houses as brothels, where they can practice their obscenity and where their pimps can go!"[43]

The story of the Prodigal Son and the prostitutes was especially relevant to the inhabitants of the new cities of northern Europe

because it criticized the materiality of life in these urban centres, presenting them as places of spiritual exile and death.[44] Another reason for the popularity of this parable in the Netherlands was the total condemnation of prostitution in Protestant countries, as opposed to its tolerance of Catholic countries, despite the reality that Amsterdam was notorious for its many brothels.[45] Finally, the episode was significant because Protestants interpreted it as an example of salvation by grace to be used in their doctrinal dispute with Catholics on the issue of salvation.[46] Not surprisingly, then, while rare in Spain and other Catholic countries, recreations of this episode are frequent in the Netherlands, such as Gulielmus Gnapheus's successful play *Acolastus* (1529).

Jan Sanders van Hemessen's *The Prodigal Son* (1536) is considered the first appearance of the theme in Dutch painting during the Renaissance (image 20). This canvas exemplifies the characteristic treatment of the parable in this area by emphasizing the scenes of debauchery through figures and scenarios of contemporary life. Accordingly, this painting shows a current-day tavern or brothel scene of debauchery that is connected to the parable by the inclusion in the background of other episodes of the parable: the Prodigal Son working as a swineherd and returning to his father's house.[47] In this and other early paintings, there is a medieval touch in the old bawd being at the same time a realistic depiction of a procuress and an allegory of Luxury or Gluttony. In this and similar paintings, the depicted procuresses were based on the real-life women. An Amsterdam ordinance of 1466 described them as "ugly old bitches, who will do anything for money, gifts, or a bite of tasty food."[48] In Hemessen's *The Prodigal Son*, the procuress's exaggerated ugliness and her eye-catching yellow dress identify her as both a real and a symbolic character. The wine glass under her hand makes her an allegory of *Incontinentia*. Her yellow dress and the way she reaches for bread in a surreptitious manner recall the figure of Judas in typical depictions of the Last Supper.

A similar old woman with a wine or beer jar in her hand appears in Hemessen's *Brothel Scene* (c. 1540), a canvas that is both a genre scene and a representation of the episode of the Prodigal Son among the prostitutes.[49] A contemporary touch is the inclusion of a sailor entering the tavern and the symbol of the bird in a cage at the entrance. A similar treatment that is at the same time realistic and allegorical is in a Cornelis Anthonisz's engraving *The Prodigal Son Wastes His Inheritance* (c. 1540), based on the Prodigal Son–inspired drama Acolastus. The engraving is an allegory, with Herexia and Vanitas as women sitting at a table. An aging male character, identified also by an inscription as Mundus, is

presiding. Avaritia, represented as a woman drinking wine from a jug, is clearly depicted as a procuress.[50]

The direct reference to the Prodigal Son and the inclusion of allegorical figures gradually disappeared when later painters started to add local flavour to the debauchery scenes. Eventually, the scene of the Prodigal Son carousing with prostitutes became a mere excuse to execute genre paintings of brothels and taverns without having to emphasize a connection to the biblical parable, which, nonetheless, the viewers immediately made.[51] Because brothels and taverns were often the same, any painting featuring drinking with both men and women could be both a genre painting of daily life and a representation of the Prodigal Son.

Such paintings appealed to a wide market because they offered a respectable combination of an underlying moralizing tone and risqué subjects.[52] They stayed in fashion during the whole era of the Golden Age of Dutch painting (1581–1672). The Protestant prohibition against using religious images resulted in a vast production of secular themes for a wealthy bourgeois clientele. Part of this production included genre paintings that presented scenes of everyday life of the time.[53] Within this group, the brothel and tavern scenes were so popular that they formed their own category, identified in Dutch by the word *bordeeltjes*. In spite of the increasing realism of these images, the moralizing element never disappeared completely. As Konrad Renger has pointed out, these paintings did not merely provide amusement. They depicted the spendthrifts, gamblers, drinkers, and whoremongers that the literature of the time repeatedly presented as counter-exemplary figures.

This subject was popular in Dutch painting in the first half of the seventeenth century but especially in the 1620s and 1630s. Two painters stand out: Dirck van Baburen (1595–1624), and Gerard van Honthorst (1592–1666). Baburen, a member of the Utrecht School of Caravaggisti, shows the strong influence of the Italian master in his three paintings that include a procuress in brothel and tavern settings.[54] The first, *The Procuress* (1622), is a typical triangular composition with a prostitute, a client, and a procuress (image 21). The client's hand is holding a coin, which he is offering to the girl, who is playing a lute. The instrument adds to the sexual nature of the scene, as, in Dutch, *luit* means both "lute" and "vagina." In the centre of the image, we can see the procuress' hands in a gesture that can be understood as enumerating the reasons in an argument or demanding more money.[55] The procuress is an ugly old woman who contrasts with the two other characters. Slatkes considers that her clothes and those of the client contribute to placing

the painting simultaneously within the traditions of the Prodigal Son and genre painting:

> By dressing his male in an old-fashioned, Burgundian-derived costume, and providing the old procuress with a turbanlike head-dress, Baburen deliberately establishes a distance between his painted world and that of his viewers. By doing so, he seems to indicate that, if not pure genre, his picture is either a depiction of the biblical Prodigal Son or that closely related and equally popular Dutch literary theme, the contemporary Prodigal Son.[56]

A similar scene is Baburen's *The Soldier and the Procuress* (c. 1620), a fresco in which a girl whose breasts are exposed is negotiating her price with an armoured soldier, while the procuress, behind her, is advising her. Finally, Baburen's *Loose Company*, also known as *Concert or the Prodigal Son amongst the Prostitutes* (1623), evidences its double interpretation in its two titles. It shows a scenario of carousing, music, and drinking in which the procuress is serving wine to one of the men. The young woman's breasts are exposed, contributing to the lustful tone of the scene.

Gerrit van Honthorst, also a member of the Utrecht School of Caravaggisti, is the most prolific painter of scenes of this type. His *Merry Company* (1622) shows a scene in a brothel in which young men, probably soldiers, mingle with prostitutes while consuming abundant alcohol and food. Music is absent, as is the exchange of money, but the tone of the scene is made clear by the uncontrolled behaviour of the characters and the presence of an old, ugly procuress with a turban, who participates while invigilating the party. Van der Pol considers Honthorst's procuresses "a traditional type, embodying what were seen as the vices and evil influences of old women, a belief which took its most extreme form in the persecution of witches in the fifteenth and sixteenth centuries."[57] Around 1619, Honthorst had painted *Supper Party*, which represents an analogous situation in which a procuress is present. This time, music is included as a sexually loaded lute is featured and wine is profusely consumed. The central figure in the painting is a reclining man being fed by one of the women. He looks like a rooster force-fed to be later sacrificed. This image also recalls earlier engravings of men trapped in cages like birds, a theme that, as we will see, Goya would expand upon with men plucked like chickens by prostitutes and procuresses.

Other Honthorst paintings are variations of the same theme. *The Dissolute Student* (1625) shows young women and a man at a table

celebrating with food, drinks, and music. An old procuress is in the background, but her figure is humanized by her holding a small child. Most prominent in the painting is an open book with a poem or song and an illustration of an older man and a nude child, likely Cupid, beating a woman. *The Concert* (c. 1626) also contains a music book and an old procuress in the background. Although wine is not present, a Bacchic ambience is provided by a big tray of fruit and a grapevine in the background. *The Procuress* (1625) represents the triangle of prostitute, client, and procuress around a table. Although there is no food or drink, music is represented by the presence of the highly symbolic lute. The client points toward the lute and the breasts of the woman, while he holds a bag of money in his left hand. The procuress points at him while looking at the woman, as if telling her pupil that he is the right kind of suitor for her.

Along with settings in which the characters are sitting around a table, Honthorst experimented with other variations of this scenario, such as in *The Flea Hunt* (1621). It shows a procuress helping a naked young woman find a flea, while two men, complicit and hidden behind the bed, are peeping in. The scenario recalls the illustrations from act 7 (for example, in 1883 Barcelona and 1947 Mexico) in which Celestina touches naked Areúsa's breasts while Pármeno is waiting. Other Honthorst paintings depict similar merrymaking and prostitution scenes, but, because the figure of the procuress is not present, they are not included in this discussion.

Vermeer is another highly esteemed seventeenth-century Dutch painter whose oeuvre included similar scenes. His *With the Procuress* (1656) was influenced by Baburen's *The Procuress*, a painting that was owned by Vermeer's mother-in-law.[58] Vermeer's version presents a similar scenario of money being offered, drinks, music, and the triangle of prostitute, procuress, and suitor, here a soldier fondling the woman's breast. A musician looking at the audience as if establishing complicity is included in the image, and some critics consider him to be Vermeer in the guise of the Prodigal Son, who in this way is inscribing himself in the narrative pattern of sin and salvation that this parable represents.[59] The procuress, even if placed in the background, is the focal centre of the painting, and its title confirms her prominence.

The last significant Dutch painter to treat brothel scenes in which a procuress is present is Jan Steen (c. 1626–79). Unlike the painters mentioned above, his brothel and tavern scenes are not aestheticized but present lower-class characters in the earlier tradition of Bruegel's paintings of peasants dancing at country fairs (for example, *The Fair at Hoboken*, 1559).[60] In spite of Steen's casual, matter-of-fact treatment of

debauchery, he is a moralist whose work contains literary references. *The Procuress* (c. 1650) shows a brothel or tavern in which a procuress is depicted as an old woman, but she is neither caricaturized nor exaggeratedly old. She is collecting the money a man is paying to have access to a girl who is waiting for him in a bed in the background. *The Wench* (c. 1660) depicts a more traditional image of the procuress as an old woman with deformed features that contrast with the youth of the prostitute. The same character appears in his *Bad Company* (c. 1665), which represents pilfering from a client asleep under the effects of alcohol and music.[61]

Procuresses also appear in Dutch canvases other than genre paintings of tavern and brothel scenes. The temptation of Saint Anthony, as we saw, was a theme that started with Bosch and often included procuresses. David Teniers the Younger's (1610–90) several paintings of this theme include a procuress offering Saint Anthony a young woman. In two of the paintings (*Temptation of Saint Anthony*, c. 1640, and *The Temptation of Saint Anthony*, c. 1650), the procuress has horns, which connects her directly with the devil. Cuttler explains that the figure of the procuress in these paintings is one of the many forms in which the devil could appear to Saint Anthony, according to Athanasius's biography of the saint.[62] This biography, later summarized in Voragine's popular *Legenda aurea*, specifies that the devil appeared to Saint Anthony as the "spirit of whoredom."[63]

In the long history of the temptation of Saint Anthony in art, the figure of the procuress evolves as a thematic condensation of the allegorical figure of *Luxuria*. She is represented both as a woman looking at herself in a mirror and as the zoomorphic devils that torture the saint. Eventually, *Luxuria* evolved into a female demon represented as an evil queen or a luxuriously dressed temptress whose demonic nature is revealed by a claw foot or tail showing under her skirt. Sometimes two other tempting women accompany her, one of them carrying a purse, which Cuttler sees as a reference to the temptation of richness. Cuttler also connects the inclusion of the figure of an old woman to the obsession with witchcraft in northern Europe toward the end of the Middle Ages. In addition, he mentions the abandoning of symbolic medieval paradigms for a more realistic pattern based on everyday life. Interestingly, Cuttler points out the popularity of the temptation of Saint Anthony in Spanish iconography toward the end of the fourteenth and the beginning of the fifteenth century.[64]

Finally, another pictorial theme that includes the procuress in Dutch art is mythological and biblical stories in which an old servant helps her young mistress. These scenes, in which men offer money for sexual

favours, were evidently perceived by painters to be related to what happened in the brothels of the day. Steen's *Bathsheba Receiving David's Letter* (c. 1659) presents an old woman bringing a missive to a young woman as a contemporary scene. Curiously, the figure he uses for the servant is like the ones he uses for the procuresses in his paintings *The Wench* and *Bad Company*.

This similarity between the depiction of a young woman's old servant and a procuress is detectable in other painting traditions. For instance, the painting *Lovers* (c. 1525) by Giulio Romano, a disciple of Raphael, represents a sexual encounter between Roxanne and Alexander the Great. An old servant, depicted in the image of a procuress, is at the door, spying on the progress of the encounter she has facilitated, as suggested by the keys in her possession. A similar treatment is Titian's *Danaë and the Shower of Gold* (c. 1560), in which the servant is an old woman with keys hanging from her belt. She is busy collecting the golden rain while her mistress lies in bed, ready to receive the embrace of Jupiter. The solution of including an old procuress-servant character next to Danaë serves to emphasize the latter's beauty and youth while pointing at its transience. It was a successful recipe followed by painters such as Gentileschi, van Loo (image 22), and Rembrandt, among others.[65]

Other related scenes underwent similar treatment, such as the popular biblical episode of Judith decapitating Holofernes, in which her servant Abra is occasionally depicted with the features of an old procuress. Traditionally, this servant, who according to the biblical narrative helps her mistress Judith, was represented as the same age as Judith, as in Titian's *Judith with the Head of Holofernes* (c. 1515; also known as *Salome with the Head of John the Baptist*). It is the contrast in the richness of their clothes that differentiates the two women. In *Judith Beheading Holofernes* (c. 1599), Caravaggio changed the servant into an old woman with the features of a procuress and has her placing Holofernes's severed head inside a bag with a ferocious gesture.[66] This decision is explainable because the scene has some similarities to the pilfering of the client at a brothel: equally stunned by sex and alcohol, Holofernes is paying not with the traditional bag of money but with his head. Not surprisingly, Caravaggio's painting – which, as we saw, was used on the cover of the edition of *LC* in Castalia, 2013 – has been identified as a source for Baburen's painting *The Procuress*.[67] Similar assimilations of the servant and the procuress exist in paintings of mythological and sacred scenes, such as in Rubens's *Samson and Delilah* (c. 1609). Even if the biblical passage does not mention a servant, Rubens presents Delilah as a harlot

and her servant as a procuress, as does van Dyck's versions of the same episode.[68]

Although no direct influence of the literary Celestina on these procuresses in these northern European and Italian paintings can be proven, it cannot be categorically discarded. We must consider the early translation of *LC* into these languages and the important political Spanish presence in these areas. In any case, these images, like the book, reveal anxieties about the extension of prostitution through scenarios of moral degradation, deception, and social and family disintegration. The figure of the procuress is central, both as the inducer of debauchery and the recipient of the wealth men are squandering.

In spite of these points in common, the cultural differences between northern Europe and Spain result in clearly separate representational traditions. Thus, the Parable of the Prodigal Son, so frequent in Dutch paintings, is not explicit in *LC*.[69] However, the procuresses depicted in the Dutch paintings and Celestina share old age, ugliness, greed, cunning, and other features that have characterized the figure since antiquity. A significant difference is sorcery, which, while a significant aspect of Celestina, is absent from her Dutch counterparts. Curiously, the character of the procuress is rare in Spanish paintings of the same period, with the possible exception of the work of Murillo, and we must wait until Goya for the procuress to become an established character in Spanish art.[70] Her absence until that time may be attributed to the recommendation of the Council of Trent against depicting lewd, immoral scenes.

Another reason for this absence is that Spain at this time had not developed a tradition of genre paintings of daily life. Unlike in northern Europe, where the new middle classes preferred intimate paintings of daily life, the main markets for paintings in Spain were the church and the Crown, which resulted in an emphasis on religious and historical scenes.[71] The only daily-life paintings were the so-called *del natural* (taken from reality) paintings, such as Velázquez's portraits of jesters or *bufones* of the Spanish court. Other real-life characters to appear in these images were popular types taken from street life.[72] To this type of paintings belong Murillo's *Dos mujeres en la ventana* (Two women at a window, c. 1655) (image 23) and *Cuatro figuras en un escalón* (Four figures on a step, c. 1655). Yet it is not unanimously accepted that the old women in these canvases represent procuresses. Although the two women at the window in *Dos mujeres* may represent the common practice of solicitation from a window and the older one be a procuress, there are doubts about this interpretation of the scene, as reflected in the different titles by which the painting is also known: *A Girl and Her*

Duenna and *Galician Women at the Window*, but also *Celestina and Her Daughter in Jail*.[73] Similarly, *Cuatro figuras en un escalón* is described in some catalogues simply as a group of peasants, as a family portrait, or even as Murillo's own family.[74] Furthermore, some critics argue that characterizing these paintings as depicting the world of prostitution is contrary to the predominantly religious tone of Murillo's oeuvre.[75] In any case, the older women in the images do not show any connections to the literary Celestina. They do not present any of the usual attributes of her figure, such as greed, drunkenness, decrepitude, and ugliness. Quite the contrary, they convey a certain air of mature beauty and dignity.

Despite critics who argue that Murillo is not a painter of Celestina types, he is the author of one of the rare images of the Parable of the Prodigal Son in Spanish painting (*The Prodigal Son Driven Out*, c. 1660). Moreover, this painting includes a procuress, which is the first clear case of this character in Spanish painting. As noted above, images of this parable are rare in Spain, even if several dramatic pieces on the theme exist, including one by Lope de Vega.[76] Thus, Murillo is exceptional among Spanish painters for having produced six paintings and a sketch with episodes of the Parable of the Prodigal Son. His work is based on ten 1635 engravings by the French printmaker Jacques Callot (see, e.g., *The Son Is Ruined*).[77]

The Murillo painting of interest here depicts the Prodigal Son being chased away by prostitutes and includes a procuress who differs considerably from the one in the French engraving. Murillo's treatment of the episode departs from the one traditionally applied in northern European painting to the point that the nineteenth-century English traveller Richard Ford (1799–1855), after seeing the painting during his visit to the Prado Museum, pointed out that Murillo treated the parable more as a picaresque story than a sacred theme.[78] Part of Murillo's peculiar treatment is that he does not place the procuress in the episode of the Prodigal Son carousing with prostitutes, as we saw was the norm in Dutch painting, but in the expulsion from their house.[79]

The ugliness of the procuress in Murillo's painting, her exaggerated old age, and her hooked nose recall what will later become the traditional image of Celestina, although similarly unattractive procuresses are also present in Dutch paintings of the period and earlier. This characterization is Murillo's own, because, as we have said, his procuress differs considerably from the one in Callot's engraving (*Return of the Prodigal Son*, 1635). In Callot's print, the woman, while old, is so inconspicuously portrayed that the critic Taggard does not even consider her to represent a procuress but, rather, a symbolic figure of the transience

of beauty.[80] Murillo changes not only her features but also her location, placing her closer to the central action and depicting her as gesturing to another man to induce him to chase the Prodigal Son. This sinister character half hidden in the shadow of the building is the first clearly identifiable procuress in Spanish painting represented with the same features that Goya, over a hundred years later, would fully develop.

From Goya to Picasso and Beyond

In spite of these early apparitions of the figure of the procuress, we have to wait until the late eighteenth century for her full-fledged presence in Spanish painting. The eighteenth century did not produce many Celestina images for a combination of reasons, among which is the afore-mentioned lack of interest in *LC* between the mid-seventeenth and early nineteenth century. Also, during that period, Spanish painting was under the influence of the foreign painters hired by the new Bourbon dynasty to decorate their French-style palaces with mythological and high-flown themes.

Only at the end of the nineteenth century did the genius of Goya redeem the humble figure of Celestina in canvases, drawings, and engravings. She appears both as a victim and an accomplice in Goya's depiction of prostitution, which is presented not as a moral issue but a social problem. In doing so, he was the first painter to systematically resort to the popular and literary figure of Celestina, combining her with real procuresses of his day. His other innovation was to depict her not by herself but in contrast to the beautiful young popular type of the *maja* in highly personal compositions that conveyed deep new meanings.[81]

Although, as we have said, images of procuresses are rare in Spanish visual arts of the eighteenth century, an important exception is the watercolour by Luis Paret y Alcázar *La Celestina y los enamorados* (Celestina and the lovers, 1784) (image 24). This image is important because Paret y Alcázar is known to have influenced Goya. Also, it is the first image of a Celestina outside an illustrated book that includes features unmistakably lifted from the description of the character in the text of *LC*.[82] Paret y Alcázar's life and career exposed him to a combination of national and foreign influences and styles that may help explain his interest in the figure of the procuress. Born in Spain to a French father and a Spanish mother, he was clearly influenced by French and Italian artists. A member of the prestigious Real Academia de San Fernando, he is usually identified as a late baroque or rococo painter, even if his paintings may contain features of neoclassicism and academicism.

Some influence of Dutch genre paintings is also detectable in the detail he pays to objects in his work.

Paret y Alcázar's *La Celestina y los enamorados* depicts an old woman who offers her humble abode as shelter for the illicit rendezvous of a young couple. Even if we cannot be sure that Paret y Alcázar gave the work its current title, the old woman in the painting is clearly reminiscent of Celestina in the text of *LC*: she is a pronouncedly old woman with a rosary in her hands, surrounded by all the ingredients and tools for potions and sorceries. This watercolour is significant because it anticipates the caricaturized depiction of the old woman and the presence of witchcraft central to Goya's treatment. Unfortunately, practically nothing was known of this painting before the twentieth century. Although some specific inspirational references for the painting have been identified, none is related to *LC*. Significantly, we know that Paret y Alcázar was familiar with the text, as he had been condemned by the Inquisition at Logroño in 1791 for owning a copy of the book, which was banned in those days.

The events and the characters in this painting are the most important sources of information about its possible connection to the figure of Celestina.[83] Basically, the painting represents the typical group of a procuress and two young lovers. The attention to details in the depiction of the humble house the old woman inhabits makes it look like a genre painting in the tradition of Dutch painting. However, this watercolour lacks the moral chastising and hostile treatment of similar subjects by Dutch artists. No monetary transaction is suggested: the tone is that of an illicit but not mercenary sexual encounter in which the old woman's role is limited to providing shelter. Even the character of Celestina, in spite of clear references to the literary model, is sympathetically portrayed: she is a quaint old woman, a follower of sorcery at a time when this practice was ridiculed, and, significantly, she wears outdated clothes.[84]

This portrait of the old woman as an endearing, even quaint, character opens a new line of interpretation of Celestina as comic character that will come to fruition in the nineteenth century. It also anticipates by fifty years Hartzenbusch's comic treatment of sorcery in *Los polvos de la madre Celestina*. Even if her left foot is resting on the skull of a horse and a dead rooster is part of the image, Paret y Alcázar's Celestina appears as an amiable character, not a moral counterexample. The resting calico cat, instead of the typical witch's black cat in an aggressive pose, adds a tone of faded domesticity, further emphasized by the reading glasses in Celestina's hand.

Although Paret y Alcázar anticipates Goya's Celestinas, the latter's treatment of the figure is radically different. Instead of presenting her as a quaint, grandmotherly figure of yesteryear, Goya makes her a sinister character. She is a combination of the crude reality of the procuresses of his day and the darkest side of the literary prototype. Goya, like Paret y Alcázar, caricaturizes the figure but emphasizes her sinister aspects, not her endearing ones. Goya is interested in the figure of Celestina as a critical, even political, tool and as a way to express complex personal issues. This focus is represented by Goya's lack of interest in the other characters of *LC*, especially in the love story at the heart of the book. Goya's Celestinas convey the darkest aspects of her personality and trade, and of the society of the time, together with the artist's own pessimism. He is the first painter to use her express complex, deeply personal meanings.[85] The moralizing, didactic aspect of the figure of the procuress as an inciter of men to sin may be presented but is mostly de-emphasized. The result is a complex figure suitable for criticizing social and human shortcomings. Given Goya's stature as a painter, the influence of his Celestina has been enormous. During the nineteenth century, a whole generation of painters imitated him, and the influence of his treatment of the character is perceptible to the present day. Indeed, practically any pictorial representation of Celestina after Goya is influenced by his treatment.

Goya's engagement with the figure of Celestina went against some trends in Spanish culture. The predominant fashion of late baroque and rococo painting was for gallant, courtly, or mythological themes in which such a character did not fit. This was also the period in which *LC* was not published and, indeed, was included in the list of forbidden books. But Goya was reflecting in his work other circumstances that made her figure pertinent. Despite the banning of *LC*, Celestina had become a popular culture prototype. Her name appeared in sayings, and she was a stock character in minor theatrical pieces and dances. Most importantly, procuresses were a common, indispensable figure of daily life, especially since prostitution had been officially banned. After centuries of tolerance, prostitution was declared illegal under Phillip IV in the proclamations of 1623 and 1661, which were not revoked until the nineteenth century. This change precipitated the closing down of the previously tolerated brothels, and the result was the burgeoning of clandestine prostitution, for which the discreet services of procuresses were needed.[86] The authorities could arrest prostitutes and procuresses and intern them in institutions for their reform, although often they preferred to extract bribes from them and then turn a blind eye. Widespread underground prostitution resulted in syphilis becoming endemic – and

some modern critics believe that Goya's health problems, including his deafness, were due to syphilis.[87] Not surprisingly, many progressive thinkers, a group to which Goya belonged, advocated for a return to the legalization and regulation of prostitution.

This complex underworld of prostitution and the literary Celestina are clearly detectable in Goya's charcoal and brush drawing *La madre Celestina* (Mother Celestina, c. 1819), the first known image of a procuress in which the word "Celestina" is written in the title by the hand of the artist himself (image 25).[88] This drawing is number 22 from Album D, which, among other images, contains several old women and witches dressed in contemporary clothing. The album is dated between 1819 and 1823,[89] years in which, as a consequence of the recent Napoleonic invasion of Spain and the Peninsular War, prostitution grew to alarming proportions and made venereal diseases a matter of public concern.[90]

The old woman portrayed in *La madre Celestina* is holding a bottle of wine in one hand and a rosary in the other. On the table there is a flask, an allusion to her work as a perfume and cosmetic maker or as a sorcerer. Her head is covered in the tradition of the Celestinas in the illustrated editions. Equally clear a reference to the literary character is a mark on her face, which can be identified as Celestina's scar mentioned in the text. Her sitting with her legs spread apart may connect to the medieval tradition of using this position to symbolize lust or desire, a position that is included in other images by Goya.[91] Finally, the title itself indicates clearly that her image is indebted to Rojas's Celestina: not only is she called "Celestina," which, after all, could be used as a generic moniker for a procuress, but the name is preceded by *madre*, matching the form in which she is repeatedly referred to in *LC*.

In spite of these clear connections to the text, Goya's *La madre Celestina* does not represent any specific episode of the book. It is not a representation of Celestina drinking in the banquet scene: the presence of the flasks and the shape of the table do not correspond to that scene. Ultimately, this image is not a portrait of the literary character but a combination of features taken from the reality of Goya's day and the literary prototype. Some of her features clearly allude to the historical moment in which it was created, such as her nose missing its tip as a result of syphilis. Other features are Goya's creative addition, such as her bloated eyes and other features denoting years of heavy drinking.

In addition to this image, some of Goya's works that do not include the word "Celestina" depict old women who are clearly influenced by this literary figure and popular type. Features such as exaggerated old age and the humble cloak that covers her like a veil of secrecy appear

in the paintings he produced at various stages of his long and evolving professional trajectory. The strongest indication that these figures are Celestinas is their placement next to the contrasting figure of the proté-gée, in the duo of the *maja* and her Celestina.

Although other paintings, such as some of the Dutch canvases discussed above, include this contrast, only Goya makes it the crucial point of his compositions. Unlike earlier images, the client is often absent, reducing the triangle of prostitute, procuress, and client to the duo of prostitute and procuress. Two consequences arise from this reduction. First, with the disappearance of the figure of the client, the whole society appears as the corruptor, making the images go beyond the moral condemnation of personal lust and venality we saw in Dutch painting.[92] In adopting this approach, Goya becomes the first artist to produce images in which the prostitute appears as a product of the society that surrounds her.[93] The second consequence of Goya's elimination or side-tracking of the client is to emphasize the intimate relation – personal, professional, and even existential – between the two women. They are linked in the present by the circumstances and in the future by the inescapable destiny of the beautiful young prostitute to become an ugly old procuress. In this second sense, Goya's images represent not the typical *vanitas* motif but a commiserating gaze on the self-satisfaction and conceit implied in the expression of the beautiful young women. This commiseration extends also to the procuress, for what she was and has become.

Chronologically, Goya's first prostitute-and-procuress duo is his painting *Maja y vieja* (c. 1780). It was probably conceived as a model for the tapestry workshop Real Fábrica de Tapices de Santa Bárbara, for which he created designs between 1775 and 1792. This period of his work is characterized by amiable images with colourful, clean designs that could be easily transmitted to the medium of tapestry. Accordingly, this first image of a procuress and her pupil lacks the dark overtones and social criticism that would characterize Goya's later production. Its most interesting aspect is that it inaugurates Goya's treatment of the two characters. It depicts a beautifully dressed *maja* and an ugly old woman in a garden, likely by the Manzanares River, a location often portrayed in his productions for the tapestry workshop. Although in a discreet manner, the painting represents a scene of the type of solicitation that was commonly seen along the pleasant banks of this river. The *maja* is sitting on a recliner, looking at the spectator and smiling alluringly. The old woman is reclining behind her, looking into the distance. Her old age and ugliness are not exaggerated to the parodic extremes of Goya's later paintings. Also, the image lacks the interaction between

the two women that was characteristic of the artist's later images of a similar subject.

A much more interesting treatment of the two character is his *Maja y Celestina al balcón* (*Maja* and Celestina on the balcony, c. 1808) (image 26). Alcalá Flecha considers this painting to be the culmination of Goya's representation of literary references to Celestina, including, here, the rosary blatantly displayed in the procuress's hand.[94] The subtle reference to prostitution in the previous images for the tapestry workshop is unmistakable in this later canvas, with its common scenario of a prostitute displaying her beauty from the balcony of the house in which she works.[95]

The placement of the *maja* behind the bars of the balcony, as if she were a bird in a cage or a prisoner, adds a refined note of social criticism to the painting.[96] Showing the prostitute behind these bars is a curious reversal of the clients in the procuress's cage that we saw in Schoen's engraving *The Cage of the Fools* earlier in this chapter. This change encapsulates the complete turn in the use of the imagery of prostitution to express social instead of moral criticism. The youth and naivety on the young prostitute's face in Goya's painting show an innovative, more sympathetic approach to her figure. He depicts the procuress, as was the case in Dutch paintings, in contrasting ugliness and old age. However, he also goes a step further by making her figure grotesque, almost a caricature. Her hooked nose and bony hands, like the talons of a bird of prey, are central in his over-characterization. The beaming face of the young woman is contrasted with the old woman's sly smile, which has a tinge of duplicity, as does her display of a rosary. Her head is not covered, unlike the images of Celestina in the illustrated editions of *LC*, many Dutch paintings, and even Goya's other similar scenes of a *maja* and her procuress. By showing her head uncovered, Goya is emphasizing her connection to the *maja*, presenting her as a later version of the equally uncovered *maja* once age and a hard life have taken their toll. The identification between the two figures is reinforced by the rosary hanging down in front of the procuress' legs. It mirrors the young woman's hands and the folds of her skirt, leading the viewer's eys to her crotch.

The most interesting and enigmatic *majas* and procuresses are not those on Goya's canvases but in his monochrome prints, including his satirical *Los caprichos* (The caprices), the eighty aquatints and etchings created between 1797 and 1798 that he published as an album in 1799. Celestina characters appear also in his equally critical and sombre series *Los desastres de la guerra* (The disasters of war, 1810–20) and *Disparates* (The follies, 1815–23), as well as in a few scattered images that are

difficult to date. Many of these images contain procuresses next to their protégées, such as *Capricho 17, Bien tirada está* (It is nicely stretched). It shows a *maja* pulling up her stockings under the eye of an old procuress. Others show varied scenes related to prostitution, such as *Capricho 20, Ya van desplumados* (There they go plucked). It depicts strange birdmen, one with symptoms of syphilis, who are swept by prostitutes from a brothel. These enigmatic scenes reveal Goya's complex, multifaceted use of Celestina and the world of prostitution, with social criticism wrapped with other highly personal, cryptic elements best represented by the witches displaying Celestina's features in his later work.[97]

As we have said, Goya does not convey the Dutch painters' easy moralizations and warnings to young men. Neither is his social criticism the dramatic denunciation of clients and procuresses present in late nineteenth-century social painting, as we will see below. Goya's original and complex views on the issue contrast also with the facile one of William Hogarth's series of engravings entitled *A Harlot's Progress* (1732). The images of Hogarth, a Briton, imply a negative moral judgment of the prostitutes and their world. Goya's images, in spite of the parodic deformation typical of his style, never lose the tragic, individual nature of his characters. Bozal sees a wider, subtler form of social criticism in Goya's representation of the relation between the procuress and the *maja*. It is an allegory of the relation between power and its subjects in which the latter are exploited by the greed of the former. By presenting the contemporary procuresses as a reincarnation of the old Celestina, Goya was stating that contemporary society remained anchored in outdated practices. The procuress belonged, together with friars and priests, to a world of ignorance, poverty, and abuse that refused to disappear.[98]

Goya's enormous influence on Spanish painting remains present in today's visual arts, where his frequent and original Celestina figures can still be seen. The first ones to continue his legacy were the *costumbrista* painters, who were great admirers of Goya's masterly pictorial treatment of the popular classes. *Costumbrismo*, although connected to European Romanticism, is a purely Spanish movement in painting and literature, although it reached those parts of the Americas under Spain's influence. In Spain, it coincided with the rule of Queen Isabel II (1833–68) and responded to the Romantic interest in the popular classes, whom the Romantics perceived as the definers of national identity in a world in which the ideas of Enlightenment and the Industrial Revolution were effacing traditional life.

Backward Spain was especially fertile in picturesque characters for *costumbrista* painters, and the colourful *maja* accompanied by the

contrasting procuress interested them. The figure of Celestina was also attractive because of *costumbristas'* nostalgic interest in the aspects of daily life about to disappear under the juggernaut of progress. The new houses of prostitution of the second part of the century made the traditional procuresses unnecessary, and they were superseded by the younger, more affluent and efficient madams of these French-style brothels.[99] Equally, magic and sorcery, the other specialties of Celestina, lost all credibility as the nineteenth century progressed. Celestina gradually became a nostalgic figure to be treated as a curiosity, even as the quaint old lady in Hartzenbusch's comedy *Los polvos de la madre Celestina* (1840). This obsolescence of the figure of Celestina is epitomized in a brief text of the *costumbrista* publication *Los españoles pintados por sí mismos*, which ironically noted in 1843: "thank goodness, today's social habits have advanced enough to make Celestina an outdated, unnecessary pawn. Love negotiations are normally done directly and without the need of an intermediary. If we live long enough, we will see how far progress can reach in this matter."[100] Yet, the author of this text later admits that Celestina never dies but is reincarnated in every century.

One of these reincarnations may well be another popular type depicted in the same publication: the woman who sells roasted chestnuts from a small stand, the *castañera*, who also acts as a part-time Celestina. The writer describes her as a mediator in sexual affairs and a former prostitute. The accompanying image shows her talking to a young woman while, around the corner, a young man is waiting impatiently.[101] As if further proving the statement that Celestina never dies, in 1892, nearly fifty years later, a *castañera* who acts as a part-time Celestina reappears in the illustrated magazine *Blanco y Negro* in an article by Rueda. The image by Méndez Bringa that accompanies the article represents an old woman in poor clothes, her head covered, selling chestnuts. This time, next to the implements to roast and sell chestnuts, she has set a stand on which she is peddling religious figurines and rosaries. The connection to the false piety of Celestina is reinforced by placing the scene next to a church.

Costumbrista painters were great admirers of Goya's treatment of the popular classes and types, including Celestina. They appropriated and developed his legacy in different directions. The Sevillian school of *costumbrista* painting concentrated on the *maja* to the detriment of Celestina's figure, whose ugliness did not match its programmatic style and specialization in pleasant scenes of daily life. This school developed around the painter Joaquín Domínguez Bécquer and was characterized by a delicate use of brush and colour, as well as by an admiration for

Murillo. Because foreigners interested in a romantic vision of Spain constituted an important part of their clientele, they produced brilliant but bland images of Andalusia. While the ugly Celestina did not appear in these canvases, a southern version of the *maja*, often connected to the figure of Carmen, was common.[102]

By contrast, the Madrilenian school of *costumbrista* painting continued to contrast the *maja* and Celestina. This school was characterized by energetic brush strokes and a disproportionate admiration for Goya that often resulted in literal copies of his work. The followers of this school copied Goya's amiable parties by the Manzanares River as well as his darkest compositions, all scenarios in which a procuress was included.[103] Another characteristic of the Madrilenian school that resulted in an interest in Celestina was its close relation to *costumbrista* writers, such as Mesonero Romanos and Estébanez Calderón. These writers often dealt with a Celestine figure in their descriptions of popular contemporary types. When their articles appeared in the periodical *Semanario Pintoresco Español* (1836–57) or in collections such as in Estébanez Calderón's *Los españoles pintados por sí mismos* (The Spaniards drawn by themselves, 1843), they were often accompanied by paintings from the Madrid school's illustrations.

The most important painters of the Madrid *costumbrista* school who repeatedly represented the character of Celestina are Eugenio Lucas Velázquez (1817–70) and Leonardo Alenza Nieto (1807–45). The two were connected to the Madrilenian Real Academia de San Fernando and strongly influenced by Goya. Eugenio Lucas Velázquez was a prolific painter whose works are sometimes confused with those by his son, Eugenio Lucas Villamil, who painted in the same style. The influence of Goya is so strong that some critics dismiss him as a mere copyist of Goya who fashioned pastiches based on Goya's themes.[104] Although he showed a preference for Goya's most picturesque and amiable *majas* and Celestinas, he also followed the master in his satirical images of the Inquisition and religious fanatism, in which Lucas Velázquez often included decrepit old women with Celestina features.

Lucas Velázquez's treatment of *majas* and Celestinas responds to the interest of *costumbrista* painters in depicting and documenting figures and traditions that were about to disappear. In the nineteenth century, legalized bordellos under medical supervision, known as "houses of tolerance," resulted in the banning of street prostitution and solicitation from balconies of previous eras. At the same time, the *maja*'s outfit became gradually outdated.[105] The resulting nostalgic treatment of these situations and types may explain the soft rendering of the figure of Celestina in Lucas Velázquez's *Pareja de majos* (*Majo* and *maja*, 1842).

It depicts a *majo* and a *maja* dressed in their traditional attire in a box at a bullfight. They are exchanging intimacies while Celestina sits to the right of the *maja*, paying attention to the conversation, and a matador is fighting a bull in the arena. Celestina's features are not caricaturized in the Goyaesque manner. A cane in her hand indicates her old age and gives her some dignity. Interestingly, the bull, the matador, and his assistant form a group in the arena in the same arrangement as the *majo*, *maja*, and Celestina. Celestina is on the first plane of the painting. This arrangement suggests that the *majo* is the bull, the *maja* the matador, and the old woman the assistant in the task of "killing" the suitor.

Lucas Velázquez also painted *La maja* (c. 1867), in which a beautifully dressed *maja*, staring at the viewer, is leaning toward her procuress, who is giving her some last-minute advice as a male client is coming through the door. The most noticeable feature of this Celestina, whose hair is not covered in the traditional way, is a strand of white hair, which attests to her age. Next to the *maja*, a guitar with a hole in the centre makes explicit the sexual nature of the encounter that is about to take place.

More traditional is Lucas Velázquez's *Maja y Celestina en el balcón* (*Maja* and Celestina on the balcony, 1847), previously known as *La hija de Celestina* (Celestina's daughter), which depicts the usual scenario of a *maja* at the balcony attracting a client, accompanied by an old woman. It is a sympathetic presentation of the characters: the *maja* seems to be bored or absent minded, while the Celestina, with her characteristic rosary, is a wretched woman whose poverty compels her to this kind of trade in her old age.[106]

Leonardo Alenza y Nieto (1807–45) is another painter of the Madrilenian *costumbrista* school who frequently includes a Celestina character in his canvases. He was also connected to the Academia de San Fernando and was highly influenced by Goya, but, unlike Lucas Velázquez, he took many liberties in his recreations of the master's work. Alenza y Nieto was in close contact with *costumbrista* writers who were critical of Spanish society. He met them in his capacity as illustrator for the *costumbrista* periodical *Semanario Pintoresco Español*.[107] Like some of the writers who published pieces in this periodical, and following Goya's lead, Alenza y Nieto portrayed prostitution not as a moral issue but as a social problem in which the client is an accomplice. He copies Goya's scenarios of the *maja* and her Celestina on the balcony, but he adds beggars, delinquents, and clients taken from reality and from the Spanish picaresque. He knew the genre of the picaresque novel well, as he had illustrated an edition of Lesage's *Aventuras de Gil Blas de Santillana*.

His paintings *Majas en el balcón* (*Majas* on a balcony, c. 1835) and *Mujer joven en un balcón* (Young woman on a balcony, c. 1840) take from Goya not only the scenario and the characters but also some specific design solutions, such as the prominent role the window curtain plays in the composition. Alenza y Nieto goes a step further by making the curtain serve nearly as a theatrical curtain in front of which only the beautiful *maja* is visible. Behind, hidden from street view, we have the ugly procuress and the seedy room where she and her pupil live and work. This is also the case with *Majas y Celestina en un balcón* (*Majas* and Celestina on a balcony, 1834; image 27), in which Celestina is sternly advising the young woman from behind the curtains, using hand gestures that recall the rhetorical use of hands in the woodcuts of the early editions of LC. In *Esperando en el balcón* (Waiting on the balcony, c. 1835), Alenza y Nieto replaces Goya's frontal view with one from inside the poor, dirty room behind the flamboyant balcony. There, we can see Celestina, partially hidden by the curtains, extending her index finger in the typical attitude of explaining or advising her protégée, who is bartering with a client in the street. There are also two clients in the room, both wrapped in sinister big cloaks, one of them asleep. The figures of the young prostitute and Celestina partially overlap, as if they are two sides of the same reality.

In *Joven y Celestina*, Alenza y Nieto departs altogether with the picturesque *maja* standing at the balcony to show a room in which there is only a quaint Celestina. Her protégée is barely visible, coming out from behind the curtain separating the adjacent room, partially naked, looking for water to begin or end her service to a client. We cannot see the client, but we know he is a soldier because he has left his helmet and sabre in the main room. The sabre acts as a phallic symbol, resting on the centre of a round brazier without fire, which alludes to the woman's lack of passion in this mercenary encounter. The phallic symbology is reinforced by the pointed tip of his helmet, as well as by the poker in the brazier. Celestina, sitting comfortably, appears more senile than evil. As if confused or blind, she is comically addressing the sabre, while pointing to a purse. The purse has the shape of a case for the sabre, suggesting a vagina. Celestina's black shawl, hanging from the back of her chair, mirrors the red one the girl has hurriedly left on another chair. This similarity suggests that the women are two versions of the same person, separated only by the passing of time.

Even if the new approach to prostitution made Celestina's role secondary or even unnecessary, she continued to appear in paintings in the last decades of the nineteenth century and the first decades of the twentieth. Some *costumbrista* painters continued to depict her in their

works. Other socially and politically engaged painters also included the character in canvases denouncing social hypocrisy and the exploitation of prostitutes. Around the same years, Picasso started to use the Celestina figure to convey highly personal meanings, a practice that he would continue for the rest of his long and productive life.

If, by this time, the traditional procuress clad in dark clothes was an outdated social type, the induction of *LC* into the literary canon boosted Celestina from a popular type to a national icon and literary myth.[108] The studies of Menéndez Pelayo and other scholars, the appearance of new critical editions, and the celebrations during the four hundredth anniversary of the publication of *LC* in 1899 were fundamental to this canonization process.[109] At the same time, aspects of Celestina as a popular type survived, sometimes as a quaint parody of her former self. An amiable vision manifests, for instance, in Cecilio Plá y Gallardo's 1899 drawing for the magazine *Blanco y Negro*, which is accompanied by words from *LC* in which Pármeno describes Celestina as a sorceress and maker of cosmetics. Plá y Gallardo's image shows a benign old woman heating a comically shaped retort in her poor kitchen. A skull and an owl on the shelves behind her add a spooky touch.

Similar in treatment is the canvas by Garza y Bañuelos entitled *Brujerías* (Witchcraft, c. 1912), which shows a young woman startled by the green and red lights resulting from the magic performed by an old woman of clear Celestina appearance in her kitchen. A spinning wheel in the room recalls the Sleeping Beauty of the brothers Grimm more than the sinister yarn Celestina used to gain access to young women. Eventually, in the early twentieth century, this type of Celestina became suitable even for children, as evidenced by the matinees of Hartzenbusch's *Los polvos de la madre Celestina* and the existence of cut-outs for home shadow-theatre, such as for *Celestina o los dos trabajadores* (Llorens, 1865).[110] In 1920, *Pulgarcito*, a popular magazine for children, published a story similar to "Hansel and Gretel" but entitled "Los polvos de la madre Celestina." Celestina appears as a witch living in an enchanted house in the forest. The magazine cover shows two terrified children in the presence of a comically gesticulating witch who is raising a skeleton out of a cauldron.

In contrast to this fairy tale–like use of Celestina, the social painting of the late nineteenth and early twentieth century presents a cruder vision of the character. She is both a victim of and a participant in the sexual traffic that fed the legalized brothels of the day. Although not as successful as in France, social paintings that represented the lower classes and their struggle for survival were popular in turn-of-the-century Spain. This change in taste from the bland images of the romantic

and *costumbrista* canvases was a result of new liberal governments, an increasing sensitivity toward social inequalities, and the popularity of the realist and naturalist novel. In Spain, Goya's images were a clear antecedent to the theme, especially his *Caprichos* that criticized the sectors of Spanish society still attached to outdated ideas of power and religion.

As early as 1840, Esquivel y Suárez de Urbina (1806–57), a painter considered to be a link between Goya and social painting, produced a canvas entitled *Celestina*. It represents a Celestina character convincing a young woman to give in to the request of an ugly friar who is offering her money. More than simply social denunciation, the image reveals an anticlericalism that connects with the grotesque friars and priests in Goya's *Caprichos*.

Social painting, properly speaking, began toward the end of the nineteenth century. It continued to use the figure of Celestina even if her role in the sex trade was, by then, marginal. The best example is Sorolla's *Trata de blancas* (White slave trade, 1894; image 28), which won an award at the Paris Salon of 1895 but was criticized for its crude, if realistic, theme by the conservative press.[111] The canvas depicts a group of young women, colourfully dressed in unsophisticated, rural clothes. They are asleep in the train car that carries them, like animals to the slaughter-house, to a brothel in the city. In the car, there is also an old woman depicted as a traditional Celestina. She is the only one awake, making sure that the human cargo reaches its destination. Sorolla's Celestina is not as decrepit as the Goyaesque Celestinas, nor are her features so deformed. In spite of her forbidding countenance, Sorolla's treatment reveals some sympathy, presenting her as tired old woman, probably a victim of similar abuse in her distant youth. Her figure recalls Goya's Celestinas, as the colourfully dressed young women on their way to the big city recall the *majas*. However, the choice of a modern train car clearly locates the scene in the present. This presence of modern technology makes the nostalgic tone of previous *costumbrista* treatments of the subject impossible.

Another social painting condemning prostitution in which a Celestina is present is Antonio Fillol Granell's *La bestia humana* (The human beast, 1897), which was exhibited in salons and expositions. The conservative press considered the theme scandalous.[112] The painting represents a modern Celestina, who is not treated sympathetically but is made the focus of the condemnation implied in the title. Not especially old, she is well fed and dressed in modern clothes. She wears glasses that hang from a string, which adds a bourgeois respectability to her figure. Her house, where she has arranged a rendezvous between a

mature man and a young woman, is not the humble or poor den usually depicted in such scenes. Rather, it is a middle-class residence, as implied by the chic tray with liqueur and pastries, a refined replacement for the indiscriminate drinking of wine and sloppy eating in earlier images of brothels and taverns. The fire pit, which, as we saw, commonly has sexual connotations, is burning to warm the house and as a sign of comfortable affluence. The male client is a middle-aged bourgeois character, patiently lighting a cigarette while he waits for Celestina to convince the young woman, probably a destitute young widow, given her dark clothes, to submit. The bullfighting painting on the wall marginally connects the event to Goya and the *costumbrista* tradition but reveals that such traditions have been relegated to an aesthetic realm. Nonetheless, the Spanish critics of the day who defended this painting justified its crude theme by connecting it to the national traditions of Goya and *LC*.[113]

José Gutiérrez Solana (1886–1945) is the painter of this period who best combines social denunciations of prostitution and the legacy of the figure of Celestina that Goya inaugurated. As was the case with some nineteenth-century painters, Gutiérrez Solana was also a writer of *costumbrista* texts that critically examined contemporary Spanish society. He frequented literary *tertulias* and was influenced by the avant-gardist writer Gómez de la Serna's unconventional optics, although some critics have related Gutiérrez Solana's distorting tragicomic lens to the generalized social and political disenchantment after Spain's defeat in the Spanish American War in 1898.[114] His most successful book, *La España negra* (1920), is a description of the sinister and eschatological side of Spain. Like Goya, he perceives it as a backward society obsessed with religion and death.

Prostitution is a subject Gutiérrez Solana criticizes in canvases painted in an expressionistic, deforming style. Without imitating Goya, his paintings recall the synthesis of death and sex that the figure of Celestina so efficiently encapsulates. This sombre view pervades *Las chicas de la Claudia* (Claudia's girls, 1929; image 29). Its title alludes to the owner of the portrayed brothel, Claudia, a name that recalls Celestina's deceased friend Claudina. In the painting, Claudia is presiding over her "girls" and is covered with a black mantilla that adds to the ominous touch given by a picador's clothes hanging on a chair. The picador – the man on horse who spears the bull in a bullfight – seems to have taken his clothes off while he is having a sexual encounter with one of the prostitutes before the bullfight. Claudia, donning the ominous dark mantilla of a widow, is ready to attend the deadly bullfight.

Equally sombre is his *Mujeres de la vida* (On the game, c. 1916), also an image of a group of prostitutes. This time, they are standing in the street of a small town whose inhabitants are gossiping in the background. The Celestina character, behind the prostitutes, is older but menacingly taller than the girls she is invigilating. Noticeably, one of her eyes is blind, which recalls Picasso's famous 1904 Celestina, which we will see below. A similar woman appears in Gutiérrez Solana's *La casa del arrabal* (The slum brothel, c. 1934). This image of a brothel includes two women who can be considered Celestinas: a relatively younger one, who is supervising the scene, and a much older one with her head covered in the traditional way, who is sleeping by the entrance door. While the younger Celestina represents the new madams, the older one is suitable only for taking care of the door in the new brothels.

In contrast to these dark Celestinas in canvases denouncing prostitution, the character also appears during the twentieth century in bright canvases. They are part of the lighter side of *costumbrismo*, which was still in vogue and practised by some painters. The Granada-born painter Francisco Soria Aedo (1897–1965), who painted variations of the *maja* and her Celestina in luminous Andalusian backgrounds, painted in this style. In *Joven con mantilla y toreros* (Young woman with mantilla and bullfighters, 1934), bullfighting serves not as an omen of death but as the excuse for a colourful, festive scene. The canvas shows a beautiful young woman courted by two bullfighters. Behind her, an old woman is holding a fan and a piece of paper, probably a missive from one of the suitors. As well as in his *Doña Paca y su prenda* (Mrs Paca and her garment, 1943) and *El piropo* (The flattery, 1928), the hints of prostitution introduced by the Celestina character are softened by her unthreatening features and the bright Andalusian atmosphere. However, even the sunny, folkloric image of *Andalousie* that permeates these paintings cannot completely efface the dark touch introduced by the Celestina characters' old age and greed. The uneasy feeling is reinforced by the black mantillas worn by the young women and the Celestinas, and the proximity of an always ominous bullring.

The painter who best expresses this gloomy combination of sex and death in Andalusian backgrounds is Julio Romero de Torres (1874–1930). Interested in modernism and symbolism, he achieved popularity for his depictions of beautiful young Spanish women with dark eyes and hair.[115] Sometimes, he includes next to them Celestina figures in symbolic roles, as in his allegorical painting *El pecado* (The sin, 1915). It depicts a beautiful naked woman reclining in front of a group of old women clad in dark clothes in the Celestina fashion, one of them tempting her with a symbolic apple. The transience of beauty, a common

theme of the *vanitas* tradition, is alluded to by a mirror another old woman is offering the reclining nude, as well as by the contrast between her beautiful naked body and the heavily clad, ugly old women.[116]

Romero de Torres is also an artist whose paintings denounce prostitution in the realistic, sober style associated with social painting. His *Vividoras del amor* (Sex workers, 1906), whose exhibition in the Exposición Nacional de Bellas Artes in the year of its creation triggered a scandal, depicts a poor rural brothel in which no Celestina figure is present. The appearance of the girls in the paintings points to the racialized exploitation of Roma women, normally idealized in Spanish art and folklore. Similarly lacking a Celestina character is his *Nocturno* (Nocturnal, 1930), which depicts prostitutes who are wearing not quaint folkloric garb but everyday clothes while waiting for clients on a city street. Again, faithful to the contemporary reality of prostitution, no Celestina character is included.[117]

Curiously, the possible presence of a Celestina affects the interpretation of Romero de Torres's most famous painting, *La chiquita piconera* (The coal little girl, c. 1929). The most circulated version of this extremely popular painting represents a young prostitute warming herself by a fire pit (*picón* in Spanish) while waiting for a client. The compositional role of the pit and the general theme relate the image to Goya's *Capricho 17, Bien tirada está*, mentioned earlier.[118] But unlike Goya's image, no Celestina accompanies Romero de Torres's young woman, which softens the undertones of prostitution. That said, an unfinished version of this painting, entitled *Composición con la chiquita piconera* (Composition with the little piconera, 1929), was executed sometime shortly before or after *La chiquita piconera*. Barely visible in the background of the sketchy, unfinished painting is an image that can be interpreted as a Celestina bringing clothes to the girl. Other elements in the unfinished version support this interpretation, such as a mirror in the background, which alludes to a *vanitas*.[119]

Ignacio Zuloaga (1870–1945) is another painter who intertwined social critique, folkloric erotism, and symbolism in canvases that include a Celestina character. He became famous internationally for his paintings that combine the dark side of the Spanish pictorial tradition and amiable *costumbrismo*. During his formative years, he lived in Paris, which made him well aware of the latest trends in painting, especially symbolism and expressionism. He was an admirer of Goya and appreciated El Greco's use of dark tones.[120]

Zuloaga's canvas entitled *Celestina* (1906) is a typical example of social painting executed with the demands of exhibitions in mind. In spite of the title, the main figure in the canvas is not a Celestina but a

beautiful naked prostitute waiting for her next client. The luxurious ambience seems to represent an upscale Parisian brothel. The voyeuristic, self-indulgent element so noticeable in the composition is softened by reconnecting it to the Spanish tradition via the title *Celestina*. This Celestina is a middle-age, red-haired woman in the adjoining room who recalls the madams painted by Toulouse Lautrec. She is recruiting a young woman dressed in simple clothes that reveal her humble condition and her recent arrival in the city. Other elements in the painting also detract from interpreting it as a merely voyeuristic image. The inclusion of a mirror in which the prostitute, holding a white flower in her hand, is looking at herself clearly alludes to a *vanitas*. The madam's red hair and her yellow outfit connect her with the traditional depiction of Judas, thus alluding to his act of betrayal for money.

Gonzalo Bilbao Martínez (1860–1938) also combined eroticism, *costumbrismo*, and social critique in canvases that include Celestinas. Born in Seville and strongly connected to the art academies, he became popular for his paintings of *cigarreras*, women from a Seville factory whom Mérimée's and Bizet's *Carmen* had turned into erotic icons of Andalusia (see, for example, his *Las Cigarreras* (The cigar makers, 1915)).[121] His *La esclava o la que vale* (The slave or the valued one, 1904) is a variation on the *cigarreras*. It depicts a group of beautiful women on a Sevillian patio. They are dressed in typical Andalusian clothes, with fans and other traditional southern elements. A Celestina, deformed in the Goyaesque fashion, is barely visible in the background. Her presence, together with the title, lets us know that we are looking not at a display of beauty and local flavour but at a denunciation of prostitution.

Until the mid-twentieth century, we can find similar folkloric paintings that contain a Celestina character, one that is often mentioned in the title. The Celestina acts as an indication that what are ostensibly just aesthetically pleasing paintings are to be understood as condemnations of prostitution. One of the last examples of this type of painting is Santasusagna's canvas that won the Premio de Honor in the Exposición de Bellas Artes de Barcelona of 1944, *El "palco" de la Celestina* (Celestina's box, 1944). The work retains aspects of Goya's social critique but accentuates Andalusian *costumbrismo* to condemn prostitution, which was illegal but tolerated under Francoism, in an image that, because of its folkloric colourfulness, was not perceived as scandalous or critical of the current situation.

A canvas that deserves attention for its original rendering of the Goyaesque tradition of the *maja* and Celestina is Benjamín Palencia Pérez's *La Celestina* (1920), currently in the Museum of Albacete (image 30). In a period in which Celestina acted as a sidekick in social paintings or

images of Andalusian belles, Palencia Pérez makes her the centre of a portrait full of psychological insight. He achieves this effect by combining Celestina and the *maja* into one character: a coquettish old woman dressed as a *maja* who is, at the same time, her own Celestina. Like the Goyaesque *majas*, she is dressed in traditional, colourful clothes. She is flirtatiously raising her skirt while partially covering her face with a fan, gestures that reflect both modesty and enticement. Yet, the visible portion of her face reveals that she is an old woman whose beauty is gone. She is smiling in a coy way, which can be interpreted as a sign of astuteness, senility, or even innocence. This combination synthesizes *maja* and Celestina into a single figure, combining old age and youth, beauty and ugliness, naivety and astuteness, in an unprecedented turn of the Goyaesque tradition.[122]

After the popularity of Celestina in the *costumbrista* and social paintings of the nineteenth and early twentieth centuries, interest in this figure decreased. She was sidetracked during the long dictatorship of General Franco because the character did not match the image of the imperial past that the regime fostered, although she never disappeared completely, given the undeniable importance of *LC* in the Spanish literary canon.[123] Only in the final years of the regime, and especially after the transition to democracy, did the figure of Celestina start to be recovered. However, this new interest manifested mostly in theatrical and screen adaptation – and, as noted earlier, in illustrated editions for young and popular audiences – rather than in painting.[124]

Painters' lack of interest in the Celestina character can be attributed to new artistic trends that did not favour the recreation of old literary figures and social critique, the areas in which Celestina traditionally thrived. In this, there is one significant exception: the Spanish giant of modern painting, Pablo Picasso (1881–1973). Picasso repeatedly engaged the figure of Celestina during his long and productive career, from the late nineteenth century until his death. His assiduous use of this figure, as well as the varied and creative treatment to which he submitted her, makes Picasso second only to Goya in the visual culture of Celestina. Not surprisingly, his famous 1904 *Portrait of Carlota Valdivia* (OPP.04:003; image 31), alternatively known as a *La Célestine*, a portrait of the alleged madame of a brothel in Barcelona, is by far the most frequently reproduced image in Celestina's large visual repertoire.[125]

This canvas reflects only one facet of his engagement with the Celestina figure, which he explored from different angles and styles at many points in his long life. Celestina prominently appears in Picasso's work

in two distinct periods: during his youth and formative years in Spain, and when he is a mature man in France. There is a gap of over twenty years between these two periods in which the figure is not prominent, although it is never completely absent from his painting. Salus, who has studied Picasso's interest in Celestina in detail, considers that Picasso used her to express his private feelings and his rapacious sexuality. In his final years, Celestina would help him give his concerns about his impotence visual form. In this sense, Salus argues, Celestina offered Picasso a way to symbolize the relentless pursuit to satisfy desire.[126]

Picasso's lifelong interest in Celestina likely began in his school years in Spain. During that time, *LC* was easily available in recent popular editions, some illustrated, including, as we saw in the preceding chapter, the 1883 Barcelona. But that volume's highly conventional images do not seem to have had any influence on his paintings.[127] Proof of his interest in *LC* is that he later acquired a copy of the Venice 1534 illustrated edition, although the images in this edition, mostly factotums of the characters, did not influence his portrayal of Celestina either.[128]

Picasso's fascination with *LC* also manifests in the surrealist poems he wrote during his mature years, in which he mentions Celestina four times – twice in 1940 and twice more in 1959. In three of these mentions, he refers to her as "madre Celestina" and alludes to her famous magical powders, confirming his familiarity with Hartzenbusch's popular comedy, which he may have seen in his early years.[129] Picasso had been acquainted with Goya's images of Celestina since his youth, as proven by his first image of Celestina (OPP.98:068): a pencil-on-paper copy of Goya's *Capricho 17*, *Bien tirada está*, which he made when he was seventeen years old (*"Bien tirada está," copy of the Capricho 17 by Goya*).

The first image of Celestina by Picasso that is not a copy is a sketch representing an old woman showing a beautiful girl, depicted with a naked breast and reclining on a sofa, to a wealthy old man in a top hat. Today, it is known with the descriptive title of *Scène d'intérieur: Viel homme, Célestine et jeune fille assise* (Interior. Old man, Celestina and seated young woman, OPP.97:068). As in all of Picasso's renderings of Celestina, she is presented as a figure simultaneously of the present and the past. She is also a combination of his first-hand experience of the madams in the brothels he frequented, of the literary Celestina, and of Goya's treatment of this figure. Thus, the Celestina in this sketch, in spite of her contemporary clothes, clearly evokes her literary and Goyaesque origins in her facial and physical features. She is an old, decrepit woman. Holloway connects this image with Goya's *Capricho 15*, *Bellos consejos* (Beautiful advice), and Rico sees it as related to the scene in act 7 in which Celestina shows the half-naked Areúsa to Pármeno.[130]

This combination of traditional and contemporary ingredients, as well as the ambiguous treatment of Celestina as something between a predator and a harmless old lady, even as a victim herself, is characteristic of Picasso's depictions of Celestina in this initial period. The sympathetic treatment of her figure is most noticeable in the 1903 drawing *Célestine tricotant* (Celestina knitting, OPP.03:238), in which he presents her as an old woman in a domestic environment, a benign figure engaged in the respectable practice of knitting.

Le divan (c. 1899, OPP.99:005), another image from this period, evidences a similarly ambiguous treatment of Celestina as something between between a victim and a predator. The image includes a vigilant Celestina keeping an eye on the behaviour of a client and a prostitute drinking at a table. Celestina is depicted in the traditional attitude of greed, counting coins, but her pronounced old age makes her look sympathetically fragile. The 1901 pencil sketch *Célestine et un couple* (Celestina and a couple, OPP.01:100) is a variation on *Le divan*, but departs from it in showing a rotund, well-fed, and not very old madam sitting in a comfortable chair. The client and the prostitute sit on the divan behind her. Like the previous scenes, this one suggests Picasso's experience as a client in brothels as well as the influence of similar images common in contemporary French art and illustrated magazines.[131] In spite of the allusion to her greed implied by her oversized hands, the madam is a serene, pleasant figure who recalls the mild treatment he gave her figure in *Célestine tricotant*.

These early images serve to exemplify an enduring characteristic of Picasso's treatment of Celestina: the lack of social denunciation or moral condemnation, which contrasts with the social paintings of the same period. With the possible exception of the over-characterization of the wealthy bourgeois in a top hat in *Scène d'interieur*, not a hint of social criticism exists in these images. Most often, Picasso takes the position of a by no means affluent client who is, at the same time, a witness to and a participant in the triangle of prostitute, client, and procuress. This is confirmed by how, in *Le divan*, the client resembles Picasso.

By assuming this dual position, Picasso is able to tap the first-person experience of these situations for intimate explorations of desire and its mediation by the Celestina character, an approach that culminates in the *347 Suite*, which he created in his old age and which we will examine later.[132] In these early scenes of clients and prostitutes, as well as in later ones, the expressive possibilities of the visual medium allow Picasso to explore meanings that go beyond facile denunciation. For instance, in *Le divan*, the prostitute and the client are wearing similar checkered scarves, a device that connects their figures and suggests a

complicity or similarity between the young client and the prostitute that excludes the old Celestina, who is relegated to a separate area of the drawing. Moreover, Picasso did not draw Celestina with the realistic hand he used for the client and prostitute; rather, he sketched her as the deformed figure of literary and Goyaesque ancestry.

Celestina gradually moved from the margins to the centre of Picasso's images, passing from a secondary to a central character. In 1903, he drew the sketch *Tête de femme avec boa* (Head of a lady with a feather scarf, OPP.03:175). It depicts a client sitting with a prostitute, a scenario similar to *Le divan*. However, in the foreground and on a much larger scale, a middle-aged madam with an elegant feather scarf is included next to the couple. Given the difference in proportions, she looks like an omniscient, preternatural presence invigilating, even controlling, the client and the prostitute.

A year later, he painted his famous *La Célestine* (OPP.04:003; image 31), also referred to as *Portrait of Carlota Valdivia*.[133] Three sketches associated with this painting have survived. One is a self-portrait of Picasso painting this canvas (*Le peintre et son modèle*, OPP.04:113); the other two are studies for the portrait. One (*La Célestine (Carlota Valdivia)*, OPP.04:008) depicts a fashionably dressed Valdivia between an elegant man and woman, as if emphasizing her role as a mediator and her acceptance in good society. The other, known as *Picasso et Sebastià Junyer-Vidal assis près de Célestine* (Picasso and his friend Sebastian Junyer-Vidal in a tavern with Celestina, OPP.04:007), presents Valdivia as a traditional Celestina figure sitting at a table next to the two men.[134]

While a real-life portrait of an alleged madam, the 1904 painting integrates the literary and popular Celestina with its model. She is depicted with a covered head, which references the old Celestina prototype. Her hair is not covered with the upper part of her cloak but with a piece of delicate fabric that recalls the traditional *mantilla* Spanish women wore at church, adding a suggestion of hypocritical religious piety that further connects her to the literary Celestina.[135] This covering makes it seem as if the elegant boa in *Tête de femme avec boa* has hybridized with the more modest cloak of the literary Celestina. Equally subtle is the treatment of Carlota Valdivia's age. She is far from being the decrepit old lady traditionally associated with Celestina. However, she shows obvious signs of aging, such as white hair and wrinkles, "without overdoing it," as Imbert writes.[136]

The most striking physical feature of the portrait is Valdivia's cloudy, completely blind left eye, an obvious deformity in her otherwise gentle face. Critics agree that Picasso's substitution of the knife scar on Celestina's face with the blind eye is his brilliant way of expressing Celestina's

complex character as well as an allusion to her dealing with the occult.[137] At the same time, this blind eye is also a sign of poverty and victimization, as Celestina's original scar was as well. As Salus states, "Picasso's vision of Celestina in spite of the rosy cheeks and a modest earring, still recalls that she had been cast out in poverty, a major theme in Picasso's early art."[138] He shows a similar sympathy for the figure of Celestina in *Le harem* (OPP.06:038), an image he painted two years later, in 1906. This painting is his response to Ingres's *Le bain turc* (The Turkish bath, 1862), but it includes, besides the naked women and a eunuch, the small figure of a Celestina. She is not an imposing madam or an evil-looking crone but an old servant providing a washing basin for the bathing women.[139]

In contrast to the centrality of Celestina in Picasso's depictions of prostitution, she is conspicuously absent in his famous painting from the following year, *Les demoiselles d'Avignon* (The young ladies of Avignon, OPP.07:001). There is no madam in this group of prostitutes posing naked for a client in an Avignon Street brothel in Barcelona. Scholars have argued that Celestina is absent in this painting because her figure represents the reality principle, the unavoidable intermediary in the fulfilment of pleasure, and does not belong in a painting presents the overpowering drive of sexuality.[140] This argument also explains why Picasso eliminated the figure of a young man with an ominous skull in hand who appears in previous sketches for this canvas (*Les demoiselles d'Avignon (Étude)*, OPP.07:022).[141]

After several years of Celestina's presence in Picasso's paintings, she largely – though never completely – disappears from his work for several decades. Only in the 1950s, when Picasso was in his seventies, does she feature again in his drawings and engravings, including *Personnages* (OPP.54:205), *Dans l'atelier I* (In the workshop I, OPP.54:572), *La danse des banderilles II* (The dance of the banderillas II, OPP.54:061), and *Les trois femmes et le torero* (The three women and the bullfighter, OPP.54:032).[142] As these titles indicate, Picasso places Celestina in environments that are common in some of his other paintings, such as the artist's studio. He paints her with characters equally common in his work, such as clowns, models, and bullfighters. All the Celestinas in these images, especially the one in *Dans la loge du clown XII* (In the lodge of the clown XII, OPP.54:568), are caricaturized in the Goyaesque manner.[143]

The strong influence of Goya, which never left Picasso, is also noticeable in his 1955 coloured ink drawing *La Célestine* (OPP.55:383). It depicts two women accompanied by a Celestina and a male character. They are behind the bars of a balcony, in a clear allusion to Goya's *maja* and Celestina paintings. In 1959, Picasso included Celestina in the composition *La fille et le moine* (The girl and the monk, OPP.59:431), which

represents a monk touching the breast of a naked girl who is presented to him by Celestina, as if echoing the lines in *LC* in which her services to clerics are noted. This theme is also represented in some of Goya's images.

Bullfights and bullfighters are another Goyaesque theme evident in Picasso's Celestina works in this late period of his life, and he often depicts Celestina and her pupil next to a *picador*. The figure of the *picador* and bullfighting in general were a constant in Picasso, who started to paint such scenes in his childhood. However, only in the bullfighting drawings executed in 1959 and 1960, some of which appear as lithographs in the 1961 book *Toros y toreros*, is there a strong presence of Celestina.[144] These Celestinas are strongly influenced by Goya, which is noticeable in some images that contrast her and the beautiful *maja* and recall specific engravings by Goya (*Picador et femmes*, OPP.60:188 and OPP.60:370). In another, the young woman is offered by Celestina to the client, in this case a *picador*, forming the usual triangle (OPP.60:361). Other images recall brothel scenes, where the naked woman is presented to the client or dances for the bullfighter (OPP.60:100, OPP.60:175, OPP.60:308, OPP.60:345, OPP.60:347).

Most interesting is how in some of the images Celestina is clapping her hands, having an enjoyable time, even dancing on a table in the centre of the image (*Danseuse et picador IV*, OPP.60:308). In one work (*La danseuse sur la table VIII*, OPP.60:348), the small Celestina with her hands and legs raised to dance resembles a puppet or other endearing figure. In other images, the role of the Celestina is like that of a grandmother, helping one or more of the children present (*Picador et personnages*, OPP.60:360, OPP.60:359, OPP.60:293). Sometimes Celestina has a cane that serves as a symbol of power, counterbalancing the phallic spear of the picador (*Picador et personnages*, OPP.60:293, OPP.60:233, OPP.60:360).

These scenes involving bullfighters are not the only images Picasso painted in his old age in which Celestina appears as a mediator of sexual desire. He also includes her in his 1960 version of the biblical scene depicted in Rembrandt's *Bathsheba at Her Bath* (1654) (*Bethsabée (d'après Rembrandt)*, OPP.60:068). In it, Celestina appears as the servant cleaning Bathsheba's feet. Picasso's transformation of the servant can be followed in his preparatory versions (OPP.60:102–8, and OPP.60:471–3). The first ones (OPP.60:068 and OPP.63:358) depict the servant as an old woman whose head is covered with a rectangular hat, similar to that in Rembrandt's original. In the next sketches, the servant is progressively deformed, influenced by Goya's famous *Capricho 17*, *Bien tirada está*, in which an old procuress examines the leg of her pupil, while one of the

later versions turns her into a clear Celestina figure (*Bethsabée (d'après Rembrandt)*, OPP.66:017).[145]

Celestina continues to appear in Picasso's works in his final years: he even places her next to a small caricature of himself as a weak old man. In these images, Salus sees empathy between Picasso and the old procuress because both, due to their age, cannot engage in sex and are compelled to act as mere voyeurs. Celestina becomes a trusted companion, an ally of Picasso, even if in some images she prevents the male suitor from getting the desired woman. This treatment of her figure is best seen in the sixty-six prints in a Celestina series he included in the *347 Suite* (1969). As its name suggests, this is a collection of 347 works, all etchings. They deal with many subjects that Picasso had previously explored in his art, including bullfights, clowns, and, of course, Celestina.[146] Eventually, the sixty-six engravings containing Celestinas were set apart and included as illustrations in a limited edition of the French text of *LC* published by Editions de l'Atelier Crommelynck in 1971. Their style is characteristic of Picasso's final years, which, under what appears as carelessness of execution, is a shorthand technique rich in expression and control.[147]

These engravings are not in any way illustrations of episodes of the text, even if we know that Picasso himself selected the order in which they should be included in the book.[148] The images represent a potpourri of characters in scenes that are mere personal fantasies, often of a sexual nature. In many, the triad of client, Celestina, and young woman is present, but the focus of the images is the naked body of the young woman. Some images can be compared to the earlier brothel scenes by Picasso, but now they are more difficult to interpret. The body of Celestina, dressed in a dark cloak and with her head covered, often overlaps with that of the young naked woman. Sometimes the black ink blotch that represents the young woman's pubic hair is echoed in Celestina's black robe. The identification between Celestina and her protégée is confirmed in some of Picasso's terracotta pieces of this period. In the two entitled *Personnages et cavalier* (OPP.68:231) and *Femmes et toreador*, OPP.68:392), the genitals and breast of the young woman are represented by the same white clay as the small Celestina figure.

Picasso remained faithful to the figure of Celestina until his death. In 1971, when he was ninety, he included her figure in brothel scenes of clients and naked women in his *Suite 156*. One of the images depicts Degas in a brothel next to a Celestina character (OPP.71:280). Most interesting is *Suite 156 L109. Maison close: Bavardages, avec perroquet, Célestine, et le portait de Degas* (Brothel. Gossip, with a parrot, bawd, and the portrait of Degas, OPP.71:127), in which a group of prostitutes engage in a lesbian

orgy to entertain Degas, who passively observes, accompanied by Celestina.[149] This drawing is unusual in presenting Celestina with her head covered by a piece of cloth. Equally unusual are the sharpened teeth in her opened mouth, which give her a menacing look, unprecedented among Picasso's Celestinas. Her left eye, quite different from the right eye, seems to allude to the damaged eye in his famous 1904 *La Célestine*. At the same time, a strong mark on her face may be interpreted as the scar of the literary character, which, until now, had never appeared in Picasso's renderings of Celestina. Interestingly, her face recalls Picasso's cubist period in the way the wrinkles of age are represented. Salus notices how the big hand of this Celestina symbolizes both a vagina and the avarice of the old woman.[150] It is worth noting that the work has a rigid near-triangular shape characteristic of Dutch brothel/tavern paintings, recalling Vermeer's *With the Procuress*.

This image proves that, even at his most advanced age, Picasso was still able to produce new versions of Celestina after a lifetime of creatively combining the literary character, Goya's images, and the real madams of his youth. Picasso had an undeniably deep knowledge of *LC* and the visual tradition of Celestina, which, combined with his genius, resulted in fascinating recreations of her character. In his final years, Picasso's Celestinas lost most of their realistic aspects and became caricatures, shorthand figures. Indeed, sometimes she is a mere blotch of black ink, but is still able to express deep personal meaning.

Her versatility is related to Celestina being neither a good or bad character for Picasso, allowing her to appear as an ally of the male pursuer or a duper of his desires. She is not a protector or teacher either, as was often the case in Goya's representations, nor the monster depicted by many of the social painters. The reality is that Picasso does not pass definitive moral judgment on Celestina. Accordingly, he rarely depicts her in the morally loaded gestures that symbolize her trade, such as handling clients' money. As Salus acutely observes, "Celestina can be identified as an autobiographical surrogate or a self-portrait, amusing or insightful, of Picasso himself."[151] The intermediary role of Celestina between the desiring man and the desired female body may represent the artist's sexual drive, his reaction to the model to be painted, his dealings with the buyers of art, and much more.

Although, as we have seen, most painters dealing with Celestina are from Spain, twentieth- and twenty-first-century painters from other countries have also depicted her. Not surprisingly, given that *LC* is part of the cultural heritage of all Spanish-speaking countries, many of these works are from Latin America. Copies of the book were sent to the Americas soon after it was first printed, as we know from inventories

of the book trade with New Spain and Peru.[152] As a result, Celestina became a popular figure embedded in the daily language and folklore of the Spanish colonies.

Celestina's pervasiveness as a popular figure is confirmed by two canvases by the Mexican painter José Agustín Arrieta (1803–74). He specialized in *costumbrista* scenes of daily life in his city of Puebla. Two of his paintings are clearly part of the tradition of Celestina. Like Goya, who matches Celestina with the emblematic *maja*, Arrieta places his Celestinas next to the young attractive *china* or *china poblana*, "an independent woman [who] became the national prototype and rose to become the equivalent of the *maja*" and a symbol of Mexican national identity.[153]

Arrieta produced several paintings in which colourful *chinas* are the protagonists, often accompanied by men pursuing their sexual favours. In one of these paintings, *Cocina poblana* (Poblana kitchen, 1865; image 32), the suitor, waiting outside the house, uses a Celestina to hand his message to the *china* working inside in the kitchen. In addition to her role as go-between, this figure matches the prototype of Celestina in her advanced age and the humble outfit that covers her body, extending to her head. The sexual nature of her commission is symbolized in the painting by the inclusion of pots, echoing the female sexual organs. Another woman in the kitchen is milling grain – a repetitive, pounding action associated with the sexual act. The intentions of the Celestina and even her connivance with the *china* are suggested by a turkey in the kitchen destined to be "desplumado" (plucked), an action associated with being duped and robbed, as stated in the caption for Goya's *Capricho 20, Ya van desplumados.*[154]

The second Arrieta painting with a *china* and a Celestina character is *Vendedora de frutas y vieja* (Fruit saleswoman and old woman). It depicts a *china* selling fruits in an open-air market. An older woman, covered in the characteristic manner, is about to convey a message to her, likely from a suitor. The young *china* is dressed like the one in *Cocina poblana*. The sexual innuendo is expressed by the exuberant open piece of tropical fruit she is holding. Another piece stands on the table, strategically placed in front of her pelvis. The turkey to be plucked in the preceding painting is here replaced by a chicken hanging from the hand of Celestina.[155] The Celestina character is extending the piece of cloth over her head to cover the young woman's head, as if figuratively bringing her into her world of secrecy. As in the previous work, Arrieta renders Celestina as a relatively younger character, not as Goya's deformed and decrepit hag.

We must wait for more than a century to find another Latin American painter who repeatedly depicted Celestinas. The Colombian

painter Fernando Botero (b. 1932) was famous for his signature over-blown figures. He places Celestina in scenes of daily life in the brothels of the provincial Colombian cities of his early youth. These brothels had fewer sordid connotations: they were popular gathering places in private homes for the sexual escapades of otherwise respectable men from small cities.[156] Botero's paintings of such scenes, like much of his production as a whole, are not moralizing but are full of ironic realism. Even if some critics consider his treatment of brothels to be similar to that by Bosch and later Dutch painters, there is a clear difference: Botero does not reflexively condemn the events and the participants. Botero's images are more complex, with more ambiguity. While they include a touch of *costumbrismo*, they are modified by the studied naivety of his bloated figures, resulting in an atmosphere of indefinite unreality.[157]

Celestina figures are included in several of Botero's paintings, such as *La casa de María Duque* (1970), *La casa de Ana Molina* (1972), *La casa de las mellizas Arias* (1973), *La casa de Amanda Ramírez* (1988), and *La casa de Raquel Vega* (1975). These paintings represent Botero's characteristic repetition of a subject or theme in subsequent canvases as variations – in this case, of images of a small brothel run from home by the eponymous women.[158]

La casa de Amanda Ramírez shows the owner as a Celestina character. She is sweeping the floor, trying to keep the space inhabitable by removing the many cigarette butts that litter the chaotic scene of sex and drunkenness. She is depicted on a much smaller scale than the rest of the figures, which makes her look like an endearing old lady. This vision of the brothel as a space of controlled chaos also occurs in *La casa de María Duque*. It depicts a similarly characterized old woman sweeping the dirty floor while five half-naked women are expecting clients and a drunk client is passed out behind them. In *La casa de Marta Pintuco* (2001), the presence of the Celestina character is restricted to the head of an old woman. She is peeping through the slightly open door into a room full of drunkards and prostitutes, as if to make sure that everything is in order. The coquettish draperies and wallpaper indicate that the brothel is a space of regulated disorder kept in control by its owner.

Only in one painting, *La casa de Raquel Vega*, is the Celestina figure depicted as a dishonest woman whose hands are in the pocket of a man distracted by the embrace of a prostitute. Although Sullivan is right that Botero's figures tend to have an inwardly directed passivity in their demeanour, the Celestinas in these paintings actively offer the merchandise and advise their pupils, cleaning the floor or making sure that alcohol is supplied.[159]

Equally busy Celestinas reappear in another three of Botero's canvases painted in and around 1998, all entitled *Celestina*. They represent

a room in which an older woman is behind or next to a young woman and a male client. In two of the paintings, the young woman is showing a naked breast. The dress of the characters and the style of the furniture indicate that, as with the paintings discussed above, the scenes are set in the Colombia of the 1940s. None of these images suggest in any way that the young women are being exploited. The three paintings show Celestina as a mature woman in the black clothes of a widow. She is not sinister but endearing, a quaint, familiar old lady. As in previous paintings, she is not submitted to the same bloating as the other figures. In two of the paintings, she is depicted in smaller scale, which makes her look older and fragile. She is always affectionately touching the young woman and speaking to her, as if giving her advice, in a friendlier version of Goya's similar scenes. Here, Celestina is a maternal priestess of a cult of sexuality who has made of her house a bracketed space beyond moral conventions.

Many critics implicitly agree with the point of view that the female figures of Botero, even if sensual, are not lascivious.[160] A long tradition of representing the clients as fools or seducers is also softened by Botero, who makes them look like out-of-control childish, egotistical figures. As well as being identified with the appealing vision of the world that characterizes magic realism, his Celestina figures have been compared to equally amiable characters such as Pilar Ternera in García Márquez's emblematic novel *Cien años de soledad* (*A Hundred Years of Solitude*), a maternal and, at the same time, sexualized figure who runs a brothel and chooses to be buried under its dance floor.[161]

Botero appropriates and transforms Celestina, as he does with many other images and myths of the European tradition, such as his *Menina (after Velázquez)* (1978). The result is a hybrid product of Latin American and European culture, part of a tendency that has been called Latin American intentional ambiguity or a cannibalization of European art.[162] And Botero has cannibalized the myth of Celestina. He has modernized and adapted it to the Latin American world of his childhood and to the individualistic morals of modernity in which sexual pleasure is not intrinsically a sin. The world of Celestina has lost its sombre transcendence to become a portrait of the pettiness of life in provincial towns. She is a participant in images that represent a provincial world that is extinct or about to disappear.

Unlike the quaint, nostalgic depiction of Celestina's world in Botero, the Portuguese painter Paula Rego (b. 1935) enlists her figure for a feminist cause. Rego was born in Portugal but spent most of her life in England. Like Botero, she is an artist for whom national traditions are not compartmentalized spaces but part of a global environment of

ideas and causes. Rego has acknowledged the influence of Goya and Picasso in her treatment of Celestina. She thinks that, even if Celestina originated in Spanish literature, her figure is also part of Portuguese culture.[163]

Rego is a feminist who uses her paintings – including those depicting Celestina – to critique patriarchal society. To this end, she enlisted Celestina as part of an art series in response to Portugal's 1998 referendum on abortion. She later exhibited the works in the Abbot Hall Gallery in the United Kingdom in 2001. The catalogue for the exhibition was entitled *Celestina's House*, even though the painting of the same title, *A casa de Celestina* (2000), was not part of the exhibition. This complex painting combines characters from the book with characters from Rego's personal life and previous work. A central table and the general disposition of the scene vaguely point to the banquet scene in Celestina's house in act 9, but other episodes and characters from the book can be identified in this complex painting. Several older women are Celestina characters, and we can clearly distinguish Pármeno, Sempronio, Calisto meeting Melibea, and a young woman, likely Melibea, jumping to her death. Given that Rego's painting is influenced by surrealism, she includes elements that are not part of *LC*, such as a lobster and shellfish on the table.[164] The complex composition has some resemblance to the allegorical paintings of Bruegel and Bosch, although no religious symbolism can be inferred, and some critics see the painting as an allegory of the ages of women.[165] The denunciation of clandestine abortion that inspired the painting is clearly conveyed by one of the Celestina figures, an older woman mending the genital area of a doll-like creature. This action is echoed by two other women working with sewing machines. The most imposing figure is a half-naked Celestina figure in the middle of the painting. She is an older woman with enormous breasts who seems to preside over the complex, chaotic events in the painting. Celestina, incarnated in several figures in this canvas, is not clearly condemned but is presented both as a victim and as an arm of the patriarchal order, whose hypocrisy she helps protect. In this regard, Rego states that Celestina may restore hymens and perform abortions to help women out, but she also gets rich in the process.[166]

Other painters have used Celestina in their work in the second part of the twentieth century and in the twenty-first century. The Mexican painter Jorge Quiroz (b. 1931) is the creator of *Celestina ataviando a Melibea post-mortem* (Celestina dressing Melibea post-mortem, 1972). The painting does not depict any scenes found in the book but, as the title indicates, seems to represent an otherworldly, post-mortem attachment of the two women. Painted in the surrealist style characteristic of

Quiroz, it depicts Melibea sitting on Celestina's lap, as a doll or a child. Both characters are painted in dark bluish tones that, together with their strange clothing, give them a Gothic, phantasmagorical look. Celestina is not the traditional old hag but a dignified mature duenna. No clear allusion to the themes usually associated with Celestina, such as sexual desire, drunkenness, or greed, are included in this unusual canvas. It is one of the rare uses of her figure in an openly surrealist painting. Another contemporary painter inspired by the Celestina figure is the Peruvian-Belgian painter Rafael Ramírez Máro. He is the author of a series of paintings about Celestina that include allusions to the *vanitas* and *memento mori* traditions. His treatment of the Celestina character is highly original, representing her as a laughing, perhaps insane old woman (see image 33). Equally surrealistic and with the oneiric touch that characterizes his paintings is Arnás Lozano's 2012 canvas *La Celestina* (on the cover of this book). Despite his innovative, highly personal treatment of the Celestina figure, some elements, like the crow on Celestina's head, recall Bosch's paintings with procuresses in the preceding chapter. Equally, the division of the pictorial space in two panels recalls the similar technique in some of the woodcuts of the early illustrated editions.

Conclusion: Reimagining Celestina

Just as the literary Celestina contained elements of earlier literary figures and reflected the reality of the procuresses of the day, visual Celestinas followed a similar process of recreation. Such depictions are based on previous literary interpretations and their visual renderings, and on the procuresses and madams of the artists' day. In this creation, Goya was the most influential figure. Although images of procuresses already existed, he created a signature image based on the text of *LC* and the reality of the prostitution in contemporary Spain. Goya's was the first clearly recognizable Celestina outside of the text and its illustrations. Compositionally, the merit in Goya's Celestina works is to have moved her from the margins to the centre of the canvas, where her dark figure stand out in contrast to the bright figure of the *maja*. Thematically, he made Celestina a central figure by releasing her from the flat, unidimensional character in moralizing scenarios of dissipated youth, as presented in the canvases of Dutch painters.

Instead of representing her as a mere collaborator in duping a client, Goya emphasized her complex interaction with a beautiful young woman, which she herself once was. He turned the teams of *majas* and procuresses that he saw in the streets of Madrid into a pictorial theme

that became popular with later painters. The contrast of beauty and ugliness, youth and old age, brightness and darkness, predator and prey, produced an explosion of meanings that the two figures did not have on their own. With his treatment, Goya is the progenitor of a double Celestina character. On the one side is the companion who stands in contrast to the picturesque young women from the popular classes, also featured in *costumbrista* painting, in works that offered social criticism. On the other, Goya also gave the Celestina figure an inward turn, making her a vehicle for introspection beyond facile moralizing and devout *vanitas* and *memento mori* ruminations.

By connecting Celestina's sorcery with witches' practices that were understood not as real events but as hallucinations, Goya made Celestina a window into the not-yet-postulated Freudian self. Following Goya's lead, painters such as Solana could go beyond *costumbrista* nostalgia in their treatment of Celestina. They placed her as a central figure in scenarios that conveyed the darkest side of life in a backward country ridden by superstition and brutality.

Picasso also used this inward turn in his treatment of the Celestina figure. He combined the literary Celestina and the madams of the brothels of his day and created a pictorial character with whom he established a contradictory, long-evolving relationship. Picasso's Celestina can act as a helper, a detractor, or even a surrogate self in his search for pleasure. Other painters used Celestina to explore equally complex issues, as Botero did in his depictions of the brothels of his youth with amiable yet ironic Celestina figures. In some cases, Celestina allowed painters to express political agendas, as did Rego, who makes Celestina play an ambiguous role as a victimizer and as victim: she is a provider of abortions to the same women she sells. Once she gained independence from her original text, Celestina's duality became her biggest asset, propelling her popularity in painting across the centuries. Her ability to reincarnate according to the times is another of Celestina's biggest assets. She offers painters the opportunity to use her synthesis of pleasure and punishment to express social and personal tensions in ways that go beyond words.

Advertising Celestina

A new kind of Celestina imagery started to appear in the late nineteenth century: promotional images on book covers and, later, posters and lobby cards for stage and film adaptations. To keep costs down and expedite their production, most of these images are adaptations of previous ones. However, they are important for the study of the visual culture of Celestina because they have been widely circulated, reaching beyond readers and audiences. For people who never read the book or attended a performance of a stage adaptation, the concept of what *La Celestina* "is about" and what characterizes Celestina is based on these images. These covers and posters are also important because they are the best indicators of how *LC* and Celestina have been perceived in the past century and a half.

The promotional images associated with *LC* are not unprecedented in their advertising function. They are specialized descendants of the illustrations that helped to sell the book. Like the promotional images, the illustrations made the book attractive to the buyers who leafed through the pages. Yet, illustrations differ from promotional images in that illustrations are designed to explain or complete the text and make it easier to understand. By contrast, promotional images are isolated shots designed to entice the viewer's curiosity through their intentional incompleteness. They often epitomize the advertising tenet that images must be designed as elliptic fragments that entice the prospective buyer to complete their meaning by acquiring the whole product.[1]

The incompleteness of promotional images can best be understood by comparing the modern covers of *LC* with the title pages of old editions of the book. Old title pages were not designed with the modern concepts of promotion in mind. As we saw in chapter 1, the woodcuts on the old title pages were synoptic images whose aim was to comprehensively display all the characters and main scenarios of the story.

They were visual versions of the old table of dramatis personae that served as an aid for readers by providing the names and roles of the characters in a dramatic text. Also, unlike modern covers, they were not the first contact the prospective reader had with the book, because they appeared on the inside of a bound the book. Title pages did help to promote sales, but only secondarily by adding extra value to the book, as did the illustrations.

Of course, on modern editions of LC, images are printed directly on the covers. They are designed to be readers' first point of contact, even before they open the book: they must entice the prospective buyer. When confronted with these covers, readers feel challenged to guess what the book is about. If they are familiar with its content, they feel the need to figure out how the image relates to the plot. Their curiosity can be satisfied by buying and reading the book. Similarly, the images promoting theatrical performances on posters, lobby cards, and press releases also are meant to trigger curiosity in prospective spectators. The way they do it, as we will see, differs in some respects from the approach on book covers, given the inner dynamics of show business and its advertising practices.

Promotional Images of Celestina:
Book Covers, Playbills, and Posters

The systematic use of promotional images on book covers, posters, and other advertising materials started in the nineteenth century with changes in the printing industry and marketing practices. Developments in lithography and later in chromolithography and photomechanical techniques, such as heliogravure and photogravure, resulted in faster and cost-effective reproduction of images. At the same time, other technical developments made it economically feasible to print images directly onto the hard covers of books and to mass produce large illustrated posters.[2]

These easily produced printed images were immediately enlisted by businesses that relied on direct purchase by the public, including the book trade and the entertainment industry. The two operated in competitive markets in which an abundance of products contended for a limited clientele and the use of advertising images gave them an edge over competitors. By the late nineteenth century, the use of illustrated covers had become the norm in publishing, and the 1883 Barcelona edition of LC followed the trend. When the story was performed on stage for the first time in 1909, promotional images of the actors and the stage were produced and circulated in accordance with well-established

show business norms. Finally, in the second half of the twentieth cen-
tury, when the book began to be adapted to the screen, producers used
numerous images in their advertising campaigns.

As a result of this promotional use of images, a considerable num-
ber of Celestina images exist, second in size and continuity only to the
woodcuts of the sixteenth- and early seventeenth-century illustrated
editions. These promotional images have not received much critical
attention, mostly because they are literally and figuratively external to
the text or performance. These images are, physically speaking, outsid-
ers because they are located outside the text and its performance, on
the covers of the books and on the walls and lobbies of theatres and cin-
emas. They are also outsiders from the point of view of their relation to
the content of the text because they belong to what Genette calls "para-
texts": liminal elements of a book or dramatic performance, including
elements such as prologues, headlines, and credits.[3] The externality of
these images is best conceptualized if we envision them as wrappers of
a product for sale. Wrappers, besides the physical function of protecting
the product, serve as a medium for advertising the product they cover.
Their surfaces are printed with images representing their contents in
an alluring way that encourages the prospective client to acquire and
unwrap the product. Significantly, these wrappings are conceived as
disposable parts of the product, meant to be discarded after the transac-
tion they have helped to facilitate has taken place.

Book covers have many similarities with these wrappers, to the point
that their designers are encouraged to conceive of them as the lids of
boxes containing a product – in this case, the pages of the text.[4] Once the
book is sold, the cover's main function, that of attracting buyers, is ful-
filled. However, unlike the boxes of other products for sale, book covers
cannot be easily discarded after purchase, as they are literally bonded to
the product.[5] These covers are not designed to serve any other purpose,
such as containing information useful past the moment of purchase.
That they are meant exclusively for attracting the purchaser is proven
by the otherwise redundant inclusion of modern title pages. Modern
title pages, descendants of the similarly named pages of early books, are
simply printed pages. Their streamlined, functional design contrasts
with that of the colourful, image-rich covers.

Modern title pages are meant to be permanent, and therefore are well
protected by the front cover and sometimes other preliminary pages.
Besides restating some of the information on the cover and spine, such
as author, title – in its real form, not the catchy, abbreviated form often
used on the covers – and publishing house, they also include technical
information for archival purposes. If the covers are torn or hidden when

the book is rebound, the title page contains all the information necessary to identify the book.[6] Although not in such a literal sense as book covers, posters and other entertainment advertising materials are also wrappers of a product they promote outside the theatre or cinema. Printed on flimsy paper, on loose sheets without the extra protection of a cover, they are clearly intended to be disposed of once the performance or projection is over. Their information is then obsolete. Fortunately, some survive as curiosities, thanks to collectors and archivists.

In spite of their externality and discardable nature, the promotional images on covers and posters deserve our attention, as they offer valuable insights into the reception of LC in the past century and a half. From their highly visible locations, these images act not only as commercial bait but also as gateways that set the expectations of readers and audiences before they open the book or access the theatre.[7] Another aspect that makes them worth studying is that they help us gauge the popularity of other images of Celestina's visual culture. Because, as we have said, covers and posters often reproduce existing Celestina images, they permit us to evaluate the popularity these originals had reached at a certain moment. Famous paintings, such as Picasso's 1904 portrait of a Barcelona procuress, discussed in the preceding chapter, are often altered for promotional materials, which allows us to gauge their popularity.

Of particular interest, as we will see, is how some pre-existing images are preferred for the covers of specific types of editions or at certain periods. Equally interesting is how the designers of promotional materials sometimes appropriate images never connected to Celestina, therefore expanding the figure's visual culture. For instance, the cover of the Castalia edition of LC (Barcelona, 2013) reproduces Caravaggio's painting *Judith Beheading Holofernes*. In this context, the image of the young Judith and her old servant becomes a representation of Celestina and one of her protégées. The viewers who recognize the fragment as belonging to this famous painting cannot but be intrigued by the possible similarities between the biblical story and LC. With this cover, the image and the story of Judith become a new addition to the visual culture of LC, and new interpretations of the text are suggested. On other occasions, advertisers come up with innovative designs that express some of the conflicts in the story through suggestive images. Examples include the sexualized keys and locks designed for use on the cover of the Alianza Editorial edition (Madrid, 2013) and on the posters of the theatrical adaptation by Escuela teatral, "La Comedia" (Cáceres, 2015).[8]

In spite of their variety, the images used for the promotion of LC have in common that they are conditioned by the advertising media on

which they are displayed. The appropriated images are often subject to cropping, blowing up, and other design interventions. This makes them fit their new location and optimizes them in their new role. Their colours and general design must integrate with and even enhance the all-important printed words of the title and author when they are on a cover.[9] Significantly, as in the case of Caravaggio's painting *Judith Beheading Holofernes*, the images may acquire new meaning because of their new location.

Images that belong to the visual culture of Celestina are affected by their new location and function. This is exemplified by the engravings from the early illustrated editions that have been repurposed for modern covers. As illustrations, the engravings relied on a close relationship to the text, both in the spatial and figurative sense: they were placed close to the passages in the text for which they functioned as visual translations. This physical and interpretative proximity is lost when the illustrations are taken out of their original location to serve on a cover or poster. Removed from their place as a link within a sequence of illustrations and from proximity to the episodes they illustrate, they become snapshots that demand that the viewer recontextualize them by reading the book or attending the performance. Finally, alterations, such as the colouring of the original black and white engraving, reassure us that the edition or adaptation is both faithfully and attractively refreshed.

La Celestina Covers

Illustrated covers are the earliest and most abundant promotional images associated with *LC*. As noted, the inclusion of illustrated covers started to be part of the standard process of book manufacturing in the nineteenth century and were valued for their promotional utility. The use of illustrated covers slowly became the norm, and, by the mid-twentieth century, unillustrated covers of *LC* were rare. By my estimate, from the late nineteenth century to the present day, close to three hundred different editions of *LC* with illustrated covers have been published. This is a considerable number, especially given that the use of illustrated covers in Spain began later than in other countries.

Although illustrated book covers were appearing in other countries by the first half of the nineteenth century, León Amarita's 1822 edition of *LC*, the one that broke the two-hundred-year publishing hiatus, did not have an illustrated cover, despite the high quality of the volume.[10] We have to wait more than sixty years, until 1883, for the first illustrated cover of *LC*. In the first half of the twentieth century, the number of editions of the book grew slowly. The 1960s saw an explosion that

continues until today, with all these editions having illustrated covers. This proliferation of editions with illustrated covers that began in the 1960s is related to *LC*'s being a safe financial bet for publishers as an undisputed masterpiece in the public domain. It was also compulsory reading for the growing cohorts attending secondary and postsecondary education in Spain and other Spanish-speaking countries, resulting in a variety of inexpensive editions saturating the market. To have a competitive edge, an illustrated cover is a must.[11]

The history of the illustrated covers of *LC* corresponds, albeit in a belated way, to the development of the book industry in the nineteenth century, with production slowly abandoning handcraft and embracing technology.[12] The century was characterized by the ascending industrialization and professionalization of the book trade, fostered by a market big enough to make the investment in machinery profitable. The modest printer-bookseller evolved into the more specialized figure of the editor, who had more means to produce and distribute books. Before these developments, covers were not part of the normal production process, but, as we saw in chapter 1, were added at specialized shops when requested by the purchaser. Gradually, books began to be sold bound in hard cardboard covers, often embellished with additions of fabric or leather.[13]

During the nineteenth century, printable, thinner cardboard covers became the norm. Spain was behind in terms of this technology, a consequence of the country's lag in industrialization and the late appearance of a reading market large enough to make the investment in the illustration of covers profitable. Eventually, toward the end of the century, Spain's output caught up with the mass production of books and modern techniques that included printed covers.[14] By the early twentieth century, the production of thin covers with some form of printed imagery was common, even for cheap books. Expensive editions with covers of leather and other difficult-to-print materials continued to exist, but they catered to a reduced market. Later, better-quality and often plasticized covers and better printing techniques resulted in the mass-produced yet attractive covers we take for granted today.[15]

Publishers embraced the illustrated cover as soon as it became technicnlologically and financially possible, recognizing that it was an efficient tool for promotion. Although new covers of *LC* inherited their general design, including the use of images, from the old title pages, they differed in fundamental aspects. The old title pages, as we saw, were not on the outside of the book but printed in soft paper that at some point required the protection of a sturdy cover. Also, even if some title pages had engravings, their general design was print-heavy. They

were conceived to convey considerable information: the name of the author, the title of the book in its long form – the standardized use of short titles was only gradually introduced in the nineteenth century – often a summary of the book's intentions and content, the name of the printer, and so on.

This prolixity contrasts with the brevity of text on modern book covers. They are conceived as predominately visual spaces, and so are light on text. The only concessions to printed words on the front cover are the all-important title, in its short form, plus the name of the author and, sometimes, the publisher. Other information deemed non-essential for the visual impact of the cover, such as a description of its content or the biography of the author, are relegated to the back cover or the front and back flaps in a hard cover with a dust jacket. Important but promotionally irrelevant data, such as the long title and legal and archival data, appear on the title page.

Modern covers are designed to grab the attention of browsing buyers through a calculated combination of image and attractive typography. They efficiently integrate image and print, something rarely achieved in the early illustrated title pages of *LC*. Woodblocks and letter blocks had their locations rigidly fixed in the printer's frame, and they could overlap only through the complex process of double pressing. On modern covers, images and print are often interwoven in a common space that is not a canvas or a printed page but a combination of both. The result is a multimodal media that engages the viewer and encourages them to simultaneously apply several visual literacies – artistic, typographic, historical, and so on.[16] Modern illustrated covers often take advantage of this space in which the pictorial rules of normal perspective and those of typographic linearity of text amalgamate. As we will see, some *LC* covers display a large head of Celestina surrounded by the letters of her name, floating above the figures of the other characters, who are represented on a smaller scale. Celestina's name and floating head act as the book title as well as a symbolic representation of her manipulative, even magical powers.

The first edition of *LC* with an illustrated cover was published in Barcelona in 1883 (image 34) (see chapter 1 for a discussion of this lavishly illustrated edition). This volume exemplifies how an illustrated cover was optimized to advertise the publisher's technical abilities in image production, contributing to the book's commercial success. The designers of this cover employed innovative technology not only to attractively present the book but also to emphasize its old pedigree. They produced an enlarged and brilliantly coloured yet faithful reproduction of the black-and-white woodcut that appeared on the title page of the 1538

Toledo edition. The old engraving, lifted from its original location, is framed by type that replicates the font on the old title page. In its original location, the woodcut was much smaller, as it was placed in portrait orientation and shared the page with the long title and other information. In its new setting, the illustration is bigger, set in a landscape format to accommodate the larger size, and is printed in a vibrant palette. To make space for the image, the printed information is reduced to the new title and attributed author.

This edition represents the culmination of the ascent of *LC* in the nineteenth century and it achieved wide circulation. It was made possible by the belated development of the Spanish publishing industry, especially in the Barcelona area, during which many new publishers were established.[17] Among them was the one that produced the edition, the Sucesores de Narciso Ramírez. It published the book as part of its series Biblioteca Amena e Instructiva (Entertaining and Instructive Library), which specialized in classical books that were intended to appeal to a large readership.[18]

The old *delectare et docere* implicit in the name of the series encapsulates this publishing house's mission: to issue classic texts in an attractive format that included illustrations printed with the newest technologies. That the technology for printing the images was an important development for increasing sales is confirmed by how the publisher's trade name appears on the title pages: Imprenta y Litografía de los Sucesores de N[arciso] Ramírez y Cia (Publishing Press and Lithographic Shop of the Successors of Narciso Ramiro Inc.). The company's name emphasized its lithographic capabilities, advertising its mastery of a state-of-the-art method of reproducing images that few Spanish printers offered at the time. The importance of staying up to date in technology is confirmed when, a few years later, the same publisher, by then Henrich y Compañía, Sucesores de N. Ramírez y Cia, included in its logotype their capability of using the newest "fototipia" and "fotograbado."[19]

The 1883 *LC* is best understood by analysing it within the context of the other books published by Sucesores de Narciso Ramírez in its Biblioteca Amena e Instructiva series. In 1881, this publisher produced a lavishly illustrated edition of *Don Quixote*. At the time, the market for this title was highly competitive, with several editions appearing, some of which had been produced by publishers in Barcelona.[20] In spite of the competition, this *Don Quixote* was so successful that it was reprinted in 1883 and 1884.[21] It is likely that this success led the publisher to consider a similarly illustrated edition of *LC*, a title traditionally considered second only to *Don Quixote* in the canon of Spanish literature. The market was far less competitive in this case, since no illustrated editions

of *LC* had been published since the 1841 Gorchs's edition, which was discussed in chapter 1. Even if Sucesores de Narciso Ramírez did not follow up with any new editions, the high survival rate of copies of the 1883 edition suggests that many were sold. The exact print run is difficult to establish but, for the period, a successful book, such as some of Galdós's novels, reached four thousand copies, and runs of ten thousand copies were not uncommon.[22]

The publisher followed the same proven recipe of its *Don Quixote*, but the cover of *LC* was more advanced in its use of image. The cover of the *Don Quixote* edition had no figurative images, only a few attractively designed golden letters and decorative motifs in intaglio. Also without images was this publisher's cover for the translation of Lamartine's epic poem *La caída de un ángel* (*La Chute d'un ange*), which appeared in the same series in 1883. That same year, the series saw the addition of Dante's *La divina comedia*, which had a cover displaying one of Gustave Doré's famous engravings representing Dante and Virgil in hell. The engraving was reproduced in black ink, but the red colour of the cardboard on which it was printed gave the background an appropriately infernal look. For the cover of the 1883 *LC*, the publisher followed a similar process, taking advantage of the red colour of the cardboard. This time, green, blue, and gold ink was generously applied to the black-and-white woodcut.

The decision to reproduce and embellish an engraving taken from an old edition on the cover of the 1883 edition sets the precedent for many later covers of *LC*. The 1883 edition is notable not only for being the first but also for striking a perfect balance between respecting the original engraving and altering it to fit its new promotional task. The carefully balanced results succeed in conveying the idea that the text inside is an old classic respectfully yet attractively updated with modern printing techniques. The choice of an illustration from the 1538 edition, from among so many others from the same period that contain engravings on the title page, is a calculated one. This engraving epitomizes the intention of the illustrations on the early title pages of *LC*, which was to represent the main characters and scenarios in a synoptic image. As we saw in chapter 1, this effect was achieved in this engraving by showing the two lovers in the garden and Celestina outside, busy in one of her many machinations.

Although other early title page images present similar scenes, the 1538 image stands out for the pre-eminent position of Celestina. This was the first woodcut on a title page to place Celestina on the same level of importance as the lovers. The effect was achieved by moving her figure to the foreground. Another asset of this woodcut is that the figure

of Celestina is distinctly drawn, with sharp, clear lines. Furthermore, her body conveys a sensation of movement and dynamism, unlike the hieratic rigidity of many other early woodcuts. Finally, her image is conveniently accessorized with all her defining attributes: a skein of yarn; a rosary, which might also be interpreted as the gold chain; and a cane, which emphasizes her old age.

The prominence of the figure of Celestina in the original engraving is also emphasized in the title and its peculiar typographic arrangement in the 1883 edition. The title is printed in a band around the image, using the same Gothic font as on the 1538 title page, but the word "Celestina" is added, so the new title reads *La Celestina: tragi-comedia de Calisto y Melibea*, instead of the 1538 original *Tragicomedia de Calisto y Melibea*. The cover also differs from the old title page in its inclusion of the name of Rodrigo Cota as the author, an attribution common in the nineteenth century. His name is printed in the old spelling as "Cotta" but is modernized to "Cota" when mentioned inside the book. This is another instance of the careful balance between old and new ingredients that characterize this cover.

The same balance is noticeable in the subtle modifications to the Gothic font of the 1538 edition that the modern cover imitates. Although the font is practically the same, some letters that modern readers would find more difficult to decipher are modernized. Others that are easily discernible by modern readers but look too plain are embellished. Thus, the long "ʃ" for "s," which to the modern reader looks like an "f," is replaced with the conventional "s" in the middle of the all-important word "Celestina." In contrast, the long "ʃ" is kept in the name "Caliʃto." The abbreviations and ligatures of consecutive Gothic letters are also eliminated to make them easier to read. To compensate for this modernization, the flavour of the original type is preserved by replacing the four instances of "d" in the original with an archaic-looking "d" that, if inauthentic, is easy for modern readers to recognize. Finally, ornate yet easily decipherable coloured initials imitating the practice of old manuscripts are used for the first letters of the words in the title.[23]

The designers of the 1883 cover exercised the same careful balance between old and new in recolouring the original engraving. As noted above, the cover is printed on red cardboard, and the chosen palette of inks is based on an intentionally naïve combination of basic colours. The result resembles a page of an illuminated codex or the hand colouring some owners applied to the black-and-white engravings in their incunabula. The inside of this cover is also enlisted to add an antique flavour to the edition while displaying the proficiency in modern imaging techniques used in this new edition. On the inside front cover appears

a black-and-white reproduction of the woodcut of Melibea's suicide taken from the 1575 Valencia edition. This visual bonus, described in the caption as a "facsimile," allows the publisher to display its technical capabilities in image reproduction. At the same time, placing this scene precisely at the beginning of the book emphasizes its dramatic content through the romantic character of Melibea. An image of her gathering flowers in the garden is also the first of the more than thirty modern illustrations in the book.

Many later scholarly and popular editions use similar adaptations of old engravings. Some modern covers follow closely the example of the 1883 edition, reproducing the woodcuts of old title pages without the accompanying type. This is the case with the popular edition by Bruguera (Barcelona, 1967), which reproduces a coloured version of the engraving on the title page of the 1501 Seville edition. Others reproduce old illustrations of a specific episode. Edime (Madrid, 1964) uses the death of Celestina at the hands of Pármeno and Sempronio from the 1528 Seville edition. Besides emphasizing the classic nature and prestige of the book, such choices were economical solutions because these early engravings were easily available and not covered by copyright.

Some of the new covers go beyond simply reproducing old engravings; instead, the designers integrate them as one element of more complex designs. An example is the Moretón edition (Bilbao, 1968), whose cover reproduces a fragment of the 1538 Toledo title page, integrating it into a complex linear pattern. Also, old factotums with the names of the characters are redeployed on modern covers, by themselves or combined with other elements. An interesting use of old factotums is the Editorial Destino cover (Barcelona, 1979), which displays a row of six factotums of the characters, with the characters' names written under the images. The figure of Celestia is emphasized by the addition of a highly visible hand-drawn arrow. Curiously, the factotums are taken not from an early *LC* edition but from Feliciano de Silva's *celestinesca* continuation *Segunda comedia de Celestina* (Medina del Campo, 1534). This peculiarity may emphasize that this new edition can also be considered a kind of continuation, which seems appropriate, as the text is the theatrical adaptation by the renowned writer Camilo José Cela, whose name is written on the cover at the same level as Rojas's. The choice of factotums also seems to allude to the fact that this is the version used for a theatrical performance staged the same year.[24]

Another common intervention when reusing old engravings is to remove buildings and vegetation from the image, keeping only the close-up images of the characters. This change has the effect of moving the characters closer to the viewer, an approach used in many covers,

as we will see later. Curiously, sometimes the architectural elements are used by themselves, as in the editions from Alianza (Madrid, 1998) or Edebé (Barcelona, 2008). Although not always taken from the old editions of *LC*, the images of old-fashioned houses and towers on the covers help to emphasize that the book contains a story written many centuries earlier. Some depict a fortress-like building or city, alluding to the situation of Melibea as a prisoner in her family mansion and her later jump from the tower, or to Calisto's assaults on Pleberio's house.

As with the 1883 cover, archaic-looking fonts are common on the covers of many modern editions, to emphasize the age of the text. Some recent designs rely on the impact of placing a letter by itself on the otherwise empty cover to emphasize their iconicity. Often these letters are inspired by old illuminated letters and dropped initials. Galaxia Gutenberg (Barcelona, 2012) uses a cover that is empty except for a large, embellished letter "C," likely for Celestina. Orbis (Barcelona, 1998) displays an artistic "T" for tragicomedia. Mixed typographical and figurative covers are another common solution; the cover of the Huemul edition (Buenos Aires, 1984) has a Cupid within the letter "C."

In spite of their popularity and expediency, the adaptation of early woodcuts and archaic fonts for the covers of *LC* has decreased since the beginning of the twenty-first century. The old woodcuts, no matter how altered and enhanced, are not impactful enough to grab the attention of today's audiences. The only versions that still follow this model are scholarly editions, likely because it implies a historically respectful treatment of the text. To this group belong the covers of editions published by the University of California Press (Berkeley and Los Angeles, 2006), Editorial Universitaria (Santiago de Chile, 2009), and Universidad de Valencia (Valencia, 2011). Despite this recent decline in covers reproducing old engravings, it is difficult to find another book in which the images of its early editions have had such a presence on modern covers.

Along with the covers that reproduce old engravings from *LC*, another important group is covers with old paintings of events and characters loosely matching those in the book. As with the covers reproducing engravings, this is a cost-effective design, as most of the paintings are in the public domain. Equally important, the paintings contribute to visually appealing covers that transfer the prestige associated with painting as an art form to the book. One of the most frequently chosen types of paintings includes three figures that loosely match the sex, age, social status, and interactions of Calisto, Melibea, and Celestina. Their figures act as "factotums" standing for the character, an association that is possible given the freedom of modern representational conventions, which

allow a sometimes-tenuous connection between the cover images and the book's content. Some designers have hurriedly selected paintings with an old woman or a couple of lovers whose appropriateness for the task is questionable. For instance, the cover of the Croatian version (Split, 1984) reproduces the painting *Ulysses and Penelope* by Francesco Primaticcio (c. 1560). The two naked characters depicted in classical style are supposed to stand for Calisto and Melibea in a sexual encounter. Although Ulysses and Penelope are not especially suitable characters, the choice of a painting by a sixteenth-century Italian artist contributes to connecting the book to its Renaissance roots.

The most frequently chosen canvases belong to the vast repertoire of the figurative painting tradition extending from the Renaissance to the nineteenth century. Even if some are the work of lesser-known painters, the cultural prestige of this type of painting contributes to highlighting the literary stature of *LC*. The old-fashioned images convey the idea of a period before our prosaic modern times. Another reason that paintings in this tradition are a popular choice is that many represent human figures engaged in actions or poses that reveal their personality and emotions. To accentuate the humanity of the figures, the designers of covers often crop the paintings, leaving out the background and sometimes concentrating only on their upper bodies and faces. The results are close-up and personal portraits that allow the viewers, by extension, to connect with the characters in the book, giving them a face and body.

Covers based on paintings excel at fulfilling the important function of eliciting the curiosity of prospective buyers. The images present a riddle in the form of a painting whose authorship and theme the buyer may or may not recognize. In both cases, the buyer's curiosity is triggered about what is happening in the depicted scene. If they recognize the painting, they likely want to understand how the events of the canvas relate to the plot of the book. This curiosity-triggering effect is exemplified by the first cover of *LC* to reproduce a painting, the edition by Editorial M. & S. (Barcelona, 1966). It displays a black-and-white reproduction of the painting *Between Wealth and Love* (1869), by the relatively unknown nineteenth-century French academic painter William-Adolphe Bouguereau. The title and authorship of the artwork are not mentioned anywhere on the cover or the book, a widespread practice in economical editions such as this one. This allegorical painting portrays a young woman in the historicist style typical of the period. She is standing between a young man and a bearded old man who is offering her money, all dressed in sixteenth- or seventeenth-century attire.

Although this painting does not reflect any scene in *LC*, the two young characters can stand for Calisto and Melibea. The theme of mercenary

love alluded to by the man offering money connects with a theme in the book, and the age of the man relates him to the equally old Celestina. The classical, academicist style of the picture suggests the gravity of the book. The goal is to pique the viewer's curiosity about what is taking place in the canvas and how it relates to the book. For new readers, this curiosity can be satisfied only by reading the book; even those familiar with the plot may be spurred into reading it one more time to refresh their memory and come up with an interpretation that explains the choice of the cover.

The viewer's reaction to the cover is different when it displays a painting so well known that it is recognized at first sight even if no indication of its title and authorship is given. This reaction is exemplified by the cover of the Editorial Universo edition (Lima, 1972). It reproduces a fragment of Velázquez's *Las meninas* (1656), with enough detail for the viewer to immediately recognize it. Only three figures of the several present in the original painting are included: one of the young ladies-in-waiting, the mature chaperon Marcela de Ulloa, and, in the background, the chamberlain José Nieto. Repurposed for the cover of *LC*, the chaperon, whose head is covered in the traditional fashion of older women, stands for Celestina. The young lady-in-waiting stands for Melibea or one of Celestina's pupils. The chamberlain stands for a suitor of the young woman, most likely Calisto, waiting at a distance for the result of Celestina's commission. The fact that the reader recognizes the original painting does not deter from the effectiveness of this cover. It presents an eternal triangle, pertinent to any period, and the status of Velázquez's painting as an undisputed masterpiece is transferred to the text.

Other reputed Spanish paintings are often used on covers that promote the book's "Spanishness." Such a choice is most common for covers of translated editions or those printed outside Spain, such as the Italian edition of Biblioteca Universale Rizzoli (Milan, 1994). It deploys a fragment of Velázquez's *Las hilanderas* (The spinners, c. 1655), which barely relates to the plot of *LC*. A similar effect is sought by covers with paintings of popular Spanish types, especially those of the picaresque tradition. This is the case with Velázquez's *Vieja friendo huevos* (Old woman frying eggs, 1618) and Murillo's *Dos mujeres en la ventana* (Two women at a window, c. 1655), which are used, respectively, on the covers of the editions published by Anaya (Madrid, 1990) and Longseller (Buenos Aires, 2002). Some covers emphasize Spain's medieval landscape, showing images of castles and old cities. Other covers achieve a similar effect through images of Spanish popular culture. The cover of the didactic edition for students of Spanish by Jinan University Press

(Guangzhou, 2016) shows the silhouettes of a bullfighter, an old build-
ing, and an old character who stands for Celestina but wears a carnation
on her head, recalling an aging flamenco dancer.

Among the covers that display Spanish paintings, Goya's work is
the most popular. This popularity is not surprising, given that his work
abounds in Celestina characters and scenarios, as we saw in chapter 2.
Moreover, his unmistakable style has become identified with the
colourful yet mysterious Spain that Romanticism popularized. The first
edition to use a Goya painting is not from Spain but from Argentina,
published by Centro Editor de América Latina (Buenos Aires, 1980).
It shows an old women taken from *El aquelarre* (Witches' Sabbath, c.
1797). The edition from Mestas (Madrid, 2016) reproduces a small frag-
ment of Goya's fresco *Milagro de San Antonio de Padua* (Miracle of Saint
Anthony of Padua, 1798). This fragment shows two women admiring
the miracle, painted in Goya's trademark sketchy style. Although they
are part of a religious painting, the two women, taken out of context in
this detail, recall the witch-like images of his darkest paintings.

Another interesting use of Goya's paintings is the cover of an Ital-
ian translation of *LC* published by Garzanti (Milan, 1995), which dis-
plays a fragment of Goya's *El paseo de Andalucía*, also known as *La maja
y los embozados* (An avenue in Andalusia / The *maja* and the cloaked
men, 1777). Curiously, the Celestina character in this painting, an old
woman in the margins of the canvas, has been cropped out. This exclu-
sion shows that the reason to choose this painting was not the Celes-
tina character but the identification of Goya's style with a mysterious
yet gallant image of Spain. The same association led the designer of
the English translation of Mérimée's *Carmen* (Oxford University Press,
1999) to use this painting.

Goya's critical view of Spanish society as well as his progressive ideas
make his paintings a common choice for covers of editions published
after the end the Francoist dictatorship in Spain. Although *LC* was never
banned under Franco, it was discreetly set aside, and its irreverent and
socially critical aspects de-emphasized.[25] This tendency was reversed
after the return of democracy, when some editions included covers that
promoted the book precisely for its controversial aspects. A good exam-
ple is the cover of the Ediciones del Orto edition (Madrid, 2009), which
reproduces the face of the old woman in Goya's painting *Maja y Celestina*
(1824). It shows only the deformed face of the old woman, cutting out
the figure of the beautiful *maja* next to her on the balcony.[26]

Picasso is another painter whose work is often used on the covers of
LC, at least after his reputation in Spain was restored with that coun-
try's transition to democracy. Like Goya, he is strongly associated with

Spain, and, as we saw in chapter 2, he returned many times to Celestina figures in his paintings. His famous 1904 portrait *La Célestine* has been repeatedly used on covers of *LC* over the past thirty years, as in the editions by Bruño (Madrid, 1993) and Alba Editores (Santiago de Chile, 2003). The first edition to use this portrait on the cover was the Brazilian edition published by Sulina in 1990, confirming the trend, in translated editions, to emphasize the book's Spanishness by featuring the work of emblematic Spanish painters. Besides a reproduction of Picasso's *La Célestine*, this cover accommodates the tradition of representing the three main characters, adding images of the two young lovers on each side of the portrait.

In spite of the subsequent popularity of Picasso's 1904 portrait, the first *LC* cover to use one of Picasso's images – Cátedra's 1987 edition, published in Madrid and edited by Dorothy Severin – reproduces not the iconic painting but his overtly sexual pencil, chalk, and coloured crayon composition *Courtisane et guerrier* (Courtesan and warrior, OPP.68:482). This cover emphasizes the sexual aspects of the book, which conservative forces had ignored for so many years. Just as the *maja* was cut out in the cover reproducing Goya's *Maja y Celestina*, here Picasso's original drawing is trimmed to its most impactful elements: the full nudity of the woman on the bed and the Celestina character next to her. The figure of the warrior (or client) is left out.

How this 1987 cover reflects a dramatic change in post-Franco Spain can be seen by comparing it to the 1974 version by the same publisher, edited by Bruno Damiani. The cover of the earlier book includes an image of Celestina counting her money, and Calisto and Melibea behind her. Unlike the cover using Picasso's image to emphasize the crudest aspects of the story, this cover emphasizes the didactic aspects of the text. It alludes to Celestina's greed and shows an idealized image of the lovers. This reading is reinforced by the inclusion of lines across the image, which give it the look of panels in cathedral windows.

Like Goya, Picasso's reputation as a painter of Celestina characters and scenarios is so widespread that even his paintings without a Celestina character or sexual content are used for covers of *LC*. This is the case of the Editorial Tomo cover (Mexico City, 2011), which reproduces Picasso's 1905 *Portrait de Madame Benedetta Canals* (OPP.05:019). This portrait of a young woman bears no relation to Celestina or the world of prostitution. However, the Blue Period style, the pose of the woman, and the brush work recall his Celestina portrait of the previous year. The young woman in the painting is wearing a black mantilla, which conveys the idea of a mourning, allowing the subject to stand for Areúsa after Celestina's and Pármeno's deaths. The mantilla also ages

her, which, together with the sombre palette, suggests the brevity of youth and other eschatological themes in *LC*.

Similar associations explain the use of another of Picasso's portraits unrelated to Celestina for the cover of the P.M.L. edition (Madrid, 1994), *Femme à la corneille* (Woman with a crow, OPP.04:005). It is a portrait of Margo Luc, stepdaughter of the owner of a Montmartre café, whom Picasso painted in 1904, the same year he painted his famous *La Céles-tine*. As with the *Portrait de Madame Benedetta Canals*, the subject does not match any specific characters of the book. Despite the association between witchcraft and the black crow, the woman is not old enough for the role of Celestina, but neither is she young enough to represent any of the young women of the story. Nonetheless, the recognizable style of Picasso's Blue Period plus the dark touch of the crow make the painting a suitable cover for *LC*. Curiously, the version used on the cover is rotated on its vertical axis, changing the orientation of the woman's gaze to the right. This probably was done to match the convention of text running from left to right on the printed pages, as if inviting the viewer to proceed to the next page.

The covers of many modern editions of *LC*, including those featuring works by Picasso, continue the trend, which we first saw with the 1883 Barcelona edition, of highlighting the character of Celestina. Her ascent is confirmed by the illustrated cover of the widely circulated edition the Spanish publishing house Sopena reprinted several times in the 1920s (image 35). The illustration, drawn specifically for this cover, features Celestina and the lovers in the garden. Surprisingly, Celestina is inside the garden with Melibea and Calisto. Her figure occupies most of the foreground, while the embracing lovers, are in the background, moving away from the viewer to a secluded place under the foliage. Celestina is rubbing her hands in a satisfied gesture easy for modern readers to interpret.[27]

Parallel to this visual ascent of the character of Celestina is the typographic ascent of her name in the titles printed on the covers. While the cover of the 1883 edition reads *La Celestina: tragi-comedia de Calisto y Melibea*, the Sopena edition (c. 1920) reads only *La Celestina*. This visual dominance of Celestina on the covers continues as the century progresses, to the point of pushing out the other characters. The 1942 Molino edition has the first cover in which Celestina is the only character depicted. It uses the figure of an old woman that is an adaptation in black and white of Botticelli's allegorical female figure symbolizing Repentance in *Calumny of Apelles* (c. 1495). In Botticelli's original painting, the old woman is next to the naked female figure of a young Truth, which has been cropped out for this cover.

Because of their expressive gestures and features, allegorical figures with negative connotations are often used to represent Celestina on modern covers. They are often altered to accentuate an evil look, as in the cover of the 1942 edition published by Molino in Barcelona, on which her profile is modified to look harder, nearly masculine. Equally, her hands are made bigger to the point of recalling the claws of a bird of prey. Curiously, none of Celestina's traditional accoutrements – rosary, yarn, gold chain – are added to this altered image. Only a stone wall is added behind her, perhaps an allusion to Melibea's garden.[28]

Paintings of women in which age is dramatically emphasized are often used on the covers. These include portraits that represent respectable matrons, as in the 1985 Editores Mexicanos Unidos cover, which reproduces Rembrandt's *The Artist's Mother* (c. 1629). The same publisher in 2006 uses Degas's *The Old Italian Woman* (1857). Even the covers of some adaptations of the Celestina tale adopts this practice: for example, Cátedra's 1988 edition of Feliciano de Silva's *La segunda Celestina* reproduces Hans Memling's *Portrait of an Old Woman* (c. 1480).

The association between old women and evil results in covers that conjure sorcery and witches. The cover of the Bruño edition (Madrid, 1993) displays a newly created illustration of an old woman with a cemetery in the background, a clear allusion to Celestina's nocturnal excursions to find the ingredients for her potions and enchantments. The EDAF cover (Madrid, 1976) conveys the same idea by representing an old woman with a snake and the wing of a bird as ingredients for a potion. Similarly, the Sansy Ediciones cover (Valencia, 2012) depicts a bird bringing Celestina a gold chain while she is casting a spell. Some covers images also suggest the demonic nature of Celestina through less direct allusions, such as by depicting her as an unembodied ghostly entity hovering over and controlling the characters from another dimension with invisible strings, as in the Editorial Lumen edition (Barcelona, 1988). Similarly, a spider web in the 2010 Oxford University Press edition evokes her ability to manipulate the characters. This type of image is typical of covers designed in the 1960s and later, when innovative uses of the pictorial space and perspective made possible these symbolic messages.[29]

A variant of the evil witch is found on the covers that represent Celestina as a quaint witch in the tradition of Hartzenbusch's *Los polvos de la madre Celestina*. This characterization is most common in editions aimed at younger readers. The Aguilar cover (Madrid, 1970) has a naïve-style depiction of Calisto climbing a wall and Celestina standing underneath him, holding Melibea's girdle and a cauldron. This

type of cover occasionally connects Celestina with the witches in fairy tales. The Editorial Vasco Americana cover (Bilbao, 1971) recalls Sleeping Beauty, showing a charming Celestina spying on Melibea working at the distaff. The connection with fairy tales can sometimes be less benign: the edition adapted for younger readers by Edebé (Barcelona, 2008) depicts Celestina wearing a cloak with a raised collar and carrying a vial with poison that recalls the evil queen in Disney's *Snow White*. Celestina even becomes a spooky character from horror subgenres, as on the Anaya cover (Madrid, 2017), in which she is made to look like a moonlit zombie with empty eye sockets.

Beginning in the 1960s, some editions featured pictures of famous actors playing Celestina in theatrical or screen adaptations, piggybacking on their popularity. These covers share design features with the posters and playbills we will study later. Rodegar (Barcelona, 1969) used a close-up of Amelia de la Torre, who played Celestina in the popular film adaptation directed by Ardavín in the same year. Her image is copied from the widely circulated poster of the movie, thus helping to ensure that the propective buyer will recognize her. However, the designers of the cover made subtle changes: in the poster, Celestina's face is in the background, while in the foreground Calisto is embracing Melibea in her bedroom; on the cover, however, Celestina is in the foreground and the lovers are relegated to the background. This alteration is easily explained: while the movie was promoted by highlighting the erotic aspects of the story, the book is presented as the classical text, in which Celestina is paramount. Another curious alteration is that the book cover is not a reprint of the image on the poster but a highly realistic sepia pencil version. This replacement of the photographic image with an artistic rendering, aided by the addition of a leather spine to the volume, gives the edition a respectable look. It reassures the purchaser that, in spite of the connection to a movie famous at the time for its erotic images, the book is reputable.

In an analogous way, an image used to advertise the 1996 film version of *LC* directed by Gerardo Vera is used on the Ediciones B cover (Barcelona, 1996). This cover takes advantage of the popularity of the movie and its advertising campaign by reproducing part of the poster. While, in 1969, concerns about respectability led the publisher to alter the movie poster for use on the book cover, such considerations did not apply in the more liberal atmosphere of Spain in the nineties. The poster and book cover, which reproduce the frame of the film in which Calisto and Melibea are lying in the garden after making love, are identical. Interestingly, no image of Celestina is included. As we saw, covers that emphasize the romantic and erotic content of the book tend to place

the figure of Celestina discreetly in the background or remove her altogether.

The use of erotic images on covers of LC to engage the viewer's attention is a longstanding practice, its pedigree reaching back to the woodcuts on the title pages of the book's early editions. Yet, the explicitness of these images increased exponentially in the twentieth century. In the early woodcuts, such as the one reproduced on the 1883 cover, the lovers are talking, not touching each other. Modern covers gradually increased the erotic intensity, beginning with the first twentieth-century cover, on the Sopena edition published in the 1920s. Significantly, this image is the first one on a cover to depict physical contact between Calisto and Melibea, who are embracing while walking into the garden. This physical contact follows the lead of the romantic illustrations inside the 1841 and 1883 Barcelona editions, which depict several images of the lovers engaged in amorous caresses. The most explicit image is on the 1996 Ediciones B cover, which uses a frame from the film that shows the lovers lying on the ground, their bodies shot from above in a voyeuristic perspective. Some covers resort to curious solutions for the depiction of this encounter. The Cooperación Editorial cover (Madrid, 2002) alludes to Zorrilla's famous love scene with Don Juan Tenorio on the chaise lounge by presenting Calisto and Melibea in the same scenario. However, the erotic tone is intensified by the visibility of Melibea's nipple, which challenged the dated erotism of Zorrilla's play.

Such a display of Melibea's anatomy is rare on covers. Her figure is normally completely dressed, while nudity is reserved for Areúsa and Elicia. Melibea's beauty is central to many covers, but is conveyed in a discreet, dignified manner, although not without erotic innuendo. This effect is achieved on some covers by reproducing old paintings of beautiful, richly dressed young women in alluring poses. The cover of the French translation published by Fayard (Paris, 2006) reproduces only part of the young woman in Robusti's *Venetian Woman* (c. 1560), cropping out even her face to show only her décolletage and pearl necklace. Similarly, the La Spiga cover (Milan, 2007) reproduces Titian's portrait of the goddess Flora, part of her left breast exposed (*Flora*, c. 1517). Taken out of context, she simply becomes a young woman, although the classical style adds a touch of respectability to her partial nudity. Only a few covers use newly created images of suggestive young women. Their features, hairstyles, and expressions match the beauty conventions and fashions of the year the book is published, as can be seen on the Mateu cover (Barcelona, 1964). It is noteworthy that the bodies of Calisto and the other male characters are never used by themselves for their erotic potential, only as admirers or enjoyers of female beauty.

Unlike the restraint exercised in the covers that evoke Melibea's beauty, those that use openly sexualized imagery resort to Areúsa and Elicia engaged in sexual activities with Pármeno and Sempronio. They present them in sexual, even orgiastic scenarios that are elaborations of the banquet in act 9, with its allusions to debauchery and prostitution. This type of openly sexualized cover began to appear in the 1940s in French editions of *LC*, which were often limited editions for bibliophiles. The cover for Les Éditions de la Nouvelle France (Paris, 1943) features an original design imitating the architectural façade from an old title page but altered to represent the front of a vaudeville stage. By the curtain on the left side of the stage, we can see a frontally nude female figure, halfway between a caryatid and a taunting show girl. This openly sexual image takes on a didactic quality with the placement of a devil on the opposite side of the stage and a skull in the orchestra.[30]

More sexually explicit and without any moralizing additions is the cover of the edition by Les Bibliophiles de France (Paris, 1949), a volume that, as we saw in chapter 1, included sexualized illustrations. The tenor of those illustations is clearly telegraphed by the cover, which presents Celestina standing as a pagan priestess flanked by the reclining naked bodies of Areúsa and Elicia. They are accompanied Pármeno and Sempronio, who are clothed but reclining and drinking. The naked women are in the foreground, in full frontal nudity. They are dark-haired beauties with flowers in their hair, recalling the Andalusian belles in the erotic paintings by Romero de Torres and other *costumbrista* artists. In the background of this orgiastic scene, the fully dressed Calisto and Melibea are standing somewhat apart, separated by the figure of Celestina.

Next to these carefully designed covers, some cheaper editions include covers with erotic images barely pertinent to the text. An example is the Editora Nacional cover (Mexico City, 1962), which, in the style of erotic pulp literature, displays a madam in modern dress with the naked silhouette of a young woman behind a screen. In Spain, we have to wait until after the end of the dictatorship of Franco to find overtly sexualized covers. The first is the cover of the edition in the collection appropriately called Clásicos Universales de la Literatura Erótica (Madrid, 1978). It shows two young lovers taking off their clothes and caressing, drawn in the nineteenth-century style of piquant illustrations. With this outdated, quaint style, the cover suggests that the book contains erotic material of historical and cultural interest. Since that edition, many covers of *LC*, especially, in Spain, show the naked or scantily dressed bodies of young women.

Covers with eroticized images of Celestina herself are rare, one exception being the cover of the Portuguese translation of the 1957 stage version of directed by Luis Escobar and adapted by Pérez de la Ossa, which was published by Coordenada (Brasilia, 1967).[31] It evokes the legends of witches' lewd ceremonies and practices, reproducing an old drawing of a naked witch in an obscene position while in a trance. The cover of the English translation published by Cervantes & Co. (Newark, 2003) uses an image of Celestina putting a spell on her yarn, taken from a performance of the play at the Edinburgh International Festival in 1989. This photograph, which was used in other covers, is cropped here to show only the face of Celestina. In Edinburgh, she was played by an attractive, mature actor, Amparo Rivelles, whose face in the photo reflects an expression of sexual ecstasy. Celestina is also presented as an attractive woman with suggestive cleavage and flirtatious eyes on the Ayuntamiento de La Puebla de Montalbán cover (Toledo, 1999), which reproduces Celestina's portrait by the painter and illustrator Teo Puebla.

Finally, there is a group of covers that ignore human figures and instead feature objects, including props used or mentioned in the text of *LC*, such as the gold chain. Some reproduce objects symbolically connected to the main themes of the story, such as hearts. This type of cover became popular in the 1960s, when innovative design trends gave advertisers more leeway in their choice of imagery. Since the days of the early woodcuts of *LC*, the inclusion of objects for the identification of characters has been common, such as the rosary attached to the figure representing Celestina. However, the illustrations or woodcuts on the title pages never presented these objects by themselves. Modern covers, on the other hand, often use objects by themselves to pique the curiosity of potential readers. This is usually achieved by presenting images of objects other than the easily decipherable props mentioned in the text. Some covers display objects whose symbolism is evident, such as hearts, but they are presented in an intriguing way. For instance, the covers of the editions published by Círculo de Lectores (Barcelona, 1981) and Alianza Editorial (Madrid, 2013) show old keys whose lower or upper part has the shape of a heart. El País (Madrid, 2004) displays a heart made from thorns. Ediciones S.M. (Madrid, 2017) shows a broken heart suspended from the strings of a puppet handler's stick. Edebé (Barcelona, 2018) displays an anatomically correct heart with windows and a key that make it look like a building, clamped within the arms of the letter "C" in allusion to Calisto or Celestina. The Penguin Random House cover (New York, 2020) features a rosary, but reworks its connection to the characters. Although the object is traditionally associated with Celestina, this cover displays a stylized image of Melibea falling to

her death with a rosary around her neck; the string holding the beads has torn, and the beads, as well as, most prominently, the cross at the tip, scatter ominously (image 36).

Objects that play a secondary role in the story and do not have evident symbolic interpretations have been used to produce intriguing covers. Sometimes the objects look uncanny, placed in vignettes or by themselves against an empty background. Good examples include the covers featuring a solid old door (Madrid: Editorial Manuscritos, 2010) and a candle (New York: Alba, 1999). Most ominous are covers that show an empty ladder placed on a wall (Madrid: Aguilar, 1963) and an empty balcony (Barcelona: Edebé, 2008). The absence of a human figure serves to foreshadow the tragic ending of the story.

Posters, Playbills, and Lobby Cards

The promotional images for stage and screen adaptations of *La Celestina* are a neglected aspect of its visual culture. Their analysis can provide us with insights into the story's reception, starting in the early twentieth century when *LC* was first brought to the stage. After its premiere in 1909, the play was not performed for the next thirty years. This was due to a combination of factors, including the lack of commercial success of the first production, the conservatism of the Spanish stage, and, later, the Spanish Civil War. After 1940, the play began to be staged again; in the 1960s, the number of performances increased exponentially until today, when dozens of different productions are mounted every year.[32] Film adaptations are not as numerous, and they began only in the 1960s, with and the most recent dating from the late 1990s.

Here we will focus on the images from these productions, not the actual adaptations or their mise-en-scène, although these do sometimes play a role in the discussion. The images constitute a considerable corpus and belong to the visual culture of Celestina in spite of their ancillary and commercial function. They are conditioned by the specific conventions of the advertising media in which they appear, such as posters or press releases. They often are by-products of the actual performances in the form of photographs. In many cases, only a few images have survived, and therefore the kind of adaptation they promoted and how it was promoted can only be inferred, aided by the recent thorough monograph by María Bastianes on the performance of theatrical adaptations of *LC* in Spain.[33]

For performances outside Spain, my sources include reviews in academic journals, such as *Celestinesca*, and journalistic articles reviewing the premieres. In the case of the few and relatively recent film

adaptations, the advertising materials have survived practically in their totality. Most of the promotional campaigns were substantial, and the films attracted much attention, both scholarly and from the general press. Also, the fact that these film adaptations are easily available, unlike the rare video recordings of theatrical productions, facilitates the study of their promotional images.

I study the promotional images used for stage and screen adaptations together because of their similarities, the result of movies being direct descendants of stage performances. Many early films were recordings, by a static camera, of the action on stage. Basic ingredients of film production, such as the use of a script and a set, clearly originate in theatre.[34] Both theatre and cinema are forms of show business that share an advertising model originating in the posters of circuses and other amusements, so it is not surprising that they use similar images for promotion.[35]

Theatre and cinema have long relied on a combination of posters, lobby cards, and newspaper ads, in which images are often central. The promotional campaigns of cinema and theatre coincide in their emphasis on the actors, whose portraits in character are reused with minor touches across the different promotional materials.[36] Images of actors are central for advertising screen and stage productions because, after all, most audiences come to see them. Their dramatic capabilities and their on-stage or on-screen personas are especially significant in the case of literary classics, like *LC*, in which the public tends to know the plot. Audiences do not come to see a disembodied, textual Melibea or Celestina, but Jeanne Moreau as Celestina in the performance at the Festival d'Avignon of 1989, or Penélope Cruz as Melibea in the 1996 screen adaptation.

The performative nature of the delivered product not only explains the emphasis on images of the actors in the advertising campaigns, but it also sets strict limits on the representational liberties promotional images can take. The advertisers are bound to images that are "true" to the reality of the performance, to what is shown on the stage or screen. In this regard, posters and other promotional materials are understood as a delivery contract with the audiences. Under the implicit conditions of this contract, to include on a poster the image of an actor not participating in the show, or in the scene represented, would qualify as false advertising and a breach of contract.

Still, advertisers enjoy some licence that permits them, for instance, to publish group images in which all the actors are artificially gathered in a collective scene. Many advertising pictures for stage performances are not snapshots taken during the live performance – something

technically unfeasible until relatively recently – but stills taken during dedicated photo sessions with specialized photographers. In the promotion of movies, off-screen pictures of the actors in or out of character, often in glamour poses, were common until recently as part of the star system.[37] However, with this exception, the images most frequently used for promotion show the actors engaged in specific scenes, even if these pictures are taken during a rehearsal or dedicated posing session. As in all advertising, these images are expected not only to act as previews but also to pique the curiosity of the viewers about what is happening in the scene. At the same time, these images serve to display the setting and decor, emphasizing the lavishly recreated historical atmosphere or the unconventional stage and mise-en-scène.

Beginning with the first staged adaptation of LC in 1909, advertising campaigns have used photography for their publicity images. Even at this early date, photography was a well-developed medium that advertising embraced as a convenient source for images that could be easily reproduced.[38] In the case of cinema, using photography in advertising has added advantages. Because the product advertised is based on photography, a suitable promotional image can be obtained instantly by selecting a frame from the twenty-four frames used for each second of projection.[39] Photography is also a natural match for entertainment advertising because of the voyeuristic implications of the medium. The peeping eye of the photographic camera mimics both the transparent fourth wall of theatre and the movie camera giving spectators access to the events being filmed.[40] Also, the claim of photographic truth – the belief that a photo represents reality without mediation – makes the medium ideal for satisfying the implicit contract between the producer and the audience regarding advertising veracity. Of course, photography's claim to provide an unmediated representation of reality is famously untrue: under the appearance of objectivity, it relies on manipulations of lighting, framing, and/or editing.[41]

Photographers, in spite of their need to meet commercial demands and the advanced technology at their disposal, are visual art workers.[42] Like illustrators and painters, the designers of advertising images for stage and film adaptations make important decisions, by themselves or in consultation with the producers. They decide which character to privilege, the moment of choice, and the point of view and perspective. Like book-cover designers, they must strive for suggestive images that, with their incompleteness, pique the curiosity of the viewer in a split second. Not surprisingly, cover designers and show business advertisers often resort to the same tactics to attract attention, such as enticing the voyeurism of the potential client. As with some of the covers we

saw, performance advertisers often choose photographs of erotic scenes to which the viewers are promised full access if they acquire the product. Designers of book covers and those of cinema and theatre posters often resort to the same compositional solutions. In the case of *LC*, the inclusion of old woodcuts or old-fashioned fonts to emphasize the canonical status of the printed or performed text are common.

Despite these similarities, there are fundamental differences between the use of images on book covers and in entertainment advertising. Book covers designers have, as we saw, considerable latitude in their choice of images. The conventions of the medium entitle them to reproduce old paintings or make up images that do not represent but only allude to the content of the book. By contrast, advertisers in the entertainment industry are bound by the implicit contract of veracity and cannot deviate much from what is being shown on stage or screen. In this binding contract of verisimilitude, they are comparable to illustrators, who are equally compelled to represent the actual events in the story. Also, like illustrators, show business advertisers face decisions such as which moment of the action to highlight. In addition, the inclusion of pictures of the members of the cast in playbills recalls the use of factotums as dramatis personae. Finally, the common advertising practice of showing staged group scenes resembles the synoptic woodcuts that were commonly used on old title pages of *LC*.

This analysis of advertising images centres on two important topics: the rivalry for visual primacy between the young lovers and Celestina, and the choice of episodes to reproduce. These are the same points covered in the analysis of book illustrations and paintings above, which will allow us to make some interesting comparisons. Posters are especially suitable to the study of which character is emphasized, as they traditionally single out the main actor or actors. As we will see, the traditional rivalry for the limelight between the two lovers and Celestina, when compounded by the tradition of privileging famous actors in posters, can be seen in designs that clearly aim at influencing the audiences' expectations. With respect to the choice of the episodes to be rendered in images, I will take advantage of the entertainment industry's frequent recourse to pictures of specific scenes, which, until recently in cinema advertising, were turned into a fixed number of lobby cards.

I will also pay attention to other secondary information on the enacting of *LC* that advertising images are good at capturing. Because some are close-up shots of the actors, they allow us to observe makeup and costumes in a detail. This helps us understand many aspects of how they (as well as makeup artists and costume designers) conceived the characters they impersonated. Their characterizations are also interesting

because often we can see in them the influence of the visual culture of Celestina, such as Picasso's innovation of the opaque eye instead of the scar.

We start with the advertising campaign for the first performance of the text of *LC*, the theatrical adaptation of 1909. It was not only the first theatrical production of *LC* but was profusely advertised with images, many of which have survived. This advertising campaign provides examples of all the formats later campaigns used, even if some of those later efforts were more sophisticated and specialized. Until this 1909 production, *LC*, written as a dramatic piece to be read aloud but not acted, had not been adapted for a conventional stage performance with actors, mostly because of its length, the abundance of rhetoric and erudition, and the crudity of some scenes.[43] The interest in bringing it to the stage is connected to its reappearance as a published book in the nineteenth century and the ensuing scholarly attention it attracted. In 1894, the scholar Menéndez Pelayo republished a not widely circulated article in the newspaper *El Liberal*, in which he argued that the text should be taken to the stage. The popular literary critic and writer Clarín endorsed this proposal and considered that an adaptation of the text by Tamayo y Baus, Echegaray, Juan Valera, and Menéndez Pelayo himself would be ideal for the reopening of the prestigious Teatro Español in Madrid, closed since 1887. Several intellectuals agreed that an adaptation for the stage of a classic like *LC* would serve to regenerate Spanish theatre, particularly if the staging was more respectful of history than the romantic historical dramas in vogue during the period. Such a production would help to make Spanish theatre more attuned to the realism and naturalism popular in the rest of Europe.[44]

The main difficulty was not in adapting *LC*'s long text but in the prudish nature of Spanish audiences and the opposition of the Catholic Church to a plot openly dealing with sex and prostitution, allusions to which were scandalous. Despite these problems, the highly respected actor María Guerrero, who had rented the Teatro Español, planned to premiere this adaptation. Eventually she gave up the license for the theatre. When the theatre reopened a few years later under the control of the company of Carmen Cobeña, one of the first productions was the adaptation of *LC* by Fernández Villegas. Cobeña herself played the role of the old bawd. Many changes were introduced, and many scenes removed, as was the character of Pleberio. The resulting two-and-a-half-hour play is more of a love story in which the seedy world of the servant and Celestina was played down.[45]

This production was widely advertised, as was the norm for the exclusively commercial and therefore profit-oriented theatre of the

period. The competition was so strong that plays that were not an immediate hit were withdrawn within days and replaced with others known from experience to attract audiences. Such a situation was the result of the abundance of shows staged simultaneously in the many theatres in Madrid. A conservative estimate is that, on an average day of 1908, thirty thousand theatrical seats were available in Madrid, a city of barely half a million inhabitants.[46] Given the competitive environment, the first adaptation of LC of 1909 was, like most other plays, heavily advertised.

In spite of the advertising campaign and some critical acclaim, this production was not a success with audiences. It remained on stage only five days in Madrid, between 22 and 26 October, and later a few performances were staged in other Spanish cities. In total, there were fewer than twenty performances, at a time when a successful production ran for at least one hundred performances in a single location.[47] This mediocre reception is not to be blamed on a lack of quality but on a combination of factors, including the scandal of representing prostitution on stage. Moreover, this production occurred at a difficult moment in which the stale Spanish stage was under assault by the new naturalist theatre, and María Guerrero was producing more appealing performances.[48]

Although theatrical producers were aware of the importance of advertising, it was not yet common for companies to have personnel whose role was exclusively promotional. The responsibility for advertising usually fell to the stage director, but smaller companies often could not afford to have a person in that role either, and so promotional efforts were sometimes minimal. Promotion of plays in newspapers was the most common and effective approach available to theatre companies in this period. Sometimes promotional material did not include images but consisted only of information on the play that the company sent to newspapers to be included in their entertainment section. These sections consisted of densely printed pages in several columns that contained practical, basic information about various local entertainments.

Two days before the first performance of LC in Madrid in 1909, the daily La Correspondencia de España, in its alphabetical section of the different theatres in the city, included information provided by the producers of play. It featured a detailed list of the actors and the roles they were to perform, and it announced that, following the performance, a lecture would be given on the significance of LC in Spanish literature. No information about the times of the show is given, probably because those interested, if they were not already subscribers of the

theatre, were expected to buy their tickets in advance or send a servant to acquire them, given that the Teatro Español specialized in audiences of higher classes.[49]

Posters were another important form of advertising in show business. Lithographed posters with images were common for entertainment spectacles, including theatre, although not all theatrical performances could afford them. The poster is an old form of advertising that descends from the smaller playbills that were either handed out in the theatre or posted outside. The modern poster became common only in the nineteenth century, after the innovations in printing and lithography discussed above in the context of modern book covers.[50]

Long before modern printed posters, some venues used hand-printed posters – they are mentioned in regulations affecting the practice of advertising theatrical plays during the Spanish Golden Age. The few hand-printed posters to have survived have no images. Some were based on printed templates with the name of the company, and an empty space to be filled in by hand with information for the specific performance. References to poster painters in this early period indicate that some illustrations may have existed, but we do not know the exact nature of their work. Fully printed theatrical posters without illustrations existed before the nineteenth century, but they contained only text, announcing the actors, prices, times, and so on. The only visual elements were basic ornamental frames that recall the façades of buildings and their use on title pages. The colours of the inks used in the production of these posters served as a form of identification or trademark of the theatre.[51] A few rare cases of posters illustrated with woodcuts also exist from the early centuries of the printing press. However, the printed images are small, owing to how time consuming the production technique was, which, together with the scarcity of paper, made the process prohibitively expensive. The situation changed only in the nineteenth century, with the capability of printing ten thousand posters per hour by 1848. By 1870, coloured posters were common.[52]

No posters of the 1909 performance of LC have survived. Still, given the importance of the company and the venue in which it premiered, as well as the famous actors in the cast, we can assume that the production was advertised through posters. We can try to reconstruct them from surviving posters of the period for other productions. As with many of these other posters, it is possible that an LC poster did not include images beyond some decorative frames based on printing templates. It would include only the title and the printed names of the actors, and, perhaps, the times of the performances. My survey of the few surviving contemporary posters indicates that this unadorned format was a

common, economical solution, even for important shows. For instance, the poster announcing the 1916 Teatro Eslava performance of Oliver's play *Los semidioses*, also with Carmen Cobeña, has no images. Cobeña's name is emphasized in big print, followed by the title of the play and, further down, in smaller print, the names of the other actors. The attendance of the author of the adaptation at the premiere is announced, together with the prices for the tickets. The only graphic element is a modest frame in black ink.

It is likely, then, that the name of Carmen Cobeña would have been the first element of any poster for the first adaptation of *LC*. It would have been followed by the title of the play as *Calisto y Melibea, La Celestina*, as it reads in other surviving promotional materials. Perhaps the words "La Celestina" were in a larger or heavier font than "Calisto and Melibea" – after all, that was the role Cobeña, the star, was playing. The names of the other actors would have been included, as well as some references to the adapter or to the fact that this was the first time the text was staged.

A more interesting and equally likely possibility is that the 1909 poster would have included a lithographic image of Cobeña in the role of Celestina, as posters with the image of the most famous actor were common in this period. A good example is the poster used in 1900 for advertising the play *La Dolores* by Josep Feliu i Codina, as staged by the Compañía cómico-dramática de Carmen Cobeña, which has survived as a playbill (image 37). Besides emphasizing her name, along with that of the theatre and the play, the poster includes a black-and-white vignette of Cobeña playing the main character, but no details of the setting are included. A similar picture of Cobeña, in character for the leading female role of Teodora, appears in a small playbill for Echegaray's *El gran Galeoto*, also staged in the Teatro Cervantes in Málaga in 1900. As in the previous poster, her image is the only visual element.

Based on these and other examples from the period, the poster for this premier of *LC* could well have included a black-and-white image of Cobeña as Celestina, along with the actor's name in big print. A poster of this type matches both the importance given to the main actor in posters from this period and the centrality of the character of Celestina. The inclusion of the images of the two lovers on the poster is unlikely, given the tendency to use only the lead actor as the hook in these posters, and the costs associated with reproducing images. Moreover, the image of the couple in an amorous pose would provide ammunition to conservatives, who had reservations about the morality of staging such a text. Although the name of Celestina was also a liability because

of her association with prostitution, her image as an old woman was more acceptable.

Any image of Carmen Cobeña as Celestina in this lost poster was likely a low-definition version of the promotional photographs of the performance distributed to the press, to the critics, and probably to the public in the lobby. The production of such promotional pictures was standard practice in the period and was later to be perfected under the star system of American cinema. In the first decade of the twentieth century in Madrid, pictures of important actors regularly appeared in entertainment publications, such as *Comedia y Comediantes* and *La Farándula*. The general press, such as the newspapers *ABC* and *Heraldo de Madrid*, had journalists who specialized in reviewing shows. Pictures of the main actors regularly accompanied them.

In early twentieth-century Madrid, show business was a small world in which journalists, producers, and actors knew each other. It was customary to allow journalists access to rehearsals. They were offered complimentary pictures of the actors in character or in specific scenes that they could include in their articles and columns. The systematic practice in advertising in the entertainment industry was to reuse the same images for the varied materials in the publicity campaign, which explains why these images were used for both playbills and posters. Because of the technology of the day, the photographs were not taken during the performance but rather during posing sessions. The prolonged exposure times and the strong illumination required resulted in contrived images in which the gestures and positions of the actors looked forced and excessively dramatic by today's standards.[53]

These images and the articles they illustrated contributed to a cult of actors as public personalities. Often the captions emphasized their names instead of describing the scene and the characters they were playing. These images, besides being used for the press, sometimes were reproduced for collections of pictures in card format that were part of the cult of famous actors.[54] Much attention was given to their clothing, hair style, and elegance. Some newspapers included columns dedicated entirely to describing what actors, especially actresses, wore. They were celebrities, invited to public events and social gatherings of high society, and their images often appeared on the covers of magazines.

The importance of the leading actress is patent in the advertising campaign of the 1909 adaptation of *LC*. Although the promotional pictures that have survived include several actors and scenes, the ones most reproduced by the press were those portraying Carmen Cobeña in the role of Celestina. She was at the time a famous actress and a social celebrity, which made her the obvious choice as the central figure

of the advertising campaign. Two years before, in 1907, the magazine *Nuevo Mundo* had dedicated an entire article to praising her elegance, dramatic adaptability, and beauty. In 1908, a pastel portrait of her by Enrique Simonet appeared on the cover of the specialized magazine *El Arte del Teatro*.[55] In reviews of the 1909 adaptation of *LC*, critics profusely praised her acting and personality. This was the practice in the period, instead of commenting on the depth of the actual production. Curiously, none of the articles question the appropriateness of casting the relatively young Cobeña, barely forty at the time, in the role of the much older Celestina. Cobeña is noticeably younger than later actresses who played the role of Celestina, normally in their sixties and older. At the time, though, the suitability of the actors' age and other physical attributes to their roles was ignored. A prevailing concept was that outstanding actors had the near-magical capability of transforming themselves into the character.

The most widely circulated promotional picture of Cobeña as Celestina was the one published by *ABC* as part of a glowing review of the production, especially her acting (image 38). This photograph is a milestone: it is the first image we have of a real person in the role of the literary Celestina. Such pre-eminence of Cobeña in the advertising campaign and in the mass media has to be seen as an important chapter in the ongoing prominence of Celestina over the other characters in the play. Given that there were no other productions of the text to act as precedents, Cobeña and her team had to come up with the costumes, hairstyles, and other details. The character of Celestina in *Los polvos de la madre Celestina*, repeatedly staged during the previous century and still popular, may have served as partial inspiration. However, Celestina in that *comedia de magia* was a comic character. Unfortunately, the only image we have of an actress dressed as madre Celestina for this comedy is an 1868 watercolour by Apel·les Mestres of a costume design. She is characterized as a bent old woman covered with a cloak of Goyaesque descent.

Cobeña's characterization clearly follows a similar traditional, Goyaesque line. Her appearance would have owed much to the work of the costume designers, who, during this period, were moving toward historically accurate dress instead of the fancy costumes that had been popular for characters of the past in Echegaray's and other high-flown historical dramas.[56] Her clothes and props, such as her cane, together with the setting and decorations, reveal an effort to be more realistic and historically accurate than had been the case in the romantic dramas.[57]

Although it is difficult to tell from the black-and-white, low-definition (by today's standards) picture, her makeup was also realistic, even

if the need to make her features visible at a distance on the poorly lit stages of the day may have resulted in makeup that looks excessive today. The picture accompanying the review shows how her face is covered with heavy makeup that suggests pronounced wrinkles. Also, the makeup makes her complexion noticeably dark (see image 39). This probably responded to the prejudice that associated prostitution and Roma women, as we saw in some of the *costumbrista* paintings of the period discussed in chapter 2. If this is the case, Cobeña's characterization is both historicist and contemporary in the sense that it relies on the Goyaesque image of Celestina and on the depiction of the sordid old women in social denunciation paintings of the late nineteenth and early twentieth century. This characterization of Celestina in the 1909 production is important not only because it is the first case of Celestina on a stage but also because it set the tone for many later productions, which copied her characterization or followed the same sources for inspiration.

Many later posters, playbills, and promotional photographs also centre on the actor incarnating Celestina. They are dressed and made up not that differently from Cobeña, although the poses and the angles from which the pictures were taken become less formal and more varied. A common exception to the strategy of making the actor playing Celestina the visual centre of the advertising campaign is seen when the actor is not famous. This is the case with the first surviving poster of a stage adaptation of *LC*, which dates from the 1949 production at the Teatro Municipal in Santiago de Chile. This is not a poster, properly speaking, but the cover of the playbill distributed to the audience, but, as noted above, playbills and posters are often identical to each other. This 1949 performance was based on an adaptation by the exiled Spanish intellectual José Ricardo Morales, which had been premiered a few months earlier in Uruguay with the famous actress Margarita Xirgu in the role of Celestina.[58] No advertising materials survived of the performance in Uruguay, but they likely relied on Xirgu's image.

By contrast, in the Chilean performances of the same adaptation, the role of Celestina was not played by a famous actress and none of the other actors were renowned. Likely for that reason, the promoters decided to put a reproduction of an old engraving on the cover of the playbill, an approach that, as we saw in the preceding section, was common for book covers. Curiously, the image chosen is not taken from an old edition of *LC* but from another unidentified book of the period. This kind of image, whether from *LC* or not, serves to emphasize the old pedigree of the text. In a production like this one, aimed at a limited audience of exiles and intellectuals, it was an excellent choice.

The reason for not using an engraving taken from an edition of *LC* is most likely that Ricardo Morales had no easy access to an appropriate engraving. His choice of a different engraving may also be explained as a way of claiming the independence of his adaptation from Rojas's text, which Ricardo Morales not only abbreviated but also altered to de-emphasize the moralizing aspects of the story.

We have to wait until 1957 for a surviving illustrated program cover printed in Spain. This is for Huberto Pérez de la Ossa's adaptation for the Teatro Eslava in Madrid, later performed in other Spanish cities and abroad. In keeping with the politico-cultural environment of Spain at the time, the text of this adaptation emphasizes the moralizing aspects of the story. In spite of this conservative touch, the mise-en-scène was not the usual historicist recreation. As directed by Luis Escobar, the staging was influenced by the new expressionist and experimental tendencies predominant in European theatre after the Second World War. Such tendencies manifested, for instance, in the use of scaffolding as part of the stage.[59]

The part of Celestina was played by Irene López Heredia, a well-established actress in her sixties with a long repertoire. Comparable in her fame and career to Cobeña in her day, López Heredia had often been on the posters of theatrical and cinematic productions both before and after the Spanish Civil War. An image of her as Celestina could have been an effective central figure for the poster and the cover of the program. Curiously, though, the program does not use her image, but rather an intriguing fragment of Bosch's *The Temptations of Saint Anthony Abbot*.[60] As we saw in chapter 2, Bosch's painting includes, next to the figure of Saint Anthony, a building representing a brothel with the gigantic head of an old woman with the typical look of a procuress. The choice of this image from a canonical painting was an excellent way to avoid provoking the censors while still conveying the dark side of the play, which the unconventional mise-en-scène also emphasized.

The seriousness of the play is emphasized in the poster by reproducing this enigmatic painting in monochrome sepia. The name "Fernando de Rojas" is printed on top and followed by "La Celestina" in an old-fashioned Gothic font in red. The connection to Saint Anthony, even if not present in the fragment of the painting, implies the moralizing tone of the text and is an allusion to deeply rooted subconscious drives. Perhaps as a precaution against an overzealous censor, the naked woman at the entrance of the strange house is rendered so sketchily in the poster that it's difficult to tell that she's nude.

Many later posters continued to use existing paintings rather than photographs of the main actors but. A typical example of this type of

poster is the one for the Teatro de la Nación del IMSS, part of a network of Mexican theatres that specialize in popular and educational performances. The poster for the 1982 production of *LC* in Mexico City features one of Goya's famous engravings of a *maja* and Celestina (*Capricho 15, Bellos consejos*). As in the case of the book covers, the association with Goya and his style serves to emphasize the Spanishness of the story as well as its deep, even disturbing, content. The same approach was used in the poster for the 1983 Nuffield Theatre production in the United Kingdom, a low-budget university production that displays an ink rendering of one of Goya's engravings. As we saw with book covers, the use of works by famous painters from the sixteenth and seventeenth century predominates in productions outside Spain. Images by more recent artists are occasionally selected, although they are less frequently used because they are still subject to copyright.

Despite the availability of engravings, paintings, and other images for advertising productions of *LC*, the most frequent practice is using a photograph of the actress playing Celestina, especially if she is famous. This is the case of the 1967 adaptation by the writer Alejandro Casona, which provides us with the first surviving playbill using the image of the actor playing Celestina for its cover.[61] It is a close-up of Milagros Leal making a gesture of cunningness or complicity. Her head is covered in the traditional way, and she has a rosary in her hands. The actor's name is in big print, followed by "in" in small print; below that, the title "La Celestina" in large print. This design is basically the same one used in many later performances of *LC* in which an important actress played the role of Celestina: Amparo Soler Leal in Barcelona in 1995, Nati Mistral in Madrid in 1999, and Gemma Cuervo in Madrid in 2012. All of them are presented with expressive gestures that convey facets of Celestina and showcase the actor's dramatic ability.

A peculiar turn in this tactic is the poster for the 2016 Madrid performance at the Teatro de la Abadía. The role of Celestina was played by the famous actor and director José Luis Gómez. The poster follows the traditional design but relies on the impact of showing his clearly masculine face. His hair is covered in the traditional Celestina fashion, and, as in Picasso's portrait, he has a damaged eye. A different kind of impact is sought in the poster for the 2012 Teatro Fernán Gómez production in Madrid, in which the popular actress Gemma Cuervo played Celestina. The poster displays a close-up of her face in a hard light that emphasizes her wrinkles (image 40). Only half of her face is shown on the poster, which further calls attention to her wrinkles. Spanish viewers would have known Gemma Cuervo from her roles as a series of attractive young women in Spanish television and cinema.[62] Displaying her

aging face, then, was an original way to impress upon the viewer the theme of the evanescence of youth so important in the text, through the lingering memory of previous roles played by an actor – the so-called ghosting effect.[63]

Only a few posters utilize a sexualized image of Celestina. This is achieved mostly by eroticizing witchcraft, as we saw with some book covers. As an example, the cover of the program for the *LC* staged at the 1989 Edinburgh International Festival displays a picture of Amparo Rivelles conveying sexual ecstasy during the enchantment scene. (This depiction was also used on some book covers.) Productions that transfer the action to the present are especially prone to showing Celestina as an attractive, mature madam. In the 1999 production by the Teatro Nacional, Bogotá, Celestina was incarnated by Fanny Mikey, an actress who had played many sexualized roles in her lengthy career; her erotic approach to the role was also evident in the promotional materials. As in the case of book covers, the eroticization of the character of Celestina is rare in promotional material for theatrical adaptations. The posters that emphasize the erotic aspects of the story normally resort to images of Calisto and Melibea, or of Areúsa, Elicia, Pármeno, and Sempronio. This erotization is often conveyed through images that, besides proclaiming the sexual content, emphasize the originality and freshness of the adaptation. In the poster for the production by the Théâtre de l'Aquarium (Paris, 2009), the young lovers are posed to recall the protagonists of telenovelas and other popular romantic genres. The composition suggests that the text has been irreverently updated for the modern taste.

Something similar is evident in the poster for the 1980 production in the Teatro Espronceda 34 in Madrid, 1980. This was near the beginning of the return to democracy in Spain, during which time some classics of Spanish picaresque literature were adapted into erotic films. The theatrical poster imitates its cinematic counterparts by emphasizing the good looks of the two actors playing Calisto and Melibea, José Sancho and Inma de Santis, who were regularly cast in romantic roles in television and movies. At the same time, the literary and erudite element is de-emphasized: while "Calisto y Melibea" is printed in large letters, "Tragicomedia de Fernando de Rojas" appears in a much smaller font. The name of the actress playing Celestina, María Guerrero, niece of the legendary actress of the same name, is at the top of the poster, but, curiously, the word "Celestina" is not written anywhere. Still, a blow up of her figure is used to create an ominous background, portraying her as a puppet master controlling the other characters through the cobwebs coming from her hands.

Again, as with book covers, some theatre posters resort exclusively to objects and symbolic images. However, the practice is less frequent in posters than in book covers, because objects do not convey the performative nature of live theatre productions, in which the actors are the key elements. For this reason, only some adaptations in cultural venues or festivals that want to emphasize the message of the text resort to this type of imagery. For example, a girdle is used in the poster for the 2017 adaptation by Málaga and Calderoni performed at the Piazza della Vittoria theatre in Pavia, Italy. A bedsheet with blood, alluding both to Melibea's lost virginity and the deaths that occur in the play, appears on the poster for the production by the Thalia Theatre in Hamburg (1974–75).

Posters portraying symbolic objects are sometimes used when two or more different posters targeting specific audiences were created for the same production at different theatres. This is the case with the adaptation by Gonzalo Torrente Ballester for the Compañía Nacional de Teatro Clásico (Madrid, 1988). The colour scheme and succinct design of the posters for display inside the theatre and for the promotion of this state-sponsored company use a highly symbolic and artistically elaborated image: a woman's long, blond hair against a red background. The words "La Celestina" and "Fernando de Rojas" are the only print on the poster. The image, which may allude to Melibea jumping from the tower or her sexual encounter in the garden, is likely too cryptic to attract the average viewer. This was remedied by the creation of a second, more conventional, poster for wider circulation, emphasizing the image of the main actress, the popular Amparo Rivelles, in the role of Celestina. The caption "un hechizo de amor" (a love spell) was added, as if reminding viewers that the young Calisto and Melibea are also part of the story.

This use of symbolic elements instead of human figures is also common among small and experimental theatre companies with no famous actors. Often these productions deploy unconventional stage arrangements, and a symbolic object acts as a leitmotif on their posters. For instance, the poster for the performance at the Centro Cultural Villa de Santa Brígida (Las Palmas, 2016–17) used hanging ropes and strings to cover the stage during the whole production, an allusion to Melibea's girdle and Celestina's thread of yarn. In the poster, the arm of a man, likely Calisto, grabs these ropes, which have been knitted in the shape of Melibea's hair, as a way to emphasize both the sexual aspects and social restrictions of the story. In other cases, symbolic objects that are not referenced as props in the text but allude to some of its themes are given predominant roles in the mise-en-scène. In an innovative

production, C'est la Vie Teatro (Madrid, 2011) used a spiral staircase as the stage to suggest the labyrinthian aspects of the plot. The staircase was also the focus of the advertising poster.

Around the beginning of the twenty-first century in Spain, there was a boom in modest productions by small independent companies that were performed as part of the cultural activities programmed for festivals organized by cities and towns to attract tourists during the summer. The informal images on promotional materials convey the idea of a collective conception of theatre in which the audiences can participate as part of a festive atmosphere encompassed by the other programmed activities. For the production of LC by the company LoTAT in 2015 as part of the Festa del Renaixement in Tortosa, the poster shows a young, attractive Celestina reading an address while laughing, as if announcing the opening of the festival. Many of these alternative theatre companies, which often call themselves "troupes" or "colectivos," in constrat to the formal "company," choose original, often irreverent images. Some emphasize the comedic aspect of the play, occasionally renaming it accordingly, such as the *Celestina, La Tragiclownmedia* by La Escalera de Tijera, staged in Casar de Cáceres in 2019. It was a humorous adaptation for three actors advertised through a cartoonish drawing of a quaint, witch-like Celestina.

Another poster design frequent among these smaller companies includes an image in which all the actors are together on the stage. They are in costume or in street clothes, not acting but informally talking as a group of friends, such as in the poster produced by Théâtre de l'Aquarium (Paris, 2009). The image highlights their conception of theatre as collective performance. Some of these posters even convey a carnivalesque impression, such as the one for Grupo Atalaya (2012), which featured a parodic apotheosis of Celestina being carried by the other characters. The image suggested a festive processional scene that parodies the religious parades in which statutes of the Virgin Mary are carried through Andalusian streets. This poster is an effective choice for the type of theatre this company systematically presents, in which the actors use their voices and physical movements to convey their concept of theatre as ritual.[64]

We now turn to the promotional posters of screen adaptations, which differ from theatrical posters only in questions of detail. It is first worth noting that the five existing adaptations for television – one in France, three in Spain, and one in Italy – did not issue printed advertising materials. From the 1960s until the 1980s, television programs were a free product offered to a captive audience by government-owned channels that did not have to compete with other channels.

Such a monopolistic situation did not apply to the cinema adaptations of *LC*, which were conceived as commercial products and promoted with advertising campaigns that included posters and other printed media. The three filmic adaptations of the book were promoted with widely distributed posters. Some posters were tailored to the delivery format – cinema or video – and to the countries in which the movie was released.[65] Promotional materials for these three movies coincide in heavily emphasizing the erotic aspects of the story.

The first film adaptation, the 1969 movie by the Spanish director César Ardavín, was possible only thanks to a temporary (and minimal) relaxation of censorship in Franco's final years. Even though little nudity and sexual activity were presented on screen, such scenes were emphasized in the film's promotional materials. In a country eager to see erotic images on screen, an aura of authorized scandal was important for the success of the film.[66]

Three full-colour posters and a videotape box cover were produced for the movie. These were reproduced with minor changes, such as grey scaling and different typography, in the entertainment sections of newspapers. The most widely circulated poster deploys the image of the classic trio of Celestina, Calisto, and Melibea (image 41). As with many book covers during those years, Celestina's image is in the background. Her disembodied head seems to be magically witnessing how Calisto embraces Melibea, who is wearing a décolleté outfit that Calisto is starting to undo. Melibea, played by the popular actress Elisa Ramírez, is the focal point of the image. The image of the two lovers is a near-photographic ink-on-paper rendition of a scene from the film, but subtly touched up. The most noticeable alteration is an increase in the size of the breasts of the actress, whose cleavage is suggestively highlighted by a contrast of light and shadows. The background is flooded with a sultry red light, which strongly contrasts with the dark cloak of Celestina, resulting in a simple yet suggestive poster.

The second poster used in the promotion of the movie presents the same characters. However, it adds a circle with a close-up of the lips of the passionately kissing lovers, as if promising front-row voyeuristic access to the spectators. Like Celestina, the audience will be invisible witnesses to the lovers' encounters. The reassurance that, in spite of the promised erotism, the story is based on a serious literary classic is indirectly stated by a line in small font that reads "según la inmortal obra de Fernando de Rojas" (following the immortal work of Fernando de Rojas). The formality is echoed by the archaic font used for the title of the movie.

The third poster and the box cover for the video also highlight the erotic scenes. One displays the visit of Celestina to Areúsa – specifically, the moment in which the latter, naked in bed, covers herself with the sheets. As we saw in chapter 1, this scene had become popular in the visual culture of Celestina, starting with the early illustrated editions. This poster introduces a peculiar innovation in its treatment: in the upper part of the scene, in the position normally reserved for Celestina's disembodied face, is Melibea's head. The result is a composition in which Melibea appears as if participating in this scene, contributing to the lesbian innuendo of old Celestina touching the naked Areúsa. This composition may suggest that female spectators are actively interested in sexual scenes in films, something unusual for the period, especially where lesbian innuendo is concerned.

Finally, a publicity image from the movie appeared on the cover of the videotape box years later, when the film was released in this format in the early 1980s. Instead of the erotic scenes described above, the image on the cover is taken from the final scene of the movie and represents the supposed burial of the dead lovers in the same tomb, a scene that the adapters added to the original story. The image shows their bodies lying next to each other, luxuriously dressed, as in the marble sculptures on the tombs of wealthy couples. This choice can be explained by the audience's change in taste when the video was commercialized through the state-owned Spanish television company TVE. Emphasizing the erotic aspects of the story did not serve to promote the adaptation in the more liberal atmosphere of the 1980s, by which time Spanish audiences were jaded with the use of nudity in advertising. TVE was starting a campaign to recover the classics of Spanish literature through quality film adaptations. Also, the choice of this subdued image is explainable by the peculiar status of the video as a hybrid between a film and a book. The cases had the same general dimensions and design of book covers: the title on the front and the spine, as well as additional images and information on the back cover. At the same time, the cases recalled cinema posters in highlighting the images and names of famous actors as well as sensationalist taglines.

The second film adaptation of LC, the 1976 Mexican production directed by Miguel Sabido, is a culmination of the story's erotic aspects. The film is a blatantly commercial production that resorts to all available means to exploiting the audiences' voyeuristic instincts. In this version, sex becomes a leitmotif, to the point that fictitious episodes are added, such as dream scenes in which Celestina fondles Melibea, among other scenes with sexual activity and nudity. The title is also amended to *Celestina (los placeres del sexo)* (The pleasures of sex).

In keeping with the film's graphic sexuality, the scene chosen for the poster is that of the actress playing Melibea half-naked in the arms of an also half-naked Calisto. Melibea is played by the erotic icon Isela Vega, a model and actress who, a couple years earlier, had posed for the magazine *Playboy*.[67]

The movie poster aims at conveying the message that the audience will have front-row access to the sex scenes. It includes an enormous eye in the upper part of the scene of the sexual encounter between Calisto and Melibea, as if somebody were spying from behind a curtain. This inclusion of the eye is a peculiar variation of representing Celestina as a disembodied head looming over the lovers' encounters, which we saw on several covers and on the poster of the 1969 Ardavín production. Here, this disembodied eye watching from behind a curtain represents both Celestina and the spectator. Curiously, the video version is publicized with a more formal, literary approach. The cover of the video case displays a reproduction of an old German engraving of a drinker, prostitutes, and a fool in a tavern, in the tradition of the moralizing engravings we saw in chapter 2. The back of the case includes an extended commentary on the importance of the text. It gives the product the appearance of a scholarly edition of the film, despite its being a low-quality erotic production.

The latest and most widely circulated film production of *LC* is the version directed by Gerardo Vera in 1996. By Spanish standards, it was a mega-production. The film presented itself not as much as a sexualized product but as a romantic story with some erotic content. The movie's main asset was the young but already popular actress Penélope Cruz in the role of Melibea. Cruz had appeared in several nude scenes in previous movies, which establishing her as an erotic icon. The actor playing Calisto, Juan Diego Botto, was also well known for his good looks. As some critics pointed out, the script seemed to have been written to allow for the maximum display of the bodies of these popular actors in love scenes.[68] The presence of these two actors transferred directly to the advertising posters, which feature their images, especially that of Cruz. Because, at the time, the Spanish cinematic market was saturated with sexual content, advertising the movie merely for its erotism did not make commercial sense. Accordingly, the scenes chosen for promotion do not present the couple naked or in openly sexual activity but in scenarios that, without neglecting erotism, emphasize the romantic aspects of their interaction. The scene used for the poster – the couple resting in the garden after lovemaking, embracing but fully dressed – accomplishes this function well. This image echoes the tomb-like presentation of the lovers on the cover of the video of Ardavín's film, but in a more explicit

position of post-coital lassitude. Vera's movie was later released in DVD and other formats and commercialized for the international market. On these posters and covers, the growing popularity of Penélope Cruz made her almost the only image used for promotion.

The moment of choice, which was examined in the analysis of the illustrated editions of *LC* in chapter 1, is also pertinent to the study of advertising materials for theatre and film adaptations. Two advertising media are especially appropriate for this study: the pictures of actors distributed for the promotion of a theatrical production and the lobby cards displayed in cinemas for the promotion of movies. When issuing these images, advertisers make crucial decisions about which scenes offer prospective audiences the most enticing images of the actors, the plot, and the setting. In the case of a classic like *LC*, in which familiarity with the plot on the part of the audience is expected, the images must also reassure them that the adaptation remains true to the book. Unlike the images in posters, which are often montages of two different scenes and may be subject to other alterations, the promotional pictures of theatrical adaptations are photographs of the action on the stage. Lobby cards are frames extracted directly from the film. Another peculiarity of these images is that they are traditionally issued in sets – normally eight for lobby cards – which gives them the sequential appearance of a narrative.

In their faithfulness to the content and their seriality, these promotional pictures and lobby cards resemble illustrations, although their functions are different. While illustrations aim to explain the text they accompany, promotional pictures and lobby cards are intended to be shown by themselves, unexplained, and to entice the viewers' curiosity. Also, while illustrators often follow an iconographic tradition in their choice of scenes and conventions such as the use of one image per act, the producers of lobby cards use criteria such as the popularity of the actors. Most decisive is their interest in portraying the actors in scenes in which they demonstrate their stage presence and dramatic capabilities.[69] This criterion is especially noticeable in promotional images from the early twentieth century. They often show close-ups of the actors with exaggerated facial expressions – histrionic by today's standards – intended to show their skill in enacting dramatic events. Clear hints of the actual scene they are performing are normally absent.

Advertisers' preference for overtly dramatic images of the actors is reflected in the frequent use of the precise moment of the encounter between Celestina and Melibea in act 10 in which Melibea faints at Celestina's mention of Calisto's name. This image is ideal for displaying the dramatic abilities of the actors involved: Celestina is portrayed

as cunningly uttering her poisonous words while Melibea shows her feelings for Calisto upon hearing his name. The scene is not a canonical image in the iconographic tradition of the old illustrated editions. It appears only in the 1520 Augsburg edition, which depicts Celestina's arrival in Melibea's room, in which Alisa and Lucrecia are still present. The 1545 Zaragoza edition moves the scene forward and includes an illustration of Melibea touching her heart as an allusion to the pain that made her call Celestina. Representing Celestina's facial expression when she utters the loaded word "Calisto" into Melibea's ear would have been difficult in these early woodcuts. We have to wait until the 1883 Barcelona edition to have a fully dramatic representation of this scene. Behind a vignette of a heart pierced by an arrow, we can see an enfeebled Melibea, resting on a chair after having heard Calisto's name.

Advertisers' fondness for showing the actors at their best explains why the most reproduced scene on lobby cards and in the press is the banquet in Celestina's house in act 9 (image 42). Unlike the previous example, this scene belongs to the iconographic tradition of illustrated editions. This scene had appeared in the 1499 Burgos edition and continued to be included, with some innovations, in all the early illustrated editions. Furthermore, it is one of the few scenes illustrated in the initial period of *LC* that continued to appear after the book's rebirth in the nineteenth century. This scene is not commonly used for book covers or theatrical or movie posters, most likely because of the absence of two of the protagonists, Calisto and Melibea. However, it is common in promotional pictures.

Erotic content and implied voyeurism make certain scenes, including the banquet scene, appealing to advertisers. Their commercial appeal is implied by Celestina's words that the 1841 Gorchs's illustrated edition used as the caption for its illustration of the banquet: "Put your arms around each other and kiss, for I have nothing left but to enjoy watching."[70] Promotional images range from presenting the characters sitting around the table, barely touching each other, as in the promotional photograph of the scene used for the 1909 Fernández Villegas adaptation (see image 39), to representations from the late twentieth and early twenty-first century of them embracing and kissing. Some images from the banquet even show the two couples lying on the ground in various stages of undress and lovemaking.

Many of these promotional images place Celestina at the centre of the table, as if acting as the director or priestess of an orgiastic ceremony.[71] Often this disposition takes a clear triangular design in which Celestina, in the middle, is the only standing character, with a cup or jug in her hands, sometimes above her head. The two pairs of lovers are at a lower

level at her sides, sitting or on the ground, engaged in sexual activities. This image serves to display the erotic and irreverent content of the play while emphasizing the centrality of the character of Celestina through this symbolic triangular composition in which she is the apex.

The advertising images of this scene also emphasize its irreverent religious symbolism. The similarities of the banquet to a black mass are emphasized even in the mises-en-scène of some productions and the corresponding advertising images. In the adaptation staged at the Teatro Albéniz (Madrid, 1999), the table for the banquet clearly has the shape and decorations of an altar. Significantly, the same table was used as Areúsa's bed in the sexual encounter with Pármeno. Also, the prominence of wine and goblets in the scene makes the parody of the mass clearly perceptible to the general audience in Catholic countries. The sacrificial implication of the wine as blood atoning for sins, sexual in this case, epitomizes the theme of a play that ends with the deaths of the transgressors.

Unlike the old illustrated editions, the promotional images for screen and stage adaptations reduce the tragic elements of the story to their romantic function. The suffering Melibea and Calisto experience because of their love is highlighted. Their deaths are presented as estheticized *mourir d'amour*. A good example is the poster of the 1996 Vera screen adaptation: Calisto and Melibea lying embracing in the garden, exhausted after their sexual encounter, is a modern expression of the analogy between orgasm and death. This and equivalent images are modern forms of conveying what nineteenth-century illustrations expressed through representing Melibea's beautiful corpse as an Ophelia or Faust's Marguerite.

The scene of Celestina putting a spell on the yarn, not illustrated in the early editions of *LC* but popular in the nineteenth century, is rarely used for the promotion of theatrical and cinema productions. A plausible reason for this is that the scene is not believable for modern audiences. The modern lack of interest in the magical aspect of the story can be traced to the comic treatment of the theme in the nineteenth century, of which *Los polvos de la madre Celestina* is a well-known example.[72] On the rare occasion in which this scene appears in promotional images, it is retooled to reflect the dramatic abilities of the actress playing Celestina. It also serves to add a sexual touch to her character, as we saw with the ecstatic face of Amparo Rivelles in the poster of the 1989 Edinburgh International Festival. However, in the actual performances, the scene of the enchantment is often carefully choreographed with dramatic displays of light, sound, and music, effects that cannot be conveyed in the photographs used for promotion.

Scenes often used in promotional images that are common in the illustrated editions are the encounters between Calisto and Melibea, although the promotional images present them with interesting changes. While the lovers' encounter in the garden is often used for posters that emphasize the sexual content of the story, promotional pictures privilege the less enticing but perhaps more dramatic scene of the meeting in which the lovers are separated by the door or gate of Melibea's garden. This scene is not represented in the old engravings, perhaps because only one image per act was illustrated, and the death of Celestina, from the same act, displaced it. It isn't until Gorchs's 1841 edition that we see an illustration of the episode – in this case, Melibea gingerly walking with Lucrecia to the place of the encounter. Two illustrations in the 1883 Barcelona edition are the first to depict the encounter properly speaking. Curiously, the two images show the moment of the encounter simultaneously from each side of the door. In one image are Calisto and his servant; in the other, Melibea is by herself. This is an unusual design that recalls the double illustrations with transparent walls of the sixteenth and seventeenth centuries.

Interestingly, today's modern stage practice allows promoters to showcase this scene by presenting the old transparent walls of the woodcuts in innovative ways. As early as 1909, one of the promotional pictures of the Fernández Villegas production with Carmen Cobeña shows a solution to the problem of representing the all-important obstacle separating the lovers while permitting the audience an unobstructed view of the scene: to replace the door for a window with bars or a grid. This solution is still common today, but an array of other ingenious solutions can be seen in the promotional photographs, such as Calisto and Melibea holding empty frames in front of their faces while talking, or a curtain or highly symbolic white sheet held by Lucrecia or by another actor positioned between the two lovers.

A darker, more tragic reading of *LC* is evident in some promotional images from northern and eastern European countries in the second part of the twentieth century. These images emphasize a transcendental vision that is mostly absent in the romantic or irreverent productions prevalent in Spain in the same years. A Calderonian or existential tone permeates some of these images that, like the old illustrations, give primacy to the tragic, dark aspects of the story through the characterization, poses, and expressions of the actors. Pleberio, whose figure is rarely included in the advertising images in Spain, is more frequently represented in these images. He clearly is made to look like Don Quixote in one of the advertising images for the 1998 Stockholm adaptation, and Calisto's gloomy air makes him look like Segismundo. Only

occasionally are images that convey a pessimistic or transcendental interpretation of the story distributed for the promotion of Spanish adaptations. An exceptional case is the promotional images of the stage monologue *Calisto, historia de un personaje* (Madrid, 2001). This is a free adaptation in which Calisto presents himself as a rebellious character in the Romantic tradition. More common in Spain are images that emphasize the social aspects of the story by highlighting the sordid world of the lower classes in nearly Dickensian or Brechtian tones.

Until now we have examined photographs taken during the performances or dedicated posing sessions. There is another small yet interesting group of images: pencil sketches drawn during the show by specialized artists working for newspapers or magazines. Even today, some Spanish newspapers continue this practice for their entertainment sections. The sketches help to illustrate the reviews and, in some cases, compensate for a lack of photographs. But even when there are photos, these sketches and caricatures of the actors often accompany the reviews, adding a personal, light, humorous touch. They combine faithfulness in the portrayal of the actors with humorous caricaturizing, often influenced by Goya, whose drawings have been traditionally the referent for these sketch artists in Spain.[73] Following the master's lead, not only do they expressively exaggerate the facial features of the actors, but also their bodies and acting. Because Goya is the creator of the traditional image of Celestina, his continued influence makes these sketches an interesting return to their visual origins.

In addition to its abundant promotional photographs, the 1909 Fernández Villegas production was captured for the magazine *El Teatro* by the pencil of Fernando Fresno, a popular caricaturist who worked for prominent newspapers.[74] Among his drawings is a depiction of Calisto at the feet of Melibea in the garden (image 43). The promotional photograph of the actual scene shows that the sketch is faithful to the actors' poses and costumes. However, the exaggerated features of the actors in the drawings make this romantic scene look like a comedic parody.[75] The same effect applies to his sketch of the scene of Celestina's death, which shows Celestina being impaled by an exaggeratedly big sword, giving the tragic event a clearly burlesque tone (no photograph of the actual scene has survived to allow a comparison). Similarly, the reviews of the 1940 Luca de Tena adaptation of *LC* in the newspapers *ABC* and *Gol* are accompanied by two sketches by the caricaturist Francisco Ugalde. One is a bust of Celestina, whose nose and scar are made to look disproportionally big. Interestingly, the caricature of Celestina from the same performance by Fernando Córdoba in the newspaper *Pueblo* also deforms her nose, making it look like a parrot's beak.[76]

These caricaturists are limited by the small space allocated to the reviews in newspapers, which compels them to express their vision of the play in a compact drawing that synthesizes several scenes, with interesting results. The second of the sketches by Ugalde in the newspaper *Gol* takes the form of a peculiar composition: Melibea appears with her parents on one side and Lucrecia and Calisto on the other, a combination of characters that never appears on stage, although it may have been inspired by the actors coming on stage for applause at the end of the show. The positions and gestures of the actors in the drawing epitomize what the caricaturist sees as the main point of the play: Melibea's dilemma of whether to obey her parents to her right or to succumb to the temptation of Calisto, with the complicitous servant Lucrecia, to her left. The article reviewing the 1965 Teatro Bellas Artes performance in the newspaper *ABC* of 13 November, offers another of these artificial compositions: Celestina is shown with a wine jug in her hands, with Areúsa on one side and Calisto and Melibea on the other.

The final advertising materials we will examine are the lobby cards used for the promotion of the three film adaptations of *LC* discussed above. This format began to be used in the early twentieth century. Some theatrical productions displayed similar images in lobbies, but their use never reached the popularity or standardization of cinema lobby cards. As their name indicates, lobby cards are pictures in a card format meant to be displayed in the lobby, although their images may also be used in other promotional materials. They were traditionally released in sets of eight, although in some cases they may reach twelve or be limited to six. Two or more different sets were often produced and distributed for different markets.

The first film adaptation of *LC*, directed by Ardavín in 1969, issued twelve lobby cards as well as a promotional booklet that contained images, some of which are the same as those used as lobby cards.[77] Of the episodes traditionally represented in the illustrated editions, only the banquet scene is included in these cards. As we saw earlier, this episode is often used in promotional images. Following the traditional pattern of representing the scene, the lobby card represents the characters sitting around the table, with only slight hints of the underlying sexual activity.[78] While the film adaptation was for adult audiences, the version for television was for a general audience that might include children. Accordingly, the television adaptation replaces the banquet with a dinner at which only Celestina and Elicia are present. A skull, used as a candle holder on the table, sets the lugubrious, moralizing tone of their conversation. Only the least controversial lines of the scene are uttered, with special attention to the *memento mori* and *vanitas* elements.

Except for the banquet scene, the lobby cards for Ardavín's cinematic production do not represent scenes easily recognizable, even by those familiar with the plot. Most show unidentifiable interactions between the characters, and the general sense they convey is of a highly dramatic, eventful story. Two of the lobby cards reassure the viewers that the movie is shot in lavishly recreated historical sets and with the actors in period costume: one card shows an elegantly dressed Melibea praying in a richly decorated church; another shows Melibea and her parents watching a medieval tournament from a stand.

The images also emphasize the good looks of the young members of the cast. When Celestina appears on a card, she is positioned in the background, similar to her position on the poster for the movie (see image 41). Despite the emphasis on the young actors' looks, the images are carefully selected to avoid openly erotic elements. Because lobby cards were visible to all who entered the cinema when other movies were shown, they had to avoid giving offence. Similar precautions may also explain the absence of images of Melibea's suicide. It was a delicate theme in the eyes of censors, who had to look for content contrary to Catholic doctrine.

As noted above, some images from lobby cards were included in the promotional booklet, but, interestingly, the booklet included distinct images as well. The booklet was meant for promoting the film in other countries and at international festivals. It contained text in Spanish, English, and German, as well as a reproduction of the engraving of the first encounter between Celestina and Calisto from the Augsburg 1520 edition in German. Reproducing an early woodcut from LC is, as we saw, a typical way to transfer the literary prestige of the text to an edition or adaptation. In this case, using an engraving from the German edition served to emphasize the international prestige of the book soon after its publication. The desire to present this screen adaptation as that of a European classic is confirmed by the text of the booklet, which describes the literary origins of the story and its influence on other literature.

In spite of this nearly erudite tone, the images included emphasize the story's erotic episodes, such as the visit of Celestina to Areúsa. These images match one of the explanatory sections, revealingly entitled "Celestina, a Master in Erotic Arts." This brochure, meant for audiences outside Spain, highlights that, frequently, in the final years of Francoism, two different versions of movies were released: the more sexually explicit cut that was distributed outside Spain was intended to bolster the film's commercial success while fostering a false impression of liberalization in the last years of the dictatorship.[79]

The second screen adaptation of *LC*, the erotic – even mildly pornographic – movie directed by Sabido in Mexico in 1976, was advertised by ten lobby cards that perfectly convey its sexual content. The images are from titillating sex scenes in which the actors are naked. Examples include the image of Lucrecia raising her skirts and masturbating while she watches Calisto and Melibea making love in the garden, and frames of a naked or semi-naked Melibea, played by the sex symbol Isela Vega. Celestina appears on only two of the lobby cards. None of the episodes traditionally chosen for illustration or other promotional images are represented, with the exception of the banquet. That scene is, however, unrecognizable: it does not show the characters around a table but rather involved in sexual activities around a bed, with Celestina absent altogether.

Ten lobby cards were issued to promote the 1996 screen adaptation directed by Vera, which is, to date, the latest adaptation. The actress Penélope Cruz was the main asset for the promotion of this movie, which is clearly noticeable in the lobby cards, which include only two scenes in which she is not present: the murder of Celestina and the death of Calisto. These two images belong to the iconographic tradition of *LC*, but only one clearly shows the influences of this tradition. The image of the death of Calisto follows the iconographic tradition by selecting the moment in which the two servants kneel next to his fallen body (image 44). Without trying to pay homage to the early illustrations of the scene, the frame can be clearly inscribed within the iconographic tradition. The treatment of the dead body of Calisto is unusual. His eyes are semi-closed, and his body is in the aestheticized position associated in cinematic language with the death of the male hero. By contrast, the murder of Celestina is represented by a dramatic close-up of her face just before she is stabbed, an unusual angle that emphasizes the dramatic abilities of the actress. Interestingly, it is the only lobby card in which Celestina appears.

Most of the other lobby cards for this movie emphasize the image of Melibea, by herself in glamorous close-ups or in romantic scenes with Calisto. The prominence of romantic instead of openly sexual images for the promotion of this production may explain why it is one of the few adaptations not to include the banquet scene in its promotional images. The only other character with a significant presence in the lobby cards is Areúsa, also played by a famous actress, who becomes the leading character of the story after Celestina's death. A close-up highlights her gesture of revengeful rage, presenting her as the bad woman opposing the heroine of the story, Melibea. As we saw with the poster for this film, the complete set of lobby cards aims at conveying the message

of a highly stylized production that puts an emphasis on the story's romantic aspects.

If, in the future, new film adaptations of *LC* are produced, they are unlikely to issue lobby cards. They belong to a bygone era of the cinematic industry that relied on audiences attending movie theatres. Other forms of advertising, such as promotional videos on websites, are more likely to be used, as they were already for the 1996 production.

Conclusion: Celestina through the Prism of Advertising

The images on book covers and advertising materials for theatre and film adaptations are relative newcomers to the visual culture of Celestina that deserve our attention. They are exceptional testimonies of the past 150 years of *LC*'s reception. They show us how its story and characters continue to be refashioned to appeal to modern audiences and readers. Although, in many aspects, these images do not differ greatly from the older images we studied in earlier chapters, they are the product of recent discoveries about how to tap into audiences' subconscious. Indeed, many are masterpieces of manipulation, carefully doctored to appeal to specific audiences' desires and fears. In this effort to make *LC* appealing in the present, these images re-enact old ways of receiving and interpreting issues in a new light. A good example is the rivalry for the limelight between Celestina, on the one hand, and Calisto and Melibea on the other. Despite centuries of Celestina's continual textual and graphic ascent, modern advertisers often choose images that confine her to the background in promotional campaigns that emphasize the story's romantic and sexual ingredients. Nonetheless, portraying Celestina alone continues to be a common choice: her multifarious personality can emphasize social and sexual contradictions of modernity, such as an ill-defined fear of old age and death in a youth-oriented society.

The designers of advertising materials are links in the industrial chain of the modern book and entertainment industries, which demand fast, economical approaches. The results are often unoriginal and repetitive designs, based on pre-existing images. Despite the many limitations facing designers, advertisers enjoy the liberty of designing covers and other promotional material that do not need to represent, but only suggest or allude to, the content. Some come up with original choices that expand the visual culture of Celestina: think of the image of Judith and her servant decapitating Holofernes used on some covers.

Especially after the 1960s, some designers started to take advantage of more innovative trends in design. Their covers display images that emphasize underlying themes of the story through symbolism rarely

used for *LC* until that time, such as cobwebs, puppet strings, locks, mechanical hearts, and so on. Celestina is transformed into a spider-like puppeteer, or a ghostly disembodied head floating over the other characters. The many constraints imposed on the characters suggested by the locks, keys, and closed doors also indicate much about our own fears and hopes.

Similarly, modern stage practices have boosted the use of creative images in advertising *LC*. Unconventional characterizations of the actors and their gestures, as well as radical mises-en-scène, often result in impactful promotional images that give unusual turns to the visual culture of Celestina. The images of the actors playing Celestina and the other characters used in advertising should not be discounted because of the photographic medium and the influence of the star system. These images are testaments to the actors' unique incarnations of the textual characters, achieved with the help of makeup and a large team working behind the stage. Photographers portray them from the best angles, making these otherwise ephemeral images permanent. We must welcome them as full-fledged members of the visual culture of *LC*. The faces and bodies carry with them the lingering memory of previous roles played and epitomize ideals and prejudices of the period. They are real flesh-and-bone testimonies to how we envision Celestina and Melibea today.

Kaleidoscopic Celestina

Reclaiming the visual culture of Celestina in its extended meanings reveals findings of interest for disciplines ranging from literature to art and sociology. The images offer us insights into the origins and reception of *La Celestina*. For some of the periods we have examined, these images are the most revealing – and sometime nearly the only – testimonies to its reception. At the same time, they provide us with information on themes ranging from the history of prostitution to social relations and women's position in society. From the point of view of art history, the images of Celestina constitute an ideal case study of the transhistorical evolution of a figure through various media and styles.

The images often confirm aspects of the reception of *LC* well known by literary critics. For instance, the book's induction into the canon of Spanish national literature in the nineteenth century is reflected in its first illustrated cover of the modern period, that of the 1883 Barcelona edition. The publisher chose to reproduce an engraving from the title page of an old edition of *LC* to emphasize its long publishing history and the importance that visual element had since the book's early days. Another well-known trend in the reception of *LC* that is strongly supported by the images is the ascent of the figure of Celestina and the displacement of Calisto and Melibea. Illustrations, covers, and posters confirm how her figure gradually moved from the margin to the centre and from the background to the foreground.

The visual culture of Celestina documents aspects of the reception of *LC* and the evolution of her figure that are too minute and elusive to be detected except in the subtle language of images. The banquet scene in Celestina's house, which appeared in the earliest illustrated editions, has a visual continuity that bears witness to its popularity. However, various aspects of the banquet are foregrounded in different periods. Since the early twentieth century, there has been a clear tendency to

present it in a sympathetic, positive light, which corresponds to the growing appreciation for the subversive ingredients of the story. Newer images of the banquet also reveal the ascent of a voyeuristic interest in the story's erotic episodes. An increasing indulgence in voyeurism explains how, beginning in the nineteenth century, images of the young couples in romantic and sexual interactions have tended to balance out the visual ascent of Celestina. Posters of some film and stage adaptations explicitly acknowledge this voyeurism by including a peeping eye above an erotic scene.

The evolution of images helps not only to confirm significant changes in the reception of *LC* but also to provide evidence of localized fads that may not be traceable otherwise. This is the case with posters and other advertising images for some theatrical performances of *LC* staged in the past twenty years during summer festivals in Spain's small cities and towns. Some of these images present the performance as a carnivalesque spectacle that celebrates the temporary breaking of social rules. To attract visitors, the play is presented as the epitome of the lightheartedness that rules during the festivals. Only time will tell if this form of understanding and staging *LC* will endure or if it is just a localized, temporary practice.

The images also document the complex, often contradictory, changes affecting the reception of specific aspects of the text, such as the debated role of sorcery. Early illustrations did not include images of Celestina practising sorcery, likely because it was a delicate subject that could run afoul of the censors and the Inquisition. The association of her figure with sorcery and even witchcraft was, however, central to the work of Goya, whose Celestinas combined ingredients of the procuress and the witch. Yet Goya's Celestinas were artistic elaborations of a world of witchcraft he dismissed as ignorant superstition, but they allowed him to express the darkest aspects of his psyche. Beginning in the late nineteenth century, images of Celestina as a sorcerer started to appear in illustrations and on covers. Here they served not so much to suggest magic happening in the story as to add a colourful note to her character. In the twentieth century, Celestina as a quaint witch became a common image in editions for young readers. At the same time, Celestina as a mistress of forbidden, magical erotic pleasures and even as a sexualized witch appeared in the promotional materials of stage adaptations and on some book covers.

In spite of its undeniable utility, the use of images to study the reception of *LC* has some intrinsic limitations: images do not have much to say on some purely textual issues that are not suitable for being conveyed visually. For instance, readers' loss of interest in the

erudite quotations in the dialogues does not lend itself to being studied through the visual culture of Celestina. However, this limitation is not absolute. If we look with the appropriate lens, we can see that some apparently unrepresentable themes left visual traces. This is the case with early publishers' and readers' interest in the moral didacticism of the story. Despite its abstract and discursive nature, some information on changing attitudes toward this didacticism can be surmised from the images – or their absence. Early editions included detailed, even gory, illustrations of the death scenes in which characters get their just deserts. In the following centuries, these images become less detailed and frequent, and we reach a point at which, if these scenes are illustrated at all, it is in a symbolic, aestheticized manner. This new model is most noticeable in the treatment of Melibea's death and, to a lesser degree, Calisto's. Beginning in the nineteenth century, there is a clear tendency to depict not their actual falls but only their corpses. And these corpses are not a locus for moral meditation, but are beautiful, even eroticized, dead bodies.

Another interesting fact that the study of Celestina's visual culture reveals is that images are more than visual manifestations or after-effects of the text. In some cases, images significantly reshape the text. Some highly personal recreations of Celestina by masters such as Goya and Picasso have been so powerful that they have altered our perception of the character and, consequently, the whole book. This influence is confirmed, for instance, by the many modern stage performances in which the actor playing Celestina has the enigmatic blind eye of Picasso's famous 1904 *Portrait of Carlota Valdivia*. A close-up of the actor with an opaque or blind eye makes an excellent promotional image, as some recent posters confirm.

This effect of images on the text opens the latter to the influence of changes in styles in the visual arts. Indeed, many of the same changes affecting painting in the past five hundred years have likewise affected the reception of *LC*. It can be argued that some of these tendencies extend to all art forms, from painting to literature. In any case, the tendency toward a closer relationship between the viewer/reader and the artwork or characters in the text is detectable in the visual culture of Celestina. We have moved from the static, even hieratic images of the characters in the early engravings to closer and more intimate portraits that imply a more sympathetic view of the characters and their sufferings. This humanizing view manifests, for instance, in how *costumbrista* and social paintings start to present Celestina as a victim or product of an unjust society. We can identify with her instead of dismissing her as an intrinsically evil other.

In spite of these and other changes, one of the most substantiated findings of this study is the stability of the character of Celestina. While everything changes around Celestina, she remains true to her core as the centre of a motley and shifting visual corpus. Unlike Celestina, the other characters in the story undergo substantial changes. This is due to their identities in the text being schematic and not as solidly built as Celestina's. There is, for example, no prototypical image of Melibea or Calisto that can be identified out of context. The images of these lovers fluctuate, even with respect to their age: in some images, they are teenagers; in others, in their early thirties. Their depiction of their clothing and beauty are conditioned by the fads of the time in which the image is created or by its particular vision of the past. Even their character varies enormously. Melibea ranges from an innocent victim to a cooperative participant in her seduction. Similarly, Calisto can be a fool, a *petit maître*, or a romantic hero.

Unlike the other characters, Celestina's core image has remained not much altered from the earliest illustrations and factotums to the most recent promotional images. This finding matches the well-known literary permanence of her figure, so solid that it has become a prototype capable of endless reincarnations, always different but always the same. At the visual level, this continuity is possible because Celestina is made up of a resilient nucleus of features that are precisely described in the text. Furthermore, they lend themselves to varied but consistent visual renderings. The text contains precise physical features and personality traits that can be consistently transferred into visual images. Her own and other characters' lines include many concrete indications of her appearance and personality. Her characterization is made clear not only through epithets but also through actions. Celestina's relentless activity, her machinations, and the execution of her plans drive the plot. She does so even after her death, as when Areúsa's revenge precipitates the tragic endings of Calisto and Melibea.

Illustrators, painters, and graphic artists can easily pick from among these descriptive elements to represent Celestina. They can play with different combinations of old age, long dark clothes, the face scar, and her several identifying accoutrements – the rosary, the yarn, the gold chain. They can also combine the personality traits that identify her as an energetic, strong-willed woman, and portray her striding to attend to her many dealings or cunningly manipulating the other characters. They can opt to convey her unquenchable desire that age can barely mitigate. They can represent her thirst for wine, and a lust she satisfies by fondling young bodies or voyeuristically participating in their

pleasure. The result will be different in every case but always consistent with the original.

Celestina's character is so intense, so "graphic," so suitable for visual representation that it facilitates these varied but unmistakable portraits. It is the distilled quintessence of previous characters whose strong traits were already stylized, such as the stock character of the *lena* of the Roman comedy. Celestina is a concrete, neatly defined figure in which form and content are indissolubly merged, making of her a paradigm of iconicity. Her whole body carries her life in it. Her ugliness, poverty, and old age are the ruins of the beauty, wealth, and youth she abused. Her clothes and her whole body are as integral to her personality and biography as the scar on her face. Every piece of her identity is consistent with her whole persona and contributes to her distinct, sharp image. Her long cloak identifies her as an old poor woman as well as surrounding her with a halo of secrecy. The cloak helps define her personality when it swings as she strides off in pursuit of her business with a dynamism surprising for her age. The cloak equally serves as a prop to show her craftiness, as when she alludes to its poor shape so Calisto will give her a new one.

The many, changing depictions of Celestina across the centuries are best understood by analysing the influence of their times and material supports. Each of the three threads of this study of the images of Celestina – illustrations in books, paintings, and advertising images – flourished in different periods, used different media, and were intended for different audiences. This distribution can help us understand aspects of the visual evolution of Celestina. The illustrations of the early books were necessarily limited in detail, given the technical constraints of woodcuts and rudimentary printing presses. Celestina appears as an old, nearly decrepit woman exclusively characterized by a long black cloak that covers her completely. She is mostly a blotch of dark ink. Occasionally, a few complements – rosary, moneybag – that are mentioned in the text are added. Perhaps the most important aspect of these images is her ubiquity in the sequence of illustrations. In her plain cloak, she appears in a variety of scenarios: in different houses, interacting with different characters, talking, and listening. She is the force behind all the action. The blob of black ink representing her figure is loaded with an energy that makes her the fulcrum of the images in which she is present. Even when she is absent, her figure looms over the action and the characters.

Later, painters develop the visual potential implicit in this blotch of ink. With more expressive tools at their disposal and not bound by the proximity of the text, they could take her to the next level in detailed, picturesque renditions. These painters do not seek to represent Rojas's

Celestina but their own interpretation of a by-then literary myth capable of being reincarnated in every period. We see, for example, contemporary figures of the world of prostitution in *costumbrista* canvases. Celestina is depicted as a transhistorical recurring character, a chameleon who can wear contemporary attire and move in new environments. She became not only a motif for personal interpretations but also a vehicle to express artists' agendas, passions, and demons. She may continue to be a prototype, as in some social paintings, but she may also be a victim of society, of old age, and of poverty. She can be loaded with complex values, such as unsatiable desire in Picasso, or, as in Goya, can be used to express the darkest side of the psyche. In some more-recent paintings, as the ones by Ramírez Máro and Arnás Lozano, the meanings she conveys are open to interpretation.

Advertising images, the newest member of the Celestina family, tend to focus on the more sensational aspects of the book for commercial purposes. In posters, book covers, and playbills, *LC*'s cultural cache must sell the product, so designers may, for example, exploit the immediate sex appeal of Melibea or other characters. A common design choice is to follow Goya's recipe of contrasting the beautiful *maja* and the ugly Celestina. However, Celestina is more than the background against which to extol the beauty of the young characters. She often becomes a participant in the sexualized scenes that are central to the commercial promotion of the story. She is presented as a voyeur in sexual scenarios and the master of ceremonies of the orgies. From the covers of books, Celestina invites us to turn the pages and enter her world. From the posters, she encourages the passer-by to acquire a ticket for the performance. She is an enticer who invites us to participate in an exciting, sexually loaded spectacle. In some images, she is even a temptress, sexually attractive herself. She is not clad with the dark cloak of the illustrated editions, or the *costumbrista* outfits of the paintings; she has become a fantastic creation of the imagination of the designers of the covers and posters. They take all kind of liberties to make her look mysterious, deranged, evil, obscene. Some basic ingredients such as her old age and energy remain a constant, but the advertisers have plenty of freedom to recreate her image. For that, they can selectively access not only the text but also the vast panoply of previous images, such as the blind eye of Picasso's Celestina. By now, the text of *LC* is barely binding. The visual has overtaken the written.

Celestina's image is so iconic, so intense and graphic, that it can be represented with a few expressive brush strokes as a caricature or an ideogram. The best examples are Goya's simple but expressive engravings, or Picasso's Celestinas scribbled in black ink in his final years. This

iconicity of Celestina recalls the visual treatment of Don Quixote, often reduced to not much more than a long vertical line accompanied by a short, round trace for Sancho. However, Celestina differs in that the Don has fewer defining visual traits to play with, besides his skinniness and a mature age that cannot be exaggerated. Contrarily, decrepit Celestina's panoply of strong features offers graphic artists many possibilities. While maintaining some of her defining features, they can add new ones without disfiguring her. This is what Picasso did when he added a cloudy eye in his 1904 portrait, which, despite the prominent innovation, leaves no doubt that it is of Celestina.

This resilience and malleability are such that painters and designers can substitute Celestina's figure with that of other women with whom she shares only some features. A typical case is the representation of Celestina as a witch, a practice common since Goya. The two characters share only gender, old age, and the practice of magic, and, in the case of Celestina, the last is restricted to mere meddling in sorcery, as her realm of expertise extends to areas in which witches do not particularly excel. Similarly, on some book covers, Celestina is impersonated by old women who are allegorical figures of vices, such as Avarice. Alternatively, many cover designers have no problem representing her through female figures taken from renowned paintings. This is the case of the use of a lady-in-waiting taken from Velázquez's emblematic *Las meninas*, or of the servant helping Judith decapitate Holofernes in Caravaggio's famous canvas.

This resiliency of her identity manifests also in how it remains unaffected by the idiosyncrasies and impositions of the different visual media. Her image is recognizable in early illustrations despite the stilted poses and the technical limitations of this medium in showing detail. Celestina continues to be Celestina even when some early publishers use factotums of generic old women or the same factotums that they used a few pages before for the respectable Alisa. At the opposite temporal and technical end, modern promotional images rely on the detail and definition of photographic close-ups of famous actors playing the role. Viewers have no problem recognizing Celestina in these familiar faces despite their strong ghosting effect – the lingering memory of previous roles played by the actors. Celestina's visual identity lends itself to being altered to match painters' stylistic and ideological agendas. She is always herself as the quaint character of *costumbrista* painting or as a brutal madam who exploits her pupils and performs abortions.

Celestina's character exceeds the role she plays in the book, as understood within the interpretative limitations of the days in which it was written. This surplus of meaning easily adapts to new interests,

agendas, and styles, resulting in new incarnations whose uniqueness is best expressed in the language of images. In the nineteenth century, as social concerns about sexual exploitation displaced those of private morals, her image as the arranger of lovers' illicit rendezvous was displaced by that of a link in the chain of prostitution. In these new scenarios, she can be portrayed as a complicit agent of exploitation and as a victim, as in some of the social paintings of the late nineteenth century. Her role as a restorer of virginity and as a provider of abortions, not central in the original plot of the book, is highlighted in some modern images. Similarly, she is often depicted as an expert in sexual pleasure, with some artists turning her into a sexually attractive character. Even her gender can be changed without affecting her identity, as in some recent stage adaptations. In the future, we can expect that other facets of Celestina's core identity will become prominent when shown under new lights. The result will be new images that will affect our perception not only of her character but also of the book in which she was born.

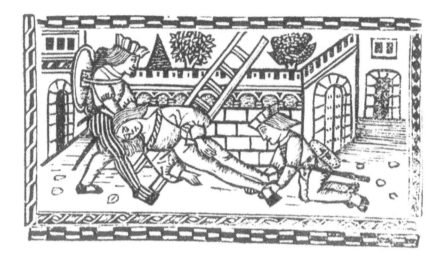

Image 1. Illustration of Calisto's fall in the 1514 Valencia edition of *LC*.

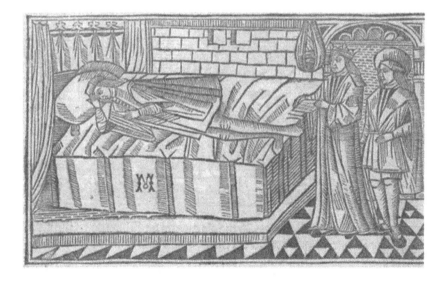

Image 2. Illustration in Camus's *Historia de Oliveros de Castilla y Artús d'Algarve*, printed by Fadrique de Basilea in 1499, which bears a clear resemblance in style to some illustrations used in the 1499 edition of *LC* (compare it, for example, to the right panel in image 6).

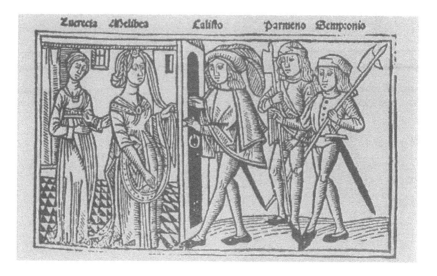

Image 3. Illustration from act 12 in the Burgos edition of *LC* printed by Fadrique de Basilea, who repurposed the image for his 1514 edition of Pedro de Urrea's *Penitencia de amor*. The same illustration was later used for the undated *Romance de Amadís y Oriana*.

Image 4. The Tiburtine Sybille in the Ulm Choir stalls (c. 1450) is a typical example of the Ulm style of carving. Attributed to Jörg Syrlin, father and son of the same name.

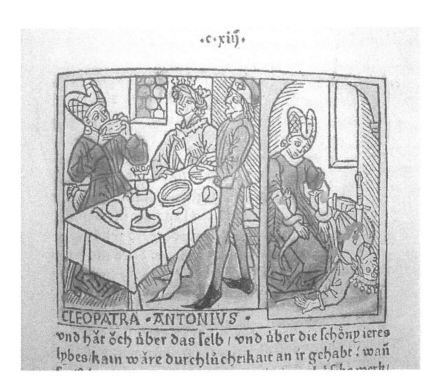

Image 5. Hand-coloured double-panel illustration in Boccaccio's *De claris mulieribus* (Ulm: Zainer, 1473) representing the banquet and the suicide of Antony and Cleopatra.

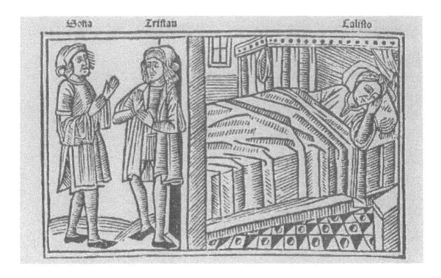

Image 6. Two-panel engraving from act 13 of the Burgos *LC*. On the left side, Sosia is telling Tristán of the deaths of Pármeno and Sempronio while, on the right, Calisto is asleep in his room. Sosia's and Tristan's hand gestures give the figures an elocutionary, dynamic thrust.

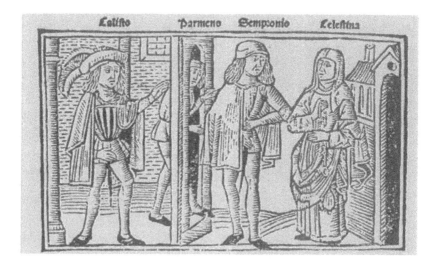

Image 7. Illustration from acts 1 and 5 of the Burgos *LC*. Notice Sempronio's arms akimbo, a gesture that originated as a military pose and was later used to convey male authority.

Image 8. Illustrations from acts 4 (top) and 10 (bottom) of the Burgos *LC*, representing the departure and return of Alisa with a servant while Celestina and Melibea are talking inside. The nearly mirrored images show the subtle changes used to convey the narrative.

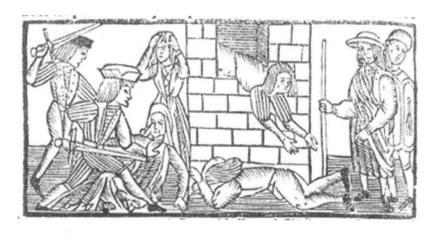

Image 9. Illustration from act 13 of the 1515(?) Rome *LC*, which reproduced the illustrations of Cromberger's edition. Notice that, exceptionally, the characters of Sempronio and Pármeno appear two times in the same illustration, once in each panel.

Image 10. Evolution of the scene of the banquet in Celestina's house in act 9: from top, Burgos, 1499; Augsburg, 1520; and Zaragoza, 1545. Notice the increase in detail and in the interaction of the characters.

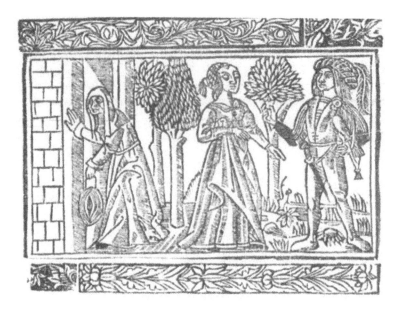

Image 11. Title page of the 1500 Toledo edition, the first surviving title page of *LC*, which sets the tone for most early editions, including an illustrated title page.

Image 12. Title page of the 1519 Venice translation of *LC* into Italian. The illustration departs from the pattern of other editions and illustrates a specific scene instead of including a synoptic image with the main characters. The Latin inscription can be translated as "The old woman is the tail of a scorpion."

Image 13. Illustration of the visit of Celestina and Pármeno to Areúsa's house (act 7) in Gorchs's 1841 edition. Notice the partial nakedness of Areúsa, and Pármeno's revealing pants.

Image 14. Illustration of Celestina's incantation in the 1883 Barcelona edition, the first time the scene is illustrated. Ramón Escaler's dramatic style recalls Gustav Doré's illustrations, which were extremely popular at the time.

Image 15. Illustration from the 1999 edition illustrated of *LC* by Teo Puebla, depicting Celestina restoring a woman's hymen.

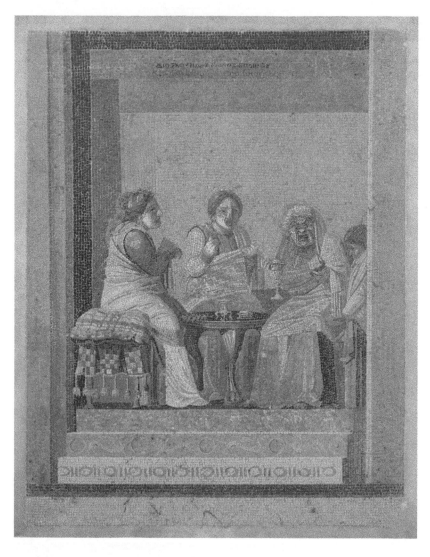

Image 16. *Consultazione della fattucchiera* (Consulting with the witch), mosaic from Pompeii, representing a banquet scene from the comedy *Synaristosia* by Menander. It depicts the procuress Philatinies, a *hetaera* (Greek courtesan), and other characters.

Image 17. Bas-relief with a procuress on a baptismal font in Palencia (c. 1100), depicting a man and a woman copulating. The old female character to the right is likely a procuress.

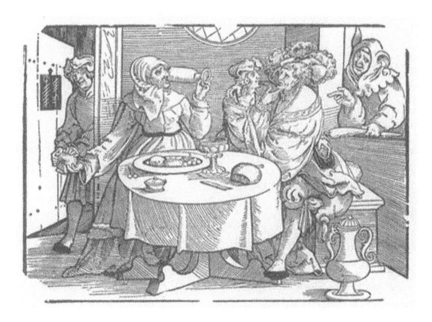

Image 18. Single-sheet engraving by Erhard Schoen entitled *The School of the Procuress* (1531). Notice the resemblance to the banquet scene of *LC* in image 10.

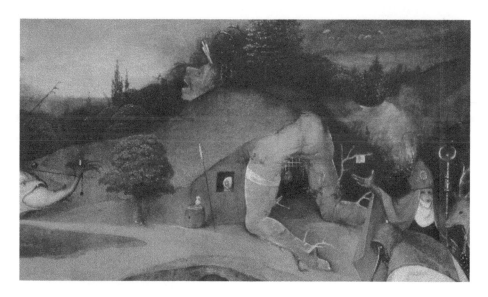

Image 19. Detail of Bosch's *Temptations of Saint Anthony* (c. 1500) representing the entrance to a tavern or brothel.

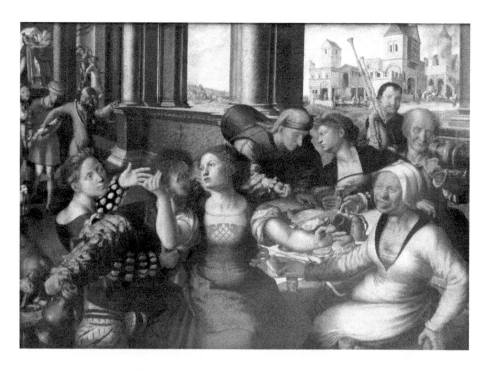

Image 20. *The Prodigal Son*, by Hemessen (1536), considered the first painting based on the Parable of the Prodigal Son from the Dutch Renaissance. The procuress on the lower right side of the painting is surreptitiously reaching for bread, a symbolic gesture often associated with Judas in the Last Supper.

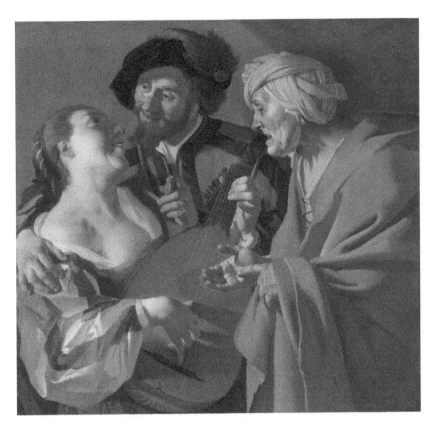

Image 21. *The Procuress* by van Baburen (1622). The presence of a lute has
a double meaning because, in Dutch, the word for lute and vagina was the
same.

Image 22. *Danae* by van Loo (c. 1655). Notice the similarity between Danae's servant and the characterization of the procuresses.

Image 23. Murillo's *Dos mujeres en la ventana* (Two women at a window, c. 1655). The scene may represent the solicitation of clients from a window, a practice common in Spain at the time.

Image 24. Luis Paret y Alcázar's watercolour *La Celestina y los enamorados* (Celestina and the lovers, 1784). Celestina's features are clearly derived from her description in *LC*.

Image 25. Goya's brush and charcoal *La madre Celestina* (Mother Celestina, c. 1819). The word "Celestina" appears in the artist's own handwriting.

Image 26. Goya's *Maja y Celestina al balcón* (*Maja* and Celestina on the balcony, c. 1808). Notice Goya's inclusion of Celestina's rosary and her deformed features.

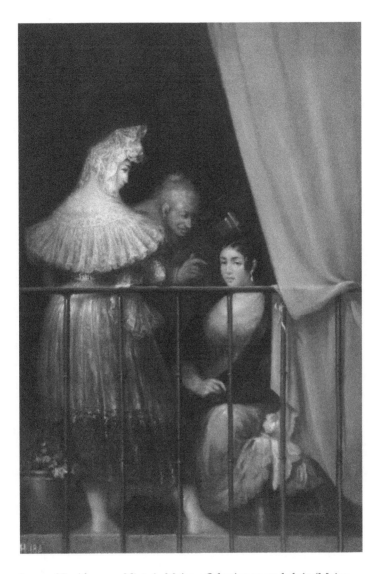

Image 27. Alenza y Nieto's *Majas y Celestina en un balcón* (Majas and Celestina on a balcony, 1834). Celestina, like a stage director, is emphatically advising the young prostitute.

Image 28. Sorolla's *Trata de blancas* (White slave trade, 1894) is a social painting denouncing the exploitation of poor women who were recruited for the new brothels in Spanish cities. Notice the Celestina character on the right.

Image 29. Gutiérrez Solana's *Las chicas de la Claudia* (Claudia's girls, 1929) is a realistic image of a brothel, treated in his characteristic dark tone. Notice the Celestina character on the left.

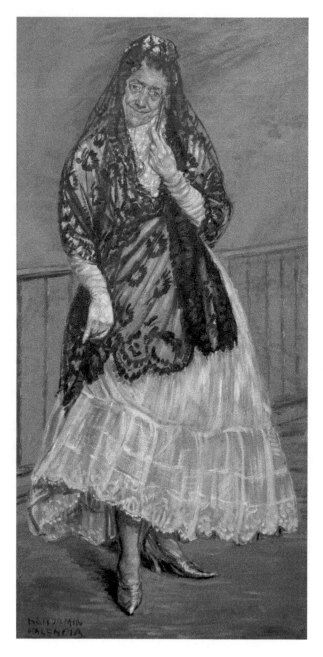

Image 30. Benjamín Palencia Pérez's *La Celestina* (1920)
combines Celestina and the *maja* into one character.

Image 31. Picasso's *Portrait of Carlota Valdivia*, also known as *La Célestine* (1904), painted during the artist's Blue Period.

Image 32. Arrieta's *Cocina poblana* (Poblana kitchen, 1865), an example of Mexican *costumbrista* painting that includes a Celestina character.

Image 33. *Celestina*, canvas by Peruvian-Belgian painter Rafael Ramírez Máro (2011) as part of his "La Celestina" cycle.

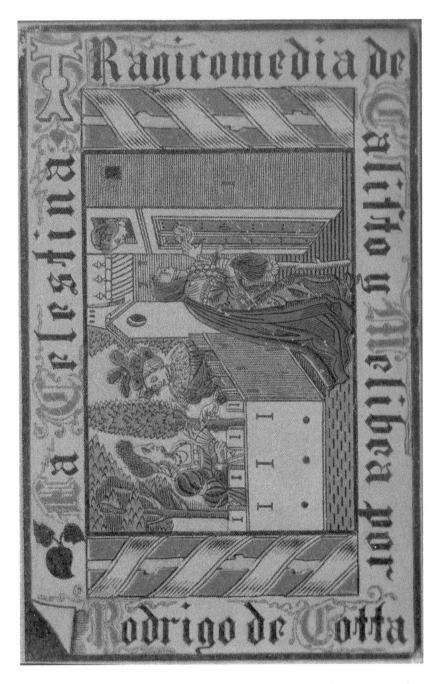

Image 34. The 1883 Barcelona *LC* is the first edition to include an illustrated cover. The image is a coloured reproduction on cardboard of the black-and-white woodcut on the title page of the 1538 Toledo edition.

Image 35. Cover of the Sopena edition of *LC* published in Barcelona the 1920s, featuring a new image of Celestina and the lovers. Interestingly, this is the first image in which Melibea and Calisto are shown touching each other.

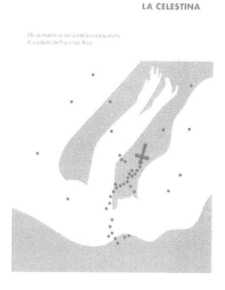

Image 36. The cover of the Penguin Random House edition of *LC* (New York, 2020). The rosary, traditionally associated with Celestina, is here attributed to Melibea and resignified.

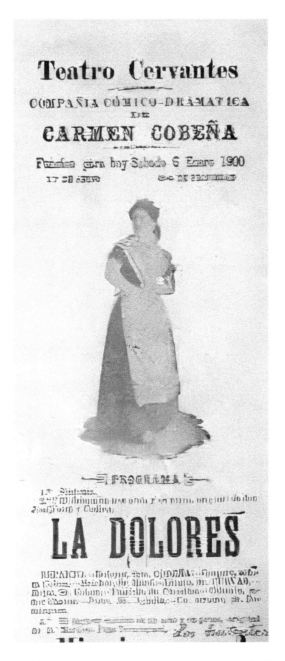

Image 37. Playbill for the 1900 production of *La Dolores* by the Compañía cómico-dramática de Carmen Cobeña at the Teatro Cervantes in Málaga. It includes an image of the lead actor, Carmen Cobeña.

LA INAUGURACIÓN DEL ESPAÑOL
La primera actriz del teatro Español, señora Cobeña, en el personaje de La Celestina, obra cuyo estreno se verificó anoche para inauguración de la temporada.

Fotografía Cifuentes.

Image 38. Carmen Cobeña as Celestina in an article in the Spanish newspaper *ABC* dedicated to this first stage adaptation of *LC* in 1909. This is the first photographic image we have of an actor dressed as Celestina.

Image 39. Scene of the banquet in Celestina's house from the 1909 production of *LC*. Notice the dark make-up on Celestina, in the centre of the shot.

Image 40. Popular actress Gemma Cuervo on the cover of the handbill for *La Celestina* performed in the Teatro Fernando Fernán Gómez (Madrid, 2012). A close-up of the aging face of an actor known for playing beautiful young women helps convey the play's central theme of the evanescence of beauty.

Image 41. Poster for the first film adaptation of *La Celestina* (1969), by the Spanish director César Ardavín. The image of Melibea and Calisto is taken from one of the movie's scenes, but the breasts of the actress playing Melibea (Elisa Ramírez) are enlarged for the poster image.

Image 42. Scene from the banquet in Celestina's house included in the handbill for the production *La Celestina* at the Teatro Fernando Fernán Gómez, Madrid, 2012.

Image 43. The two upper rows are Fernando Fresno's caricatures of scenes and characters in Fernández Villegas's production of *La Celestina* (Madrid, 1909).

Image 44. Lobby card for the 1996 screen adaptation of *LC*, representing
the dead body of Calisto, played by the actor Juan Diego Botto, who was
only twenty-one at the time, and his two servants. Calisto is presented in
the cinematic tradition of the romanticized hero, the scene not showing the
spilled brains specified in the text. Interestingly, his left hand is placed over his
genitals, in a gesture similar to that in image 1).

Notes

Introduction

1 In the original Italian, the passage reads: "Insomma, gli uomini comunicano con le parole, non con le immagini: quindi un linguaggio specifico di immagini si presenterebbe come una pura e artificiale astrazione … Ma c'è di più, nell'uomo, che si esprime con prevalenza attraverso immagini significanti … si tratta del mondo della memoria e dei sogni" (Pasolini, *Empirismo eretico*, 171).

2 "Visual culture" and "visual studies," which are defined later in the chapter, are often used as synonyms I am using the terms "image" and "imagery" in the meaning of representation in a visual medium, such as paper or canvas. This is the most common meaning, because, as Mitchell states, the initial default meaning of the word "image" is always visual image. He sketches a family tree of the concept of "image," which he subdivides into graphic, optical, perceptual, mental, and verbal ("Image," 42). Here, I am dealing with only the first category, not with verbal imagery or symbology, as studied, for instance, in Weiner's "Adam and Eve Imagery in *La Celestina*." See Carmona Ruiz, "La recepción," 324, for a review of the studies on this kind of symbolic imagery in *LC*.

3 Whether the Burgos edition by Fadrique de Basilea is the actual *editio princeps* of *LC* and whether it was really published in 1499 is a whole subfield of *LC* scholarship, too complex to summarize here. A recent survey can be seen in Canet Vallés, "Early Editions." In any case, what matters for the present study of the images of *LC* is that the Burgos 1499 edition is the first fully illustrated edition.

4 Sorolla's painting is analysed in chapter 2.

5 Regarding the title of the book and its changes across the centuries, see Kelley, "Peripecias de un título," and Kirby, "¿Cuándo empezó?"

6 Chevalier, *Lectura*, 142–3.

7 The inclusion of the Spanish definite article "la" before the word "Celestina" in the title of some of the paintings that will be discussed below seems to indicate that we are being presented with the original literary character, but this is not a reliable criterion. The difference between the use of "Celestina" and "L/la Celestina" to refer both to a character, be it the original or the myth, as well as to the title of the book is inconsistent in Spanish and is impossible to convey in English translation. The situation is further complicated by the common practice of using *Celestina*, without the article and italicized, for the title of the book in English, while, in Spanish, the preferred form for referring to the book is *La Celestina*, although the name without an article was common in previous periods.

8 I use the initial uppercase form "Celestina," not the lowercase "celestina." The use of lowercase for the descendants of Celestina is common but inconsistent in Spanish. Goya's famous painting is referred to as both *Maja y Celestina al balcón* and as *Maja y celestina al balcón*. Trying to trace the original capitalization of this and other titles back to Goya or other painters through the fog of time and the vagaries of changing capitalization rules in Spanish is impossible. Furthermore, the English title commonly used for this painting – the form that we will use for most paintings after their first mention – capitalizes all nouns, making the title *Maja and Celestina on the Balcony*. My use of the same name "Celestina" to refer both to the original literary character and her many descendants will, I hope, not be a problem, as the context should make such references clear.

9 Guerry, "Du personnage Celestina," 13; Heugas, *La Célestine*. The Celestina characters in the sequels of the book, today known collectively as *celestinesca*, appeared in the first or second century after LC was published, including Silva's *Segunda Celestina* (1534) and Muñón's *Tercera Celestina* (1542), but some have appeared more recently, such as Sastre's *Tragedia fantástica de la gitana Celestina* (The fantastic tragedy of the gypsy Celestina, 1978). In some of these texts, the descendant of Celestina may have a different name and identity, but she clearly inherits defining features of her predecessor and is easily identifiable as a Celestina character.

10 François, *La Celestina*, 88, 94, 104–7.

11 Schmidt, *Critical Images*, xiii; Lucía Megías, *Leer el* Quijote, 97.

12 For a summary of the variations of the myths of Don Juan and Carmen, see Weinstein, *Metamorphoses of* Don Juan, and Utrera Macías, "Representación cinematográfica." The identification of Don Juan, Don Quixote, and Celestina as foundational literary prototypes integral to the national character of Spain originated in a book the influential intellectual Ramiro de Maeztu published in 1925, *Don Quijote, Don Juan y la Celestina*: *Ensayos en simpatía*.

13 Hodnett, *Image and Text*, 45.

14 A recent summary of the studies on the visual aspects of *LC* can be found in Carmona Ruiz, "La cuestión," 80–5, and "La recepción," 320–72.
15 This book is made possible by the work I did for the creation of the online database Celestina Visual (http://celestinavisual.org), which catalogues over three thousand images of the visual culture of Celestina.
16 Dikovitskaya, "Major Theoretical Frameworks," 68. For other definitions of "visual culture," see Barnard, "What Is Visual Culture?" The expression "word and image studies" is preferred in some continental circles, and there is an International Association for Word and Images Studies (https://iawis.org/). The label "visual studies" is more common in North America. It is, however, difficult to establish a clear theoretical differentiation between the two schools.
17 Alpers et al., "Visual Culture Questionnaire," 40.
18 Herbert, "Visual Culture," 456.
19 Dikovitskaya, "Major Theoretical Frameworks," 73, 83.
20 On such signs, see Jenks, *Visual Culture*, 2–5.
21 Mitchell, *Picture Theory*, 5, and "Showing Seeing," 170.
22 Mitchell, *Iconology*, 431.
23 Benveniste, "Semiology of Language," 235.
24 Stöckl, "In between Modes," 18.
25 As we point out in the next chapter, Dürer's detailed engravings, such as his Apocalypse series, especially the famous *The Four Horsemen of the Apocalypse* (1498), are productions of exceptional quality executed in a bigger format. In spite of their popularity, they do not represent the average work of commercial wood engravers illustrators at the time.
26 A theoretical analysis according to the theories of Iser and Jauss of how the images in the early illustrated editions of *LC* affected its reception is examined by Montero, who writes: "For medieval psychology, the process of reading and the process of viewing were tightly intertwined because there was not a drastic separation between written and visual text … The medieval act of reading cannot be isolated from this written-visual interaction, and Celestina's illustrations should be taken into account when exploring the possibilities of actualization of the wide semantic potential of Rojas's work" ("Reading at the Threshold," 198).

1 Illustrating Celestina

1 Mitchell, *Picture Theory*, 3–4.
2 Hodnett, *Image and Text*, 13.
3 Barthes, "Rhetoric," 25, 39. Other possible classifications of the relations between words and images have been proposed, such as Marsh and White, who list up to forty-nine possible types based on a set of categories such

as decoration, control, contrast, on so on ("Taxonomy of Relationships").
Theoretical paradigms that do not separate the functions of the word
and the image in a printed book exist, such as that of Peter Wagner, who
considers illustrated books to work as an "iconotext," a combination in
which both elements are simultaneously present and produce a new type
of meaning that cannot be separated (*Icons*). Equally, Ionescu talks of a
"composite pictorial-verbal form," a "mixed text," or an "imagetext" (*Book
Illustration*, 33). These paradigms apply best to specific types of illustrated
book, such as emblem books, and are of limited utility for our study.

4 Hodnett, *Image and Text*, 5.
5 Gombrich, *Essential Gombrich*, 134.
6 Hodnett, *Image and Text*, 14.
7 Schmidt, *Critical Images*, 12.
8 "The most important decision an artist has to make about an illustration
 is the moment of choice ... As in a still from a cinema film, the action is
 stopped" (Hodnett, *Image and Text*, 7).
9 Carrete Parrondo, *El grabado*, 48.
10 Fernández Rivera, "La caída," 138.
11 Mitchell, "Image," 39–40.
12 The printing of Spanish books in Antwerp, which began in the sixteenth
 century, lasted well into the seventeenth century, fostered by political
 connections with Spain and the large Spanish-speaking population of
 the region. A detailed description of the commercial relations of Dutch
 publishers with the Iberian Peninsula is in Manrique Figueroa, "Printing in
 Antwerp."
13 The early illustrated editions of *LC*, with access to the illustrations, can
 be seen on the website Celestina Visual, http://celestinavisual.org
 /ilustracionesantiguas. The images of the 1499 Burgos edition can also
 be seen at the Portal de la Celestina, on the Biblitoeca Virtual Miguel de
 Cervantes site, https://www.cervantesvirtual.com/portales/la_celestina/.
 See also Portal Celestinesco, http://parnaseo.uv.es/PortalCelestinesco,
 and M. Lacarra, "Fernando de Rojas."
14 The crisis of the book market in the seventeenth century, with special
 attention to Spain, is described in Wilkinson and Ulla Lorenzo, *Maturing
 Market*.
15 Griffin, "*Celestina*'s Illustrations," 60n4.
16 It is difficult to establish the exact number of editions of *LC* in this period.
 Dunn writes that, although it is impossible to give an accurate number, 100
 for the whole sixteenth century is not unreasonable (*Fernando de Rojas*, 37).
 The most recent study, by M. Lacarra, speaks of 81 editions until 1599 ("*La
 Tragicomedia*," 237). Marciales calculates 89 editions until 1633–4, and then
 adds 20 others whose existence is uncertain, to a total to 109 in 135 years,

noting that we must add the close to 50 in other languages published in the same years (*Celestina*, 1: 1). Griffin speaks of more than 100 in the same period ("*Celestina*'s Illustrations," 60–1, 60n6). M. Lacarra notes that, in the sixteenth century, more than 50 per cent of the editions were illustrated with representations of the episodes or factotums ("La tradición," 1687).

17 Gallego notes that, in the first part of the sixteenth century, 157 chivalry books were published, with the genre reaching its zenith around 1550. In the second part of the century, 86 more editions were published (*Historia del grabado*, 100). In a study of the illustrations of the chivalry books, Lucía Megías reaches some conclusions that can be applied to *LC*. For instance, he points out a gradual decline in the quality of images as the century progresses, as well as the reusing of images, especially of factotums of the generic figures of the knight, the king, the lady, and so on (*Imprenta*, 481).

18 Fernández Rivera, "Calisto."

19 Lucía Megías, *Imprenta*, 469–70, 609–18.

20 Cacho Blecua, "Los grabados," 64.

21 Griffin, "*Celestina*'s Illustrations," 60.

22 Canet Vallés, "Early Editions," 31.

23 Alvar, "De *La Celestina* a *Amadís*," 98.

24 Torello-Hill and Turner, *The Lyon Terence*, 64.

25 Torello-Hill and Turner, *The Lyon Terence*, 3.

26 Saguar García, "The Concept."

27 "Magnífico contenido el de nuestra literatura del Siglo de Oro, en pobre continente," Gallego, *Historia del grabado*, 133, my translation.

28 Chevalier, *Lectura*, 20.

29 Sometimes the words "engraving" and "wood engraving" are reserved for the cutting of the images not with the grain of the wood (plankwise) but on endgrain wood, which requires a different technique and tools. Here, I will not reserve the term for this specific meaning but use the terms "woodcutting" and "engraving" as synonyms.

30 For "block books," in which both images and text were cut out in wood, see Parshall, *Woodcut*. Nothing of this kind of chapbook has been found in Spain, although some references to the existence of printed images of saints and religious figures exist, as well as few playing cards and other images, though of a later date and, curiously, not in wood but in metal (Gallego, *Historia del grabado*, 18–23, 62–5; Ainaud, "Grabado," 245). Bland thinks that separated illustrated sheets did not become popular in Spain until Goya (*History of Book Illustration*, 192).

31 A good overview of the process of producing woodcuts for books is in Chamberlain, *Thames and Hudson Manual*. For Spain, see Gallego, *Historia del grabado*, and García Vega, *El grabado*.

32 That several people participated in the production of woodcut illustrations is often inferred from inconsistences of style. In the Lyon Terence (Terentius), for example, the illustrations can be attributed to an individual artist, but their uneven quality suggests the work of engravers of different ability (Torello-Hill and Turner, *The Lyon Terence*, 160).

33 Bolton, *Fifteenth-Century Printing*, 9.

34 Gallego, *Historia del grabado*, 19.

35 Lyell and Martín Abad, *La ilustración*, 3. The dependence on foreign images was common in other countries at the time, such as England (Hodnett, *Image and Text*, 5).

36 Gallego, *Historia del grabado*, 25–34.

37 Gallego, *Historia del grabado*, 4. Martín Abad, "Cum figuris," studies Hurus's use of illustrations, although only for the incunabula period.

38 Gallego, *Historia del grabado*, 4, 35.

39 Fernández Valladares, *Imprenta*, 130.

40 On the problematic date of the 1499 edition of *LC*, see Penney, *The Book Called* Celestina, 31–3, and Marciales, *Celestina*, 1:19–24. For more sources on the issue, see Griffin, "*Celestina*'s Illustrations," 59n2, and a more up-to-date summary in Canet Vallés, "Early Editions," 95n39.

41 Carrick, "Lyon's *Terence*," 109–10.

42 The fact that, in the prologue to the 1502 edition, Rojas referred to the pages that he claims to have found circulating in Salamanca, and also referred to the first act of *LC* as a "Terentian work," shows that *LC* was considered part of the same tradition as Terence's comedies (Rodríguez-Solás, "A la vanguardia," 2).

43 Griffin, "*Celestina*'s Illustrations," 68.

44 Cull, "Possible Influence."

45 Rodríguez-Solás, "A la vanguardia," 3.

46 The literary genre of *LC* is an area of debate that dates back to the pioneering work of Menéndez Pelayo (*Orígenes de la novela*) and Lida de Malkiel (*La originalidad artística de* La Celestina). On the connections between *LC* and the sentimental romance, see Corfis, "*Cárcel de amor*" and Iglesias, *Una nueva mirada*. This connection is confirmed by how the same illustrations are interchangeable: the title page of *LC* printed by Estanislao Polono in Seville in 1501 was reused by Cromberger in 1512 for the title page of Piccolomini's *Historia muy verdadera de dos amantes, Euríalo franco y Lucrecia senesa* (Morato Jiménez, "La portada," 76).

47 Fernández Rivera, "Calisto."

48 Alvar, "De *La Celestina* a *Amadís*," 100–6; Fernández Valladares, "Biblioiconografía," 115–24, and "De la tipobibliografía."

49 For instance, Hurus's 1491 edition of Rodrigo Sánchez de Arévalo's *Espejo de la vida humana* contains thirty-nine engravings copied from

Zainer's 1471 Augsburg edition of the same book. Similarly, Hurus's 1493 *Exemplario contra los engaños y peligros de la vida*, the Spanish version of Johannes de Capua's *Directorium humanae vitae*, has seventeen engravings taken from the German edition of the book printed in Ulm by Holle in 1483. Fadrique de Basilea printed another Spanish edition of this book in 1498 but used different engravings.

50 See Amelung, *Der Frühdruck*, for a description of the origins of the printing press in German-speaking areas in this region.

51 Laube, "Stylistic Development," 50. See Bornstein, "A Late Gothic Sculpture," for a comprehensive discussion of the Ulm style of sculpture.

52 Bolaños and Chapuis, *Últimos fuegos góticos*, 8–12.

53 Bolton, *Fifteenth-Century Printing*, 9–10.

54 Torello-Hill and Turner, *The Lyon Terence*, 141. The use of the arch as a way to separate spaces in painting and sculpture originates in religious art (Keller and Kinkade, *Iconography*, 17–18).

55 Cull, "Possible Influence."

56 Martín Abad and Moyano Andrés, *Estanislao Polono*, 18.

57 Fadrique de Basilea worked in Basel with the printer Michael Wenssle and was probably born in that city. See Delgado Casado, *Diccionario*, 1: 69–71.

58 Ulm style is also the inheritor, among other influences, of what Torello-Hill and Turner, talking about the Lyon Terence, call "an illustrative tradition that kept developing over time, preserving some distinctive features while at the same time introducing elements of originality" (*The Lyon Terence*, 6).

59 Snow, "La iconografía." I am using "iconographic program" in the sense of the number of illustrations, the episodes they depict, and how they depict them in the images.

60 Carrick, "Lyon's *Terence*," 112. The location of the images at the beginning of each act in the 1499 *LC* can be connected to the Lyon Terence's innovative "introduction of illustrations at the start and the end of each play, which function as a Prologue and Epilogue respectively" (Torello-Hill and Turner, *The Lyon Terence*, 143).

61 This arrangement is affected by the summary being placed toward the end of the page, as in acts 3 and 4, which compels the image to be located at the beginning of the next page. Because paper was so expensive, leaving empty space in order for each act to start on a new page was not an option. Also, as mentioned, the first of the two illustrations of act 1 is different because it is placed before the summary of the first act. In this unusual position, the image appears to function as a title page or cover for the whole book, even if it depicts only the first scene of the first act, serving as a kind of title page illustration.

62 Rivera, "Visual Structures," 10, 25.

63 The important role the summaries play in the design of the images does not mean that the illustrator did not know details of the story not included in the summaries. For instance, the illustration from act 3 shows Celestina going to Pleberio's house with the spool of yarn in her hands, a detail not mentioned in the summary.

64 Rodríguez-Solás, "A la vanguardia," 3. As this critic recognizes, the illustrations of the Lyon Terence are not completely static, because they include some hints of the action in the story.

65 The engraver's decision to illustrate specific events could not have been based on a live theatrical performance of LC or of any other texts, because the Spanish stage had not yet developed. The comedia humanística, the dramatic genre in vogue in the period and to which the book is strongly connected, was, as far as we know, not performed on stage (Paolini, "La comedia"). We must also discard the influence of medieval Terentian manuscripts with hand-painted scenes of performances from Roman times, as they were rare, and their images are of a completely different style (Neithart and Amelung, Die Ulmer Terenz-Ausgabe). However, other studies consider that some hand gestures of the actors that are represented in the illustrations of the Lyon Terence are direct descendants of late antique and medieval performance practices, although they are also connected to the gestures that some monks used following their vow of silence and then use as support in their preaching (Torello-Hill and Turner, The Lyon Terence, 2, 145).

66 The depiction of the figures as if speaking lines of the text is also noticeable in the Lyon Terence (Carrick, "Lyon's Terence," 127).

67 The rhetorical hand gestures of the characters in the illustrations of Terentian manuscripts, the oldest known cases of the dramatic use of these gestures, are curiously related not so much to theatrical performance as to the rhetoric tradition explained in Quintilian's Institutio oratoria (Torello-Hill and Turner, The Lyon Terence, 42). Next to their purely elocutionary function, gestures in medieval imagery symbolically serve to codify relations of power and hierarchy between master and servant, man and woman, and so on (Schmitt, La raison des gestes, 14–16). See Jiménez Ruiz's interpretation of the hand gestures of Calisto and Melibea on the cover of the 1501 Seville LC as a parody of the iunctio dextrarum in the marriage ceremony ("Colombia").

68 Torello-Hill and Turner, The Lyon Terence, 167.

69 Quotations from LC are from the 2009 translation by Margaret Sayers Peden, and are referenced by page number.

70 Rodríguez-Solás sees the use of double panels as way to economize space, and therefore paper, not used before in any illustrated book in Spain ("A la vanguardia," 15), although similar solutions can be found in earlier books.

Torello-Hill and Turner point out that the Lyon Terence uses this technique profusely (*The Lyon Terence*, 142).

71 Carrick, "Lyon's *Terence*," 109–10.

72 The depiction of successive or simultaneous actions in a single pictorial space is common in medieval art, especially in illuminations, and goes back to at least Byzantine art (Keller and Kinkade, *Iconography*, 20–1; Kessler, *Illustrated Bibles*, 13–14; Carrick, "Lyon's *Terence*," 120–9).

73 I want to thank Amaranta Saguar García and her blog for this reference to the illustrated edition of *Melusina* as an example of the placement of characters going through doors in the early period of the printing press (*Por treze, tres* (blog), 5 July 2021, https://portrezetres.hypotheses.org/).

74 A similar double presence of the same figure is noticeable in the illustration from act 9, in which Celestina's body is partially inside the room where the banquet is taking place, and in the street outside, where Lucrecia is arriving.

75 The left-to-right order is also present in the illustrated manuscripts of Terentian plays. In these manuscripts, this order tries to represent both the temporal succession of events and the order of intervention of the characters in the play, which sometimes do not coincide (Torello-Hill and Turner, *The Lyon Terence*, 40).

76 The use of labels to identify the characters in illustrations is connected to the Carolingian tradition of manuscripts containing illustrations next to the text of Terence's plays. It appears also in the Lyon Terence (Torello-Hill and Turner, *The Lyon Terence*, 141). This use seems to connect the Burgos edition to the dramatic and stage tradition, since these labels are related to the list of dramatis personae included at the beginning of printed plays to help the reader. Labels are also used profusely in medieval art and in narrative texts.

77 According to Rodríguez-Solás, the figure of Calisto with the sword and the feather on the cap is inspired by the character of Thraso depicted in the Lyon Terence ("A la vanguardia," 13). However, this kind of figure is commonly used to represent wealthy young men in other images of the period.

78 Snow, "La iconografía"; Penney, *The Book Called* Celestina, 98; Marciales, *Celestina*, 6–7.

79 The repetition of a character in the same illustration can be traced to the images in the manuscripts of Terence's plays as an effort to show the succession of events (Torello-Hill and Turner, *The Lyon Terence*, 41).

80 Álvarez Moreno, "Notas," 316.

81 Gallego, *Historia del grabado*, 71.

82 Carmona Ruiz, "La recepción," 339–43.

83 Kish, "*Celestina*," 98.

84 Saguar García, "Las ilustraciones," 149. She also points out the influence of the 1499 Burgos illustrations on the German engravings.

85 Kish and Ritzenhoff, "The *Celestina* Phenomenon"; Saguar García, "Las ilustraciones."

86 Kish, "*Celestina*," 98–9.

87 Van der Pol, "The Whore," 9.

88 M. Lacarra, "*La Tragicomedia*," 242.

89 M. Lacarra, "*La Tragicomedia*"; Saguar García, "Un programa."

90 As Saguar García asserts in "Las ilustraciones," even if these illustrations follow the Burgos and Cromberger iconographic program, we cannot be sure whether some of the innovations are taken from a lost illustrated edition in Spanish.

91 Saguar García, "Un programa."

92 The peculiar treatment of the execution matches a similar inclusion in an illustration in the Salamanca 1540 edition, which includes a *rollo* (a pillory with ropes to tie the prisoners or expose their bodies after the execution). See M. Lacarra, "*La Tragicomedia*," 246.

93 Saguar García, "Un programa."

94 Goldschmidt, *The Printed Book*, 37; Keefe, "Manuscripts and Illustration."

95 Cole, "Historical Development," 306–7.

96 Morato Jiménez, "La portada," 61–3.

97 Montero, "Reading at the Threshold," contains an analysis of *LC*'s title pages, with conclusions similar to mine, including the increasing importance of the figure of Celestina.

98 Jiménez Ruiz, "Colombia."

99 Weiner, "Adam and Eve Imagery."

100 Albalá Pelegrín, "Gestures," 87.

101 Montero points out that the rosary can also be taken for a gold chain, given its size, and that "the way the necklace looks, as well as its excessive size … remind us of a noose, which may emphasize the connection of Calisto's *cadenilla* with her violent death" ("Reading at the Threshold," 208).

102 The use of the same engraving to illustrate acts 14 and 19 is part of Cromberger's iconographic program, as its edition was the first one to repeat them, a practice later followed by several other illustrated editions of the first period.

103 Ferguson, *Signs and Symbols*, 34.

104 The illustration on the cover of the 1519 Venice edition may be taken from or inspired by a gynecological book, because it represents an old woman in the common role of adviser to young women. The way the young woman's legs are spread apart and her belt high under her breasts may indicate that she is pregnant and getting ready for a gynecological exploration.

105 The last edition of *LC* printed in Spain in this period was printed in
 Madrid in 1632, although several bilingual editions with French and
 Spanish text were printed in France in the same decade and even later
 (Paolini, "Ediciones"; Serrano, *"La Celestina,"* 265).
106 On the problems of *LC* and the Inquisition, see Green, *"Celestina* and
 the Inquisition," and Gagliardi, *"La Celestina* en el *Índice."* On the lack of
 interest during the eighteenth century, due to new trends in literature,
 see Álvarez Barrientos, *"La Celestina,"* 88, 93, and Calderón Calderón,
 "Printing Licenses," 193.
107 Snow, "Peripecias," 16.
108 Simon, *500 Years of Art*, xi.
109 Snow, "A *Celestina* Revival," 177.
110 Marfany, "La 'Renaixença'"; Snow, "A *Celestina* Revival," 175n11.
111 The Augsburg 1520 edition is the only old edition with full-page illustrations.
112 Some books of the period that were sold by instalments included in their
 first instalment a table of contents that specified the location of the full-page
 illustrations when the book was bound (Botrel, "La doble función," 76).
113 Sánchez García, "Las formas del libro," 117–18.
114 Bastianes, *Vida escénica*, 22.
115 Rico, "Las primeras celestinas," 617.
116 Cotoner Cerdó, "La biblioteca," 17.
117 Rodríguez Gutiérrez, "Noticias" and "Ilustrando."
118 Barrero, "Orígenes," 34.
119 On the dominance of illustrated editions of *Don Quixote* among the
 editions for young audiences, see Sotomayor Sáez and Fernández
 Rodríguez, *El Quijote*.
120 Cabañas Bravo, "Miguel Prieto."
121 *LC* was popular in France at the beginning of the twentieth century, as
 proved by the publication of a free adaptation in 1929 by Fleuret and
 Allard. On this edition, see Verdevoye, *"La Célestine."*
122 The comical treatment of Celestina as a witch goes back to
 Hartzenbusch's successful comedy *Los polvos de la madre Celestina*, which,
 although not originally intended for children, eventually was perceived
 as such. In the early twentieth century, illustrated or partially illustrated
 short stories for children with the character of Celestina were published.
 She appears as a cute animal character in "Los polvos de la madre
 Celestina" in the comic *Bobín* (1932), and as a terrifying witch in the
 tradition of Grimms' stories in *Los polvos de la madre Celestina* (no relation
 to Hartzenbusch's comedy, except for the theme of witchcraft) by the
 popular publisher for children Pulgarcito (c. 1920). More recently, a comic
 format edition was published in Mexico in the didactic series Joyas de la
 Literatura (1988) by Bastien, and a peculiar version, also in comic format,

in which the characters are represented as birds, appeared in 2017, by Palmerín Navarro.

123 Iglesias, "*Celestina* in Film."

124 Bastianes, *Vida escénica*, 317; Fernández Rivera, "La picaresca," 885.

125 Teo Puebla's paintings are the only canvas series I know of that describes episodes of *LC* in pictorial. Some of these paintings were used for an illustrated edition published by the city of La Puebla de Montalbán in 1999. Now the paintings are part of the permanent collection of the Museum La Celestina, in that city.

126 Puebla, La Celestina *ilustrada*, 8.

127 Email exchange with Teo Puebla, 19 August 2018.

128 Holloway, *Making Time*, 103, 111.

129 On the interest of Picasso in *LC*, see Kleinfelder, *The Artist*, 200; Holloway, *Making Time*, 97–8, 116; Salus, "Picasso's Version" and *Picasso and Celestina*; and Rico, "Las primeras celestinas."

130 Baker, "A Duel," 221; Salus, *Picasso*, 124; Nowak, "Picasso's *Celestina* Etchings," 67n1.

131 Nowak, "Picasso's *Celestina* Etchings," 58, 67.

132 Salus, *Picasso and* Celestina, 221, 124.

133 Nowak, "Picasso's *Celestina* Etchings," 57.

134 Kleinfelder, *The Artist*, 97.

135 Baker, "A Duel," 227.

136 Nowak, "Picasso's *Celestina* Etchings," 57.

137 Holloway, *Making Time*, 101–2.

138 Kleinfelder, *The Artist*, 197.

2 Painting Celestina

1 The only exception to the lack of big canvases depicting episodes of *LC* is Teo Puebla's group of paintings in the Museo de La Celestina in Puebla de Montalbán. In spite of their large format, they were intended to be used for an illustrated edition of the book, as we saw in the previous chapter.

2 Taggard, *Murillo's Allegories*, 16.

3 Franklin, Beklen, and Doyle, "Influence of Titles," 104.

4 I thank Amaranta Saguar García for having pointed out to me the tradition of the *Bärentreiberin*, a similar type of medieval lecherous procuress, in German-speaking countries. See Loleit, *Wahrheit*, 179.

5 Interestingly, in the Parable of the Prodigal Son, Luke may be borrowing, as he does on other occasions, from the Greco-Roman comedies, specifically the figure of the young man who, with the help of a servant, appropriates and spends his father's money on courtesans (Callon, "Adulescentes and Meretrices").

6 Lida de Malkiel, *La originalidad artística*, 534–5.

7 *Codex Ambrosianus*, Milan, Bibliotheca Ambrosiana, S.P.4/bis or H 75 inf. known as F.

8 *Publius Terencius Afer*, fol. 99v.

9 *Publius Terencius Afer*, fol. 100r.

10 *Publius Terencius Afer*, fol. 102r, 103r, 104r.

11 Saunders, *Costume in Roman Comedy*, 57–8.

12 Menander, *Synaristosia*, 328, vv. 1–119.

13 De Caro and Pedicini, *National Archaeological Museum*, 141. The mosaic is in the National Archaeological Museum in Naples, inv. 9987. Later versions of mosaics of this scene exist: the mosaic from the House of Zosimus, Zeugma (Gaziantep Museum of Archaeology, inv. 8177); the mosaic from the House of Menander, Mytilene (New Archaeological Museum of Mytilene; see description in Menander, *Synaristosia*, 326); and the mosaic from Daphne near Antioch (Hatay Archaeology Museum).

14 Plautus: "Raro nimium dabat quod biberem, id merum infuscabat" (Too seldom did the servant give me something to drink, and, as it was, it clouded the colour of the wine, vv. 18–19).

15 On the laws against procuresses in the late medieval period, see Dillard, *Daughters of the Reconquest*, 196–213, and E. Lacarra, "Alcahueterías."

16 Campbell, "Prophets," 812–14.

17 Torrens, "Illicit Sex," 110. According to Torrens, this image is the only identified representation of a procuress in Western Romanesque art.

18 Torrens, "Illicit Sex," 106, 114.

19 See Lähnemann, Der *"Renner,"* for a complete description of *Der Renner*. Above the image of the woman is written the word *Bärentreiberin*, a reference connected to the procuress.

20 Schama, "Wives and Wantons," 13.

21 A similar engraving entitled *The Procuress* (c. 1537) by Vogtherr is probably a free copy of Schoen's image.

22 Mohrland, *Die Frau*, 186.

23 Silver, *Peasant Scenes*, 73.

24 "Crebrior imprimis potandis procreat usus omne inhonestatis luxuriaeque genus." Although they may not contain an indication in their titles, Renger (*Lockere Gesellschaft*, 24) connects these engravings with the tradition of an episode of the Prodigal Son that we will examine in detail later.

25 Roper, "Discipline," 3–4, and "Mothers," 17.

26 As we saw in the previous chapter, an illustrated edition of *LC* in German was produced as early as 1520 and a later one in 1534. The text was available in Dutch starting in 1550, and two other Dutch editions by the same printer followed in the following decades, to a total of probably five different editions, the last one in 1616 (Penney, *The Book Called* Celestina,

115–16). In addition, different cities in the area printed copies of the Spanish version for export, beginning in 1539. As Beardsley notices, about 22 per cent of the editions of the book in Spanish in the sixteenth century were produced in that region ("Lowlands Editions," 10). As Behiels and Kish note in the introduction to the scholarly edition of the Dutch translation, the population of Antwerp, where the translation was printed, "included a nucleus of Spanish businessmen, as well as a cultured class who could appreciate Spanish texts in the original language," a number that was increased after 1567 with the troops accompanying the Duke of Alba, which included many officers (Behiels and Kish, *Celestina*, 13–14).

27 "Sic Hispana Venus loculos excantat. Sic fucata rapit basia stultus amans."

28 Bond, "Mapping Culture," 542.

29 Aristotle, *Nicomachean Ethics*, 1121b11; Sluijter, "Emulating Sensual Beauty"; Hartung and Maierhofer, *Narratives of Life*, 134; Minois, *History of Old Age*, 95.

30 Ripa, *Iconologia*, 8; Kahr, "Danaë," 46n25.

31 Klein, *Graphic Worlds*, 102.

32 Ricardo Morales, "Tres Celestinas," 6.

33 Cuttler, "The Lisbon *Temptation*," 117.

34 Soler, 3, 41.

35 Although some critics consider the women behind the window prostitutes, their covered heads indicating their advanced age make them match the profile of the procuress (Cuttler, "The Lisbon *Temptation*," 113).

36 Silva Maroto, *Bosch*, 258–9.

37 The Parable of the Prodigal Son, one of the most represented parables, has generated a vast imagery of its seven episodes: petition of portion, departure, carousing with prostitutes, working as a swineherd, repentance, return, resentment of the older brother (Spieker, "The Theme of the Prodigal Son," 30–1). See Renger, *Lockere Gesellschaft*, for a study of the theme of the Prodigal Son in Dutch painting.

38 Philip, "The *Peddler*."

39 C. Brown, *Scenes*, 11; Renger, *Lockere Gesellschaft*, 143.

40 Delcorno, *In the Mirror*, 3, 8; Guest, "The Prodigal's Journey," 35, 42; Morris, "Pictures of Debauchery," 214; Haeger, "Cornelis Anthonisz's Representation," 146.

41 Verdier, "Tapestry," 24. The depiction of debauchery scenes of this type for moralizing purposes has two different origins in the art of the Low Countries: the festivities of peasants after the harvest and during other celebrations, and the fable of the Prodigal Son. The festivities of peasants began to be a common theme at the end of the fifteenth century in northern Europe, connected to printed engravings, which, as a new

medium, were more prone to depicting innovative subjects, such as daily
life. Drinking and debauchery were common in depictions of peasants
working in the different seasons and of their festivities, and inscriptions
condemning or deriding these behaviours were often added, as in
Bruegel's *The Fair at Hoboken*, printed in 1559 (C. Brown, *Scenes*, 9–13).

42 Wallen *Jan van Hemessen*, 55.

43 Delcorno, *In the Mirror*, 177–8.

44 Guest, "The Prodigal's Journey," 55.

45 Van der Pol, "The Whore," 3.

46 Delcorno, *In the Mirror*, 18, 370.

47 Van der Pol, "The Whore," 17n18.

48 Van der Pol, "The Whore," 17n18.

49 Some critics, such as Franits, do not agree that the depictions of
prostitution and brothels in these images are realistic, but rather that
they are somehow aestheticized (Franits, *Dutch Seventeenth-Century Genre
Painting*, 68).

50 Wallen, *Jan van Hemessen*, 56.

51 Morris, "Pictures of Debauchery," 213–17.

52 Franits, *Dutch Seventeenth-Century Genre Painting*, 68.

53 The denomination "genre painting" was not used until centuries later. On
the evolution of this denomination and its definition, see Renger, *Lockere
Gesellschaft*, 11–16, and Stechow and Comer, "History."

54 Van der Pol, "The Whore," 10.

55 Franits *Dutch Seventeenth-Century Genre Painting*, 82, 68.

56 Slatkes, "Utrecht and Delft," 85–6.

57 Van der Pol, "The Whore," 11.

58 Van der Pol, "The Whore," 15n2.

59 Blankert, Aillaud, and Montias, *Vermeer*, 43.

60 Franits, *Dutch Seventeenth-Century Genre Painting*, 203.

61 Van der Pol, "The Whore," 12.

62 Cuttler, "The Lisbon *Temptation*,"109n1.

63 Voragine, *Jacobi a Voragine*, 124.

64 Cuttler, "The Tempations of Saint Anthony," 40, 53–62, and "The Lisbon
Temptation," 112.

65 There are at least six very similar paintings by Titian of this subject, but
some do not include the servant (Detlev, "Another Version of the *Danaë*").
The figure of the servant appears only in some versions of the story
(Sluijter,"Emulating Sensual Beauty," 28n107). Kahr, "Danaë," provides a
complete review of the treatment of Danaë in art. Including a character who
looks like a procuress in the scene is especially justified because Danaë had
been a symbol of mercenary love since antiquity, and she appears as a bad
influence in Terence's *Eunuchus* (Santore, "Danaë," 417–20). The association

of Danaë with prostitution is still pertinent in this period: the Dutch painting *The Story of the Prodigal Son*, attributed to a follower of the painter Frans Franck II includes a painting of Danaë (also accompanied by an old woman) on the wall (Sluijter,"Emulating Sensual Beauty," 28–9). For a survey of the treatment of Danaë in literature and the presence of an older servant, see Panofsky, *Problems in Titian*, 144–7.

66 Brine, Ciletti, and Lähnemann, *The Sword of Judith* , 56. A similar face to that of Judith's servant Abra appears in a painting attributed to Caravaggio, *The Toothpuller* (c. 1608) (Gash, "Caravaggio's Maltese Inspiration").

67 Slatkes, "Utrecht and Delft," 85. Paintings of Judith with a procuress-like servant are not as common as those of Danaë, given the Biblical origin of the Judith story and her symbolism as a predecessor of the Virgin Mary in defeating sin or the devil. During the Counter-Reformation, the episode of Judith and Holofernes was seen as prefiguring the Visitation, with the old servant compared to Elizabeth. Furthermore, in some southern European countries, Judith became an allegorical figure of the Catholic Church decapitating the monster of heresy.

68 Santesso, "William Hogarth," 520n32; C. Brown, "Anthony," 51.

69 It can be argued that the theme of the profligate young man who wastes his inheritance is latent in Calisto. Even Pármeno, whose supposed inheritance Celestina is keeping, is, in some respects, the reversal of the figure.

70 Alcalá Flecha, *Matrimonio*, 79.

71 Cantera Montenegro, "El pícaro," 215.

72 McKim-Smith et al., "Velázquez," 79; Haraszti-Takács, *Spanish Genre Painting*, 119.

73 Haraszti-Takács, *Spanish Genre Painting*, 186. On prostitutes using the windows for their trade, see Kuffner, *Fictions of Containment*, 135–46.

74 Tomlinson and Welles, "Picturing the Picaresque," 68. Only since Jonathan Brown has the interpretation of these two painting as depicting characters and events related to prostitution been common (see J. Brown, "Murillo").

75 Taggard, *Murillo's Allegories*, 121n4.

76 Oteiza Pérez, "Para la historia"; Taggard, *Murillo's Allegories*, 16–19.

77 Dorival, "Callot."

78 Taggard, *Murillo's Allegories*, 200.

79 Murillo also differs from the Dutch tradition in his avoidance of lewd images, following the Council of Trent's advice in the scene of the Prodigal Son carousing with the prostitutes: he makes their outfits and behaviours more circumspect, not showing money or embraces or other gestures than can be taken as suggestions of sexual acts (Taggard, *Murillo's Allegories*, 36).

80 Taggard, "A Source," 93, and *Murillo's Allegories*, 52.

81 Alcalá Flecha, *Matrimonio*, 79. A *maja* is a young woman of the popular class dressed according to the fashion of the period and exhibiting cheeky

behaviour. "*Majismo*, a cultural phenomenon that embodied the popular aesthetic from the second half of the eighteenth century, was partially a xenophobic reaction to the perceived boost in outside influence on Spain, as well as a challenge to the progressive reforms instituted during the Enlightenment. More significantly, *majismo* served as a means to 'regain' Spanish heritage" (Zanardi, *Framing Majismo*, 19).

82 Paret y Alcázar also painted *La carta* (The missive, c. 1772), a typical rococo painting of an elaborate garden in which a woman is reading a letter, probably from a suitor, while an older woman, who could be her servant or the courier who brought the letter, is sitting as if waiting for an answer. However, the older woman is not depicted as a Celestina character.

83 Matilla, "*La Celestina*," 61; Snow, "A *Celestina* Revival," 48; Bray, "Paret y Alcázar."

84 Matilla, "*La Celestina*," 62.

85 López-Rey, *Goya's Caprichos*, 15–20; López Vázquez, "Prostitución."

86 Guereña, "Prostitution," 218. "In 1623 brothels were declared illegal by a law which was repeated in 1632. Some seven years later, the Crown made an incongruous concession to prostitutes when it allowed them to wear certain clothes forbidden to other women. However, the axe fell in 1661, when Philip IV decreed that prostitution was a penal offence" (Harrison, "Nuns and Prostitutes," 56). Evidence of social acceptance of men's discreet frequenting of prostitutes is Nicolás Fernández de Moratín's satire *El arte de las putas* (1770), in which he compares the good and the bad procuress from the point of view of the male client (Alcalá Flecha, *Matrimonio*, 77–81).

87 Gordon, "Goya Had Syphilis."

88 Alcalá Flecha, *Matrimonio*, 96.

89 Some images in the Album may be earlier, according to Wilson-Bareau and Lubbock, *Goya*, 135.

90 Schmidt, "Celestinas," 281.

91 Pérez Sánchez and Sayre, *Goya*, 299–300.

92 Alcalá Flecha, *Matrimonio*, 78.

93 Puelles Romero, "La representación de la 'mujer pública,'" 114.

94 Alcalá Flecha, *Matrimonio*, 102–3.

95 Some critics, such as Angulo Íñiguez, connect this balcony scene to Murillo's painting of two women at a window ("Murillo y Goya," 211–12). Related to this painting by Goya is also his watercolour and ink on ivory *Maja y Celestina* (c. 1824), which shows a similar scene. Another painting that represents two women sitting on a balcony, known as *Majas en el balcón* (c. 1808), which sometimes is connected to this one, is not considered today to be by Goya. There is also a recently identified painting on alabaster by Goya with a procuress and a *maja* (*Maja y Celestina*, c. 1824) (Schmidt, "Celestinas," 287n11, 288).

96 Pérez Sánchez and Sayre, *Goya*, 160.
97 Ricardo Morales, for instance, considers Goya's *Dos mujeres y un hombre* (Two women and a man, c. 1820), one of the Black Paintings he did for his Quinta del Sordo house at the end of his life, and another example of a Celestina character ("Tres Celestinas," 7).
98 Bozal, "Dibujos grotescos," 411–15.
99 Schmidt, "Celestinas," 287.
100 "Porque felizmente los tiempos que alcanzamos, las costumbres han adelantado lo bastante para que la Celestina se considere como un peón que sobra y como pieza que no tiene aplicación. Las negociaciones de amor suelen hacerse ahora directamente y sin necesidad de mandato o procuraduría. Denos Dios larga vida para ver hasta dónde en este ramo podemos llegar progresando." Estébanez Calderón, *Los españoles pintados*, 11 (my translation).
101 Estébanez Calderón, *Los españoles pintados*, 29.
102 Reina Palazón, "El costumbrismo."
103 Schmidt, "Celestinas," 275.
104 Ginger, *Painting*, 54.
105 Schmidt, "Celestinas," 291–2; Ginger, *Painting*, 262.
106 Schmidt, "Celestinas," 293.
107 Delgado Bedmar, "Vida y obra."
108 Álvarez Barrientos, *"La Celestina,"* 96.
109 Snow, "Los estudios."
110 Lloret i Esquerdo, García Juliá, and Casado Garretas, *Documenta títeres*, 37.
111 Carrasco Garrido, "Arte, moral y prostitución," 384.
112 Caparrós Masegosa and Guillén Marcos, "Prensa católica," 125–6.
113 Carrasco Garrido, "Arte, moral y prostitución," 382.
114 Rodríguez Fischer, "La España negra," 29–32.
115 Valverde Madrid, "En el centenario," 95.
116 Raya Téllez sees *El pecado* as a homage to Velázquez's *La Venus del espejo* ("Modelos de mujer," 247). Interestingly, Ricardo Morales identifies a hardly visible figure in Velázquez's *La Venus del espejo* as Celestina, who is included as an allegory of past beauty ("Velázquez").
117 Raya Téllez, "Modelos de mujer," 245–6.
118 Goya's *Capricho 31*, *Ruega por ella* (Pray for her, 1799) is another proposed source of inspiration for this Romero de Torres painting (Litvak, *Julio Romero de Torres*, 51).
119 A more modest version entitled *La Fuensanta* (1929), in which the same model is reclining over a water jar, was chosen for the reverse of the one hundred peseta banknote, and this image, together with *La chiquita piconera*, was common in calendars of the period. A version conveniently cut at the hips was also issued as a Spanish postal stamp in 1965.

120 Storm, "Zuloaga, Ignacio"; Crosson, "Ignacio Zuloaga," 27–9, 58–60, 70.
121 Rodríguez Aguilar, *Arte y cultura*, 552.
122 Fernández Rivera, "Dos ilustraciones."
123 Pérez Magallón, *Calderón*, 345.
124 Iglesias, "*Celestina* in Film"; López Ríos, "*La Celestina*"; Bastianes, *Vida escénica*.
125 The references to Picasso are to the catalogue number in Enrique Mallen, ed., On-line Picasso Project, Sam Houston State University, 1997–2021, https://picasso.shsu.edu/.
126 Salus, *Picasso*, 16, 25, 44, 132.
127 Rico, "Las primeras celestinas."
128 Salus, *Picasso*, 23.
129 "Tercera chorreando" in *Carnet parchemin*, 1940, P:1, L:4; P:9; L:11; "Las cajas de betún" (1959) P:8, L:9 and P:3, L:17. See Mallen, On-line Picasso Project, for the whole text.
130 Holloway, *Making Time*, 116; Rico, "Las primeras celestinas," 615–16.
131 Salus, *Picasso*, 38–44.
132 Salus, *Picasso*, 40.
133 Rico, "Las primeras celestinas," 620.
134 Imbert, *Picasso*, 38–9.
135 Rico, "Las primeras celestinas," 623.
136 Imbert, *Picasso*, 40.
137 Rico, "Las primeras celestinas," 624; Salus, *Picasso*, 68–76.
138 Salus, *Picasso*, 76. Blindness is a frequent attribute in figures Picasso painted during his Blue Period (1901–4), in which he often portrayed underdogs, without falling into the contrived pathos of social realism.
139 Salus, *Picasso*, 92.
140 Steinberg, "Philosophical Brothel"; Imbert, *Picasso*, 51.
141 Steinberg, "Philosophical Brothel," 10; Rubin, *Les demoiselles d'Avignon*, 60. Some similarity between *Le harem* and *Les demoiselles d'Avignon* made Rubin suggest that the crouching woman to the right in the latter was inspired by the Celestina figure in *Le harem* (62).
142 Celestina appears in several other of Picasso's paintings of that period, such as *Personnages et colombe* (OPP.54:127), *Le modèle et deux personnages* (OPP.54:129), *La présentation III* (OPP.54:203), and *L'Atelier du vieux peintre* (OPP.54:132).
143 Salus, *Picasso*, 98.
144 Dominguín and Boudaille, *Pablo Picasso*. Celestina appears in a similar book on bullfighting with text by Sabartés. The plates are OPP.60:100, OPP.60:175, OPP.60:188, OPP.60:233, OPP.60:293, OPP.60:308, OPP.60:345, OPP.60:347, OPP.60:355, OPP.60:356, OPP.60:359, OPP.60:360, OPP.60:361, and OPP.60:370.
145 Schama, "Rembrandt's Ghost."
146 Holloway, *Making Time*.

147 Schiff, *Picasso*, 11.
148 Salus, *Picasso*, 124.
149 Schiff, *Picasso*, 60.
150 Salus, *Picasso*, 129.
151 Salus, *Picasso*, 132.
152 Leonard, *Books of the Brave*, 98, 222.
153 Alba-Koch, "*Celestina*," 347.
154 Unlike the usual depiction of *chinas*, the one in this painting is blond, which Alba-Koch sees as an allusion to the corruption that the intervention of foreign powers introduced to the liberal ideals of the young Mexican Republic ("*Celestina*," 360).
155 Moriuchi, *Mexican Costumbrismo*, 26.
156 González Ruiz, "Colombia," 103; Sillevis et al., *The Baroque World*, 39, 49–51.
157 Ratcliff, *Botero*, 31; Chiappini, "Affirmation," 2–5; Sillevis et al., *The Baroque World*.
158 Chiappini, "Affirmation," 1–2.
159 Sullivan, *Fernando Botero*, xiii.
160 Sullivan, *Fernando Botero*, xii; Vargas Llosa, *Fernando Botero*, 24.
161 González Ruiz, "Colombia," 186.
162 Sillevis et al., *The Baroque World*, 37; Vargas Llosa, *Fernando Botero*, 34, 38.
163 Bradley, "Introduction."
164 Rosenthal, *Paula Rego*, 227.
165 Weissberger, "Genesis," 410.
166 Rosenthal, *Paula Rego*, 228.

3 Advertising Celestina

1 Male, *Illustration*, 176–8.
2 Wakeman, *Victorian Book Illustration*, 161–3; Weill, *The Poster*, 17–23.
3 Genette, *Paratexts*, 1–2.
4 Pérez, "La imagen," 106.
5 The proof that covers are important from a promotional point of view is that they continue to be used for electronic books, which do not need physical protection. In the few circulating editions of LC in this format, some reproduce the images of the physical covers of the paper edition. Small presses that produce exclusively electronic versions tend to produce covers mostly with stock pictures not especially connected to the content of the book or the visual culture of Celestina, a result of hurried editorial decisions. At the moment, these editions are mostly commercialized via Amazon; many do not have an ISBN, but rather a merchandise number provided by Amazon. For all these reasons, we are not including them in this study.

6 Morato Jiménez, "La portada," 31–6. The disposable status of modern covers is epitomized by one of their variations: the dust jacket. Removable, and printed on normal paper with colourful images, dust jackets are conceived not so much to offer the protection their name implies but as an added selling prop easily discarded after purchase.

7 The idea of the cover or title page as the entrance to the book is evidenced from the early days of the printing press in the use of architectural frames decorating the title pages (Moreno Garrido and Pérez Galdeano, "El frontispicio," and Cacheda Barreiro, "La portada").

8 I thank María Bastianes for her remark that these covers representing locks coincide with the beginnings of the trend in Spain of lovers fixing locks to bridges and other public structures as symbols of their love. Personal communication, 4 June 2020.

9 Male, *Illustration*, 178.

10 Snow, "A *Celestina* Revival." From the surviving copies – unfortunately many of which have been rebound – we can infer that it was sold with hard covers in materials ranging from leather to paper paste, with the title and name of the author printed only on the spine. Its title page was an unadorned sheet with editorial information, similar to today's title pages. The only promotional concession was the inclusion on the title page of the line "nueva edición con las variantes de las mejores ediciones antiguas" (new edition made with the variants of the best old editions). On the old editions that Amarita may have consulted, some of them with an illustrated title page and other illustrations inside, see Rank, "Significance."

11 A survey of the library and ISBN catalogues shows the increased popularity of LC beginning in the sixties. The demographics of Spain, the extension of postsecondary education, and the incipient trends of political liberalization fostered this increase in the number of editions of LC, along with other books. As Botrel states, the number of printed books in 1970 in Spain is four times larger than those published in 1960 (*Libros*, 62).

12 Wakeman, *Victorian Book Illustration*, 11.

13 Martínez Martín, "La edición artisanal," 32.

14 Rueda Laffond, "La fabricación del libro," 73.

15 Sánchez García, "Las formas del libro," 247.

16 Jewitt and Kress, *Multimodal Literacy*, 2.

17 Cotoner Cerdó, "La biblioteca."

18 Rodríguez Gutiérrez, "Noticias," 106.

19 Clarke, *A Further Range*, 268n20.

20 Ashbee, *Iconography*, 156.

21 Thirteen copies of this edition are available at the National Library in Madrid, which testifies to its editorial success.

22 Rueda Laffond, "La fabricación del libro," 79.
23 A similar use of typography was adapted for León Amarita's 1822 title page, in which a Gothic font imitating the old books is used for the word "Celestina," while more modern but also elegant fonts are used for the rest of the page. The text of Amarita's edition uses the modern-looking Times Roman font, which is easy to read even today.
24 Cruz, "Camilo José Cela." Cela's adaptation of the LC text for this version is described in Bastianes, *Vida escénica*, 213n3.
25 López-Ríos, "*La Celestina.*"
26 This 2009 edition contains a free adaptation of LC for a theatrical version by Jesús Torres (Bastianes, *Vida escénica*, 392).
27 The gesture of rubbing her hands in satisfaction reappears on several LC covers from the twentieth century, such as Fama (Barcelona, 1955) and Editorial Ferma (Barcelona, 1967), perhaps influenced the Sopena edition (c. 1920).
28 Covers that, like the 1942 Molino edition, emphasize the evil-looking Celestina but suppress the lovers emphasize a moralistic reading while downplaying the erotic aspects of the book, in accordance with the strict censorship under Francoism in Spain. This hypothesis seems to be confirmed by how the same figure by Botticelli is used in the Editorial Época 1997 and 2010 editions of LC, but the old woman is not touched up to look evil and a young couple of lovers is added next to her.
29 Male, *Illustration*, 54.
30 The text of this edition was used for a theatrical adaptation in 1943. As Bastianes writes, this adaptation pioneered the comic treatment of the sexual scenes in the story (*Vida escénica*, 142, 258n63).
31 Torres Lins, "A encenação," 43, 122–7.
32 Bastianes, *Vida escénica*, 59.
33 I thank María Bastianes for allowing me to read her book during the final stage of its production before it was published.
34 Brewster and Jacobs, *Theatre to Cinema.*
35 Forbes, *Illustrated Playbills*, 1–17.
36 Morales Carrión, "El retrato"; Bueno Doral and García Castillo, "El cartel."
37 McAuley, "Photography."
38 Pinney, *Advertising Photography*, 19.
39 Sobieszek, *Art of Persuasion*, 34.
40 Among others, Sontag, in her work on photography, famously comments on the voyeuristic nature of the camera. The spying capability of the photographic lenses is enhanced with the common use in advertising of so-called candid photos of the actors, off-stage photos, and so on, which add an aura of direct access to their true nature (McAuley, "Photography," 7).
41 Gunning, "Plenary Session II."

42 The artistic nature of photography is confirmed by how, in the first years after its invention, photographers adapted techniques of composition and contrast taken directly from other visual arts, especially painting (Savedoff, *Transforming Images*, 93–4).

43 Although the first documented stage adaptation of *LC* is from 1909, scholars claim that several previous performances took place. First are the dramatized readings implicit in the added material in the 1514 Valencia edition. Nothing is known of these readings, or of a supposed performance that took place in 1501 during the festivities for the wedding of Lucrezia Borgia and Alfonso d'Este in Rome. See Scoles, "Note" and Paolini, "La comedia."

44 Bastianes, *Vida escénica*, 30–3.

45 Bastianes, *Vida escénica*, 46–60.

46 Delgado and Gies, *History of Theatre*, 282–7.

47 "Four Stage Adaptations," 48; Bastianes, *Vida escénica*, 72.

48 Bastianes, *Vida escénica*, 58.

49 Delgado and Gies, *History of Theatre*, 282 and 287; Bastianes, *Vida escénica*, 35–6.

50 Delgado and Gies, *History of Theatre*, 286; Smyth, "Beyond the Picture-Frame Stage," 5; Weill, *The Poster*, 9–23.

51 Peña, "Los carteles" and "A vueltas."

52 Barnicoat, *Concise History*, 7.

53 Bastianes, *Vida escénica*, 69.

54 Delgado and Gies, *History of Theatre*, 290.

55 *Nuevo Mundo*, no. 725, 28 November 1907, 8–9; *El Arte del Teatro*, no. 45, 1 February 1908.

56 Delgado and Gies, *History of Theatre*, 277.

57 Bastianes, *Vida escénica*, 63–5.

58 Diago Moncholí, "José Ricardo Morales"; Bastianes, *Vida escénica*, 225.

59 Bastianes, *Vida escénica*, 104–50.

60 A similar image was used in the advertising campaign of Arnaut's stage adaptation of the Espace culturel Térraqué (Carnac, France, 2014), which resorts to a fragment of Bosch's triptych *The Garden of Earthly Delights* (c. 1490).

61 Bastianes, *Vida escénica*, 163. Although several adaptations of LC were staged in Spain in the preceding years, their posters and handbills have not survived.

62 A variation of this technique is the poster used for the much more modest 2014 adaptation by Calvo and Bernárdez for the XVIII Certamen de Teatro Universitario UCM, Madrid. The two halves of the face of the actress playing Celestina are shown separated by a vertical line, but the right side has been digitally altered to show the wrinkles in a much more prominent way than the other half.

63 Carlson, *The Haunted Stage*, 7–11.
64 Bastianes, *Vida escénica*, 396.
65 We omit from this review free adaptations, such as *La Celestina P… R..* by Lizzani (1965), because they barely relate to the text of LC except for a few names and situations.
66 Iglesias, "*Celestina* in Film," 388.
67 Iglesias, "*Celestina* in Film," 390.
68 Iglesias, "*Celestina* in Film," 394.
69 McAuley, "Photography," 7.
70 *Celestina*, edited by Gorchs (1841), 134.
71 Nadeau, "Transformation."
72 François, *La Celestina*, 177; Vian Herrero, "El pensamiento" and "Transformaciones."
73 Rubio Jiménez and Puebla, *Retratos*, 39–40, 46.
74 Sánchez de Palacios, "La caricatura."
75 Akkad Galeote, "Casandra," 4.
76 Ugalde in *ABC* of 14 November 1940. INAEM https://www.teatro .es/catalogo-integrado/julia-delgado-caro-9623-1. Córdoba in *Pueblo Newspaper*, 14 November 1940.
77 Booklet of the 1969 film *La Celestina*, written by César Ardavín Fernández and Fernando de Rojas, and directed by César Ardavín Fernández, produced by Aro Films, Hesperia Film, and Berlin Television System.
78 In 1967, Fuller's adaptation for Spanish television completely altered the scene, suggesting that a more explicit image of this episode could have had problems with censorship.
79 Gubern and Font, *Un cine*, 90.

Bibliography

Old Editions of *La Celestina* Cited, by Date

1499? *Comedia de Calisto y Melibea*. Burgos: Fadrique de Basilea.

1500. *Comedia de Calisto y Melibea*. Toledo: Pedro Hagenbach.

1501. *Comedia de Calisto y Melibea*. Seville: Estanislao Polono.

1502 (1511). *Tragicomedia de Calisto y Melibea*. Seville: Jacobo Cromberger.

1507. *Tragicomedia de Calisto y Melibea*. Zaragoza: Jorge Coci.

1514. *Tragicomedia de Calisto y Melibea*. Valencia: Juan Joffre.

1515? *Tragicomedia de Calisto y Melibea*. Rome: Marcelo Silber.

1518. *Tragicomedia de Calisto y Melibea*. Valencia: Juan Joffre.

1519. *Celestina. Tragicomedia de Calisto et Melibea*. Translated by Alphonso Hordognez. Venice: Cesare Arrivabene.

1520. *Ain hipsche Tragedia*. Translated by Christoph Wirsung. Augsburg: Sigmund Grimm and Marx Wirsung.

1523. *Tragicomedia de Calisto y Melibea*. Seville: Juan Batista Pedrezano.

1526. *Tragicomedia de Calisto y Melibea*. Toledo: Remón de Petras.

1528. *Tragicomedia de Calisto y Melibea*. Seville: Jacobo and Juan Cromberger.

1529. *Tragicomedia de Calisto y Melibea*. Valencia: Juan Viñao.

1531. *Tragicomedia de Calisto y Melibea*. Venice: Juan Bautista Pedrezano.

1534. *Ain hipsche Tragedia*. Translated by Christoph Wirsung. Augsburg: Heinrich Steiner.

1534. *Tragicomedia de Calisto y Melibea*. Venice: Stefano Nicolini da Sabio.

1538. *Tragicomedia de Calisto y Melibea*. Toledo: Juan de Ayala.

1539. *Tragicomedia de Calisto y Melibea*. Antwerp: Guilielmus Montanus.

1540. *Siguese la Tragicomedia de Calisto y Melibea trobada y sacada de prosa en metro castellano por Juan Sedeño*. Salamanca: Pedro de Castro.

1540. *Tragicomedia de Calisto y Melibea*. Lisbon: Luís Rodrigues.

1545. *Tragicomedia de Calisto y Melibea*. Zaragoza: Diego Hernández.

1545. *Tragicomedia de Calisto y Melibea*. Zaragoza: Jorge Coci, Pedro Bernuz and Bartolomé de Nájera.

1550. *Celestina: ende is een tragicomedie van Calisto en Melibea*. Antwerp: Hans de Laet.

1554. *Tragicomedia de Calisto y Melibea*. Zaragoza: Pedro Bernuz.

1557. *Tragicomedia de Calisto y Melibea*. Estella: Adrián de Amberes.

1561. *Tragicomedia de Calisto y Melibea*. Valladolid: Francisco Fernández de Córdoba.

1563. *Tragicomedia de Calisto y Melibea*. Alcalá de Henares: Francisco de Cormellas and Pedro de Robles.

1569. *Tragicomedia de Calisto y Melibea*. Madrid: Pierres Cosin and Antón García.

1574. *Een tragicomedie van Calisto ende Melibea*. Antwerp: Heyndric Heyndricz.

1575. *Tragicomedia de Calisto y Melibea*. Valencia: Joan Navarro.

1577. *Tragicomedia de Calisto y Melibea*. Salamanca: Pedro Lasso.

1582. *Tragicomedia de Calisto y Melibea*. Medina del Campo: Francisco del Canto.

1590. *Tragicomedia de Calisto y Melibea*. Salamanca: Juan and Andrés Renaut.

1595. *Tragicomedia de Calisto y Melibea*. Tarragona: Felipe Roberto.

1607. *Tragicomedia de Calisto y Melibea*. Zaragoza: Carlos de Lavayen and Juan de Larumbe.

1616. *Tragicomedie van Calisto ende Melibea*. Antwerp: Heyndric Heyndricz.

1632. *Tragicomedia de Calisto y Melibea*. Madrid: Viuda de Alonso Martín.

Modern Editions of *La Celestina* Cited, by Date

1822. *La Celestina ó, tragi-comedia de Calisto y Melibea*. Madrid: Don León Amarita.

1835. *La Celestina ó, tragi-comedia de Calisto y Melibea*. Madrid: Don León Amarita.

1841. *La Celestina o Calixto y Melivea*. Edited by Tomás Gorchs. Barcelona: Tomás Gorchs.

1846. *La Celestina*. In *Novelistas anteriores a Cervantes*, edited by Buenaventura Carlos Aribau, 1–75. Madrid: Imprenta de Rivadeneyra.

1872. *La Celestina: Traji-comedia de Calisto y Melibea*, edited by Buenaventura Carlos Aribau. Madrid: Imprenta y Estereotipia de M. Rivadeneyra.

1883. *La Celestina: Tragi-comedia de Calisto y Melibea … obra famosísima escrita por Rodrigo de Cota. Biblioteca Amena e Instructiva*, by Fernando de Rojas, Juan de Mena y Rodrigo de Cota. Illustrated by Ramón Escaler. Barcelona: Imprenta y Litografía de los Sucesores de Narciso Ramírez y Cia.

1886. *La Celestina: Tragi-comedia de Calisto y Melibea*, by Fernando de Rojas, Juan de Mena, and Rodrigo de Cota. Barcelona: D. Cortezo.

c. 1920. *La Celestina*. Barcelona: Ramón Sopena.

1922. *La Célestine ou Tragi-comédie de Calixte et Mélibée*. Translated by A. Germond de Lavigne. Illustrated by D. Galanis. Paris: La Nouvelle Revue Française.

1929. *La Célestine, tragi-comédie imité de l'espagnol*, adapted by Fernand Fleuret and Roger Allard. Paris: Éditions Trianon.

1942. *La Celestina*. Edited by José Mallorquí Figuerola. Barcelona: Molino.

1943. *La Célestine. Tragi-comédie de Calixte et Melibee*. Adapted by Paul Achard. Illustrated by Maurice L'Hoir. Paris: Les Éditions de la Nouvelle France.

1946. *La Celestina*. Illustrated by Josep Segrelles. Valencia: Castalia.

1947. *La Celestina, Tragicomedia de Calisto y Melibea*. Edited by A. Millares Carlo and José Ignacio Mantecón. Illustrated by Miguel Prieto. Mexico City: Editorial Leyenda.

1949. *La Célestine. Tragi-comédie de Calixte et Mélibée*. Translated by Germond de Lavigne. Illustrated by Maurice Lalau. Paris: Les Bibliophiles de France.

1955. *La Celestina*. Barcelona: Editorial Fama.

1959. *La Celestina y Lazarillos*. Edited by Martín de Riquer. Illustrated by Lorenzo Goñi, J. Palet and R. de Capmany. Barcelona: Editorial Vergara.

1962. *La Celestina*. Mexico City: Editora Nacional.

1963. *La Celestina*. Prologue by Federico Carlos Sainz de Robles. Madrid: Aguilar.

1964. *La Celestina*. Barcelona: Mateu.

1964. *La Celestina*. Madrid: Edime.

1966. *La Celestina*. Colección Eterna. Barcelona: Editorial M. & S.

1967. *La Celestina*. Prologue by J. García Pérez. Barcelona: Editorial Ferma.

1967. *La Celestina*. Translated by Walmir Ayala. Prologue by Rosa Chacel. Brasilia: Coordenada.

1967. *La Celestina. Tragicomedia de Calixto y Melibea*. Barcelona: Bruguera.

1968. *La Celestina*. Edited by Manuel Criado de Val. Bilbao: Moretón.

1968. *La Celestina (Tragicomedia de Calisto y Melibea)*. Illustrated by F. Ezquerro. Barcelona: Ediciones Marte.

1969. *La Celestina*. Annotated by Javier Costa Clavell. Barcelona: Rodegar.

1970. *La Celestina*. Adapted and illustrated by A.J.M. Madrid: Aguilar.

1971. *La Celestina*. Bilbao: Editorial Vasco Americana.

1971. *La Célestine*. Illustrated by Pablo Ruiz Picasso. Translated by Pierre Heugas. Paris: Editions de l'Atelier Crommelynck.

1972. *La Celestina*. Preface by Enrique Carrión Ordóñez. Lima: Editorial Universo.

1974. *La Celestina*. Edited by Bruno Mario Damiani. Madrid: Cátedra.

1976. *La Celestina*. Madrid: EDAF.

1978. *La Celestina*. Clásicos Universales de la Literatura Erótica. Madrid: Club Internacional del Libro.

1979. *La Celestina*. Adapted by Camilo José Cela. Barcelona: Editorial Destino.

1980. *La Celestina*. Preliminary study by Josefina Delgado. Buenos Aires: Centro Editor de América Latina.

1981. *La Celestina*. Barcelona: Círculo de Lectores.

1984. *Celestina*. Translated by Vojmir Vinja, and Drago Ivanisevic. Introduction by Ivo Hergesic. Split: Logos.

1984. *La Celestina*. Annotated by Regula Rohland de Langbehn. Buenos Aires: Huemul.

1985. *La Celestina*. Mexico City: Editores Mexicanos Unidos.

1987. *La Celestina*. Edited by Dorothy S. Severin. Annotated by Maite Cabello. Madrid: Cátedra.

1988. *La Celestina*. Edited by Enrique Ortenbach. Illustrated by Bartolomé Liarte. Graphic designer Joaquín Monclús. Barcelona: Editorial Lumen.

1989. *La Celestina*. Illustrated by Pablo Ruiz Picasso. Translated by Fritz Vögelsang. Frankfurt: Insel.

1990. *A Celestina*. Translated by Paulo Hecker Filho. Porto Alegre: Sulina.

1990. *De la edad media al renacimiento: La Celestina*, by Florencio Sevilla Arroyo. Madrid: Anaya.

1993. *La Celestina*. Edited by Manuel Cifo González. Madrid: Bruño.

1994. *La Celestina*. Madrid: P.M.L.

1994. *La Celestina*. Translated by Antonio Gasparetti. Edited by Francisco J. Lobera Serrano. Introduction by Carmelo Samonà. Milan: Biblioteca Universale Rizzoli.

1995. *La Celestina*. Translated by Viviana Brichetti. Introduction by Pier Luigi Crovetto. Milan: Garzanti.

1996. *La Celestina*. Introduction by María Eugenia Lacarra. Barcelona: Ediciones B.

1997. *La Celestina*. Preface by Guadalupe Obón León. Mexico City: Editorial Época.

1998. *La Celestina*. Annotated by Pilar G. Moreno. Preface by Emiliano M. Aguilera. Barcelona: Orbis.

1998. *La Celestina*. Edited by Dorothy S. Severin. Introduction by Stephen Gilman. Madrid: Alianza Editorial.

1999. *La Celestina*. Edited by Julio Rodríguez Puértolas. Illustrated by Teo Puebla. Prologue by Juan Goytisolo. La Puebla de Montalbán, Toledo: Ayuntamiento de La Puebla de Montalbán.

1999. *La Celestina*. Introduction by Juan Manuel Rodríguez. New York: Alba.

2002. *La Celestina*. Edited by Esther Borrego. Madrid: Cooperación Editorial.

2002. *La Celestina*. Illustrated by Eulogia Merle. Buenos Aires: Editorial Longseller.

2003. *La Celestina*. Edited by Patricia S. Finch. Newark, DE: Cervantes & Co.

2003. *La Celestina*. Santiago de Chile: Alba Editores.

2004. *La Celestina*. Madrid: El País.

2006. *The Celestina. A Fifteenth-Century Spanish Novel in Dialogue*. Translated by Lesley Byrd Simpson. Berkeley and Los Angeles: University of California Press.

2006. *La Celestina*. Mexico City: Editores Mexicanos Unidos.

2006. *La Célestine*. Translated by Aline Schulman. Preface by Juan Goytisolo and Carlos Fuentes. Paris: Fayard.

2007. *La Celestina*. Edited by Lucia Do Rey. Annotated by Victoria Sanz. Cover illustration by Antonio Franchi Flora. Milan: La Spiga.

2007. *Tragicomedia de Calisto y Melibea*. Illustrated by Pablo Ruiz Picasso. Barcelona: Editorial Planeta.

2008. *La Celestina*. Edited by Francisco Bautista. Barcelona: Edebé.

2009. *La Celestina*. Adapted by Jesús Torres. Madrid: Ediciones del Orto.

2009. *La Celestina*. Adapted by José Ricardo Morales. Santiago de Chile: Editorial Universitaria.

2009. *La Celestina*. Edited by Roberto González Echevarría. Translated by Margaret Sayers Peden. New Haven, CT: Yale University Press.

2010. *La Celestina*. Mexico City: Editorial Época.

2010. *La Celestina*. Edited by Vicente Muñoz Puelles. Illustrated by Beatriz Martín Vidal. Madrid: Oxford University Press.

2010. *La Celestina*. *Tragicomedia de Calisto y Melibea*. Edited by María Gil-Ortega. Illustrated by Javier Jódar. Clásicos de Fácil Lectura 3. Madrid: Editilia.

2010. *Comedia de Calisto y Melibea*. *Hacia La Celestina anterior a Fernando de Rojas*. Edited by José Antonio Bernaldo de Quirós Mateo. Madrid: Editorial Manuscritos.

2011. *La Celestina*. Edited by Luis Rutiaga. Mexico City: Editorial Tomo.

2011. *Comedia de Calisto y Melibea*. Edited by José Luis Canet Vallés. Valencia: Universidad de Valencia.

2012. *La Celestina*. Adapted by Laura Pérez Sánchez. Illustrated by Rosana Mora Corella. Didactic proposal by Agustín Martín Lázaro. Valencia: Sansy Ediciones.

2012. *La Celestina*. Edited by Francisco J. Lobera. Barcelona: Galaxia Gutenberg.

2013. *La Celestina*. *Comedia o tragicomedia de Calisto y Melibea*. Edited by Peter E. Russell. Barcelona: Clásicos Castalia.

2013. *La Celestina*. Edited by Dorothy S. Severin. Madrid: Alianza Editorial.

2016. *La Celestina*. Madrid: Mestas Ediciones.

2016. *Español Práctico: Apreciación Literaria de* La Celestina. Guangzhou: Jinan University Press.

2017. *La Celestina*. Adapted by Fran Zabaleta. Illustrated by Magoz. Madrid: Ediciones S.M.

2017. *La Celestina*. Edited by José Antonio Torregrosa Díaz. Illustrated by David Guirao. Madrid: Anaya.

2018. *La Celestina*. Adapted by Rosa Navarro Durán. Barcelona: Edebé.

2020. *La Celestina*. Edited by Francisco Rico. New York: Penguin Random House.

Other Print Sources Cited

Aesop. *Isopete istoriado*. Zaragoza: Pablo Hurus and Juan Planck, 1482.
– *Libro del Ysopo, famoso fablador, historiado en romançe*. Burgos: Fadrique de Basilea, 1496.
– *Vita et fabulae*. Translated by Heinrich Steinhöwel. Ulm: Johann Zainer, 1476.
Ainaud, Juan. "Grabado." In *Ars Hispaniae*, 18: 245–320. Madrid: Editorial Plus-Ultra, 1962.
Akkad Galeote, Sara. "Casandra: La profeta olvidada. Cien años de un estreno." *Don Galán: Revista de investigación teatral*, no. 1 (2011): 1–4.
Alba-Koch, Beatriz de. "*Celestina* and Agustín Arrieta's China Poblana: Mexico's Female Icon Revisited." In *Companion to* Celestina, edited by Enrique Fernández Rivera, 339–61. Leiden: Brill, 2017.
Albalá Pelegrín, Marta. "Gestures as a Transnational Language through Woodcuts: *Celestina*'s Title Pages." *Celestinesca* 39 (2015): 79–112.
Alcalá Flecha, Roberto. *Matrimonio y prostitución en el arte de Goya*. Cáceres: Servicio de Publicaciones Universidad de Extremadura, 1984.
Alighieri, Dante. *La divina comedia*. Illustrated by Gustave Doré. Biblioteca Amena e Instructiva. Barcelona: Nueva de San Francisco, 1883.
Alpers, Svetlana, Emily Apter, Carol Armstrong, Susan Buck-Morss, Tom Conley, Jonathan Crary, Thomas Crow, et al. "Visual Culture Questionnaire." *October* 77 (1996): 25–70.
Alvar, Carlos. "De *La Celestina* a *Amadís*: El itinerario de un grabado." In *Atti del Simposio Filologia dei Testi a Stampa (Área Ibérica)*, edited by Patrizia Botta, 97–109. Modena: Mucchi, 2005.
Álvarez Barrientos, Joaquín. "*La Celestina*, del siglo XVIII a Menéndez Pelayo." In *Celestina, recepción y herencia de un mito literario*, edited by Gregorio Torres Nebrera, 73–96. Cáceres: Universidad de Extremadura, 2001.
Álvarez Moreno, Raúl. "Notas a la ilustración de un duelo: El suicidio de Melibea en los grabados antiguos de *Celestina*." *eHumanista: Journal of Iberian Studies* 35 (2017): 311–31.
Amelung, Peter. *Der Frühdruck im Deutschen Südwesten, 1473–1500: Eine Ausstellung der Württembergischen Landesbibliothek Stuttgart*. Stuttgart: Wurttembergische Landesbliothek, 1979.
Angulo Íñiguez, Diego. "Murillo y Goya." *Goya: Revista de arte*, no. 148 (1979): 210–13.
Arcipreste de Hita, Juan Ruiz. *Libro de buen amor*. Barcelona: Ediciones Marte, 1968.
Aristotle. *The Nicomachean Ethics*. Edited by Lesley Brown. Translated by David Ross. Oxford: Oxford University Press, 2020.
Ashbee, Henry Spencer. *An Iconography of* Don Quixote, *1605–1895*. London: Aberdeen University Press, 1895.

Badius Ascensius, Jodocus. *Stultifera navis*. Burgos: Fadrique de Basilea, c. 1499.

Baker, Susan. "A Duel with Fernando de Rojas: Picasso's *Celestina* Prints." *Janus Head* 11, no. 2 (2009): 219–38.

Barnard, Malcolm. "What Is Visual Culture?" In *Art, Design and Visual Culture: An Introduction*, 10–31. London: Macmillan, 1998.

Barnicoat, John. *A Concise History of Posters*. London: Thames & Hudson, 1972.

Barrero, Manuel. "Orígenes de la historieta española, 1857–1906." *Arbor: Ciencia, pensamiento y cultura*, no. 2 (2011): 15–42.

Barthes, Roland. "Rhetoric of the Image." In *Image, Music, Text*. Translated by Stephen Heath, 32–51. London: Fontana, 1977.

Bastianes, María. *Vida escénica de* La Celestina *en España (1909–2019)*. Vol 3. New York: Peter Lang, 2020.

Bastien, Rémy. "La Celestina." *Joyas de la literatura*, año VI, no. 88, 15 August 1988. Mexico: Novedades Editores.

Beardsley, Theodore S. "The Lowlands Editions of *Celestina* (1539–1601)." *Celestinesca* 5, no. 1 (1981): 7–12.

Behiels, Lieve, and Kathleen V. Kish, eds. Celestina*: An Annotated Edition of the First Dutch Translation (Antwerp, 1550)*. Leuven: Leuven University Press, 2005.

Benveniste, Emile. "The Semiology of Language." In *Semiotics, an Introductory Reader*, edited by R.E. Innis, 226–46. Bloomington: Indiana University Press, 1986.

Bizet, Georges. *Carmen*, composed by Georges Bizet, based on novel by Prosper Mérimée, libretto by Henri Meilhac and Ludovic Halévy. Opéra-Comique, Paris, France, 3 March 1875.

Bland, David. *A History of Book Illustration: The Illuminated Manuscript and the Printed Book*. London: Faber, 1969.

Blankert, Albert, Gilles Aillaud, and John Michael Montias. *Vermeer*. New York: Overlook Press, 2007.

Boccaccio, Giovanni. *De claris mulieribus*. Ulm: Johann Zainer, 1473.

– *De duobus amantibus Guiscardo et Sigismunda*. Translated into German by Nikolaus von Wyle. Ulm: Johann Zainer, 1476.

– *Las mujeres ilustres*. Zaragoza: Pablo Hurus, 1494.

Bolaños, María, and Julien Chapuis. *Últimos fuegos góticos: Escultura alemana del Bode Museum de Berlín*. Madrid: Ministerio de Educación, Cultura y Deporte, Subdirección General de Documentación y Publicaciones, 2016.

Bolton, Claire. *The Fifteenth-Century Printing Practices of Johann Zainer, Ulm, 1473–1478*. Oxford: Oxford Bibliographical Society, 2016.

Bond, Katherine. "Mapping Culture in the Habsburg Empire: Fashioning a Costume Book in the Court of Charles V." *Renaissance Quarterly* 71, no. 2 (2018): 530–79.

Boner, Ulrich. *Der Edelstein*. Bamberg: Albrecht Pfister, 1461.

Bornstein, Christine Verzar. "A Late Gothic Sculpture of the Ulm School." *Bulletin: The University of Michigan Museums of Art and Archeology* 3 (1980): 30–49.

Botrel, Jean-François. "La doble función de las ilustraciones en las novelas por entregas." In *La literatura española del siglo XIX y las artes (Barcelona, 19–22 de octubre de 2005)*, edited by Sociedad de Literatura Española del Siglo XIX, 67–74. Barcelona: Promociones y Publicaciones Universitarias, 2008.

– *Libros y lectores en la España del siglo XX*. Rennes: Université de Rennes, 2008.

Bozal, Valeriano. "Dibujos grotescos de Goya." *Anales de historia del arte*, special issue (2008): 407–26.

Bradley, Fiona. "Introduction: Automatic Narrative" In *Paula Rego*, 6–8. London: Tate Gallery Publishing, 1997.

Brandt, Sebastian. *Das Narrenschiff*. Illustrated by Albrecht Dürer. Basel: Johann Bergmann, 1494.

Bray, Xavier. "Paret y Alcázar, Luis." In *Enciclopedia del Museo Nacional del Prado*. Madrid: Fundación de Amigos del Museo del Prado, 2006. https://www.museodelprado.es/aprende/enciclopedia/voz/paret-y-alcazar-luis/9feac181-c1c4-4d8d-a91e-ab47d081213e.

Brewster, Ben, and Lea Jacobs. *Theatre to Cinema: Stage Pictorialism and the Early Feature Film*. Oxford: Oxford University Press, 1997.

Brine, Kevin R., Elena Ciletti, and Henrike Lähnemann. *The Sword of Judith: Judith Studies across the Disciplines*. Cambridge: Open Book Publishers, 2010.

Brown, Christopher. "Anthony van Dyck at Work: 'The Taking of Christ' and 'Samson and Delilah.'" *Wallraf-Richartz-Jahrbuch* 55 (1994): 43–54.

– *Scenes of Everyday Life: Dutch Genre Painting of the Seventeenth Century*. London: Faber, 1984.

Brown, Jonathan. "Murillo, pintor de temas eróticos: Una faceta inadvertida de su obra." *Goya: Revista de arte*, no. 169 (1982): 35–43.

Bueno Doral, Tamara Rosa, and Noelia García Castillo. "El cartel en el 'realismo social' del cine español." *Vivat academia*, no. 119 (2012): 31–41.

Byron, George Gordon. *Don Juan: El hijo de doña Inés*. Illustrated by Ramón Escaler. Barcelona: Biblioteca Salvatella, 1883.

Cabañas Bravo, Miguel. "Miguel Prieto y la escenografía en la España de los años treinta." *Archivo Español de arte* 84, no. 336 (2011): 355–78.

Cacheda Barreiro, Rosa Margarita. "La portada del libro como soporte iconográfico. Un ejemplo del siglo XVII." In *Ante el nuevo milenio. Raíces culturales, proyección y actualidad del arte español: XIII Congreso Nacional de Historia del Arte. Granada, del 31 de octubre al 3 de noviembre de 2000*, edited by Comité Español de Historia del Arte. 2: 993–8. Granada: Universidad de Granada, 2000.

Cacho Blecua, Juan Manuel. "Los grabados del texto de las primeras ediciones del *Amadís de Gaula*. Del *Tristán de Leonís* (Jacobo Cromberger, h. 1503–1507)

a *La Coronación* de Juan de Mena (Jacobo Cromberger, 1512)." *Rilce* 23, no. 1 (2007): 61–88.

Calderón Calderón, Manuel. "Printing Licenses and the Trade in Fiction in Spain in the First Half of the Seventeenth Century." In *A Maturing Market: The Iberian Book World in the First Half of the Seventeenth Century*, edited by Alexander Samuel Wilkinson and Alejandra Ulla Lorenzo, 192–210. Boston: Brill, 2017.

Calisto, historia de un personaje. Dir. Miguel Seabra, featuring Álvaro Lavín. Teatro Meridional, Madrid, Spain, 2001. http://en.celestinavisual.org /items/show/636.

Callon, Callie. "Adulescentes and Meretrices: The Correlation between Squandered Patrimony and Prostitutes in the Parable of the Prodigal Son." *Catholic Biblical Quarterly* 75, no. 2 (2013): 259–78.

Campbell, Erin J. "Prophets, Saints, and Matriarchs: Portraits of Old Women in Early Modern Italy." *Renaissance Quarterly* 63, no. 3 (2010): 807–49.

Camus, Philippe. *L'Histoire d'Olivier de Castille et Artus d'Algarbe.* Geneva: Louis Cruse, 1492.

– *Historia de Oliveros de Castilla y Artús d'Algarve.* Burgos: Fadrique de Basilea, 1499.

Canet Vallés, José Luis. "The Early Editions and the Authorship of *Celestina.*" In *A Companion to* Celestina, edited by Enrique Fernández Rivera, 19–40. Leiden: Brill, 2017.

Cantera Montenegro, Jesús. "El pícaro en la pintura barroca española." *Anales de historia del arte*, no. 1 (1989): 209–22.

Caparrós Masegosa, María Dolores, and Esperanza Guillén Marcos. "Prensa católica y pintura española en el último cuarto de siglo XIX. Aproximaciones a una crítica 'integrista.'" *Cuadernos de arte de la Universidad de Granada* 39 (2008): 113–29.

Capua, Johannes de. *Directorium humanae vitae. Buch der Weisheit der alten Weisen.* Translated by Anton von Pforr. Ulm: Lienhart Holle, 1483.

– *Directorium humanae vitae.* Strasbourg: Johann Prüss, c. 1489.

– *Exemplario contra los engaños y peligros de la vida.* Zaragoza: Pablo Hurus, 1493.

– *Exemplario contra los engaños y peligros de la vida.* Burgos: Fadrique de Basilea, 1498.

Carlson, Marvin A. *The Haunted Stage: The Theatre as Memory Machine.* Ann Arbor: University of Michigan Press, 2001.

Carmona Ruiz, Fernando. "La cuestión iconográfica de la *Celestina* y el legado de Hans Weiditz." *eHumanista* 19 (2011): 79–112.

– "La recepción de *La Celestina* en Alemania en el siglo XVI." Doctoral diss., University of Fribourg, 2007.

Carrasco Garrido, Reyes. "Arte, moral y prostitución: Un asunto escabroso en la Nacional de 1897." *Anuario del Departamento de Historia y Teoría del Arte*, no. 9 (1997): 379–86.

Carrete Parrondo, Juan. *El grabado en España*. Vol. 31. Madrid: Espasa-Calpe, 1931.

Carrick, Nancy Ellen. "The Lyon's *Terence* Woodcuts." Doctoral diss., University of Arizona, 1980.

Celestina's House. Paula Rego exhibition, 12 June–7 October 2001. Abbott Hall Art Gallery, Kendal, UK.

Cervantes Saavedra, Miguel de. *El ingenioso hidalgo Don Quijote de la Mancha*. Barcelona: Imprenta de Tomás Gorchs, 1859.

– *El ingenioso hidalgo Don Quijote de la Mancha*. Biblioteca Amena e Instructiva. Barcelona: Imprenta y Litografía de los Sucesores de Narciso Ramírez y Cia, 1881.

– *El ingenioso hidalgo Don Quijote de la Mancha*. Biblioteca Amena e Instructiva. Barcelona: Imprenta y Litografía de los Sucesores de Narciso Ramírez y Cia, 1883.

– *El ingenioso hidalgo Don Quijote de la Mancha*. Biblioteca Amena e Instructiva. Barcelona: Imprenta y Litografía de los Sucesores de Narciso Ramírez y Cia, 1884.

– *L'Ingenieux hidalgo Don Quichotte de la Manche*. Illustrated by Gustave Doré. Paris: Librairie de L. Hachette et Cie, 1863.

Chamberlain, Walter. *The Thames and Hudson Manual of Woodcut Printmaking and Related Techniques*. London: Thames and Hudson, 1978.

Chevalier, Maxime. *Lectura y lectores en la España de los siglos XVI y XVII*. Madrid: Turner, 1976.

Chiappini, Rudy. "The Affirmation of an Inner Vision in the Fullness of Form." In *Botero: Works, 1994–2007*, edited by Fernando Botero, 1–6. New York: Distributed in North America by Rizzoli International Publications, 2007.

Clarke, Anthony H., ed. *A Further Range: Studies in Modern Spanish Literature from Galdós to Unamuno. In Memoriam Maurice Hemingway*. Exeter: University of Exeter Press, 1999.

Codex Ambrosianus. Bibliotheca Ambrosiana Milan, S.P.4/bis / H 75 inf., 950, c. https://ambrosiana.comperio.it/opac/detail/view/ambro:catalog:58002.

Cole, Garold. "The Historical Development of the Title Page." *Journal of Library History (1966–1972)* 6, no. 4 (1971): 303–16.

Corfis, Ivy A. "*Cárcel de amor* and *Celestina*: Notes on Two Early Modern Bestsellers." *Bulletin of Spanish Studies* (2018): 1–10.

Cotoner Cerdó, Luisa. "La biblioteca 'Arte y Letras,' primera aproximación." *Quaderns: Revista de traducció*, no. 8 (2002): 17–27.

Crosson, Dena. "Ignacio Zuloaga and the Problem of Spain." Doctoral diss., University of Maryland, 2009.

Cruz, Juan. "Camilo José Cela habla sobre su versión de *La Celestina*." *El País*, 1 February 1978. https://elpais.com/diario/1978/02/02/cultura/255222008_850215.html.

Cull, John T. "A Possible Influence on the Burgos 1499 *Celestina* Illustrations: The German 1486 Translation of Terence's *Eunuchus*." *La Corónica: A Journal of Medieval Hispanic Languages, Literatures, and Cultures* 38, no. 2 (2010): 137–60.

Cuttler, Charles David. "The Lisbon *Temptation of Saint Anthony* by Jerome Bosch." *Art Bulletin* 39, no. 2 (1957): 109–26.

– "The Temptations of Saint Anthony in Art, from Earliest Times to the First Quarter of the Sixteenth Century." Doctoral diss., New York University. ProQuest Dissertations Publishing, 1952.

d'Arras, Jean. *Melusina: Von einer frowen genant Melusina*. Translated by Thüring de Ringoltingen. Augsburg: Johann Schönsperger, c. 1488.

De Caro, Stefano, and Luciano Pedicini. *The National Archaeological Museum of Naples*. Naples: Electa Napoli, 2007.

Delcorno, Pietro. *In the Mirror of the Prodigal Son: The Pastoral Uses of a Biblical Narrative (c. 1200–1550)*. Vol. 9. Leiden: Brill, 2018.

Delgado, Maria M., and David T. Gies, eds. *A History of Theatre in Spain*. Cambridge: Cambridge University Press, 2012.

Delgado Bedmar, José Domingo. "Vida y obra de Leonardo Alenza y Nieto (1807–1845)." In *El Mediterráneo y el arte español: Actas del XI Congreso del CEHA, Valencia, Septiembre 1996*, edited by Joaquín Bérchez, Mercedes Gómez-Ferrer Lozano, and Amadeo Serra Desfilis, 447–8. Valencia: Comité Español de Historia del Arte, 1998.

Delgado Casado, Juan. *Diccionario de impresores españoles*. 2 vols. Madrid: Arco Libros, 1996.

Delicado, Francisco. *Retrato de la lozana andaluza*. Barcelona: Ediciones Zeus, 1968.

Detlev, Baron von Hadeln. "Another Version of the *Danaë* by Titian." *Burlington Magazine for Connoisseurs* 48, no. 275 (1926): 78–83.

Diago Moncholí, Nel. "José Ricardo Morales y *La Celestina*." *Artescena*, no. 6 (2018): 1–9.

Dikovitskaya, Margaret. "Major Theoretical Frameworks in Visual Culture." In *The Handbook of Visual Culture*, edited by Ian Heywood, Barry Sandywell, Michael Gardiner, Nadarajan Gunalan, and Catherine M. Soussloff, 68–89. London: Berg, 2012.

Dillard, Heath. *Daughters of the Reconquest: Women in Castilian Town Society, 1100–1300*. Cambridge: Cambridge University Press, 1984.

Dominguín, Luis Miguel, and Georges Boudaille. *Pablo Picasso: Toros y toreros*. Paris: Cercle d'Art, 1961.

Dorival, Bernard. "Callot, modèle de Murillo." *La Revue des arts* 2 (1951): 94–101.

Du Bellay, Joachim. *La vieille courtisane de Rome*. Illustrated by Maurice L'Hoir. Paris: Les Bibliophiles du Grenier, 1949.

Duclos, Charles P. *Les confessions du comte de x*. Illustrated by Maurice L'Hoir. Paris: Editions de la Grille, 1929.

Dunn, Peter N. *Fernando de Rojas*. Boston: Twayne Publishers, 1975.

Earle, Peter G. "Four Stage Adaptations of *La Celestina*." *Hispania* 38, no. 1 (1955): 46–51.

Echegaray, José. *El gran Galeoto*. Protagonized by Carmen Cobeña, Compañía Cómica dramática de Carmen Cobeña. Teatro Cervantes, Málaga, Spain, 1900.

Erasmus. *Moriae encomium* [Praise of Folly]. Translated by Gueudeville. Illustrated by Maurice L'Hoir. Paris: G. Girard, 1946.

Los españoles pintados por sí mismos. Vol. 1. Madrid: I. Boix, 1843.

Estébanez Calderón, Serafín. *Los españoles pintados por sí mismos*. Madrid: Ignacio Boix, 1843–4.

Feliu i Codina, Josep. *La Dolores*. Produced by Compañía cómica dramática de Carmen Cobeña. Teatro Cervantes, Málaga, 1900.

Ferguson, George Wells. *Signs and Symbols in Christian Art*. New York: Oxford University Press, 1959.

Fernández de Moratín, Nicolás. *El arte de las putas*. Madrid, 1770/1898.

Fernández Rivera, Enrique. "La caída de Calisto en las primeras ediciones ilustradas de *La Celestina*." *eHumanista: Journal of Iberian Studies* 19 (2011): 137–56.

– "Calisto, Leriano, Oliveros: Tres dolientes y un mismo grabado." *Celestinesca* 36 (2012): 119–42.

– "Dos ilustraciones y un cuadro: Testimonios de la recepción de *La Celestina* en tres épocas." In *Videoactas del I Congreso del CELPYC (4–5 de junio de 2020)*, edited by Enrique Fernández Rivera and Amaranta Saguar García. New York: Celpyc, 2020.

– "La picaresca y la celestinesca en las pantallas españolas de los sesenta a los ochenta." *eHumanista: Journal of Iberian Studies* 38 (2018): 873–89.

Fernández Valladares, Mercedes. "Biblioiconografía y literatura popular impresa: La ilustración de los pliegos sueltos burgaleses (o de babuines y estampas celestinescas)." *eHumanista* 21 (2012): 87–131.

– "De la tipobibliografía a la biblioiconografía: Consideraciones metodológicas para un *Repertorio digital de materiales iconográficos de los impresos españoles del siglo XVI*." In *La palabra escrita e impresa: Libros, bibliotecas, coleccionistas y lectores en el mundo hispano y novohispano, in memoriam Víctor Infantes & Giuseppe Mazzocchi*, edited by Juan Carlos Conde and Clive Griffin, 57–99. New York: Hispanic Seminar of Medieval Studies, 2020.

La imprenta en Burgos (1501–1600). Madrid: Arco Libros, 2005.

Fleuret, Fernand, and Roger Allard. *La Célestine: Tragi-comédie imitée de l'espagnol*. Paris: Éditions du Trianon, 1929.

Forbes, Derek. *Illustrated Playbills: A Study Together with a Reprint of a Descriptive Catalogue of Theatrical Wood Engravings (1865)*. London: Society for Theatre Research, 2002.

François, Jéromine. La Celestina, *un mito literario contemporáneo*. Madrid: Iberoamericana Editorial Vervuert, 2020.

Franits, Wayne E. *Dutch Seventeenth-Century Genre Painting: Its Stylistic and Thematic Evolution*. New Haven, CT: Yale University Press, 2004.

Franklin, Margery B., Robert C. Becklen, and Charlotte L. Doyle. "The Influence of Titles on How Paintings Are Seen." *Leonardo* 26, no. 2 (1993): 103–8.

Gagliardi, Donatella. "*La Celestina* en el *Índice*: Argumentos de una censura." *Celestinesca* 31 (2007): 59–84.

Gallego, Antonio. *Historia del grabado en España*. Madrid: Cátedra, 1990.

García Márquez, Gabriel. *Cien años de soledad*. Buenos Aires: Editorial Sudamericana, 1967.

García Vega, Blanca. *El grabado del libro español: Siglos XV–XVI–XVII (Aportación a su estudio con los fondos de las bibliotecas de Valladolid)*. 2 vols. Valladolid: Institución Cultural Simancas, 1984.

Gash, John. "Caravaggio's Maltese Inspiration." *Melita Historica* 12, no. 3 (1998): 253–66.

Genette, Gérard. *Paratexts: Thresholds of Interpretation*. Cambridge: Cambridge University Press, 1997.

Ginger, Andrew. *Painting and the Turn to Cultural Modernity in Spain: The Time of Eugenio Lucas Velázquez (1850–1870)*. Selinsgrove, PA: Susquehanna University Press, 2007.

Gnapheus, Guilielmus. *Acolastus*. Antwerp: Godfridus Dumaeus, 1529.

Goldschmidt, Ernst Philip. *The Printed Book of the Renaissance: Three Lectures on Type, Illustration and Ornament*. Cambridge: Cambridge University Press, 2010.

Gombrich, Ernst Hans. *The Essential Gombrich: Selected Writings on Art and Culture*. Edited by Richard Woodfield. London: Phaidon Press, 1996.

González Ruiz, Nubia Janeth. "Colombia en la pintura de Fernando Botero: El realismo mágico en el imaginario boteriano." Doctoral diss., Universitat Politècnica de Catalunya, 2006.

Gordon, A.G. "Goya Had Syphilis, Not Susac's Syndrome." *Practical Neurology* 9, no. 4 (2009): 240.

Green, Otis. "The *Celestina* and the Inquisition." *Hispanic Review* 15, no. 1 (1947): 211–16.

Griffin, Clive. "*Celestina*'s Illustrations." *Bulletin of Hispanic Studies* 78, no. 1 (2001): 59–79.

Gubern, Román, and Domènec Font. *Un cine para el cadalso: 40 años de censura cinematográfica en España*. Barcelona: Editorial Euros, 1975.

Guereña, Jean-Louis. "Prostitution and the Origins of the Governmental Regulatory System in Nineteenth-Century Spain: The Plans of the Trienio Liberal, 1820–1823." *Journal of the History of Sexuality* 17, no. 2 (2008): 216–34.

Guerry, François-Xavier. "Du personnage Celestina au type célestinesque: Stéréotypie et innovations dans un cycle littéraire du Siècle d'or (1499–1570)." *Crisol*, no. 10 (2020): 1–17.

Guest, Gerald B. "The Prodigal's Journey: Ideologies of Self and City in the Gothic Cathedral." *Speculum* 81, no. 1 (2006): 35–75.

Gunning, Tom. "Plenary Session II. Digital Aestethics. What's the Point of an Index? Or, Faking Photographs." *Nordicom Review* 25, no. 1 (2017): 39–49. https://doi.org/10.1515/nor-2017-0268.

Gutiérrez Solana, José. *La España negra*. Edited by G. Hernández and Galo Sáez. Madrid: Beltrán, 1920.

Haeger, Barbara. "Cornelis Anthonisz's Representation of the Parable of the Prodigal Son: A Protestant Interpretation of the Biblical Text." *Nederlands Kunsthistorisch Jaarboek (NKJ) / Netherlands Yearbook for History of Art* 37 (1986): 133–50.

Haraszti-Takács, Marianne. *Spanish Genre Painting in the Seventeenth Century*. Budapest: Akadémiai Kiadó, 1983.

Harrison, Nikki. "Nuns and Prostitutes in Enlightenment Spain." *Journal for Eighteenth-Century Studies* 9, no. 1 (1986): 53–60.

Hartung, Heike, and Roberta Maierhofer, eds. *Narratives of Life: Mediating Age*. Münster: LIT Verlag, 2009.

Hartzenbusch, Juan Eugenio. *Los polvos de la madre Celestina*. Madrid: Yenes, 1840.

Herbert, James D. "Visual Culture/Visual Studies." In *Critical Terms for Art History*, edited by Robert S. Nelson and Richard Shiff, 452–64. Chicago: University of Chicago Press, 2003.

Heugas, Pierre. *La Célestine et sa descedance directe*. Bordeaux: Institut d'Études Ibériques et Ibéro-Américaines de l'Universite de Bordeaux, 1973.

Hodnett, Edward. *Image and Text: Studies in the Illustration of English Literature*. London: Scholars Press, 1982.

Holloway, Memory Jockisch. *Making Time: Picasso's Suite 347*. New York: Peter Lang, 2006.

Iglesias, Yolanda. "*Celestina* in Film and Television." In *A Companion to Celestina*, edited by Enrique Fernández Rivera, 383–402. Leiden: Brill, 2017.

– *Una nueva mirada a la parodia de la novela sentimental en* La Celestina. Madrid: Iberoamericana, 2009.

Imbert, Didier, ed. *Picasso: La Célestine*. Paris: Didier Imbert Fine Art, 1988.

Ionescu, Christina. *Book Illustration in the Long Eighteenth Century: Reconfiguring the Visual Periphery of the Text*. Newcastle upon Tyne: Cambridge Scholars Publishing, 2011.

Iser, Wolfgang. *The Act of Reading: A Theory of Aesthetic Response*. Baltimore: Johns Hopkins University Press, 1978.

Jauss, Hans Robert. *Toward an Aesthetic of Reception*. Translated by Timothy Bahti. Minneapolis: University of Minnesota Press, 1982.

Jenks, Chris. *Visual Culture*. New York: Routledge, 1995.

Jewitt, Carey, and Gunther R. Kress, eds. *Multimodal Literacy*. New York: P. Lang, 2003.

Jiménez Ruiz, Ana Milagros. "La primera portada celestinesca sevillana: Estudio de una parodia iconográfica e iconológica." In *Videoactas del I Congreso del CELPYC (4–5 de junio de 2020)*, edited by Enrique Fernández Rivera and Amaranta Saguar García. New York: Celpyc, 2020.

Kahr, Madlyn Millner. "Danaë: Virtuous, Voluptuous, Venal Woman." *Art Bulletin* 60, no. 1 (1978): 43–55.

Keefe, Beatrice Radden. "The Manuscripts and Illustration of Plautus and Terence." In *The Cambridge Companion to Roman Comedy*, edited by Martin T. Dinter, 276–96. Cambridge: Cambridge University Press, 2019.

Keller, John Esten, and Richard P. Kinkade. *Iconography in Medieval Spanish Literature*. Lexington: University Press of Kentucky, 1984.

Kelley, Erna Berndt. "Peripecias de un título: En torno al nombre de la obra de Fernando de Rojas." *Celestinesca* 9, no. 2 (1985): 3–46.

Kessler, Herbert L. *The Illustrated Bibles from Tours*. Princeton, NJ: Princeton University Press, 1977.

Kirby, Steven D. "¿Cuándo empezó a conocerse la obra de Fernando de Rojas como *Celestina*?" *Celestinesca* 13, no. 1 (1989): 59–62.

Kish, Katheleen V. "*Celestina* según Christof Wirsung, autor de las traducciones alemanas de 1520 y 1534." In *Actas del VIII Congreso de la Asociación Internacional de Hispanistas: 22–27 agosto 1983*, edited by A. David Kossoff, et al., 2: 97–104. Madrid: Ediciones Istmo, 1986.

Kish, Katheleen V., and Ursula Ritzenhoff. "The *Celestina* Phenomenon in Sixteenth-Century Germany: Christof Wirsung's Translation of 1520 and 1534." *Celestinesca* 4, no. 2 (1980): 9–18.

Klein, H. Arthur. *Graphic Worlds of Peter Bruegel the Elder*. New York: Dover Publications, 1963.

Kleinfelder, Karen L. *The Artist, His Model, Her Image, His Gaze: Picasso's Pursuit of the Model*. Chicago: University of Chicago Press, 1993.

Kuffner, Emily. *Fictions of Containment in the Spanish Female Picaresque: Architectural Space and Prostitution in the Early Modern Mediterranean*. Amsterdam: Amsterdam University Press, 2019.

Lacarra, Eukene. "Alcahueterías en las ciudades bajomedievales y su representación en la literatura coetánea: *Libro de buen amor* y *Celestina*." In *Two Spanish Masterpieces: A Celebration of the Life and Work of María Rosa Lida de Malkiel*, edited by Pablo Ancos and Ivy A. Corfis, 225–44. New York: Hispanic Seminary of Medieval Studies, 2013.

Lacarra, María Jesús. "Fernando de Rojas, Celestina." Comedic: Catálogo de obras medievales impresas en castellano hasta 1600. https://doi.org /10.26754/uz_comedic/comedic_322.

– "La tradición iconográfica de *La Tragicomedia de Calisto y Melibea* (Zaragoza: Pedro Bernuz y Bartolomé de Nájera, 1545)." In *Avatares y perspectivas del medievalismo ibérico*, edited by Isabella Tomassetti et al. 2: 1685–96. San Millán de la Cogolla: Cilengua, 2019.

– "*La Tragicomedia de Calisto y Melibea* en Zaragoza (1507–1607): Los modelos iconográficos y su pervivencia." In *La fisonomía del libro medieval y moderno: Entre la funcionalidad, la estética y la información*, edited by Manuel José Pedraza Gracia, Camino Sánchez Oliveira, and Alberto Gamarra Gonzalo, 237–50. Zaragoza: Prensas de la Universidad de Zaragoza, 2019.

Lähnemann, Henrike. *Der "Renner" des Johannes Vorster: Untersuchung und Edition des cpg 471*. Tübingen: Francke, 1998.

Lamartine, Alphonse de. *La caída de un ángel* [La Chute d'un ange]. Biblioteca Amena e Instructiva. Barcelona: Imprenta y Litografía de los Sucesores de Narciso Ramírez y Cia, 1883.

Laube, Daniella. "The Stylistic Development of German Book Illustration, 1460–1511." In *A Heavenly Craft: The Woodcut in Early Printed Books*, edited by Daniel De Simone, 47–71. New York: George Braziller, 2004.

Leonard, Irving Albert. *Books of the Brave: Being an Account of Books and of Men in the Spanish Conquest and Settlement of the Sixteenth-Century New World*. Berkeley and Los Angeles: University of California Press, 1992.

Lesage, Alain-René. *Aventuras de Gil Blas de Santillana*. Illustrated by Leonardo Alenza y Nieto. Madrid: Jenes, 1840.

Lessing, Gotthold Ephraim. *Laocoon: An Essay on the Limits of Painting and Poetry*. Translated by E.C. Beasley. London: Longman, Brown, Green, and Longman, 1853.

Lida de Malkiel, María Rosa. *La originalidad artística de* La Celestina. Buenos Aires: Eudeba, 1962.

Litvak, Lily. *Julio Romero de Torres*. Madrid: Electa, 1999.

Livy (Titus Livius). *Las quatorze décadas*. Translated by Fray Pedro de la Vega. Zaragoza: Jorge Coci, 1520.

Lloret i Esquerdo, Jaume, César Omar García Juliá, and Ángel Casado Garretas. *Documenta títeres 1*. Alicante: Festitíteres, 1999.

Loleit, Simone. *Wahrheit, Lüge, Fiktion: Das Bad in er Deutschsprachigen Literatur des 16. Jahrhunderts*. Bielefeld: Transcript, 2008.

López-Rey, José. *Goya's Caprichos: Beauty, Reason and Caricature*. Princeton, NJ: Princeton University Press, 1953.

López-Ríos, Santiago. "*La Celestina* en el franquismo: En torno a una frustrada película de José Luis Sáenz de Heredia." *Acta Literaria* 49 (2014): 139–57.

López Vázquez, José Manuel B. "Prostitución y celestinaje en tres Caprichos de Goya: El engaño y la mentira como las enfermedades más viejas del reino." *Semata: Ciencias sociais e humanidades*, no. 21 (2009): 201–24.

Lucía Megías, José Manuel. *Imprenta y libros de caballerías*. Madrid: Ollero & Ramos, 2000.

– *Leer el* Quijote *en imágenes: Hacia una teoría de los modelos iconográficos*. Madrid: Calambur Editorial, 2006.

Lyell, James P.R., and Julián Martín Abad. *La ilustración del libro antiguo en España*. Madrid: Ollero y Ramos, 1997.

Maeztu, Ramiro de. *Don Quijote, Don Juan y la Celestina: Ensayos en simpatía*. Madrid: Calpe, 1925.

Male, Alan. *Illustration: A Theoretical and Contextual Perspective*. New York: Bloomsbury Visual Arts, 2017.

Manrique Figueroa, César. "Printing in Antwerp in the Early 17th Century and Its Connections with the Iberian World." In *A Maturing Market: The Iberian Book World in the First Half of the Seventeenth Century*, edited by Alexander Samuel Wilkinson and Alejandra Ulla Lorenzo, 26–44. Boston: Brill, 2017.

Marciales, Miguel, ed. *Celestina: Tragicomedia de Calisto y Melibea*, by Fernando de Rojas. 2 vols. Urbana: University of Illinois Press, 1985.

Marfany, Joan Lluís. "La 'Renaixença' i la 'invención de la literatura española.'" *Els Marges: Revista de llengua i literatura*, no. 100 (2013): 103–9.

Marsh, Emily E., and Marilyn Domas White. "A Taxonomy of Relationships between Images and Text." *Journal of Documentation* 59, no. 6 (2003): 647–72.

Martín Abad, Julián. *"Cum figuris": Texto e imagen en los incunables españoles: Catálogo bibliográfico y descriptivo*. Madrid: Arco Libros, 2018.

Martín Abad, Julián, and Isabel Moyano Andrés. *Estanislao Polono*. Alcalá de Henares: Universidad de Alcalá de Henares, 2002.

Martínez, Marcos. *El espejo de príncipes y caballeros III*. Zaragoza: Pedro Cobarte, 1623.

Martínez Martín, Jesús Antonio. "La edición artesanal y la construcción del mercado." In *Historia de la edición en España (1836–1936)*, edited by Jesús Antonio Martínez Martín, 29–72. Madrid: Marcial Pons, 2001.

Matilla, José Manuel. "*La Celestina* y los enamorados." In *Memoria de actividades 2016*, 62–6. Museo Nacional del Prado, Madrid. https://www.museodelprado.es/coleccion/obra-de-arte/la-celestina-y-los-enamorados/5199b371-b9aa-41b8-a181-175fec685a2f.

McAuley, Gay. "Photography and Live Performance: Introduction." *About Performance*, no. 8 (2008): 7–13.

McKim-Smith, Gridley, Inge Fiedler, Rhona Macbeth, Richard Newman, and Frank Zuccari. "Velázquez: Painting from Life." *Metropolitan Museum Journal* 40 (2005): 79–91.

Menander. *Synaristosia* [Women Lunching Together]. Translated by William Geoffrey Arnott. Cambridge, MA: Harvard University Press, 2000.

Menéndez Pelayo, Marcelino. "El bachiller Fernando de Rojas. Autor de *La Celestina*." *El Liberal* (Madrid), 6 April 1894. http://hemerotecadigital.bne.es/issue.vm?id=0001239486&search=&lang=en.

– *Orígenes de la novela: Cuentos y novelas cortas.* La Celestina. Madrid: Consejo Superior de Investigaciones Científicas, 1943.

Mérimée, Prosper. *Carmen*. Paris: Michel Lévy, 1846.

– *Carmen and Other Stories.* Translated by Nicholas Jotcham. Oxford: Oxford University Press, 1999.

Minois, Georges. *History of Old Age: From Antiquity to the Renaissance.* Chicago: University of Chicago Press, 1989.

Mitchell, William John Thomas. *Iconology: Image, Text, Ideology.* Chicago: University of Chicago Press, 1986.

– "Image." In *Critical Terms for Media Studies*, edited by W.J.T. Mitchell and Mark B.N. Hansen, 35–48. Chicago: University of Chicago Press, 2010.

– *Picture Theory: Essays on Verbal and Visual Representation.* Chicago: University of Chicago Press, 1994.

– "Showing Seeing: A Critique of Visual Culture." *Journal of Visual Culture* 1, no. 2 (2002): 165–81.

Mohrland, Juliane. *Die Frau zwischen Narr und Tod: Untersuchungen zu einem Motiv der frühneuzeitlichen Bildpublizistik.* Münster: LIT Verlag, 2013.

Molina, Tirso de. *El burlador de Sevilla o el convidado de piedra.* Edited by Alfredo Rodríguez López-Vázquez. Madrid: Cátedra, 2016.

Montero, Ana Isabel. "Reading at the Threshold: The Role of Illustrations in the Reception of the Early Editions of *Celestina*." *Celestinesca* 39 (2015): 197–224.

Morales Carrión, María T. "El retrato en los primeros cartelistas españoles de cine: De la escena costumbrista al retrato realista." *Arte, individuo y sociedad* 27, no. 1 (2015): 149–63.

Morato Jiménez, Mónica. "La portada en el libro impreso español: Tipología y evolución (1472–1558)." Doctoral diss., Universidad Complutense de Madrid, 2014.

Moreno Garrido, Antonio, and Ana María Pérez Galdeano. "El frontispicio o portada, antecedente en imágenes del contenido del libro Barroco: 'El teatro de las religiones' de Fray Pedro de Valderrama, 1612." *Cuadernos de arte de la Universidad de Granada* 40 (2009): 69–82.

Moriuchi, Mey-Yen. *Mexican Costumbrismo: Race, Society, and Identity in Nineteenth-Century Art.* University Park: Pennsylvania State University Press, 2018.

Morris, Anita Boyd. "Pictures of Debauchery: Profane Images of the Prodigal Son's Revels in Seventeenth-Century Dutch Paintings." *Dutch Crossing* 35, no. 3 (2011): 213–28.

Muñón, Sancho de. *Tragicomedia de Lysandro y Roselia llamada Elicia y por otro nombre quarta obra y tercera Celestina*. Salamanca: n.p., 1542.

Nadeau, Carolyn. "Transformation and Transgression at the Banquet Scene in *La Celestina*." *Scholarship* 71 (2013). https://digitalcommons.iwu.edu /hispstu_scholarship/71.

Neithart, Hans, and Peter Amelung. *Die Ulmer Terenz-Ausgabe*. Dietikon: Verlag Bibliophile Drucke von Josef Stocker, 1970.

Norton, Frederick John. *A Descriptive Catalogue of Printing in Spain and Portugal, 1501–1520*. Cambridge: Cambridge University Press, 1978.

Nowak, William J. "Picasso's *Celestina* Etchings: Portrait of the Artist as Reader of Fernando de Rojas." *Arizona Journal of Hispanic Cultural Studies* 9 (2005): 53–69.

Oliver, Federico. *Los semidioses*. directed by Federico Oliver, Compañía del Teatro Español de Carmen Cobeña. Teatro Eslava, Madrid, 1916.

Oteiza Pérez, Blanca. "Para la historia de un topos literario: El 'hijo pródigo.'" *Hipogrifo: Revista de literatura y cultura del Siglo de Oro* 5, no. 1 (2017): 345–55.

Pacheco, Francisco. *Arte de la pintura, su antigüedad y grandezas*. Seville: Simon Faxardo, 1649.

Palmerín Navarro, Víctor. *La Celestina (Tragicomedia de Calisto y Melibea)*. Tarragona: MS Publishers, 2017.

Panofsky, Erwin. *Problems in Titian, Mostly Iconographic*. New York: New York University Press, 1969.

Paolini, Devid. "La comedia humanística: *La Celestina* y España." In *Rumbos del hispanismo en el umbral del Cincuentenario de la AIH*, edited by Patrizia Botta, Aviva Garribba, María Luisa Cerrón Puga, and Debora Vaccari, 2: 281–7. Rome: Bagatto Libri, 2012.

– "Ediciones de *La Celestina* anteriores al siglo XIX en la Biblioteca Nacional de España." *Revista de literatura medieval*, no. 22 (2010): 351–60.

Parshall, Peter W, ed. 2009. *The Woodcut in Fifteenth-Century Europe: Proceedings of "The Woodcut in Fifteenth-Century Europe" Symposium, Center for Advanced Study in the Visual Arts, Washington, D.C., November 18–19, 2005*. Washington, DC: National Gallery of Art.

Pasolini, Pier Paolo. "The Cinema of Poetry." In *Movies and Methods: An Anthology*, edited by Bill Nichols, 1: 542–58. Berkeley and Los Angeles: University of California Press, 1976.

– *Empirismo eretico*. Milan: Garzanti, 1972.

Penney, Clara Louisa. *The Book Called* Celestina *in the Library of the Hispanic Society of America*. New York: Order of the Trustees, 1954.

Peña, Mercedes de los Reyes. "A vueltas con los carteles de teatro en el Siglo de Oro." *Hipogrifo: Revista de literatura y cultura del Siglo de Oro* 3, no. 1 (2015): 155–86.

– "Los carteles de teatro en el Siglo de Oro." *Criticón*, no. 59 (1993): 99–118.

Pérez, Karen. "La imagen en función de la palabra: Estudio de la gráfica de las portadas para *Cien años de soledad* de Gabriel García Márquez." *Escena: Revista de las artes* 76, no. 1 (2016): 103–18.

Pérez Magallón, Jesús. *Calderón: Icono cultural e identitario del conservadurismo político*. Madrid: Cátedra, 2010.

Pérez Sánchez, Alfonso E., and Eleanor A. Sayre. *Goya and the Spirit of Enlightenment*. Boston: Museum of Fine Arts, 1989.

Petrarca, Francesco. *Historia Griseldis*. Translated by Heinrich Steinhöwel. Ulm: Johann Zainer, 1473.

Philip, L. Brand. "The *Peddler* by Hieronymus Bosch: A Study in Detection." *Nederlands Kunsthistorisch Jaarboek (NKJ) / Netherlands Yearbook for History of Art* 9 (1958): 1–81.

Picasso, Pablo Ruiz. *347 Suite*. Printed by Aldo and Piero Crommelynck. Paris: Galerie Louise Leiris, 1968.

– "*Carnet parchemin*: January 9, 1959 – Part 1." *On-line Picasso Project*. https:// picasso.shsu.edu/index.php?view=WritingsInfo&mid=122&year=1959.

– "*Carnet parchemin*: November 7, 1940 – Part 9." *On-line Picasso Project*. https://picasso.shsu.edu/index.php?view=WritingsInfo&mid=109&year=1 940&page=4&part=9.

Piccolomini, Eneas Silvio. *Historia muy verdadera de dos amantes, Euríalo franco y Lucrecia senesa*. Seville: Jacobo Cromberger, 1512.

Pinney, Roy. *Advertising Photography: A Visual Communication Book*. New York: Hastings House, 1962.

Plautus, Titus Maccius. *The Comedies of Plautus*. Translated by Henry Thomas Riley. London: G. Bell & Sons, 1912.

"Los polvos de la madre Celestina." *Bobín. Periódico infantil de risa y alegría* año 3, no. 95 (1932). Barcelona: Editorial El Gato Negro.

Los polvos de la madre Celestina. Pulgarcito. Editorial El Gato Negro, c. 1920.

Puebla, Teo. La Celestina *ilustrada: Casa de cultura del 16 de abril al 2 de mayo de 1999, La Puebla de Montalbán (Toledo)*. La Puebla de Montalbán: Ayuntamiento de La Puebla de Montalbán, 1999.

Puelles Romero, Luis. "La representación de la 'mujer pública' en el arte moderno." In "*Mal menor": Política y representaciones de la prostitución (siglos XVI–XIX)*, edited by Francisco J. Vázquez, 99–134. Cádiz: Servicio de Publicaciones Universidad de Cádiz, 1998.

Quevedo Villegas, Francisco de. *La cumbre del parnaso español: Poesías de D. Francisco de Quevedo Villegas*. Edited by D.M. Bermejo. Barcelona: Imprenta de Cristóval Miró, 1846.

Rank, Jerry R. "The Significance of León Amarita's 1822 Edition of *La Celestina*." *Papers of the Bibliographical Society of America* 69 (1975): 243–55.

Ratcliff, Carter. *Botero*. New York: Abbeville Press, 1980.

Ratdolt, Erhard, printer. *Calendarium*, by Johannes Müller von Königsberg. Venice: Erhard Ratdolt, 1476.

Raya Téllez, José. "Modelos de mujer: Arquetipos femeninos en la pintura de Julio Romero de Torres." *Laboratorio de arte: Revista del Departamento de Historia del Arte*, no. 21 (2008): 241–64.

Reina Palazón, Antonio. "El costumbrismo en la pintura sevillana del siglo XIX." In *Romanticismo 6: Actas del VI Congreso. El costumbrismo romántico*, 265–74. Rome: Bulzoni Editore, 1996.

Renger, Konrad. *Lockere Gesellschaft. Zur Ikonographie des verlorenen Sohnes und von Wirtshausszenen in der niederländischen Malerei*. Berlin: Mann, 1970.

Ricardo Morales, José. "¿Tres Celestinas en el Museo del Prado?" *Celestinesca* 9, no. 1 (1985): 3–10.

– "Velázquez y *La Celestina*. Una Venus que no es tal." *Mapocho. Revista de humanides*, no. 53 (2003): 9–22.

Rico, Francisco. "Las primeras celestinas de Picasso." *Bulletin Hispanique* 92, no. 1 (1990): 609–26.

Ripa, Cesare. *Iconologia, overo descrittione dell'imagini universali cavate dall'antichita et da altri luoghi*. Rome: Per gli Heredi di Gio. Gigliotti, 1593.

– *Iconologia, or, Moral Emblems*. Edited by Pierce Tempest and Isaac Fuller. London: Printed by Benj. Motte, 1709.

Rivera, Isidro J. "Visual Structures and Verbal Representation in the *Comedia de Calisto y Melibea* (Burgos, 1499?)." *Celestinesca* no. 19 (1995): 3–30.

Rodríguez Aguilar, Inmaculada Concepción. *Arte y cultura en la prensa: La pintura sevillana (1900–1936)*. Seville: Secretaría de Publicaciones de la Universidad de Sevilla, 2000.

Rodríguez de Montalvo, Garci. *Amadís de Gaula*. Seville: Meinardo Ungut and Stanislao Polono, 1496.

– *Los cuatro libros de Amadís de Gaula*. Zaragoza: Jorge Coci, 1508.

Rodríguez Fischer, Ana. "La España negra de José Gutiérrez Solana." *Cuadernos Hispanoamericanos*, no. 690 (2007): 29–42.

Rodríguez Gutiérrez, Borja. "Ilustrando los romanticismos europeos: Las bibliotecas ilustradas barcelonesas del final de siglo XIX." In *La península romántica: El Romanticismo europeo y las letras españolas del XIX*, edited by José María Ferri Coll and Enrique Rubio Cremades, 241–82. Palma de Mallorca: Genueve Ediciones, 2014.

– "Noticias de la biblioteca 'Artes y Letras' (Barcelona, 1881–1898)." *Cuadernos de investigación filológica* 35 (2009): 105–37.

Rodríguez-Solás, David. "A la vanguardia del libro ilustrado: *El Terencio* de Lyón (1493) y *La Celestina* de Burgos (1499)." *Bulletin of Spanish Studies* 86, no. 1 (2009): 1–17.

Rolevinck, Werner. *Fasciculus temporum*. Cologne: Arnold Ther Hoernen, 1474.

– *Fasciculus temporum*. Venice: Georgius Walch, 1479.

– *Fasciculus temporum*. Seville: Bartolomé Segura and Alonso del Puerto, 1480.

Romance de Amadís y Oriana. Burgos: Fadrique de Basilea, c. 1515.

Roper, Lyndal. "Discipline and Respectability: Prostitution and the Reformation in Augsburg." *History Workshop*, no. 19 (1985): 3–28.

– "Mothers of Debauchery. Procuresses in Reformation Augsburg." *German History* 6, no. 1 (1988): 1–19.

Rosenthal, T.G. *Paula Rego: The Complete Graphic Work*. New York: Thames & Hudson, 2003.

Rubin, William Stanley. *Les demoiselles d'Avignon*. New York: Museum of Modern Art, 1994.

Rubio Jiménez, Jesús, and Lola Puebla. *Retratos en blanco y negro: La caricatura de teatro en la prensa (1939–1965)*. Madrid: Centro de Documentación Teatral, 2008.

Rueda Laffond, José Carlos. "La fabricación del libro: La industrialización de las técnicas, máquinas, papel y encuadernación." In *Historia de la edición en España (1836–1936)*, edited by Jesús Antonio Martínez Martín, 73–110. Madrid: Marcial Pons, 2001.

Rueda, Salvador. "Cuadro Madrileño." *Blanco y Negro* (Madrid), 13 November 1892, 11.

Sabartés, Jaime, and Pablo Picasso. *Picasso: Toreros: With Four Original Lithographs*. Translated by Patrick Gregory. New York: George Braziller, 1961.

Saguar García, Amaranta. "The Concept of '*Imago Agens*' in *Celestina*: Text and Image." *Celestinesca* 39 (2015): 247–74.

– "Las ilustraciones de las traducciones alemanas de *Celestina*: Hans Weiditz y la *Tragicomedia de Calisto y Melibea*." *Celestinesca* 41 (2017): 139–52.

– "¿Un programa iconográfico original? Modelos alemanes para los tacos de la edición Zaragoza, en la oficina de Jorge Coci a costa de Pedro Bernuz y Bartolomé de Nájera, 17 de junio de 1545, de *Celestina*." In *Videoactas del I Congreso del CELPYC (4–5 de junio de 2020)*, edited by Enrique Fernández Rivera and Amaranta Saguar García. New York: Celpyc, 2020.

Salas Barbadillo, Alonso Jerónimo de. *La hija de la Celestina*. Edited by Juan de Bonilla. Zaragoza: Viuda de Lucas Sánchez, 1612.

Salazar y Torres, Agustín de, and Sor Juana Inés de la Cruz. *La segunda Celestina*. 1687(?).

Salus, Carol. *Picasso and Celestina: The Artist's Vision of the Procuress*. Newark, DE: Juan de la Cuesta, 2015.

– "Picasso's Version of *Celestina* and Related Issues." *Celestinesca* 15, no. 2 (1991): 3–17.

San Pedro, Diego de. *Cárcel de amor*. Zaragoza: Pablo Hurus and Jorge Coci, 1493.

– *Cárcel de amor*. Burgos: Fadrique de Basilea, 1496.

– *Tratado de amores de Arnalte y Lucenda*. Burgos: Fadrique de Basilea, 1491.

Sánchez de Arévalo, Rodrigo. *Espejo de la vida humana*. Zaragoza: Pablo Hurus, 1491.

– *Espejo de la vida humana*. Augsburg: Günther Zainer, 1471.

Sánchez de Palacios, Mariano. "La caricatura y los caricaturistas. Fernando Fresno." *ABC* (Madrid), 7 November 1969. https://www.abc.es/archivo/periodicos/abc-madrid-19691107-139.html.

Sánchez García, Raquel. "Diversas formas para nuevos públicos." In *Historia de la edición en España (1836–1936)*, edited by Jesús Antonio Martínez Martín, 241–68. Madrid: Marcial Pons, 2001.

– "Las formas del libro. Textos, imágenes y formatos." In *Historia de la edición en España (1836–1936)*, edited by Jesús Antonio Martínez Martín, 111–34. Madrid: Marcial Pons, 2001.

Santesso, Aaron. "William Hogarth and the Tradition of Sexual Scissors." *Studies in English Literature, 1500–1900* 39, no. 3 (1999): 499–521.

Santore, Cathy. "Danaë: The Renaissance Courtesan's Alter Ego." *Zeitschrift Für Kunstgeschichte* 54, no. 3 (1991): 412–27.

Sastre, Alfonso. *La taberna fantástica: Tragedia fantástica de la gitana Celestina*. Madrid: Cátedra, 2005.

Saunders, Catharine. *Costume in Roman Comedy*. New York: Columbia University Press, 1909.

Savedoff, Barbara E. *Transforming Images: How Photography Complicates the Picture*. Ithaca, NY: Cornell University Press, 2000.

Schama, Simon. "Rembrandt's Ghost." *New Yorker*, 19 March 2007. https://www.newyorker.com/magazine/2007/03/26/rembrandts-ghost.

– "Wives and Wantons: Versions of Womanhood in 17th Century Dutch Art." *Oxford Art Journal* 3, no. 1 (1980): 5–13.

Schiff, Gert. *Picasso, the Last Years, 1963–1973*. New York: G. Braziller, in association with the Grey Art Gallery and Study Centre, New York University, 1983.

Schmidt, Rachel Lynn. "Celestinas y majas en la obra de Goya, Alenza y Lucas Velázquez." *Celestinesca* 39 (2015): 275–328.

– *Critical Images: The Canonization of* Don Quixote *through Illustrated Editions of the Eighteenth Century*. Montreal and Kingston: McGill-Queen's University Press, 1999.

Schmitt, Jean-Claude. *La raison des gestes dans l'Occident médiéval*. Paris: Bibliothèque des Histoires, Gallimard, 1990.

Scoles, Emma. "Note sulla prima traduzione italiana della *Celestina*." *Studi Romanzi* 33 (1961): 157–217.

Serrano, Florence. "*La Celestina* en la Francia del Renacimiento y del Siglo de Oro: Texto y contexto, difusión y fortuna." *Celestinesca* 32 (2008): 265–78.

Sillevis, John, Fernando Botero, David Elliott, and Edward J. Sullivan. *The Baroque World of Fernando Botero*. New Haven, CT: Yale University Press, 2006.

Silva, Feliciano de. *Segunda Celestina*. Madrid: Cátedra, 1988.

– *Segunda comedia de Celestina*. Medina del Campo: Pedro Tovans, 1534.
Silva Maroto, María Pilar. *Bosch: The 5th Centenary Exhibition*. New York: Thames & Hudson, 2017.
Silver, Larry. *Peasant Scenes and Landscapes: The Rise of Pictorial Genres in the Antwerp Art Market*. Philadelphia: University of Pennsylvania Press, 2012.
Simon, Howard. *500 Years of Art in Illustration, from Albrecht Dürer to Rockwell Kent*. Garden City, NY: Garden City Publishing Co., 1949.
Slatkes, Leonard J. "Utrecht and Delft: Vermeer and Caravaggism." *Studies in the History of Art* 55 (1998): 80–91.
Sluijter, Eric Jan. "Emulating Sensual Beauty: Representations of Danaë from Gossaert to Rembrandt." *Simiolus: Netherlands Quarterly for the History of Art* 27, nos 1–2 (1999): 4–45.
Smyth, Patricia. "Beyond the Picture-Frame Stage: Late Nineteenth-Century Pictorial Theatre Posters." *Nineteenth Century Theatre and Film* 37, no. 2 (2010): 4–27.
Snow, Joseph Thomas. "A *Celestina* Revival in the Nineteenth Century." In *Studies in Honor of Donald W. Bleznick*, edited by Delia V. Galván, Anita K. Stoll, and Philippa Brown Yin, 171–84. Newark, DE: Juan de la Cuesta, 1995.
– "Los estudios celestinescos 1999–2099." In La Celestina, *V centenario (1499–1999): Actas del congreso internacional Salamanca, Talavera de la Reina, Toledo, La Puebla de Montalbán, 27 de septiembre–1 de octubre de 1999*, edited by Felipe B. Pedraza Jiménez, Gemma Gómez Rubio, and Rafael González Cañal, 121–32. Cuenca: Universidad de Castilla-La Mancha, 2001.
– "La iconografía de tres *Celestinas* tempranas (Burgos, 1499; Sevilla, 1518; Valencia 1514): Unas observaciones." In *Estudios sobre* La Celestina, edited by Santiago López-Ríos, 56–82. Madrid: Ediciones Istmo, 2001.
– "Peripecias dieciochescas de Celestina." *Dieciocho: Hispanic Enlightenment* 22, no. 1 (1999): 7–16.
Sobieszek, Robert A. *The Art of Persuasion: A History of Advertising Photography*. New York: H.N. Abrams, 1988.
Soler, Richard. "Goya and the Northern Tradition." Master's thesis, Rice University, 1985.
Sontag, Susan. *On Photography*. New York: Farrar, Straus, and Giroux, 1977.
Sotomayor Sáez, María Victoria, and Amelia Fernández Rodríguez, eds. El Quijote *para niños y jóvenes, 1905–2008: Historia, análisis y documentación*. Cuenca: Universidad de Castilla–La Mancha, 2009.
Spieker, Joseph B. "The Theme of the Prodigal Son in XVII Century Spanish Art and Letters." *Hispanic Journal* 5, no. 2 (1984): 29–53.
Stechow, Wolfgang, and Christopher Comer. "The History of the Term 'Genre.'" *Allen Memorial Art Museum Bulletin* 33, no. 2 (1975): 89–94.
Steinberg, Leo. "The Philosophical Brothel." *October* 44 (1988): 7–74.

Stöckl, Hartmut. "In between Modes: Language and Image in Printed Media."
In *Perspectives on Multimodality*, edited by Eija Ventola, Cassily Charles,
and Martin Kaltenbacher, 9–30. Amsterdam: John Benjamins Publishing
Company, 2004.

Storm, Eric. "Zuloaga, Ignacio." Encyclopedia of Romantic Nationalism in
Europe.. http://show.ernie.uva.nl/IZu.

Sullivan, Edward J. *Fernando Botero: Drawings and Watercolours*. New York:
Rizzoli, 1993.

Taggard, Mindy Nancarrow. *Murillo's Allegories of Salvation and Triumph:
The Parable of the Prodigal Son and the Life of Jacob*. Columbia: University of
Missouri Press, 1992.

– "A Source for the Interpretation of Murillo's *Parable of the Prodigal Son*: The
Golden Age Stage." *RACAR: Revue d'art canadienne / Canadian Art Review* 14,
nos 1–2 (1987): 90–5.

Terence. *Eunuchus*. Translated by Hans Neidhart. Ulm: Conrad Dinckmut,
1486.

– *Guidonis Juvenalis natione Cenomani in Terentium familiarissima interpretatio
cum figuris unicuique scænæ præpositis* [Lyon Terence]. Lyon: Johann Trechsel,
1493.

– *Publius Terencius Afer, comoediae* [Terence des Ducs]. Illustrated by Maître
de Luçon, Maître de Bedford, Maître de la Cité des Dames, Maître des
Adelphes, Maître d'Orose. Paris, c. 1410.

– *Terentius cum directorio vocabulorum, sententiarum, artis comice, glosa
interlineali, comentariis Donato, Guidone, Ascensio*. Strasbourg: Johann
Grüninger, 1496.

Tomlinson, Janis A., and Marcia L. Welles. "Picturing the Picaresque: Lazarillo
and Murillo's Four Figures on a Step." In *The Picaresque: Tradition and
Displacement*, edited by Giancarlo Maiorino, 66–85. Minneapolis: University
of Minnesota Press, 1996.

Torello-Hill, Giulia, and Andrew J. Turner. *The Lyon Terence: Its Tradition and
Legacy*. Leiden: Brill, 2020.

Torrens, Harriet M. Sonne de. "Illicit Sex and *Alcahuetas* in Medieval Castile:
The Pictorial Program on the Rebanal de las Llantas Baptismal Font." *La
Corónica: A Journal of Medieval Hispanic Languages, Literatures, and Cultures* 38,
no. 1 (2009): 97–120.

Torres Lins, Dulciane. "A encenação de *La Celestina* por Ziembinski: O
clássico de Fernando de Rojas no Brasil do regime militar." Doctoral diss,
Universidade de São Paulo, 2010.

Trimberg, Hugo von. *Der Renner: "Tafel der christlichen Weisheit."* Nuremberg,
c. 1425. Universitätsbibliothek Heidelberg, Cod. Pal. germ. 471, fol. 027r, c.
1439. https://doi.org/10.11588/diglit.266#0065.

Urrea, Pedro Manuel Jiménez de. *Penitencia de amor*. Burgos: Fadrique de Basilea, 1514.

Utrera Macías, Rafael. "Representación cinematográfica de mitos literarios: *Carmen* y *Celestina, Don Quijote* y *Don Juan* según el cine español." *Versants*, no. 37 (2000): 197–230.

Valverde Madrid, José. "En el centenario de Julio Romero de Torres." *Goya: Revista de arte*, no. 122 (1974): 95–8.

Van der Pol, Lotte C. "The Whore, the Bawd, and the Artist: The Reality and Imagery of Seventeenth-Century Dutch Prostitution." *Journal of Historians of Netherlandish Art* 2, nos 1–2 (2010): 1–20. https://jhna.org/articles/whore-bawd-artist-reality-imagery-seventeenth-century-dutch-prostitution/.

Vargas Llosa, Mario. *Fernando Botero: Celebración*. Madrid: La Fábrica, 2012.

Vega, Lope de. *El hijo pródigo*. Edited by J. Enrique Duarte-Lueiro. Pamplona-Kassel: Universidad de Navarra-Reichenberger, 2017.

Verdevoye, Paul. "*La Célestine* et l'adaptation de Paul Achard." *Bulletin Hispanique* 45, no. 2 (1943): 198–201.

Verdier, Philippe. "The Tapestry of the Prodigal Son." *Journal of the Walters Art Gallery* 18 (1955): 8–58.

Vian Herrero, Ana. "El pensamiento mágico en *Celestina*, 'instrumento de lid o contienda.'" *Celestinesca* 14, no. 2 (2021): 41–92.

– "Transformaciones del pensamiento mágico: El conjuro amatorio en la *Celestina* y en su linaje literario." In *Cinco siglos de* Celestina*: Aportaciones interpretativas*, edited by José Luis Canet Vallés and Rafael Beltrán Llavador, 209–38. Valencia: Universitat de València, 1997.

La vida de Lazarillo de Tormes y de sus fortunas y adversidades. Amberes: Martín Nucio, 1554.

Villena, Enrique de. *Los doce trabajos de Hércules*. Zamora: Antón de Centenera, 1483.

Voragine, Jacobus de. *Jacobi a Voragine Legenda aurea, vulgo Historia lombardica dicta*. Edited by Johann Georg Theodor Grässe. Leipzig: Impensis Librariae Arnoldianae, 1850.

Wagner, Peter. *Icons, Texts, Iconotexts: Essays on Ekphrasis and Intermediality*. New York: Walter de Gruyter, 1996.

Wagner, Richard. *The Romance of Tristram and Iseult*. Illustrated by Maurice Lalau; translated by Joseph Bedier. Philadelphia: J.B. Lippincott, 1910.

Wakeman, Geoffrey. *Victorian Book Illustration: The Technical Revolution*. Newton Abbot, UK: David & Charles, 1973.

Wallen, Burr. *Jan van Hemessen: An Antwerp Painter between Reform and Counter-Reform*. Ann Arbor, MI: UMI Research Press, 1983.

Weill, Alain. *The Poster: A Worldwide History and Survey*. London: Sotheby's Publications, 1985.

Weiner, Jack. "Adam and Eve Imagery in *La Celestina.*" *Papers on Language and Literature* 5, no. 4 (1969): 389–96.

Weinstein, Leo. *The Metamorphoses of* Don Juan. Vol. 18. Stanford: Stanford University Press, 1959.

Weissberger, Barbara F. "The Genesis of Paula Rego's A Casa de Celestina." In *"La pluma es lengua del alma": Ensayos en honor de E. Michael Gerli*, edited by José Manuel Hidalgo, 407–32. Newark, DE: Juan de la Cuesta, 2011.

Wilkinson, Alexander Samuel, and Alejandra Ulla Lorenzo. *A Maturing Market: The Iberian Book World in the First Half of the Seventeenth Century*. Boston: Brill, 2017.

Wilson-Bareau, Juliet, and Tom Lubbock. *Goya: Drawings from His Private Albums*. London: Hayward Gallery in association with Lund Humphries, 2001.

Zanardi, Tara. *Framing Majismo: Art and Royal Identity in Eighteenth-Century Spain*. University Park: Pennsylvania State University Press, 2016.

Zorrilla y Moral, José. *Don Juan Tenorio: Drama religioso-fantástico en dos partes*. Madrid: Delgado, 1844.

Images Cited with "Celestina" in the Title

ABC. "Celestina (Carmen Cobeña)." Photograph of Carmen Cobeña as Celestina in the theatre representation *Calisto y Melibea, La Celestina*, dir. Francisco Fernández Villegas, protagonized by Carmen Cobeña. Teatro Español, Madrid. 1909. Photograph taken by R. Cifuentes.

– "*La Celestina*, versión de Alejandro Casona, en el teatro de Bellas Artes." 13 November 1965. Sketch of Celestina, Melibea, Calisto, and Areúsa for the representation *La Celestina*, adapted by Alejandro Casona, dir. José Osuna in Teatro Bellas Artes, Madrid.

Alenza y Nieto, Leonardo. *Majas y Celestina en un balcón* [*Majas* and Celestina on a balcony]. 1834. Oil on canvas, 193.5 × 130 cm. Museum of Fine Arts, Budapest.

Arnás Lozano, Vicente. *La Celestina*. 2012. Oil on canvas, 92 × 73 cm.

Botero, Fernando. *Celestina*. 1998. Oil on canvas, 34.92 × 45.72 cm. Museo Botero, Centro Cultural de Bogotá, Bogotá. https://www.banrepcultural .org/coleccion-de-arte/obra/celestina-ap3233.

– *Celestina*. c. 1998. Oil on canvas, 194 × 128 cm. Private collection.

– *Celestina*. c. 1998. Oil on canvas, 177 × 115 cm. Private collection.

Córdoba, Fernando. Caricature of the actor playing Celestina in *La Celestina* production directed by Cayetano Luca de Tena in Teatro Español, Madrid, 1940. "Español. Inauguración de la temporada, 'La Celestina,' by Fernando de Igoa." *Pueblo* (Madrid), 14 November 1940.

Esquivel y Suárez de Urbina, Antonio María. *Celestina*. Unknown location. 1840. http://www.artnet.de/k%C3%BCnstler/antonio-mar%C3%ADa -esquivel-su%C3%A1rez-de-urbina/celestina-g3Drz0Tae9M9dBbHyxlSVg2.

Fresno, Fernando Gómez-Pamo del. "Intérpretes de *La Celestina*."*El Teatro* (magazine), 1909. Centro de Documentación Teatral. https://www.teatro .es/contenidos/donGalan/imagenesCitadas.php?vol=1&doc=4_1.

Garza y Bañuelos, Ciriaco de la. *Brujerías* [Witchcraft]. c. 1912. Oil on canvas, 150 × 175. Museo del Prado. https://www.museodelprado.es/coleccion /obra-de-arte/brujerias/2988c3e9-280a-4080-a30f-cb3f3018c104.

Goya y Lucientes, Francisco de. *La madre Celestina* [Mother Celestina]. c. 1819. Brush and carbon black ink on laid paper, 23 × 14.5 cm. Museum of Fine Arts, Boston. https://collections.mfa.org/objects/267388/la-madre -celestina-mother-celestina-sheet-22-from-album-d?ctx=e31d5585-6ee5 -4ed2-a25b-ef3b600a9b4d&idx=0.

– *Maja y Celestina*. c. 1824. Watercolour on ivory, 5.4 × 5.4 cm. Private collection.

– *Maja y Celestina al balcón* [*Maja* and Celestina on the balcony]. c. 1808. Oil on canvas, 166 × 108 cm. Private collection. https://fundaciongoyaenaragon .es/eng/obra/maja-y-celestina-al-balcon/182.

Llorens, Juan. *Celestina o los dos trabajadores*. Barcelona: Juan Llorens, 1865.

Lucas Velázquez, Eugenio. *Maja y Celestina en el balcón* [*Maja* and Celestina on the balcony]. 1847. Tempera on paper, 25 × 16.5 cm. Hispanic Society of America, New York. http://hispanicsociety.emuseum.com/objects/5362 /on-the-balcony?ctx=28d991b2-4ef1-470e-bb85-ad82c08b1506&idx=0.

Méndez Bringa, Narciso. Engraving of Celestina *castañera*. "Cuadro Madrileño," by Salvador Rueda. *Blanco y Negro* (Madrid), 13 November 1892, 11.

Mestres i Oñós, Apel·les. *Los polvos de la madre Celestina*. 1868. Watercolour. Institut del Teatre and Centre de documentació i Museu de les Arts Escèniques, Barcelona. http://colleccions.cdmae.cat/catalog/bdam:222703.

Palencia Pérez, Benjamín. *La Celestina*. 1920. Oil on canvas, 174 cm × 85 cm. Museo de Albacete, Albacete, Spain.

Paret y Alcázar, Luis. *La Celestina y los enamorados* [Celestina and the lovers]. 1784. Watercolour on laid paper, 41 × 30 cm. Museo Nacional del Prado, Madrid. https://www.museodelprado.es/coleccion/obra-de-arte/la -celestina-y-los-enamorados/5199b371-b9aa-41b8-a181-175fec685a2f.

Picasso, Pablo Ruiz. *La Célestine* (OPP.55:383). 1955. Colour ink on transparent paper, 55 × 73 cm. Musée National Picasso – Paris, Paris.

– *La Célestine (Carlota Valdivia): Carlota Valdivia et Sebastià Junyer-Vidal* (OPP.04:008). c. 1903. Crayon and charcoal on paper, 36.5 × 27 cm. Private collection.

– *La Célestine / Portrait of Carlota Valdivia / La femme à la taie* (OPP.04:003). 1904. Oil on canvas, 74.5 × 58.5 cm. Musée National Picasso – Paris, Paris. https://www.museepicassoparis.fr/en/collection-en-ligne#/artwork/1600 00000001230?filters=query%3AC%C3%A9lestine&page=1&layout=grid&sort=by_author.

La Célestine avec une femme, un cavalier et son valet [Celestina with girl, a cavalier, and his valet] (OPP.68:532). 1968. Linoleum cut in brown on wove paper, 11.5 × 17.5 cm. Private collection.

– *La Célestine avec une femme et un cavalier à pied* [Celestina with girl and a cavalier on foot] (OPP.68:533). 1968. Linoleum cut in colours on wove paper, 17.5 × 11.5 cm. Private collection.

– *Célestine et un couple* [Celestina and a couple] (OPP.01:100). 1901. Graphite pencil on card, 33.1 × 24 cm. Museu Picasso, Barcelona. https://cataleg.museupicasso.bcn.cat/fitxa/museu_picasso/H289881/?resultsetnav=6153bfaa689fe.

– *Célestine tricotant* [Celestina knitting] (OPP.03:238). 1903. Pen and ink on paper, 23 × 23 cm. Private collection.

– *Picasso et Sebastià Junyer-Vidal assis près de Célestine* [Picasso and his friend Sebastian Junyer-Vidal in a tavern with Celestina] (OPP.04:007). c. 1903. Wax crayons on paper, 25 × 32.9 cm. Private collection.

– *Scène d'intérieur: Viel homme, Célestine et jeune fille assise* [Interior. Old man, Celestina and seated young woman] (OPP.97:068). c. 1898. Conté crayon on paper, 16.4 × 24.7 cm. Museu Picasso, Barcelona. https://cataleg.museupicasso.bcn.cat/fitxa/museu_picasso/H288743/?lang=en&resultsetnav=615394c24d759.

Plá y Gallardo, Cecilio. *La Celestina*. Drawing in *Blanco y Negro* (magazine) (1899), 24.

Primaticcio, Francesco. *Ulysses and Penelope*. c. 1560. Oil on canvas, 113.6 × 123.8 cm. Toledo Museum of Art, Toledo, OH. http://emuseum.toledomuseum.org/objects/54742.

Puebla, Teo. *Celestina*. 1999. Acrylic on canvas, 38 × 46 cm. La Celestina Museum, La Puebla de Montalbán, Spain. https://www.teopuebla.com/obra/celestina.

Quiroz, Jorge. *Celestina ataviando a Melibea post-mortem* [Celestina dressing Melibea post-mortem]. 1972. Oil on canvas, 80 × 60 cm. Private collection.

Ramírez Máro, Rafael. *"La Celestina" cycle*. 2011. Ramírez Máro Institute. https://web.archive.org/web/20160811223637/http://rafael.ramirezmaro.org/2012/02/29/%E2%80%9Cla-celestina%E2%80%9D-%E2%80%93-zyklus/.

Rego, Paula. *A casa de Celestina* [Celestina's house]. 2000. Pastel on paper, 200 × 240 cm. Private collection.

Santasusagna i Santacreu, Ernest. *El "palco" de la Celestina* [Celestina's box].
1944. Oil on canvas, 235 × 175 cm. Museu Nacional d'Art de Catalunya,
Barcelona. https://www.museunacional.cat/ca/colleccio/el-palco-de-la
-celestina/ernest-santasusagna/040468-000.
Ugalde, Francisco. Caricature of the actors playing Melibea, Melibea's parents,
Lucrecia and Calisto in *La Celestina*, directed by Cayetano Luca de Tena in
Teatro Español, Madrid, 1940. "Teatro Español. Fro, "La Celestina," by R. de
los Reyes, *Gol* (Madrid), 14 November 1940.
– "Julia Delgado Caro." Caricature of the actor playing Celestina in *La
Celestina* representation directed by Cayetano Luca de Tena in Teatro
Español, Madrid, Spain. *ABC* (Madrid), 14 November 1940. Centro de
Documentación de las Artes Escénicas y de la Música. https://www.teatro
.es/catalogo-integrado/julia-delgado-caro-9623-1.
Zuloaga, Ignacio. *Celestina*. 1906. Oil on canvas, 151.5 × 180.5 cm. Museo
Nacional Centro de Arte Reina Sofía, Madrid. https://www.museoreinasofia
.es/en/collection/artwork/celestina-matchmaker.

Other Images Cited

Alenza y Nieto. *Esperando en el balcón* [Waiting on the balcony]. c. 1835. Colour
gouache with bugalla ink on vellum paper, 17.2 × 20.9 cm. Museo Lázaro
Galdiano, Madrid.
– (attributed to). *Majas en el balcón* [*Majas* on a balcony]. c. 1835. Pezzoli
collection, Paris.
– *Mujer joven en un balcón* [Young woman on a balcony]. c. 1840. Oil on panel,
21.5 × 17.5 cm. Private collection.
Anthonisz, Cornelis. *The Prodigal Son Wastes His Inheritance*. c. 1540. Engraving,
27 × 21.2 cm. Rijksmuseum, Amsterdam. http://hdl.handle.net/10934
/RM0001.COLLECT.37325.
Arrieta, José Agustín. *Cocina poblana* [Poblana kitchen]. 1865. Oil on canvas,
76.5 × 101 cm. Museo Nacional de Historia Castillo de Chapultepec, Mexico
City. https://mediateca.inah.gob.mx/repositorio/islandora/object
/pintura%3A4135.
– *Vendedora de frutas y vieja* [Fruit saleswoman and old woman]. n.d. Private
collection.
Baburen, Dirck van. *Loose Company / Concert or the Prodigal Son amongst the
Prostitutes*. 1623. Oil on canvas, 110 × 154 cm. Landesmuseum, Mainz, Germany.
– *The Procuress*. 1622. Oil on canvas, 101.6 × 107.6 cm. Museum of Fine Arts,
Boston. https://collections.mfa.org/objects/33414/the-procuress?ctx
=2a0a1bae-85db-4d83-ba53-5b8e4e545ce4&idx=0.
– *Krieger und Kupplerin* [The soldier and the procuress] c. 1620. Fresco.
Ehemalige fürstbischöfliche Residenz, Westwand, Napoleonzimmer,

Würzburg, Germany. https://www.deutsche-digitale-bibliothek.de/item
/7LW2Y4R67ZIXW2D5VWLSCLLX5Q7K6A3V?isThumbnailFiltered=true&
query=Krieger+und+Kupplerin&rows=20&offset=0&viewType=list&firstH
it=7LW2Y4R67ZIXW2D5VWLSCLLX5Q7K6A3V&lastHit=lasthit&hitNumb
er=1&lang=en.

Bas-relief in Baptismal Font. c. 1100. El Salvador Church, Rebanal de las
Llantas, Palencia, Spain.

Bilbao Martínez, Gonzalo. *Las cigarreras* [The cigar makers]. 1915. Oil on
canvas, 305 × 402 cm. Museo de Bellas Artes de Sevilla, Seville. http://
www.museosdeandalucia.es/web/museodebellasartesdesevilla/obras
-singulares/-/asset_publisher/GRnu6ntjtLfp/content/las-cigarreras

– *La esclava o la que vale* [The slave or the valued one]. 1904. 13 cm × 18 cm.
Museo Civico Revoltella, Galleria d'Arte Moderna, Trieste.

Bosch, Hieronymus. *The Garden of Earthly Delights Triptych.* c. 1490. Oil on oak
panel, 185.8 × 249 cm. Museo Nacional del Prado, Madrid. https://www
.museodelprado.es/en/the-collection/art-work/the-garden-of-earthly
-delights-triptych/02388242-6d6a-4e9e-a992-e1311eab3609.

– *The Haywain Triptych.* c. 1512. Oil on panel, 147.1 × 224.3 cm. Museo
Nacional del Prado, Madrid. https://www.museodelprado.es/en/the
-collection/art-work/the-haywain-triptych/7673843a-d2b6-497a-ac80
-16242b36c3ce.

– *The Hermit Saints Triptych.* c. 1493. Oil on panel, 86 × 60 cm. Gallerie
dell'Accademia di Venezia, Venice. https://www.gallerieaccademia.it/en
/hermit-saints-triptych.

– *Last Judgment Triptych.* c. 1504. Oil on panel, 163.7 × 247 cm. Akademie der
bildenden Künste Wien, Vienna. https://www.akbild.ac.at/en/museum
-and-exhibitions/art-collections/paintingsgallery/the-collection.

– *The Pedlar.* c. 1500. Oil on panel, 71 × 70.6 cm. Museum Boijmans Van
Beuningen, Rotterdam. https://www.boijmans.nl/en/collection
/artworks/1556/the-pedlar

– *Temptations of Saint Anthony.* c. 1500. Oil on oak, 131.5 × 228 cm. Museu
Nacional de Arte Antiga, Lisbon. http://www.museudearteantiga.pt
/collections/european-painting/temptations-of-st-anthony.

– *The Temptations of Saint Anthony Abbot.* c. 1510. Oil on oak panel, 70 × 115
cm. Museo Nacional del Prado, Madrid. https://www.museodelprado
.es/en/the-collection/art-work/the-temptations-of-saint-anthony-abbot
/96647605-48f3-4250-95c9-729d7d6288ea.

Botero, Fernando. *La casa de Amanda Ramírez.* 1988. Private collection.

– *La casa de Ana Molina.* 1972. Oil on canvas. Private collection.

– *La casa de las mellizas Arias.* 1973. Oil on canvas. Private collection.

– *La casa de María Duque.* 1970. Oil on canvas, 180 × 186 cm. Private collection.

– *La casa de Marta Pintuco.* 2001. Private collection.

– *La casa de Raquel Vega (Medellin, Colombia)*. 1975. Oil on canvas, 76.77 × 96.85 in. Museum Moderner Kunst Stiftung Ludwig Wien, Vienna. https://www .mumok.at/en/casa-de-raquel-vega-medellin-colombia.

– *Menina (after Velázquez)*. 1978. Oil on canvas, 199.7 × 182.6 cm. Private collection.

Botticelli, Sandro. *Calumny of Apelles*. c. 1495. Tempera on panel, 62 × 91 cm. Gallerie degli Uffizi, Florence.

Bouguereau, William-Adolphe. *Between Wealth and Love*. 1869. Oil on canvas, 106.5 × 89 cm. Private collection.

Bruegel the Elder, Pieter. *Avarice*. 1558. Engraving, 22.5 × 29.7 cm. Metropolitan Museum of Art, New York. https://www.metmuseum.org /art/collection/search/383074.

– *Kermis at Hoboken* [The Fair at Hoboken]. 1559. Drawing, 27 × 39 cm. The Courtauld, London. https://courtauld.ac.uk/highlights/kermis-at-hoboken/.

Callot, Jacques. *Return of the Prodigal Son*. 1635. Etching on laid paper, 6.7 × 8.8 cm. National Gallery of Art, Washington, DC. https://www.nga.gov /collection/art-object-page.51992.html.

– *The Son Is Ruined*. 1635. Etching, 7.2 × 9.3 cm. Princeton University Art Museum, Princeton, NJ. https://artmuseum.princeton.edu/collections /objects/46975.

Caravaggio, Michelangelo Merisi da. *Judith Beheading Holofernes*. c. 1599. Oil on canvas, 145 × 195 cm. Galeria Nazionale d'Arte Antica, Palazzo Barberini, Rome. https://www.barberinicorsini.org/en/opera/judith -beheading-holofernes/.

– *The Toothpuller*. c. 1608c. Oil on canvas, 139.5 × 194.5 cm. Galleria Palatina, Palazzo Pitti, Florence.

Consultazione della fattucchiera [Consulting with the Witch]. 2nd century BCE. Mosaic. Villa of Cicero, Pompeii. Museo Archeologico Nazionale di Napoli, Naples. https://mannapoli.it/mosaici/#gallery-9.

Córcholis [Francisco Flores García]. "Memorias íntimas del teatro. Carmen Cobeña." *Nuevo Mundo*, no. 725, 28 November 1907. http://hemerotecadigital .bne.es/issue.vm?id=0001648183&page=8&search=&lang=es.

Degas, Edgar. *The Old Italian Woman*. 1857. Oil on canvas, 74.9 × 61 cm. Metropolitan Museum of Art, New York. https://www.metmuseum.org /art/collection/search/436120.

Dürer, Albrecht. *Allegory of Avarice* [Avarice]. 1507. Oil on limewood, 35 × 29 cm. Kunsthistorisches Museum, Vienna.

– *The Four Horsemen of the Apocalypse*. 1498. Woodcut, 38.7 × 27.9 cm. Staatliche Kunsthalle, Karlsruhe, Germany. https://www.kunsthalle -karlsruhe.de/kunstwerke/Albrecht-D%C3%BCrer/Die-apokalyptischen -Reiter/FD3AB77448DAB571422E10865442EDB2/.

Dyck, Anthony van. *Samson and Delilah*. c. 1618. Oil on canvas, 152.3 × 232 cm. Dulwich Picture Gallery, London. https://www.dulwichpicturegallery.org .uk/explore-the-collection/101-150/samson-and-delilah/.

– *Samson and Delilah*. c. 1628. Oil on canvas, 146 × 254 cm. Kunsthistorisches Museum, Vienna. https://www.khm.at/objektdb/detail/645/?offset= 0&lv=list.

Fillol Granell, Antonio. *La bestia humana* [The human beast]. 1897. Oil on canvas, 190 × 280 cm. Museo Nacional del Prado, Madrid. https://www .museodelprado.es/coleccion/obra-de-arte/la-bestia-humana/3a8218ba -0434-422d-8894-24fb798482ee.

Franck II, Frans (attributed to a follower of). *The Story of the Prodigal Son*. c. 1610. Oil on panel, 60.4 × 85.9 cm. Private collection. https://www.wga.hu /art/f/francken/frans2/prodiga2.jpg.

Goya y Lucientes, Francisco de. *El aquelarre* [Witches' Sabbath]. c. 1797. Oil on canvas, 43 × 30 cm. Museo Lázaro Galdiano, Madrid.

– Capricho 15. *Bellos consejos* [Beautiful advice]. 1799. Etching and aquatint on laid paper, 30.6 × 20.1 cm. Museo Nacional del Prado, Madrid. https:// www.museodelprado.es/coleccion/obra-de-arte/bellos-consejos/462c8335 -c53a-433b-be28-77ff0ffe8c29.

– Capricho 17. *Bien tirada está* [It is nicely stretched]. 1799. Etching, burnished aquatint, burin, 24.99 × 15.01 cm. Metropolitan Museum of Art, New York. https://www.metmuseum.org/art/collection/search/333786.

– Capricho 20. *Ya van desplumados* [There they go plucked]. 1799. Etching, burnished aquatint on laid paper, 30.6 × 20.1 cm. Museo Nacional del Prado, Madrid. https://www.museodelprado.es/coleccion/obra-de-arte /ya-van-desplumados/3c40c37d-e81b-40f1-848d-d72e8880fee4.

– Capricho 31. *Ruega por ella* [Pray for her]. 1799. Etching, burnished aquatint on laid paper, 30.6 × 20.1 cm. Museo Nacional del Prado, Madrid. https:// www.museodelprado.es/coleccion/obra-de-arte/ruega-por-ella/198f8041 -ca91-431c-bb2f-dbbf31686023.

– *Los desastres de la guerra*. 1810–20. Eighty-two etching and aquatint prints. Madrid: Real Academia de Nobles Artes de San Fernando, 1863.

– *Disparates / Proverbios*. 1815–23. Etching and aquatint prints. Madrid: Real Academia de Bellas Artes de San Fernando, 1864.

– *Dos mujeres y un hombre* [Two women and a man]. c. 1820. Mural transferred to canvas, 125 cm 66 cm. Museo Nacional del Prado, Madrid. https://www .museodelprado.es/en/the-collection/art-work/two-women-and-a -man/87e805f0-84c5-4de0-ba99-65a4ba8a20e8.

– *Maja y vieja*. c. 1780. Oil on canvas, 75 cm × 113 cm. Private collection.

– (previously attributed to). *Majas en el balcón* [*Majas* on a balcony]. c. 1808. Oil on canvas, 162 × 107 cm. Rothschild collection, Switzerland.

– *Milagro de San Antonio de Padua* [Miracle of Saint Anthony of Padua]. 1798. Fresco painting, 550 cm in diameter. Hermitage of San Antonio de la Florida, Madrid.

– *El paseo de Andalucía / La maja y los embozados* [An avenue in Andalusia / The *maja* and the cloaked men]. 1777. Oil on canvas, 275 × 190 cm. Museo Nacional del Prado, Madrid. https://www.museodelprado.es/en/the -collection/art-work/an-avenue-in-andalusia-or-the-maja-and-the /a4af7051-a0c2-4a63-8aef-5fa080890873.

Gutiérrez Solana, José. *La casa del arrabal* [The slum brothel]. c. 1934. Oil on canvas, 160 × 230 cm. Fundación Banco Santander, Madrid. https:// www.fundacionbancosantander.com/en/culture/art/banco-santander -collection/la-casa-del-arrabal-las-chicas-del-arrabal.

– *Las chicas de la Claudia* [Claudia's girls]. 1929. Oil on canvas. Museo Thyssen-Bornemisza, Madrid.

– *Mujeres de la vida* [On the game]. c. 1916. Oil on canvas, 99 × 121 cm. Museo de Bellas Artes de Bilbao. https://bilbaomuseoa.eus/obra-de-arte/mujeres -de-la-vida/.

Hemessen, Jan Sanders van. *Brothel Scene.* c. 1540. Oil on oak, 103 x 132 cm. Staatliche Kunsthalle, Karlsruhe, Germany. https://www.kunsthalle -karlsruhe.de/kunstwerke/Jan-van-Hemessen/Lockere-Gesellschaft /F89E75D645149E3B2802E7B7FE79755C/.

– *The Prodigal Son.* 1536. Oil on oak, 140 × 198 cm. Koninklijke Musea voor Schone Kunsten van België. Brussels. https://www.fine-arts-museum.be /nl/de-collectie/jan-sanders-van-hemessen-en-meester-van-paulus-en -barnabas-de-verloren-zoon?artist=van-hemessen-jan-sanders-1#.

Hogarth, William. *A Harlot's Progress.* 1732. Six paintings and engravings.

Honthorst, Gerrit van. *The Concert.* c. 1626. Oil on canvas, 168 × 202 cm. Galleria Borghese, Rome.

– *The Dissolute Student.* 1625. Oil on canvas, 125 × 156 cm. Bayerische Staatsgemäldesammlungen, Munich. https://www.sammlung.pinakothek .de/en/artwork/wq4jXaELWo.

– *The Flea Hunt.* 1621. Oil on canvas, 132.7 × 199.4 cm. Dayton Art Institute, Dayton, OH. http://collection.daytonartinstitute.org/objects/764/the-flea -hunt?ctx=a0605c36-a05e-499b-957e-bce17b58352b&idx=0.

– *Merry Company.* 1622. Oil on wood, 132.8 × 196.5 cm. Bayerische Staatsgemäldesammlungen, Munich.

– *The Procuress.* 1625. Oil on panel, 71 × 104 cm. Centraal Museum, Utrecht. https://www.centraalmuseum.nl/nl/collectie/10786-de-koppelaarster -gerard-van-honthorst. https://www.sammlung.pinakothek.de/en /artwork/wq4jE3mGWo.

– *Supper Party.* c. 1619. Oil on canvas, 138 × 203 cm. Gallerie degli Uffizi, Florence.

Ingres, Jean-Auguste-Dominique. *Le bain turc* [The Turkish bath]. 1862. Oil on canvas, 108 × 110 cm. Musée du Louvre, Paris. https://collections.louvre .fr/en/ark:/53355/cl010066606.

Lucas Velázquez, Eugenio. *La maja*. c. 1867. Oil on canvas, 133 × 111.5 cm. Museo Lázaro Galdiano, Madrid.

– *Pareja de majos* [*Majo* and *maja*]. 1842. Oil on canvas, 81 × 63 cm. Museo Carmen Thyssen Málaga, Málaga. https://www.carmenthyssenmalaga .org/en/obra/pareja-de-majos.

Matham, Jacob. *Couple Drinking*. c. 1621. Engraving with plate tone from the series *The Consequences of Drunkeness*, 25.6 × 27.6 cm. Philadelphia Museum of Art, Philadelphia. https://www.philamuseum.org/collection /object/20986.

Memling, Hans. *Portrait of an Old Woman*. c. 1480. Oil on wood, 25.7 × 17.8 cm. Museum of Fine Arts, Houston, TX. https://emuseum.mfah.org /objects/46231/portrait-of-an-old-woman?ctx=011ab0319e7c6837d65dd648 81c7c52fef9092fd&idx=0.

Murillo, Bartolomé Esteban. *Cuatro figuras en un escalón* [Four figures on a step]. c. 1655. Oil on canvas, 109.9 × 143.5 cm. Kimbell Art Museum, Fort Worth, TX. https://kimbellart.org/collection/ap-198418.

– *Dos mujeres en la ventana* [Two women at a window]. c. 1655. Oil on canvas, 125.1 × 104.5 cm. National Gallery of Art, Washington DC. https://www .nga.gov/collection/art-object-page.1185.html.

– *The Prodigal Son Driven Out*. c. 1660. Oil on canvas, 104.5 × 134.5 cm. National Gallery of Ireland, Dublin. http://onlinecollection.nationalgallery .ie/objects/8715/the-prodigal-son-driven-out?ctx=7da51619-64a2-40e6 -9e22-983814a535a2&idx=7.

Paret y Alcázar, Luis. *La carta* [The missive], c. 1772. Oil on canvas, 37 × 22 cm. Private collection.

Picasso, Pablo Ruiz. *347 Suite*. 1968. Etchings. Printed by Aldo and Piero Crommelynck. Paris: Galerie Louise Leiris.

– *L'Atelier du vieux peintre* [The studio of the old painter] (OPP.54:132). 1954. Lithograph in colours on arches, 50.17 × 66.2 cm. Yale University Art Gallery, New Haven, CT. https://artgallery.yale.edu/collections /objects/12711.

– *Le bain de pieds II* [The foot bath II] (OPP.60:102). 1960. Pencil, 21 × 27 cm. Private collection.

– *Le bain de pieds II* (OPP.60:113). 1960. Pen and India ink on paper, 20.9 × 26.9 cm. Private collection.

– *Le bain de pieds III* (OPP.60:103). 1960. Pencil, 21 × 27 cm. Private collection.

– *Le bain de pieds III* (OPP.60:114). 1960. Pen and India ink on paper, 20.8 × 26.9 cm. Private collection.

– *Le bain de pieds IV* (OPP.60:104). 1960. Pencil, 21 × 27 cm. Private collection.

- *Le bain de pieds IV* (OPP.60:115). 1960. India ink, 21 × 27 cm. Private collection.
- *Le bain de pieds V* (OPP.60:116). 1960. India ink, 24 × 30 cm. Private collection.
- *Le bain de pieds VI* (OPP.60:471). 1960. Colour crayons on paper, 21 × 27 cm. Private collection.
- *Le bain de pieds VII* (OPP.60:472). 1960. Colour crayons on paper, 21 × 27 cm. Private collection.
- *Le bain de pieds VIII* (OPP.60:473). 1960. Colour crayons on paper, 21 × 27 cm. Private collection.
- *Le bain de pieds IX* (OPP.60:105). 1960. Pencil, 21 × 27 cm. Private collection.
- *Le bain de pieds X* (OPP.60:106). 1960. Pencil, 21 × 27 cm. Private collection.
- *Le bain de pieds XI* (OPP.60:107). 1960. Pencil, 21 × 27 cm. Private collection.
- *Le bain de pieds XII* (OPP.60:108). 1960. Pencil, 21 × 27 cm. Private collection.
- *Le bain de pieds et chien dalmate I* [The foot bath and Dalmatian dog I] (OPP.60:112). 1960. India ink, 21 × 27 cm. Private collection.
- *Bethsabée (d'après Rembrandt)* [Bathsheba (after Rembrandt)] (OPP.60:068). 1960. Oil on canvas, 140 × 195 cm. Private collection.
- *Bethsabée (d'après Rembrandt)* (OPP.66:017). 1966. Aquatint printed in colours on Rives wove paper, 26.2 × 37 cm. Private collection.
- *Bethsabée (d'après Rembrandt) (II)* (OPP.63:358). 1963. Graphite and colour crayons on white wove paper, 26.9 × 37.3 cm. Private collection.
- *"Bien tirada está," copy of the Capricho 17 by Goya* (OPP.98:068). 1898. Sanguine on paper, 17.3 × 10.6 cm. Museu Picasso, Barcelona. https://cataleg .museupicasso.bcn.cat/fitxa/museu_picasso/H288417/?lang=en&resultset nav=61538f784be32.
- *"Las cajas de betún." On-line Picasso Project*, 9 January 1959. https://picasso .shsu.edu/index.php?view=WritingsInfo&mid=122&year=1959.
- *"Carnet parchemin.* November 7, 1940 – Part 9." *On-line Picasso Project.* https://picasso.shsu.edu/index.php?view=WritingsInfo&mid=109&year=1 940&page=4&part=9.
- *Courtisane et guerrier* [Courtesan and warrior] (OPP.68:482). 1968. Pencil, colored pencil and sanguine on paper, 49.5 × 76 cm. Acquavella Galleries, New York. https://www.acquavellagalleries.com/exhibitions/works-on -paper-from-cezanne-to-freud?view=slider#3.
- *Dans l'atelier I* [In the workshop I] (OPP.54:572). 1954. India ink on paper, 24 × 32 cm. Private collection.
- *Dans la loge du clown XII* [In the lodge of the clown XII] (OPP.54:568). 1954. India ink on paper, 24 × 32 cm. Private collection.
- *La danse des banderilles II* [The dance of the banderillas II] (OPP.54:061). 1954. Lithograph on paper, 50.2 × 65.2 cm. Tate Modern, London. https://www .tate.org.uk/art/artworks/picasso-dance-of-the-banderillas-p11367.

– *Danseuse et picador* [Dancer and picador] (OPP.60:175). 1960. Brush, India ink, and wash on paper, 50.9 × 65.3 cm. Private collection.
– *Danseuse et picador III* (OPP.60:345). 1960. Wash, 51.5 × 66 cm. Private collection.
– *Danseuse et picador IV* (OPP.60:308). 1960. Ink and wash on paper, 51 × 65.5 cm. Private collection.
– *Danseuse et picador VI* (OPP.60:347). 1960. Wash, 51.5 × 66 cm. Private collection.
– *La danseuse sur la table VIII (The dancer on the table VIII)* (OPP.60:348). 1960. Wash, 51.5 × 66 cm. Private collection.
– *Les demoiselles d'Avignon* [The young ladies of Avignon] (OPP.07:001). 1907. Oil on canvas, 243.9 × 233.7 cm. Museum of Modern Art, New York. https://www.moma.org/collection/works/79766.
– *Les demoiselles d'Avignon (Étude)* (OPP.07:022). 1907. Black chalk and pastel over pencil on Ingres paper, 47.7 × 63.5 cm. Kunstmuseum Basel, Basel. http://sammlungonline.kunstmuseumbasel.ch/eMuseumPlus?service=ExternalInterface&module=collection&objectId=12133&viewType=detailView.
– *Le divan* (OPP.99:005). c. 1899. Charcoal, pastel, and colored pencil on varnished paper, 25.2 × 29 cm. Museu Picasso, Barcelona. https://cataleg.museupicasso.bcn.cat/fitxa/museu_picasso/H287477/?resultsetnav=6153bd828c3e7.
– *Femme à la corneille* [Woman with a crow] (OPP.04:005). 1904. Charcoal, watercolour, and gouache on paper, mounted on pressboard, 64.8 × 49.5 cm. Toledo Museum of Art, Toledo, OH. http://emuseum.toledomuseum.org/objects/50946/woman-with-a-crow?ctx=9f0c365b-a0f1-4191-9e82-35e2e76910a9&idx=0.
– *Femmes et toreador*. OPP.68:392. 1968. Rectangular earthenware plaque, edition 500, 16.5 × 10.2 cm. Fundació Palau, Caldes d'Estrac (Inv 0000223).
– *La fille et le moine* [The girl and the monk] (OPP.59:431). 1959. Pen and India ink and wash on paper, 51.6 × 70.6 cm. Private collection.
– *Le harem* (OPP.06:038). 1906. Oil on canvas, 154.3 × 110 cm. Cleveland Museum of Art, Cleveland, OH. https://www.clevelandart.org/art/1958.45.
– *Le modèle et deux personnages* [The model and two characters] (OPP.54:129). 1954. Lithograph in colours on arches, 50.5 × 71.8 cm. Private collection.
– *Le peintre et son modèle (La Célestine)* [The painter and his model] (OPP.04:113). c. 1903. Conté pencil and coloured pencil on paper, 26.7 × 20.6 cm. Private collection.
– *Personnages* (OPP.54:205). 1954. Brush and India ink on paper, 32 × 24 cm. Private collection.
– *Personnages et cavalier*. (OPP.68:231). 1968. Rectangular earthenware plaque, edition 450, 16.2 × 10.7 cm. Fundació Palau, Caldes d'Estrac. (Inv 0000799).

– *Personnages et colombe* [Characters and dove] (OPP.54:127). 1954. Lithograph on Arches wove paper, 50.5 × 65 cm. Private collection.

– *Picador et femmes* [Picador and women] (OPP.60:188). 1960. Collotype print, 40.8 × 51.5 cm. Private collection.

– *Picador et femmes IV* (OPP.60:361). 1960. Wash, 44 × 55.5 cm. Private collection.

– *Picador et femmes V* (OPP.60:355). 1960. Wash, 37 × 26.5 cm. Private collection.

– *Picador et femmes VI* (OPP.60:370). 1960. Wash, 40.8 × 51.5 cm. Private collection.

– *Picador et personnages* [Picador and characters] (OPP.60:233). 1960. India ink and wash, 50 × 65 cm. Galerie Beyeler, Basel.

– *Picador et personnages I* (OPP.60:293). 1960. Pen and ink wash on paper, 50.5 × 65.5 cm. Private collection.

– *Picador et personnages II* (OPP.60:359). 1960. Wash, 50 × 65 cm. Private collection.

– *Picador et personnages III* (OPP.60:360). 1960. Wash, 50 × 65 cm. Private collection.

– *Picador, femme et morte* [Picador, woman, and death] (OPP.60:100). 1960. Offset lithograph, 40.6 × 52.1 cm. Unknown location.

– *Picadors et femmes VI* (OPP.60:356). 1960. Wash, 37 × 26.5 cm. Private collection.

– *Portrait de Madame Canals* (OPP.05:019). 1905. Oil and charcoal on canvas, 90 × 69.5 cm. Museu Picasso, Barcelona. https://cataleg.museupicasso .bcn.cat/fitxa/museu_picasso/H290834/?lang=en&resultsetnav=61675780 6ab7b.

– *La présentation III* (OPP.54:203). 1954. India ink on paper, 31.8 × 23.9 cm. Musée National d'Art Moderne, Centre Georges Pompidou, Paris. https:// www.centrepompidou.fr/en/ressources/oeuvre/c6b5Rer.

– *Suite 156 L087. Brothel. Degas with His Sketchbook, Procuress, Three Prostitutes and a Moroccan Pouffe.* (OPP.71:280). 1971. Etching, 36.7 × 48.7 cm. Museu Picasso, Barcelona. https://cataleg.museupicasso.bcn.cat/fitxa/museu _picasso/H290074/?lang=en&resultsetnav=6157a9e3d32fa.

– *Suite 156 L089. Degas, Célestine et trois filles, dont une avec quatre seins* [Degas, Célestine and three girls, including one with four breasts] (OPP.71:158). 1971. Etching on wove paper, 36.8 × 48.9 cm. Private collection.

– *Suite 156 L109. Brothel. Gossip, with a Parrot, Bawd, and the Portrait of Degas.* (OPP.71:127). 1971. Etching on wove paper, 36.5 × 49 cm. Museu Picasso, Barcelona. https://cataleg.museupicasso.bcn.cat/fitxa/museu_picasso /H290058/?lang=en&resultsetnav=6157ab9ff3c0b.

– *Tête de femme avec boa* [Head of a lady with a feather scarf] (OPP.03:175). 1903. Conté pencil and pen on paper, 23 ×18 cm. Museu Picasso, Barcelona. https://cataleg.museupicasso.bcn.cat/fitxa/museu_picasso/H290269 /?resultsetnav=6153c479a3c82.

– *Les trois femmes et le torero* [The three women and the bullfighter] (OPP.54:032). 1954. Lithograph, 50.2 × 65.1 cm. Museu Picasso, Barcelona.

https://cataleg.museupicasso.bcn.cat/fitxa/museu_picasso/H290399
/?resultsetnav=61565a9b42489.

Rembrandt Harmenszoon van Rijn. *The Artist's Mother.* c. 1629. Oil on panel, 61.3
× 47.4 cm. Cumberland Art Gallery, Hampton Court Palace, London. https://
www.rct.uk/collection/405000/an-old-woman-called-the-artists-mother.

– *Bathsheba at Her Bath.* 1654. Oil on canvas, 142 × 142 cm. Musée du Louvre,
Paris. https://collections.louvre.fr/en/ark:/53355/cl010060453.

Ribera, José de. *Vieja usurera* [The old usurer]. 1638. Oil on canvas, 76 × 62 cm.
Museo Nacional del Prado, Madrid. https://www.museodelprado.es
/coleccion/obra-de-arte/vieja-usurera/7e6d2cb3-d8bc-4e63-8101
-debb3e6b798f.

Robusti, Marietta (Tintoretta). *Venetian Woman.* c. 1560. Museo Nacional del
Prado, Madrid.

Romano, Giulio. *Lovers.* c. 1525. Oil on canvas, 163 × 337 cm. State Hermitage
Museum, St Petersburg. https://www.hermitagemuseum.org/wps/portal
/hermitage/digital-collection/01.%20paintings/30438/!ut/p/z1/04
_Sj9CPykssy0xPLMnMz0vMAfIjo8zi_R0dzQyNnQ28_J1NXQwc_YMCTIOc
_dwNDE30w8EKDHAARwP9KGL041EQhd94L0IWAH1gVOTr7Juu
H1WQWJKhm5mXlq8fYWCop1CQmJlXkpmXXqwfYWxgYmwBdEs
Ummme3uZA00JMPfz9w5yNnE2gCvC4pyA3NKLKx8Mg01FREQAhGVnd
/dz/d5/L2dBISEvZ0FBIS9nQSEh/?lng=en.

Romero de Torres, Julio. *La chiquita piconera* [The coal little girl]. c. 1929.
Oil and tempera on canvas, 100 × 80 cm. Museo Julio Romero de Torres,
Córdoba. https://museojulioromero.cordoba.es/sala/sala-6-el-espiritu-de
-cordoba/la-chiquita-piconera.

– *Composición con la chiquita piconera* [Composition with the little piconera]. 1929.
Oil on canvas, 144 × 111 cm. Museo de Bellas Artes de Córdoba, Córdoba.
http://www.museosdeandalucia.es/web/museodebellasartesdecordoba
/obras-singulares/-/asset_publisher/GRnu6ntjtLfp/content/composicion
-con-la-chiquita-piconera.

– *La Fuensanta.* 1929. Oil on canvas, 100 × 80 cm. Private collection.

– *Nocturno* [Nocturnal]. 1930. Oil and tempera on canvas, 140 × 168 cm.
Museo Julio Romero de Torres Córdoba.

– *El pecado* [The sin]. 1915. Oil and tempera on canvas, 185 × 202 cm. Museo
Julio Romero de Torres, Córdoba. http://webempresa.gestumm.com
/julioromero/sala/sala-6-el-espiritu-de-cordoba/el-pecado.

– *Vividoras del amor* [Sex workers]. 1906. Oil on canvas, 129.5 × 182.9 cm.
Fondos de Arte de la Fundación La Caja de Canarias, Las Palmas de Gran
Canaria, Spain.

Rubens, Peter Paul. *The Rape of the Sabine Women.* c. 1635. Oil on oak, 169.9 ×
236.2 cm. National Gallery, London. https://www.nationalgallery.org.uk
/paintings/peter-paul-rubens-the-rape-of-the-sabine-women.

– *Samson and Delilah*. c. 1609. Oil on panel, 52.1 × 50.5 cm. Cincinnati Art Museum, Cincinnati, OH. https://www.cincinnatiartmuseum.org/art /explore-the-collection?id=22338034.

Schoen, Erhard. *The Cage of the Fools*. c. 1522. Woodcut, 17.4 × 34.2 cm. Kupferstich-Kabinett, Staatliche Kunstsammlungen, Dresden. https:// skd-online-collection.skd.museum/Details/Index/548334.

– *The School of the Procuress*. 1531. Woodcut, 17 cm × 24.5 cm. Albertina, Vienna.

Simonet, Enrique. "Carmen Cobeña." *El Arte del Teatro* (Madrid), no. 45, 1 February 1908. http://hemerotecadigital.bne.es/issue.vm?id=0003653871 &search=&lang=es.

Soria Aedo, Francisco. *Doña Paca y su prenda* [Mrs Paca and her garment]. 1943. Private collection.

– *Joven con mantilla y toreros* [Young woman with mantilla and bullfighters]. 1934. Oil on canvas, 200 × 140.5 cm. Museo de Bellas Artes de Sevilla, Seville.

– *El piropo* [The flattery]. 1928. Private collection.

Sorolla, Joaquín. *Trata de blancas* [White slave trade]. 1894. Oil on canvas, 166.5 × 195 cm. Museo Sorolla, Madrid. https://www.culturaydeporte.gob.es /msorolla/colecciones/colecciones-del-museo/pintura/trata-de-blancas.html.

Steen, Jan. *Bathsheba Receiving David's Letter*. c. 1659. Oil on panel, 41.5 × 33 cm. Private collection.

– *The Procuress*. c. 1650. Oil on panel, 31.8 × 25.7 cm. Private collection.

– *Bad Company*. c. 1665. Oil on wood, 415 × 355 cm. Musée du Louvre, Paris. https://collections.louvre.fr/en/ark:/53355/cl010064787.

– *The Wench*. c. 1660. Oil on canvas, 40 × 36.2 cm. Musée de l'Hotel Sandelin, Saint-Omer, France.

Syrlin the Elder, Jörg, and Jörg Syrlin the Younger. Ulm choir stalls. c. 1450. Oak choir stalls. Ulm Minster, Ulm, Germany.

Teniers the Younger, David. *Temptation of Saint Anthony*. c. 1640. Oil on copperplate, 36.4 × 47.3 cm. State Hermitage Museum, St Petersburg.

– *The Temptation of Saint Anthony*. c. 1650. Oil on panel, 48.6 × 63.8 cm. Minneapolis Institute of Art, Minneapolis. https://collections.artsmia.org /art/2278/the-temptation-of-st-anthony-david-teniers-the-younger.

Titian (Tiziano Vecellio). *Danaë and the Shower of Gold*. c. 1560. Oil on canvas, 129.8 × 181.2 cm. Museo Nacional del Prado, Madrid. https://www .museodelprado.es/en/the-collection/art-work/danae-and-the-shower -of-gold/0da1e69e-4d1d-4f25-b41a-bac3c0eb6a3c.

– *Flora*. c. 1517. Oil on canvas, 79.7 × 63.5 cm. Gallerie degli Uffizi, Florence. https://www.uffizi.it/en/artworks/titian-flora.

– *Salome with the Head of John the Baptist / Judith with the Head of Holofernes*. c. 1515. Oil on canvas, 89.5 cm × 73 cm. Doria Pamphilj Gallery, Rome. https://www.doriapamphilj.it/en/portfolio/titian/.

Van Dyck, Anthony. *Samson and Delilah.* c. 1618. Oil on canvas, 152.3 × 232 cm. Dulwich Picture Gallery, London. https://www.dulwichpicturegallery.org .uk/explore-the-collection/101-150/samson-and-delilah/.

– *Samson and Delilah.* c. 1628. Oil on canvas, 146 × 254 cm. Kunsthistorisches Museum, Vienna. https://www.khm.at/objektdb/detail/645/?offset=0&lv =list.

van Loo, Jacob. *Danae.* c. 1655. Canvas, 62 × 74 cm. Collectie Kremer, Amsterdam. https://www.thekremercollection.com/jacob-van-loo/.

Velázquez, Diego Rodríguez de Silva y. *Las hilanderas o la fábula de Aracne* [The Spinners, or the Fable of Arachne]. c. 1655. Oil on canvas, 220 × 289 cm. Museo Nacional del Prado, Madrid. https://www.museodelprado.es/en /the-collection/art-work/the-spinners-or-the-fable-of-arachne/3d8e510d -2acf-4efb-af0c-8ffd665acd8d.

– *Las meninas.* 1656. Oil on canvas, 320.5 × 281.5 cm. Museo Nacional del Prado, Madrid. https://www.museodelprado.es/en/the-collection/art -work/las-meninas/9fdc7800-9ade-48b0-ab8b-edee94ea877f.

– *La Venus del espejo* [The toilet of Venus]. c. 1647. Oil on canvas, 122.5 × 177 cm. National Gallery, London. https://www.nationalgallery.org.uk /paintings/diego-velazquez-the-toilet-of-venus-the-rokeby-venus

– *Vieja friendo huevos* [Old woman frying eggs]. 1618. Oil on canvas, 100.5 × 119.5 cm. Scottish National Gallery, Edinburgh. https://www .nationalgalleries.org/art-and-artists/5531/old-woman-cooking-eggs.

Vermeer, Johannes. *With the Procuress.* 1656. Oil on canvas, 143 × 130 cm. Gemäldegalerie Alte Meister, Staatliche Kunstsammlungen, Dresden. https://skd-online-collection.skd.museum/Details/Index/415421.

Vermeyen, Jan Cornelisz. *A Spanish Feast.* 1545. Etching, 30.4 × 42.5 cm. British Museum, London. https://www.britishmuseum.org/collection /object/P_1869-0612-376.

Vogtherr, Heinrich the Younger. *The Procuress.* c. 1537. Woodcut, 47.5 × 33 cm. Kupferstichkabinett, Berlin.

Theatre Representations of *La Celestina* Cited, by Date

1909. *Calisto y Melibea, La Celestina.* Directed by Francisco Fernández Villegas, featuring Carmen Cobeña. Teatro Español, Madrid. http:// en.celestinavisual.org/items/show/857.

1940. *La Celestina.* Adapted by Felipe Lluch, directed by Cayetano Luca de Tena, featuring Julia Delgado Caro. Teatro Español, Madrid. http:// en.celestinavisual.org/items/show/1175.

1949. *La Celestina.* Adapted by José Ricardo Morales, directed by José Ricardo Morales, featuring Brisolia Herrera. Teatro Municipal, Santiago de Chile, Chile. http://en.celestinavisual.org/items/show/556.

1953–60. *La Celestina*. Directed by Álvaro Custodio, Teatro Español de México. Ateneo Español de México, Mexico City. http://en.celestinavisual.org /items/show/612.

1957. *La Celestina*. Adapted by Huberto Pérez de la Ossa, directed by Luis Escobar, featuring Irene López Heredia. Teatro Eslava, Madrid. http:// en.celestinavisual.org/items/show/2001.

1965. *La Celestina*. *Tragicomedia de Calisto y Melibea*. Adapted by Alejandro Casona, directed by José Osuna, featuring Milagros Leal, Compañía Lope de Vega. Teatro Bellas Artes, Madrid. http://en.celestinavisual.org/items /show/557.

1967. *La Celestina*. Adapted by Alejandro Casona, directed by José Osuna, featuring Milagros Leal. Teatro Reina Victoria, Madrid. http:// en.celestinavisual.org/items/show/614.

1974–75. *Celestina*. Directed by Gerd Heinz. Thalia Theatre, Hamburg. http:// en.celestinavisual.org/items/show/2906.

1980. *Calisto y Melibea, Tragicomedia*. Directed by Manuel Manzaneque, featuring María Guerrero, José Sancho, and Inma de Santis, Tirso de Molina Company. Teatro Espronceda 34, Madrid. http://en.celestinavisual.org /items/show/2020.

1982. *La Celestina*. *Tragicomedia de Calisto y Melibea*. Adapted by Tina French and Salvador Garcini, directed by Salvador Garcini, featuring Ofelia Guilmain, Teatro de la Nación del IMSS. Teatro Julio Prieto, Mexico City. http://en.celestinavisual.org/items/show/561.

1983. *Celestina*. Adapted by David Gilmore, directed by David Gilmore. Nuffield Theatre, University of Southampton, Southampton, UK. http:// en.celestinavisual.org/items/show/562.

1988. *La Celestina*. Adapted by Gonzalo Torrente Ballester, directed by Adolfo Marsillach, featuring Amparo Rivelles, Compañía Nacional de Teatro Clásico, Madrid. http://en.celestinavisual.org/items/show/618.

1989. *La Celestina*. Directed by Adolfo Marsillach, featuring Amparo Rivelles and Jesús Puente, Compañía Nacional de Teatro Clásico. Edinburgh International Festival, Royal Lyceum Theatre, Edinburgh. http:// en.celestinavisual.org/items/show/621.

1989. *La Célestine*. Adapted by Florence Delay, directed by Antoine Vitez, featuring Jeanne Moreau, Odéon-Théâtre de l'Europe. Festival d'Avignon, Avignon, France. http://en.celestinavisual.org/items/show/622.

1995. *La Celestina*. Adapted by José Ruibal, directed by Hermann Bonnin, featuring Amparo Soler Leal. Teatro Condal, Barcelona. http:// en.celestinavisual.org/items/show/563.

1998. *Celestina*. Translated by Einar Heckscher, adapted by Adam Nashman, directed by Robert Lepage, featuring Anita Björk. Dramaten Elverket Theatre, Stockholm. http://en.celestinavisual.org/items/show/632.

1999. *La Celestina*. Directed by Jorge Alí Triana, protagonized by Fanny Mikey. Teatro Nacional, Bogotá. http://en.celestinavisual.org/items/show/1151.

1999. *La Celestina. Tragicomedia de Calisto y Melibea*. Adapted by Luis García Montero, directed by Joaquín Vida, featuring Nati Mistral. Teatro Albéniz, Madrid. http://en.celestinavisual.org/items/show/1345.

2001. *Calisto, Historia de un Personaje*. Directed by Miguel Seabra, featuring Álvaro Lavín. Teatro Meridional, Madrid. http://en.celestinavisual.org /items/show/636.

2009. *La Célestine*. Directed by Christian Esnay, Ecole Régionale d'Acteurs de Cannes. Théâtre de l'Aquarium, Paris. http://en.celestinavisual.org/items /show/2578.

2011. *La Celestina. Tragicomedia de Calisto y Melibea*. Adapted by María Lourties, directed by Magali Bruneau and María Lourties. C'est la Vie Teatro, Madrid. http://en.celestinavisual.org/items/show/2006.

2012. *La Celestina*. Adapted by Eduardo Galán, directed by Mariano de Paco Serrano, featuring Gemma Cuervo. Teatro Fernán Gómez, Madrid. http:// en.celestinavisual.org/items/show/644.

2012. *Celestina, la Tragicomedia*. Adapted by Ricardo Iniesta, directed by Ricardo Iniesta, featuring Carmen Gallardo, Grupo Atalaya. Teatro Calderón, Valladolid, Spain. http://en.celestinavisual.org/items /show/1171.

2014. *La Celestina*. Directed by Sara Calvo and Carlos Bernárdez, featuring Carmen Barreiro, Celia Guisado, Uniteatra2. XVIII Certamen de Teatro Universitario UCM, Madrid. http://en.celestinavisual.org/items/show /2730.

2014. *La Célestine*. Directed by. David Arnaud, featuring Claudine Even, Theatre group Les Clameurs de l'Estran. Espace culturel Térraqué, Carnac, France. http://en.celestinavisual.org/items/show/2840.

2015. *La Celestina*. Directed by Nuria Galache, Escuela teatral "La Comedia," Salamanca. Gran Hotel Balneario, Baños de Montemayor, Cáceres, Spain. http://en.celestinavisual.org/items/show/2009.

2015. *La Celestina, Tragicomèdia de Caliste i Melibea*. Directed by LoTAT, Tortosa Arts Teatrals. XX Festa del Renaixement, l'esplendor d'una ciutat al segle XVI, Tortosa, Spain. http://en.celestinavisual.org/items/show/2805.

2016. *La Celestina*. Adapted by Brenda Escobedo and José Luis Gómez, directed by José Luis Gómez, featuring José Luis Gómez, Compañía Nacional de Teatro Clásico. Teatro de la Abadía, Madrid. http:// en.celestinavisual.org/items/show/1153.

2016–17. *La Celestina*. Adapted by Iván Álamo, directed by Iván Álamo, featuring Fernando Navas, D'hoy Teatro. Centro Cultural Villa de Santa Brígida, Las Palmas, Spain. http://en.celestinavisual.org/items/show /2398.

2017. *La Celestina*. Adapted by Manuela Málaga and Elisa Calderoni, directed by Manuela Málaga and Elisa Calderoni, In Scena Veritas, Almo Collegio Borromeo. Piazza della Vittoria, Pavia, Italy. http://en.celestinavisual.org /items/show/2729.

2019. *La Celestina, La Tragiclownmedia*. Directed by Javier Uriarte, featuring Lola Carmona, Javier Rosado and Roberto Calle, La Escalera de Tijera. La Nave del Duende, Casar de Cáceres, Spain. http://en.celestinavisual.org /items/show/3146.

Film Adaptations of *La Celestina* Cited, by Date

1965. *La Celestina P... R*. Written by Sandro De Feo, Massimo Franciosa, Carlo Lizzani, Luigi Magni, Assia Noris, and Girogio Stegani, directed by Carlo Lizzani. Italy: Aston Film. http://en.celestinavisual.org/collections /show/33.

1967. *La Celestina*. Adapted by José Vila-Selma, directed by Eduardo Fuller, performed by the Agrupación Antigua de Madrid. Spain: TVE, Teatro de Siempre. http://en.celestinavisual.org/collections/show/34.

1969. *La Celestina*. Written by Fernando de Rojas and adapted by César Fernández Ardavín, directed by César Fernández Ardavín, featuring Amelia de la Torre. Spain and Western Germany: Aro Films, Hesperia Film and Berlin Television System. Released as video by TVE c. 1980. http:// en.celestinavisual.org/collections/show/35.

1976. *Celestina (los placeres del sexo)*. Written by Fernando de Rojas and adapted by Miguel Sabido and Margarita Villaseñor, directed by Miguel Sabido, featuring Isela Vega. Mexico: Ludens Films and Televisa. http:// en.celestinavisual.org/collections/show/37.

1996. *La Celestina*. Written by Fernando de Rojas, adapted by Rafael Azcona and Gerardo Vera, directed by Gerardo Vera, featuring Penélope Cruz. Spain: Lolafilms, Iberoamericana Films, and Sogetel. http:// en.celestinavisual.org/collections/show/39.

Index

Toronto Iberic